Oriental Art

A Handbook of Styles and Forms

by Jeannine Auboyer, Michel Beurdeley,
Jean Boisselier, Huguette Rousset
and Chantal Massonaud

translated by Elizabeth and Richard Bartlett

D1623772

RIZZOLI
NEW YORK

The illustrations in the following chapters were prepared by Odette Mukherjee: Sri Lanka, Burma, Thailand, Laos, Cambodia, Indonesia, Champa, Vietnam, The Buddha's Gestures, Korea, Japan; and the illustrations in the other chapters were prepared by Muriel Thiriet. Marie-Claude Lepeyre was responsible for the maps.

© 1980, Office du Livre, Fribourg, Switzerland

English edition published 1980
in the United States of America by:

*R*IZZOLI INTERNATIONAL PUBLICATIONS, INC.
712 Fifth Avenue/New York 10019

Library of Congress Catalog Card Number: 79-92107
ISBN: 0-8478-0272-8

Printed in Switzerland

CONTENTS

There are a list of major museums and a concise bibliography following the introduction to each country.

PREFACE

Western tourists travelling to the East are confronted with a multitude of artistic impressions that are difficult to classify, unless they have acquired—during repeated visits—a 'knowledge of the East'.

The Western education we receive in the 20th century does not normally acquaint us with the styles, mythologies, religions and civilizations of that region. When encountering Asiatic civilizations, we need to have recourse to a reliable guide to be able to perceive the correct relationship of the objects, sculptures or temples we may come across to similar works belonging to other Oriental civilizations, with which we may already be more familiar, and so understand these works of art and compare them with others.

To compare and to understand is, in brief, the aim of this handbook. It is the outcome of my frequent journeys to the East and Far East, when I have continually felt the need for such a work of reference. The book can clearly fulfil the same functions in a museum, a sale-room or elsewhere.

How should it be used? The general arrangement is this. Each great civilization is treated separately. A short introduction giving a brief account of its art and history is followed by a classification of that civilization's art into a number of categories: e.g. temples, architectural decoration, sculpture, ceramics, the minor arts, etc. The arrangement within each category is always chronological so that the reader can pursue the development of different styles for a particular type of object in one civilization and compare them with developments occurring in neighbouring civilizations.

JEAN HIRSCHEN

SYSTEMS OF TRANSCRIPTION USED

- for Chinese: Wade-Giles transcription
- for Tibetan: English transcriptions
- for Sanskrit: transcriptions of the Ecole française d'Extrême-Orient, occasionally adapted in cases where the letters used in English to denote a particular sound differ from those used in French, and with the following additional modifications:

 - Long vowels are indicated by having a dash (–) placed over them (except in the case of the names of existing Indian states, for which their normal spelling has been given);
 - Except in the case of the palatal ś and the ñ, dots beneath consonants have been ignored; s is transcribed as ṣh;
 N.B. 'c' is pronounced as if it were ch.

7

LIST OF ABBREVIATIONS

See also Glossary abbreviations, p. 600

A.A. Mus.	Asian Art Museum, San Francisco
Arch. Coll.	Archaeological Collection
Arch. Dept.	Archaeological Department
Arch. Mus.	Archaeological Museum
Arch. Rep.	Archaeological Repository, Angkor
B.C.A.I.	*Bulletin de la Commission archéologique de l'Indochine,* Paris
B.E.F.E.O.	*Bulletin de l'Ecole Français d'Extrême-Orient,* Hanoi, Saigon and Paris
B.M.	British Museum, London
c.	century
c.	*circa*
C.	Cambodia
Cen. Mus.	Central Museum, Djakarta
Ch.	Champa
circum.	circumference
cm.	centimetres
coll.	collection
D.	diameter
dist.	district
F.G.A.	Freer Gallery of Art. Washington, DC
ft.	feet
H.	height
Hist. Mus.	Historical Museum, Hanoi
I.	India
K.I.v.T.	Koninklijk Instituut voor de Tropen, Amsterdam
L.	length
L.C.M.A.	Los Angeles County Museum of Art, Los Angeles
m.	metres
M.	museum
M.F.E.A.	Museum of Far Eastern Art, Stockholm
M.N.A.O.	Museo Nazionale D'Arte Orientale, Rome
M.o.K.	Museum für Ostasiatische Kunst, Berlin
Mun. Mus.	Municipal Museum, Modjokerto
Mus.	museum
Mus. Nat.	Musée Nationale, Phnom Penh
Mus. P. Rep. China	Museum(s) of the People's Republic of China
M.v.L.V.	Museum voor Land- en Volkenkunde, Rotterdam
Nat. Mus.	National Museum
n.d.	no date
N.G.A.	W.R. Nelson Gallery of Art, Atkins Museum, Kansas City, Nebraska

8

No.	number
P.D.F.	Percival David Foundation, London
Phil. Mus. of Art	Philadelphia Museum of Art, Philadelphia
porc.	porcellanous (stoneware)
Pr.	Prāsāt
pref.	prefecture
Publ. E.F.E.O.	*Publications de l'Ecole Français d'Extrême-Orient*
R.C.	Royal Collection, Luang Prabang
R.P.	Royal Palace, Angkor Thom
R.v.V.	Rijksmuseum voor Volkenkunde, Leiden
S.B. Mus.	Sana Budaja Museum, Jogjakarta
S.L.	Sri Lanka
Suppl.	supplement
Th.	Thailand
t.H.	total height
Topkapu S.M.	Topkapu Sarayi Museum, Istanbul
trs.	translation
Univ.	university
V. & A. Mus.	Victoria and Albert Museum, London
VN.	Vietnam
W.	width
(?)	uncertain, unknown

India – Pakistan – Afghanistan – Bangladesh

by Jeannine Auboyer
Curator of the Guimet Museum, Paris

INDIA – PAKISTAN – AFGHANISTAN –
BANGLADESH

The countries that now make up the Indian Union and the republics of
Pakistan and Afghanistan and Bangladesh formed, at certain periods in their
history, a more or less united empire. Although peopled by different races
speaking widely differing languages, this empire's cohesion was brought
about by religious events, the earliest of which was the spread of Buddhism.
Buddhism became established in north-eastern India in the 6th century B.C.
and was introduced from the 1st century A.D. onwards into the other areas
here under consideration. The 7th century A.D. saw the introduction of Islam
into the western areas, while Hinduism (Brahminism) continued to develop
in India itself.

PROTOHISTORY. The area's earliest artistic activity of note occurred during
the period of the Indus Valley civilization. Its main sites (Mohenjo-dāro,
Harappā and Lothal) were inhabited between about 2500 and 1200 B.C.
These settlements are related either directly or indirectly to those of Meso-
potamia, Iran (Susa), Afghanistan (Mundigak), Baluchistan (Kulli, Nal),
and north-west India (Amri in Sind, Kot-diji in Pakistan, etc.). Pottery is
an important means of dating at all these sites thanks to the technique of
stratigraphic archaeology, and some of the receptacles can be regarded as
works of art by virtue of their purity of line and the beauty of their decora-
tion, which consists of stylized animal or plant forms. Sculpture is on a small
scale and includes some rare pieces, notably those excavated at Mohenjo-
dāro and Harappā. The materials used are bronze (cast by the *cire perdue*
or 'lost wax' process), red sandstone, soapstone and limestone; the styles of
these sculptures vary considerably, some pieces bearing a resemblance to
Sumerian types whilst others (those datable to about 1200 B.C.) are already
recognizably Indian. The many terracotta figurines of mother-goddesses and
domestic animals that have been found, are the folk-art of the common people
and are contemporary with the sculptures. A great many examples of carved
soapstone have survived. Although they are inspired by Sumero-Akkadian
seals, these skilfully executed carvings nevertheless represent animals of
Indian origin and portray figures, one of which may be related to the god
Śiva. The writing in hieroglyphics that appears on these soapstone carvings
has not yet been deciphered. Good finds of jewellery have also been made.

THE EARLY HISTORICAL PERIOD. The present state of our knowledge
does not enable us to state categorically that works of art as such were pro-
duced during the long interval between the end of the protohistoric period
and the beginning of the historical period; nevertheless, archaeological ex-
cavations have shown that there was some continuity right through to the
3rd and 2nd centuries B.C.—a continuity both of human habitation in these

areas and of its traces, especially in the form of pottery. Not until the appearance of the Mauryan style in the 3rd and 2nd centuries B.C. do the historical period's earliest works of art occur; they are executed in stone. The Mauryan style and the similar Śunga-Kānva style, which prolonged it until the 1st century A.D., prevailed in northern India where they are seen in single commemorative pillars of Persepolitan inspiration, temples and monasteries, cut into the rock, monumental hemispherical reliquaries (stupas) surrounded by balustrades (some of which are decorated with low reliefs representing human figures and animals) and, though these are not numerous, freestanding sculptures usually on a large scale. Apart from the single pillars, which may have an imperial rather than a religious significance, and the earliest caves (both pillars and caves dating from the reign of the Emperor Aśoka, 271–31 [?] B.C.), all the above-mentioned sculptures and monuments were of Buddhist inspiration.

The dominant feature of the architecture of this period is the exact imitation, in stone or rock, of timberwork. These constructions resemble wooden ones held together by nails or by mortise and tenon joints; such characteristics were to influence Indian art for a long time to come. The sanctuaries (caitya) have front entrances consisting of horseshoe-shaped bays. Their barrel-vaulted naves, hewn out of the rock, soar upwards and are sometimes flanked by aisles with half-barrel vaulting. The rows of pillars, separating the nave from the aisles, curve inwards at the far end of the sanctuary to form a semicircular apse containing a miniature stupa around which the ritual circumambulation (pradakshinā) took place. Entry to the temples or monasteries (vihara) is by way of a pillared verandah. The vihara are square and comprise a central room with a flat ceiling around which are the monastic cells.

Two main techniques of sculpture are found: free-standing sculpture, which is not often seen, and high and low reliefs. Statues of figures modelled in the round are somewhat ungainly, and their outlines still lack sharpness, but they do show a taste for detail (jewellery, hairstyles, textiles, etc.). The reliefs that appear on the handrails, the uprights and the cross-beams of the balustrades surrounding the stupas (Bhārhut, Sāñcī = Sānchī, etc.) illustrate episodes from the life of the Buddha and from his previous lives (jātaka) in a style which, though at first naïve (3rd and 2nd centuries B.C.), became more elaborate later (1st century B.C. to 1st century A.D.).

THE TRANSITIONAL PERIOD. The 1st to 4th centuries A.D. saw the development of styles which, though new, nevertheless retained many of the characteristics of earlier styles, because of continuity in motifs and iconographic themes. There were three main schools of art during this period: in northern India, the Mathurā School; in Pakistan (in what was the ancient kingdom of Gandhāra) the so-called Graeco-Buddhist School; in south-east India, the School of the Krishnā (Kistnā) or the Amarāvatī School. These schools have certain features in common, yet each has its own distinguishing characteristics. The styles are linked by their adoption of Buddhism and by their creation of its iconography and of the aesthetic ideal that informs it— an ideal of calm and serenity into which a deliberate dynamism was injected only towards the end of the period.

Cave architecture continued to develop. In the temples cut into the rock, architectural decoration played an increasingly important role (capitals, broad friezes, donors' screens on façades, etc.), as can be seen at Kārlī, Kanherī, etc. (Bombay region, 2nd and 3rd centuries A.D.).

Free-standing architecture is represented by stupas and by the brick foundations of monasteries and temples as well as by iconographic representations. The monumental stupas of this period, in a better state of preservation

in Pakistan (Guldara and elsewhere), are more cylindrical in shape and bear architectural decoration (blind arcades, pseudo-Corinthian pilasters) that continues the tradition of Hellenistic architecture modified by Persian influence but with the addition of the Indian arch. The smaller votive stupas are decorated with a profusion of iconographic compositions made of schist carved in relief.

This period is most strongly represented by its sculpture, which includes free-standing figures and narrative reliefs carved out of schist in Gandhāra, red sandstone at Mathurā and white marmoreal limestone at Amarāvatī. The Buddha had previously been represented in Buddhist scenes by mere symbols, but during the Transitional Period he begins to appear in sculptures at about the same time in Gandhāra and at Mathurā (1st to 2nd century A.D.), though slightly later at Amarāvatī.

The styles of these three places are sharply differentiated: in Gandhāra, Hellenistic influences predominate—draped garments carved in the antique manner so as to appear 'damp', faces with straight noses that seem mere continuations of the foreheads, boldly delineated mouths and narrow curled moustaches. At Mathurā, the feminine aesthetic continues that of Sāñcī (fullness of forms, supple figures in the triple-bend posture *(tribhanga)*, details standing out clearly in sharp relief). The sculptors at Amarāvatī excelled in the carving of very beautiful narrative reliefs, many of which are circular. The poses of the figures in these compositions give an impression of life and vitality—a feature that becomes more pronounced in the later phase of this school's activity, during the 3rd and 4th centuries; fine examples can be seen at Nāgārjunakonda.

Our knowledge of Indian sculpture during this period is increased by the ivories unearthed at Begrām (Afghanistan); they are modelled in a style akin to that of the Schools of Mathurā and Amarāvatī.

Mural painting is represented at Ajantā (caves 9 and 10) by compositions in the style of Amarāvatī, which are now much effaced by the passage of time.

THE CLASSICAL PERIOD. The Gupta dynasty, which ruled during the 4th and 5th centuries, provided the stimulus for a period in which the notable achievements in every sphere of human activity caused Indian civilization to become an influential force throughout much of Asia. The Gupta style, the result of refining and idealizing the features of the earlier styles from which it is derived, survived by several centuries the dynasty after which it is named. In its later phase, when the forms became heavier and more stereotyped, the Gupta style generated other styles which, though varied, were all ultimately derived from it. This period also saw the gradual development of Hindu art, which had hitherto been virtually non-existent. Generally speaking, it can be distinguished from Buddhist art by virtue of its more dynamic character.

Cave architecture continued to evolve before reaching its full development around the 8th or 9th century. At the beginning of the Classical Period (4th to 6th centuries), the plans of the caves remained unchanged; carved decoration spread to the façades and was also employed on capitals and columns. The thirty caves forming the Buddhist grottoes at Ajantā include fine examples of such decoration. This complex, famous for its mural paintings, is composed of several sanctuaries and numerous monasteries, most of which have chapels. Later, in the 7th century, Brahminic complexes ware carved. A famous Vaishnavite example exists at Mahābalipuram (Māmallapuram) in southeast India. In some places, temples have been carved out of huge boulders, while elsewhere outcropping rocks have been hollowed out to form caves. The plans of these temples vary: some are square, others oblong. Finally, in

the 8th century, the celebrated Kailāsa Temple, part of the large group of caves at Ellorā (not far from Ajantā), was carved in such a way that it stands within the quarry excavated around it. The two-storey temple is linked by a bridge to a building that serves as an antechamber. The shapes adopted for these two complexes dug out of rocky hillsides are the same as those chosen for contemporary structures above ground, whether built of flimsy or durable materials. The shapes common to both types of building make it easier to trace the development of architecture in the open.

Examples of free-standing architecture constructed during the early part of the Classical Period have not survived in large numbers; nevertheless, a few temples still exist. Some are square and flat-roofed with verandahs supported on pillars (temple 17 at Sāñcī), while others are oblong and covered with barrel-vaulted roofs (Kapoteśvara). Later, both types evolved in the same way. The square temples are covered with pyramidal roofs rising in steps to an angular cupola divided into sections; each step is decorated with miniature buildings. The same arrangement was adopted in the case of the oblong temples, the ends of their barrel-vaulted roofs terminating in horseshoe-shaped pediments, having tympana with varying degrees of decoration.

From this period onwards, very little sculpture in the round was carved; henceforth, the sculptures usually took the form of figures carved in very high relief on steles. The sculpture compensates for a certain loss of technical innovation by the beauty with which its heavily draped figures are modelled, by the idealization of physical features and by the polished manner of its execution. Buddhist sculpture reached its apogee in the 5th century, and this age of supreme achievement continued into the 6th century. Two schools can be distinguished: the sculptors of the Mathurā School carved figures of the Buddha wearing a robe and a monastic cloak covering both shoulders and draped in shallow, concentric folds; those of Sārnāth (Benares) sculptured Buddhas with clothing that does not cover the right shoulder and is so smooth and tight-fitting that the whole body appears naked. Behind the head of each type of Buddha is a large halo decorated with floral scrollwork. The faces of the Buddha, with their half-smiling lips and slightly lowered eyes, are idealized. It was during this period that the marks of saintliness (the spot between the eyes, the curly hair, the elongated ear-lobes, etc.) and the canonical hand gestures *(mudrās)* became conventionalized (see 'The Buddha's Gestures', p. 365). The expressiveness and composition of the Buddhist narrative low reliefs, on the other hand, went into a sharp decline at this time.

In the second part of the Classical Period, Brahminic high reliefs of excellent quality were carved: the magnificent 7th-century Vaishnavite compositions at Mahābalipuram (Māmallapuram) are among the finest examples ever executed in the Pallava style, while the huge figures carved at Elephantā in the 7th century and the scenes carved at Ellorā in the 8th illustrate the mythology of the *Mahābhārata* and the *Rāmāyana,* epics of Hindu India. These sculptures, in which violent rhythms and dynamic figures predominate, possess little of the calm and serenity so typical of Buddhist carvings.

Some of the most beautiful works of art of this period are the bronze statues and statuettes cast by the *cire perdue* technique; those found at Nālandā in Bengal are especially fine.

Terracottas had been produced since prehistory, but those created during the Classical Period are particularly varied, and some attain considerable proportions (Ahichhatrā). Reliefs modelled in this material decorated the bases of monuments (Pahārpur, 8th century). The animated appearance of these terracottas, a part of the folk-art of India, provides a pleasing contrast to the rather stiff style of some of the more official art.

THE MEDIEVAL PERIOD. After the fall of the Gupta dynasty, power-ful kingdoms became established throughout India. Buddhism had almost totally disappeared from India, but it retained some adherents in the north-east of the country. The slow but relentless advance of Islam, which had be-gun in the 8th century, continued from west to east until Islam finally reached southern India. While tradition remained an important influence on the arts, local variations of each major style resulted in the creation of local styles, each having their own distinguishing features. Considerable development of free-standing architecture occurred during the Medieval Period with the construction, both in north and south India, of great temples and vast reli-gious complexes. The temples are of two main types: in the south, preference was given to the *vimāna* that continued the use of a square structure sur-mounted by a roof in the form of a stepped pyramid, crowned with an angular cupola divided into sections—the type of temple built at Mahābalipuram in the 7th century; in the north are found square temples each surmounted by a *śikhara*—a truncated pyramid curving inwards and resembling an artillery shell. The finest examples of these two types of temple were constructed about the year 1000 at Tanjore in the south and at Bhuvaneśvara and Khajurāho in the north. There exist many variations on these two styles (cuspate and stellate plans, etc., as for example at Mysore).

The form of the early temples, oblong in shape and with barrel-vaulted roofs, was now adopted for the monumental gateways let into the walls surrounding temples. These gateways became more and more gigantic (Chidambaram, 14th century; Madurai, 16th century) and are profusely decorated with sculptures of deities. Hardly any Buddhist sculpture was carved from now on, except that executed in the Pāla style in north-east India. From the 9th century to the 12th, the Pāla style reflected the influence of the post-Gupta styles but rendered details in a drier and less naturalistic manner. Sculptures of Hindu deities were also carved in this area.

There were two main types of sculpture during the Medieval Period. The number of sculptures used for decorating the exteriors of buildings gradually increased until they covered almost the entire wall surface. The figures be-longing to the second category—that of sculpture in the round—were either of stone or of bronze; these were set up inside temples, consecrated and used in worship. The stylized rendering of the bodies and faces of the beauti-fully carved 'loving couples' *(mithunas)* and erotic groups of the north makes them quite unique (Bhuvaneśvara, Khajurāho, 11th century, Konārak, 13th century). The style of southern-Indian sculpture was more restrained but not lacking in elegance (Tanjore, Gangaikondacolapuram, 11th century).

Narrative low reliefs were henceforth relegated to a largely ornamental func-tion, and the medieval examples in this genre do not bear comparison with the beautiful compositions of earlier periods.

Bronze was employed throughout India for casting figures as well as for the production of ritual objects such as lamps, dishes, bells, etc. The bronze figures of southern India owe their reputation to their absolute purity of form allied with a sense of balance in movement (dancing Śiva, for example). The greatest achievements in the realm of bronze-casting belong to the 10th and 11th centuries.

THE MUSLIM AND MEDIEVAL PERIOD. The Muslims, having reached Sind (Pakistan) during the 8th century, advanced slowly eastwards until, by the 12th or 13th century, they had occupied northern and central India where they fought among themselves. During the 16th century, their Indian con-quests, which by then included part of the south, came under Moghul domination. The Moghuls, of Turkic extraction, ruled until the 18th century.

India – Pakistan – Afghanistan

Islamic architecture abounds in India—mosques, palaces, citadels, fortified castles, bridges, etc.—and is not only plentiful but varied, its style changing from one region to the next. In the north-west (Sind, Gujarāt, Kāthiāwār), materials from the Hindu temples destroyed by the invaders were reused during the 13th and 14th centuries, and the buildings constructed from them can literally be termed Indo-Islamic. At the same time, mosques and minarets of Persian inspiration tempered by Indian influence were built at Delhi (the Qut'b Minār, for example). The Moghul dynasty's seat of government was in this region, which is more renowned than any other for the many vast and magnificently decorated examples of Islamic architecture surviving within it (Sahsaram, Fatehpur-Sikri, Agrā, Sikandra, 16th and 17th centuries). Although these buildings were at first of Persian inspiration, Indian influence is discernible in the later Islamic architecture, and, here and there, Turkish and Persian features also appear.

During the same period, more massive and severe buildings with bulbous or fluted domes were constructed in the south (Bijapur, Golconda, Gulbarga, 14th century to the 17th).

MINOR ARTS AND TECHNIQUES. The illustrations to manuscripts, executed on palm-leaf or on paper, are the supreme achievement of India's Islamic period. Although there had already been in India a long and continuous history of manuscript illustration (especially of Buddhist manuscripts), it was during this period that this tradition acquired a new lease on life and reached greater heights than ever before. Similarly, many of the other techniques practised in ancient India were revived in the Moghul Period (16th to 18th centuries) and have flourished ever since. Metal-working was commonly practised in India; iron-casting attained a high degree of perfection as early as the 4th century (the column at Dhāra, 13 metres [43 feet] high; the pillar at Delhi, 5th century). Solid gold and silver were used for coinage, jewellery and figurines, and some of the statues cast in bronze, brass or copper by the *cire perdue* technique in the non-Muslim areas of India are on a large scale. Newly discovered alloys came into vogue during the Medieval Period. One of these is *bidri* (named after Bidar in the Deccan)—an alloy of lead, zinc and tin. Work with one metal inlaid on another was much in demand, either for the sharp contrasts it offers (silver or gold on *bidri*-ware, the surface of which is blackened by a chemical process) or for the subtle effects of 'tone upon tone' (brass on copper, etc.) that it makes possible. The techniques of damascening and chasing were also practised; these methods of fashioning and ornamenting metalwork were used by Hindu craftsmen for objects associated with worship (receptacles, vases, lamps, spoons, combs, etc.) as well as for everyday utensils (trays, boxes, betel-cutters, hairpins) and ceremonial arms such as elephant-goads. It goes without saying that Muslims used these techniques for decorating utilitarian objects and weapons only.

An art allied to metal-working is that of enamelling. It flourished from the Moghul Period (16th to 18th centuries) onwards at centres such as Jaipur, Delhi, Lucknow and Multān. Two methods of enamelling were employed—the champlevé technique (on gold, silver and copper) and the cloisonné technique.

Wood-working is one of the oldest crafts practised in India as is proved by the innumerable copies in rock and stone of buildings constructed of timber; however, ever-increasing urbanization reduced demand for this material. Carts decorated with panels of teak carved in bold relief, depicting the Hindu pantheon and its mythology, are still made in the south-east, but this craft is dying out. From the Moghul Period onwards, inlaid work and marquetry—

used to decorate furniture and stringed musical instruments—attained a high degree of perfection; sandalwood, teak and ebony were employed, with the addition, for greater decorative effect, of mother-of-pearl and, in Bengal, of strips of brass.

Ivory-carving has been practised continuously in India and Sri Lanka (Ceylon) from a very early period and is mentioned in texts of great antiquity. Ivory may be pierced, fretted, turned on a lathe, carved in high or low relief, engraved or decorated with coloured pigments and therefore lends itself to the brilliant displays of virtuosity for which it has increasingly tended to be reserved. Statuettes, cases, caskets, combs, book-covers, compasses and many other objects have either been made from solid ivory or decorated with a veneer or an inlay of it. Sometimes ivory is overlaid with coloured lacquer or decorated with miniature paintings.

Many other materials were used in the making of the costly and prestigious articles that supplied the markets in which India's reputation was made. For example, from early times rock-crystal had been fashioned into Buddhist reliquaries in Pakistan and into weights and sandalwood burnishers in Sri Lanka. Precious stones, for which India was, and still is, famous, also deserve mention. The Moghuls used rock-crystal to make cups and bowls and jade inlaid with gems set in gold to make hookah-bases, handles for sabres and daggers, jewellery, rosaries, archers' thumb-rings, etc. Glassware, imported from Persia, was highly prized. Earthenware, of Muslim origin, was used to make tiles decorated with animals, flowers and geometric designs; these were arranged to form the splendidly colourful floors and walls still to be seen at Gwālior, Lahore, Multān and elsewhere. The production of white marble inlaid with coloured stones was the speciality of the craftsmen at Agrā (Taj Mahal; 17th century).

Two other materials worthy of mention are stucco, used for architectural decoration, and lacquer, used for decorating objects. The former, frequently employed during the earliest centuries of the Christian era in what is now Afghanistan, was, during the period of Muslim rule, shaped while still a paste and then left to harden. A rich decorative effect was achieved when stucco was covered with a layer of gesso that was then gilded by brushing on it a mixture of myrrh, copal and oil that was varnished when dried. The technique of lacquering as practised in India was far inferior to the process invented by the Chinese. The sticks or pellets of partially solidified lacquer are pressed against a rapidly revolving wooden object; the heat thus generated causes the lacquer to adhere to the body of the object.

Finally we come to textiles, which, throughout the historical period, were an Indian speciality. Cotton, wool and silk (the latter imported from China since a very early period) were the basic materials from which Indian textiles were woven on foot-operated, low-warp looms. Some textiles were enriched with gold thread; others were decorated by dyeing, by printing either with wood-blocks or blocks of carved earthenware (Lucknow, Lahore, Sanganir, etc.), by embroidery (Rājasthān, Punjāb, Lucknow, Sri Lanka) or by stencilling. In Rājasthān, the design is reserved on the material by the batik process—a technique widely used nowadays in the other regions; small pieces of mirror-glass secured by buttonhole stitches are inserted into many of these textiles.

THE MODERN PERIOD. It must be admitted that, as far as architecture and sculpture are concerned, the creative powers so much in evidence during India's glorious artistic past have gradually waned. This process can perhaps be attributed to the stranglehold exercised over Hindu India, firstly by the Muslims and later by the English. The output of India's craftsmen is,

however, still considerable, for the Muslims stimulated production to the continuing benefit of the Hindu crafts. There are, nonetheless, some grounds for apprehension, since the directives issued by the state workshops, although well intentioned, may result in a permanent loss of creative talent.

PAKISTAN

BEFORE ISLAM. Two very fecund periods in the early history of the area covered by present-day Pakistan were the prehistoric period (the cultures of Sind and Baluchistan around 3000 B.C.) and the protohistoric period (the Indus Valley civilization of about 2500 to 800 B.C.). These periods were followed by a historic phase of great interest, since this area, at first part of the Achaemenid Empire, experienced in 326 B.C. the effects of the 'raid' of Alexander the Great of Macedon, as he advanced towards the Indus. During the centuries that followed, Buddhism, spreading westwards from India, came into contact with this Hellenistic culture; the resultant, highly original, artistic flowering, which continued unbroken over several centuries, is known as 'Graeco-Buddhist' art.

The conversion to Buddhism of the inhabitants of several provinces in Pakistan heralded a period of remarkable religious and artistic activity (Gandhāra, Swāt) that continued under the rule of the (Indianized) Kushāns during the 1st and 2nd centuries A.D. This activity was suppressed by the brutal destruction inflicted by the Hephtalite Huns around the middle of the 5th century and had, according to the Chinese Buddhist pilgrim, Hsuan-tsang, almost ceased by about A.D. 630. In the 7th century this area was conquered by Islam, and Buddhist art having been banished quite soon died out completely.

RELIGIOUS ARCHITECTURE. A distinction should be drawn within this category between monasteries (of which only the excavated foundations remain) and the reliquary or commemorative monuments known as stupas. Although each of the two sometimes stood alone, they no less frequently formed part of a complex of civil architecture whose foundations alone, as in the case of the monasteries, have survived.

One such complex is that at Taxila where the buildings of the early period were covered by four successive towns. Taxila is mentioned as early as the 6th century B.C. in Persian inscriptions, and Alexander the Great, advancing towards the Indus two centuries later, was received there. The University of Taxila was renowned throughout the Indian world, both Buddhist and Brahminical. Temples have been found at Taxila inspired by Greek archetypes, with Ionic pillars and classical mouldings (Jandiāl, 1st century B.C.); there is also a royal palace within its own stone ramparts with paved courtyards, tiered roofs and tiled and painted walls (Chārsadda, Sirkáp, 1st century A.D.), as well as sacred buildings of Graeco-Iranian character (mostly Buddhist but some Jaïn) and a religious building containing an altar dedicated to fire (Jandiāl), an apsidal temple (Dharmarājika, end of the 1st century A.D.) and several stupas (Sirkap, 1st century B.C., Kālawam, etc.). The architectural decoration of these buildings and some of the methods used in their construction bear witness to the wide variety of stylistic influences (Greek, Hellenistic, Iranian and Indian) acting upon them.

This same phenomenon of varied influences can be observed in all the other ancient Hellenistic provinces that comprise modern Pakistan; these provinces

include Gandhāra (the region around Peshāwar) and Uddiyāna (the Swāt Valley). Most of the towns had an acropolis with a palace/castle as at Udegram and Butkara, both in Swāt. Some monasteries and stupas were also erected on the acropolis, but others were built at some distance from it (Chārsadda, 2nd to 1st century B.C., Takht-i-Bahi, Jamal Garhī, in Gandhāra, etc.). The plan of these monasteries (Giri, Kumāla, Mohra Moradu, Pippala, Jauliān, Bhamāla, etc.) was 'Indian': a square, central courtyard enclosed by pillared cloisters facing inwards, on to which the doors of the monks' cells opened. It was not uncommon for a monastery to have a stupa in the centre of its courtyard. The growth of the religious community sometimes necessitated building on to the earlier monastery a second one constructed according to the same plan. Witnesses have described the splendour of the stupas, many of which now lie in ruins: that of the Emperor Kanishka at Peshāwar was 167 metres (548 feet) high and had 25 'umbrellas' of gilt copper (Hsuan-tsang, c. 630).

SCULPTURE. An extraordinarily large number of sculptures, modelled partly in the round, and of narrative high and low reliefs have been collected from the ruins of these buildings. They are all Buddhist, and it has even been proved that the schools of Gandhāra and Swāt gave birth to the iconographic repertory of Buddhism by providing illustrations for texts that were not, in some cases, illustrated by the Indians who had written and distributed them.

The material most frequently employed for sculpture was schist; its colour varies from one region to another, ranging from light grey through bluish- or greenish-grey to dark grey. Sometimes, though it was less common, moulded stucco was used, and further detail was added by the use of a spatula. The style of this type of sculpture is markedly Hellenistic in the treatment of the draperies and muscles and in its representation of certain persons (for instance, Vajrapāni/Herakles or donors) as particular physical types with stylized costumes and hairstyles incorporating laurel wreathes, as well as in other minor details. The Indian influence can be detected in the details of the narratives—the bodies turned at the hips (in the *tribhanga* pose), the naked torsos, the wealth of jewellery and the symbolic hand-gestures *(mudrās)*. It is even possible that the very earliest representations of the iconographic figure of the Buddha Śākyamuni were created by the School of Gandhāra and not by the Indian School of Mathurā. The Buddha, as portrayed by the sculptors in both Gandhāra and Mathurā, has the features of Apollo and wears a monastic robe whose drapery appears 'damp' as in the sculptures of Antiquity.

This style, known as Graeco-Buddhist, was very classical in Gandhāra but was less refined almost to the point of primitiveness in Swāt.

MINOR ARTS. In addition to the very large numbers of coins dug up from all over this area and representing the entire period, excavations have unearthed numerous examples of pottery and of terracotta figurines (mother-goddesses, pull toys), objects of bone and ivory (gaming dice, dolls) and a wealth of ornaments fashioned in a wide variety of materials (iron, glass, shells, gold, silver). The most elaborate ornaments are those from Taxila (Bhīr Mound, 4th century B.C.; Sirkap, 1st century A.D.).

THE ISLAMIC PERIOD. Sind (the western part of modern Pakistan) was among the first areas of the Indian subcontinent to be occupied by the Muslims. Although this settlement began as early as the beginning of the 8th century, it was only slowly that the Muslims succeeded in gaining control of

the country's administration. One result of this gradual seizure of power was that, at the beginning of the Islamic period, the Muslims erected very few buildings to replace the Hindu temples that they destroyed. During the 11th and 12th centuries, however, mosques were constructed by re-using building materials from these temples.

The development of a truly Islamic style of architecture did not occur until the accession of the Turkic Moghul dynasty early in the 16th century. This architecture was at first derived from Persian models and included the two mosques at Tatta (the Daggīr Masjid of 1588 and the Jāmī Masjid of 1644, constructed of brick with mosaic decoration in white and two shades of blue) and impressive tombs (Jām Nizāmud-dīn, 16th century), for which materials from demolished Hindu monuments were re-employed as they had been several centuries earlier. These buildings are, by and large, lumpish and provincial in style.

Throughout the 17th century and in the 18th century until the decline of the Moghul dynasty's power, the finest examples of Moghul architecture in what is now Pakistan were built in Lahore: bulb domes flanked by two subsidiary domes (cf. Nos. 72–3), pavilions of Indian inspiration and arches inspired by Indian stonework and wood-carving. The red sandstone of Mathurā was used extensively, often in conjunction with black or white marble, with inlaid work using grey or yellow stone and, as in earlier times, decoration with glazed tiles (Lahore Fort, 1631–2). Excellent painted decoration was also produced (the Mariam Zamānī Mosque, 1614), but the high standard of this painting was not sustained over a long period. Many buildings of the period have been destroyed or have fallen into decay through lack of upkeep. The most beautiful of those that have survived are the intact parts of Lahore Fort. The walls are inlaid with a rich decoration of fragments of mirror-glass (Shish Mahal) or of coloured stone set in white marble (the tomb of the Emperor Jahāngīr, dating from 1627, but restored).

Since the area covered by modern Pakistan was an integral part of the Moghul Empire and then of India until the 'Partition' of 1947, the observations made earlier on the history of Indian art during these periods apply with equal validity to Pakistan.

AFGHANISTAN

BEFORE ISLAM. Because of its geographical situation, the area of modern Afghanistan has always been traversed by itinerant merchants who, despite being peoples of different races speaking several languages, traded with one another. From prehistoric times up to the present day, commercial activity has flourished in this region, where important trading routes have always converged.

The earliest recorded period is represented at Mundigak by objects which lead one to believe that, even at such an early date (3000 B.C. to c. 800 B.C.), trading links (albeit sporadic) had been established with Mesopotamia (Susa) and the sites of eastern Iran and Baluchistan (Amri, Nal, Quetta, etc.). The objects excavated consist of plain and decorated pottery, arrowheads, etc. The archaeological site of Mundigak (period II) has affinities with Nad-i Ali—a site of the 8th century that displays close similarities to others to the north and south of the Caucasus.

THE HISTORICAL PERIOD. Much of the free-standing architecture is in a very ruined state, but a notable surviving example is the acropolis of King Kanishka Kushāna (2nd century) at Surkh Kotal. Here a long flight of steps of dressed stone leads up to a wall enclosing a group of temples. A peribolus was situated in front of the largest temple that may have contained a fire-altar. Another fire-altar (temple B) was decorated with birds (eagles?). Pilasters with pseudo-Corinthian capitals decorated with figures and made of dressed stone were the main feature of the Buddhist terrace constructed on a lower level.

The stupas are very similar in style to those of Gandhāra (Guldara, 2nd to 3rd century, Shevaki, 4th century [?]), having capitals decorated with acanthus leaves and cinctures on which rest blind arcades. Another category of stupa is that found within monasteries (for example, at Bāgh-Gai, Tepe-i Kafarihā, Gar-Nao and Tepe Kalan). These stupas, generally of later date and varying considerably in size, are decorated with multi-coloured reliefs executed in stucco. Finally, there are the monasteries: 'the monastery of the Chinese hostages' of Kanishka at Shotorak (2nd century), the large group of monuments of Tepe Shotor at Hadda (Jelalabad) that are being excavated at present and the Irano-Buddhist monastery at Fondukistan (7th century), etc.

Rock-hewn architecture is restricted, for the most part, to the valleys near Bāmiyān, Kakrak and Foladi (c. 3rd to 7th centuries), where Buddhist convents and shrines have been carved out of the high rock-faces as in India and China. Two 'architectural' types were in vogue during the same period: the domed vault and the *Laternendecke* or 'lantern roof', a method of carving that produced an effect resembling cantilevered beams. There are three variants of the domed-vault type—one having transverse ribs running from corner to corner and forming pendentives (cave G at Bāmiyān), another having a single or double tambour (caves A and B at Bāmiyān) and the third having an octagonal shape (Kakrak). The first type is in the Iranian tradition and spread westwards, through Byzantine art, into Romanesque art and architecture. The second type imitates wooden structures and spread eastwards as far as Korea, deriving its impetus from Buddhist art. The walls of all these Buddhist monuments are decorated with paintings.

Much sculpture modelled in limestone, schist, stucco, terracotta or white marble has survived. The most noteworthy examples of sculpture in the round are large statues of royalty similar to that of Kanishka at Mathurā (Surkh Kotal, 2nd century). The style of the schist sculpture closely resembles that of Gandhāran sculpture (Shotorak, 2nd century, Paitava, c. 3rd century, etc.). The figures modelled in stucco and terracotta are the most original, presenting a large variety of types and reflecting, until as late as the 7th century, the influence of Hellenistic and Iranian art. Some of these figures are of colossal proportions (the statues of the Buddha at Bāmiyān are 55 and 35 metres [180 and 115 feet] high), while others are extremely small. Most of them were made at Hadda, and the excavations carried out there can be visited. Finally, influence from Kashmīr can be seen in the sculptures of Brahminic subjects that were executed in white marble during the 8th and 9th centuries.

THE ISLAMIC PERIOD. The golden age in Afghanistan is that of the Ghaznavids (976–1174) and the Ghorids (1174 to the 13th century). Fortresses (Shahr-i-Gholghola in the Bāmiyān valley), three great fortified royal castles (Lashkari Bazar, early 11th century), minarets (Ghaznī, 12th century; Jam, 12th to 13th century) and ruined mosques (the arch at Bust, 13th century [?]) afford ample proof of the beauty of the architecture: spacious

courtyards, buildings of fired or unfired brick, openings with semicircular corbelled arches, and decoration consisting of carved stucco and blue-glazed earthenware often with the addition of ornamental Kufic (Jam, etc.).

Funerary art is represented by the beautiful, white-marble tomb of Mahmud of Ghaznī (11th century). A series of reliefs, also of white marble, depicts people and animals in a style inspired by Iranian art. Lamps and bronze receptacles such as ewers and bowls with engraved or chased designs have also survived from this period, and pictorial ceramics having a shiny metallic finish similar to that of wares from Rayy and Kashan have come down to us from the 13th century.

The 14th, 15th and 16th centuries also saw impressive architectural achievements in Afghanistan. The decorative features of mosques (the Great Mosque at Herāt, the mosque at Mazār-i-Sharīf), and madrasahs (Herāt, 15th to 16th century), tombs (Gāzurgāh, 1425) and sanctuaries (Balkh, late 15th century) were inspired by the Persian Timurid style. The magnificence of these buildings owes much to their facings of glazed earthenware with colour-schemes usually consisting of a combination of various shades of blue heightened by yellow, and to their smooth or ribbed turquoise domes and their tiles with floral decoration.

BANGLADESH

The most important archaeological site in Bangladesh is the great monastery of Paharpur (late 8th to 11th century), which has 177 cells. At Paharpur there is a central, cruciform temple with several terraces. The plinths of the terraces are decorated with almost 2000 terracotta panels depicting, in low relief, various Buddhist and Brahminic (especially Śivaite) subjects rendered in a dynamic, almost popular style. Of special interest are the arches with a voussoir—a method of construction rare in India, but common in Burma, because of the Chinese influence. The same style is seen at the sites that have been examined at Pattikerā (along the road from Dacca to Chittagong).

THE ISLAMIC PERIOD. On the whole, the architecture reflects a provincial style, bearing no relationship to those buildings that contributed so much to the magnificence of the great periods of Muslim rule over northern India.

Five types of building (tombs and mosques) from the pre-Moghul period and dating from 1389/1409 to the beginning of the 16th century may be distinguished: the tomb of Ghiyāt-ud Dīn A'zam Shāh in the shape of a pavilion with columns in imitation of the Delhi style (early 15th century); mosques of oblong shape with pyramidal domes (Shath Gumbad of Khān-i Jahān 'Ali, c. 1459; Daras bārī at Gaūr, 1479); square tombs and mosques having a single dome (1459 to the beginning of the 16th century) and sometimes, as at Surat (1475), a hypostyle narthex; finally, there are some mosques with several domes (from 1465 until 1558). The best example is the Chhotā Sonā Masjid at Gaūr built early in the 16th century. These same types were also used in the 16th, 17th and 18th centuries but with the addition of octagonal turrets at the corners and of stones of varied colours: black basalt from Gaya, grey sandstone from Chunar and white marble from Rājasthān—as seen, for example, on the tomb of Bībī Parī near Lalbagh Fort (1684). In this later period, bricks were also used, and in some areas terracotta was employed for decoration.

MAJOR MUSEUMS

India
Archaeological Museum, Mathurā
Archaeological Museum, Sārnāth
Government Museum and National Art Gallery, Madras
Indian Museum, Calcutta
Municipal Museum, Allahabad
Municipal Museum, Hyderabad
National Museum of India, New Delhi
Patna Museum, Patna
Prince of Wales Museum of Western India, Bombay
State Museum, Lucknow
and numerous museums at sites such as Sāñcī, Bodh-Gayā, Amarāvatī, Nāgārjunakonda, etc. and at temples such as Srīrangam, etc.

Pakistan
Lahore Museum, Lahore
National Museum of Pakistan, Karachi
Peshawar Museum, Peshawar
museums at sites such as Taxila

Afghanistan
Kabul Museum, Kabul

Bangladesh
Dacca Museum, Dacca

France
Guimet Museum, Paris

Great Britain
British Museum, London
Victoria and Albert Museum, London

Italy
Museo Nazionale d'Arte Orientale, Rome

U.S.A.
Boston Museum of Fine Arts, Boston
Los Angeles County Museum of Art, Los Angeles
The Metropolitan Museum of Art, New York
Philadelphia Museum of Art, Philadelphia

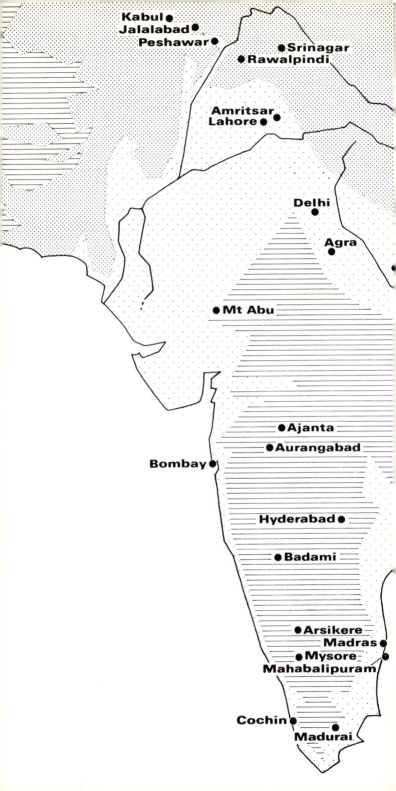

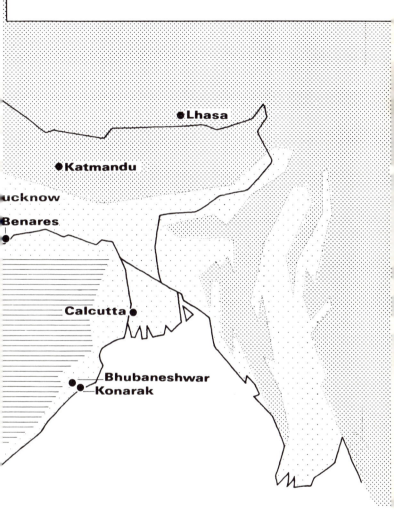

INDIA AND ADJOINING AREAS

░ mountainous ≡ plateau ——————— 250 km (155 miles)

●Lhasa

●Katmandu

ucknow

Benares

Calcutta●

Bhubaneshwar
Konarak

CONCISE BIBLIOGRAPHY

AUBOYER, J. *L'Afghanistan et son art.* Paris, 1968.
——————— *Les arts de l'Inde.* Paris, 1968.
——————— 'Le char du Soleil à Konarak' in *Archaeologia,* no. 23. Dijon, 1968.
——————— 'Kajurâho' in *Encyclopaedia Universalis.* Paris, 1971.
BAREAU, A. *Les religions de l'Inde.* Paris, 1966.
BARRETT, D. *Sculpture of Amarāvatī in the British Museum,* London, 1954.
BROWN, P. *Indian Architecture: Buddhist and Hindu Periods.* 3rd rev. ed. London, 1971.
——————— *Indian Architecture: the Islamic Period.* 5th rev. ed. London, 1968.
COOMARASWAMY, A. *La sculpture de Bhârhut.* Paris, 1956.
DENECK, M.M. *Indian Sculpture* (trs. by Iris Irwin). London, 1962.
DUPUIS, J. *Histoire de l'Inde et de la civilisation indienne.* Paris, 1963.
FERGUSSON, J. and BURGESS, J. *Cave Temples of India.* London, 1880.
FOUCHER, A. *L'art gréco-bouddhique du Gandhāra.* Paris, 1905
——————— and MARSHALL, J. *The Monuments of Sānchī.* 3 vols. Calcutta, 1947.
HACKIN, J. *Nouvelles recherches archéologiques à Begram.* Paris, 1954.
HALLADE, M. *The Gandhāra Style and the Evolution of Buddhist Art* (trs. by Diana Imber). London, 1968.
KRAMRISCH, S. *The Art of India.* London, 1954.
MARCEL-DUBOIS, C. *Les instruments de musique de l'Inde ancienne.* Paris, 1941.
MUNSTERBERG, H. *Art of India and Southeast Asia,* New York, 1970.
VOGEL, J.P. 'La sculpture de Mathurā' in *Ars Asiatica* XV. Paris, 1930.
VOLWAHSEN, A. *Living Architecture: Islamic Indian* (trs. by Ann E. Keep). London, 1970.
——————— *Living Architecture: Indian* (trs. by Ann E. Keep). London, 1969.
YAZDANI, G. *Ajantā.* London, 1930–55.
ZIMMER, H. *The Art of Indian Asia.* New York, 1955.

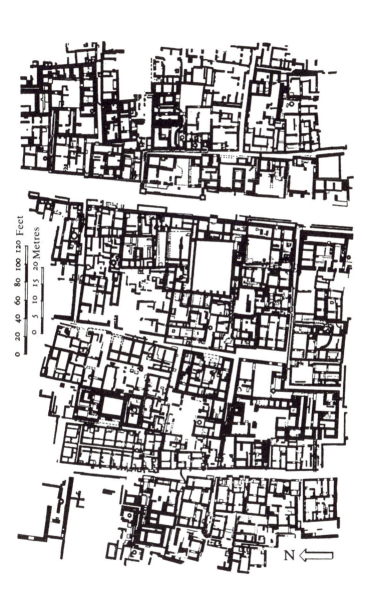

1 Plan: Mohenjo-dāro, *c.* 2000 B.C., Indus valley, Pakistan

2 Plan: cave of Lomās Rishi, Mauryan period (façade 2nd c. A.D.), Bihar

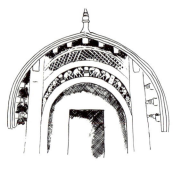

3
Doorway: *dvara torāna* with a frieze of elephants, 2nd c. A.D., cave of Lomās Rishi

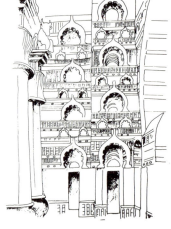

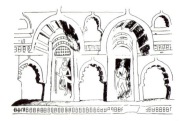

5
Monastery (vihara) no. 20, 2nd c. A.D., Bhāja, Maharashtra

4
Sanctuary *(caitya)* and verandah, 2nd c. A.D., Bedsa, Maharashtra

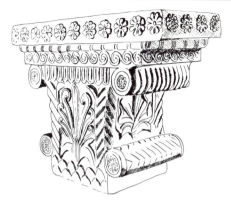

6 Capital: decoration of palmettes, stone, Mauryan period, 3rd–2nd c. B.C., Mus., Patna

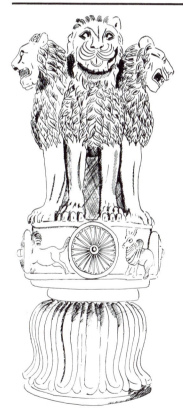

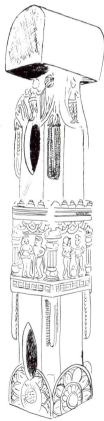

7
Lion capital: 4 lions facing the cardinal points, stone, Mauryan period, Arch. Mus., Sārnāth

8
Column no. 22, stone (notice the mortices), 1st c. B.C., Bodh-Gayā, *in situ*

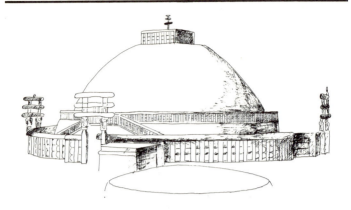

9 Stupa, 1st c. B.C.–1st c. A.D.,| Sāñcī (= Sānchī),\Madhya Pradesh

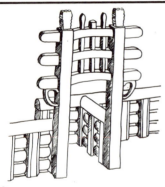

10
Reconstruction of a *torāna* (door-way), Sāñcī, after P. Brown, *Indian Architecture*

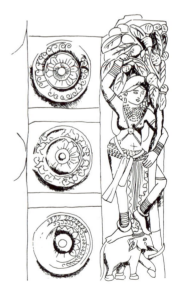

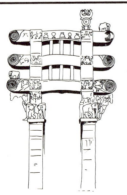

11
Eastern gateway: *2 yakshinī* (protec-tive spirits) forming consoles, stone, 1st c. A.D., Sāñcī

12
The upright of a *vedika* (balustrade): *yakshinī*, red sandstone, h. 2.01 m., 2nd c. B.C., Bhārhut

13
2nd c. A.D., cave of Lomās Rishi,
Bihar

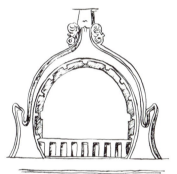

14
1st c. A.D., Bhāja, Maharashtra

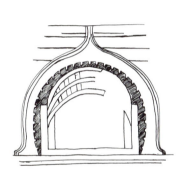

15
2nd c. A.D., Kārlī, Maharashtra

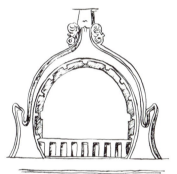

16
6th c., Ajantā, Maharashtra

17
8th c., Viśvakarma, Ellorā, Maha-
rashtra

18
10th c., Bhuvaneśvara, Orissa

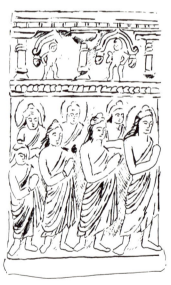

20
Votive stupa, stone, 2nd c. A.D., Takht-i-Bahi, Pakistan

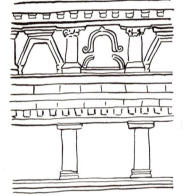

19
Stupa with arches, 2nd c. A.D., Dharmarājikā, Taxila, Pakistan

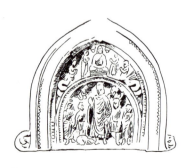

21
Low relief within an arch, schist, 2nd c. A.D., Gandhāra, Belmont Coll., Basle

22
Praying figures, guardian spirits under arches, low relief, schist, 2nd c. A.D., Gandhāra, Belmont Coll., Basle

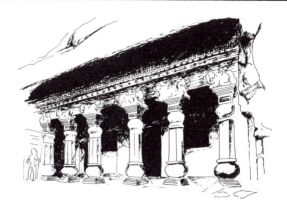

23 Pandulena: cave with Buddhist art, 2nd c. A.D., Nasik, Maharashtra

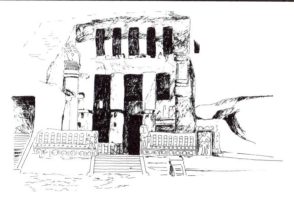

24 Cave 3, 2nd c. A.D., some reliefs are of the Gupta period (4th–6th c.),
 Kanherī

25
Rāni Gumpha, 2 excavated levels,
1st c. B.C., Udayagiri, Orissa

26
Cave 19 at Ajantā, 6th c., recon-
struction as sectional drawing, after
P. Brown

27
Column in cave 12, stone, 6th–7th
c., Ellorā, Maharashtra

28
Column in cave 14, stone, 6th–7th
c., Ellorā, Maharashtra

29 Jaïn cave no. 32, stone, c. 9th c., Ellorā, Maharashtra

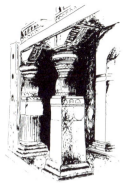

30
Columns midway between *mandapa* (gathering area) and sanctuary, *c.* 7th c., cave 1, Bādāmī

31
Standing Jina, stone, *c.* 7th c., cave 4, Jaïn, Bādāmī, Mysore

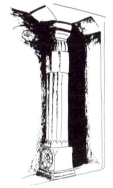

32
Column, stone, *c.* 7th c., Jaïn cave at Aihole, Mysore, *in situ*

33
Jaïn cave, 7th c., outside the village of Aihole, Mysore

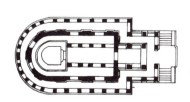

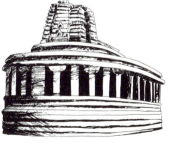

34
Durga Temple: plan after P. Brown showing apsidal shape, 6th–7th c., Aihole, Mysore

35
Durga Temple, back view, 6th–7th c., Aihole, Mysore

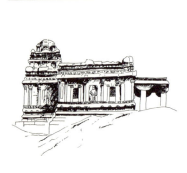

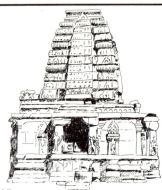

36
Malegitti Śivaleya Temple, 7th c.,
Bādāmī, the Calukya capital in the
6th–7th c.

37
Pāpanātha Temple, *śikhara* (pyramid
dome) in the northern style, 8th c.,
Pattadakal

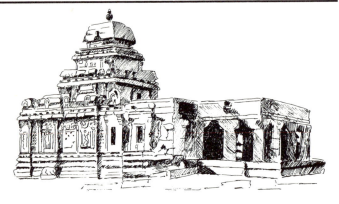

38 Sangameśvara Temple, southern style, 8th c., Pattadakal, Mysore

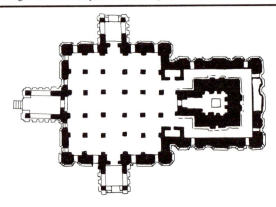

39 Plan of the Virūpāksha Temple, 8th c., Pattadakal, Mysore

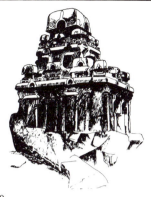

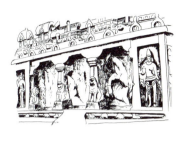

40
Unfinished rock sculpture, *c.* 7th c., Valian Kuttai

41
Dharmarāja-ratha, monolithic sanctuary, 7th c., interior unfinished

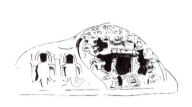

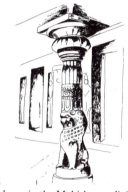

42
'Tiger Cave', with carved lion-caryatids, 8th c., Mahābalipuram

43
Column in the Mahishamardinī cave, 7th–8th c., Mahābalipuram, Tamil Nadu

44
One of the decorative niches on either side of the entrance, Rāmānuja cave, 7th c.

45
Nakula-Sahadeva, the only temple of apsidal plan in the complex of the *ratha* (rock), 7th c., Mahābalipuram

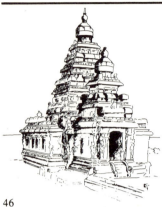
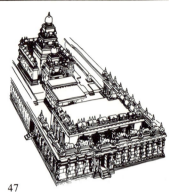

46
Shore Temple, stone, Śivaite, 2 sanc-
tuaries, 8th c.

47
Shore Temple: reconstruction after
P. Brown of its appearance in the
8th c.

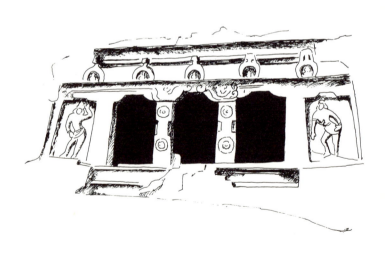

48 2 *dvarapālas* (temple guardians), stone, 8th c., entrance to the Pallava
cave, Delavānūr, Tamil Nadu

49 Temple and sanctuary-tower, Pallava period, 8th c., Panamalai

50 Kailāsanātha Temple: reconstruction after P. Brown, 8th c., Kāñcīpuram

51 Śivaite temple, Cola period, 12th c., Gangaikondacolapuram, Tamil
 Nadu

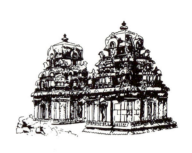

52
South tower, south façade, 10th c.,
Kodumbalur, Tamil Nadu

53
Sanctuary-towers, the only remains
of the Mūvarkoyil temples, 10th c.,
Kodumbalur

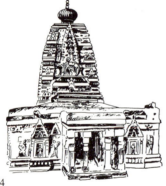

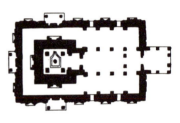

54
East façade of the Svarga Brahmā
Temple, Calukya dynasty, 7th c.,
Ālampur

55
Plan of the Svarga Brahmā Temple,
7th c., Ālampur, Andhra Pradesh

56
Column inside the Viśva Brahmā
Temple, stone, 7th c., Ālampur

57
Mandapa with sculpture of Nandi
the bull, *c.* 10th c., Bandatandra-
pādu, Andhra Pradesh

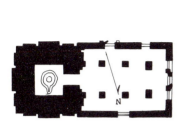

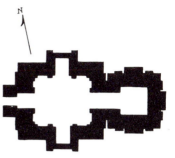

58
Plan of the Paraśurāmeśvara Temple, 7th c., Bhuvaneśvara, Orissa

59
Plan of the Mukteśvara showing its cruciform *mandapa*, 10th c., Bhuvaneśvara

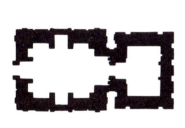

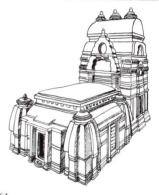

60
Plan of the Vaitāl Deul Temple, 7th–8th c., Bhuvaneśvara

61
Vaitāl Deul Temple: reconstruction after P. Brown, Bhuvaneśvara

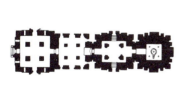

62
Plan of the Lingarāja, a great Śivaite temple, 11th c., Bhuvaneśvara

63
The Sun Temple: ruined sanctuary-tower, 13th c., Konārak, Orissa

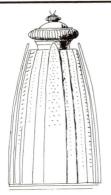

64
Śikhara: Adinātha Temple, 10th c., Khajurāho, Madhya Pradesh

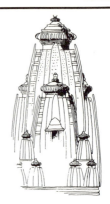

65
Development of the *śikhara,* Temple of Bisvanātha, 10th c., Khajurāho

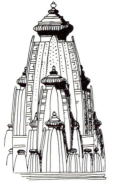

66
Development of buildings in miniature around the *śikhara,* Parsvanātha, 11th c.

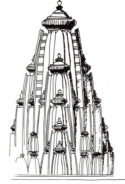

67
Complexity of the *śikhara,* Kandariyamahadeo Temple, 11th c., Khajurāho

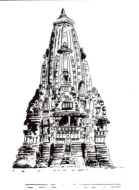

68
Viśvanātha Temple, Candela dynasty, 11th c., Khajurāho

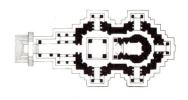

69
Plan of the Kandariyamahadeo Temple, dated to 1050, Khajurāho

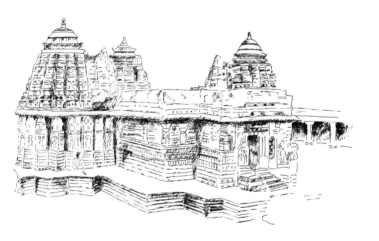

70 Keśava Temple, 15th c., Somnathpur, Mysore

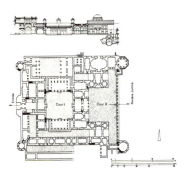

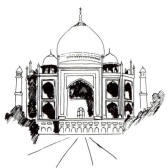

71
Plan of the Jahāngīri Mahal, 1570, Red Fort at Agrā

72
The Taj Mahal: mausoleum of Mumtaz Mahal, marble, 1632–54, Agrā

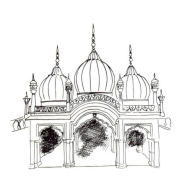

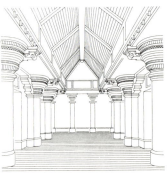

73
Moti Masjid (Aurangzeb's mosque), red sandstone and marble, 17th c., Delhi

74
Audience chamber, Man Singh's Palace, marble, 15th c., Gwālior Fort

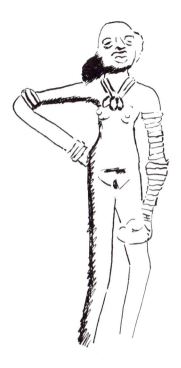

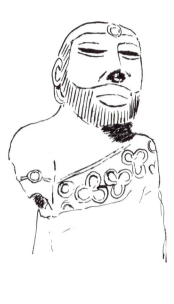

75
Woman called 'the dancer', bronze, *c.* 2000 B.C., Mohenjo-dāro, Karachi Mus.

76
Man (bust) wearing cloak, limestone, H. 0.175 m., *c.* 2000 B.C., Mohenjo-dāro, Nat. Mus. of India, New Delhi

77
Torso of a man, H. 0.09 m., *c.* 2000 B.C., Harappā, Pakistan, Nat. Mus. of India, New Delhi

78
Square seal: humped ox and inscription, *c.* 2000 B.C., Mohenjo-dāro, Nat. Mus. of India, New Delhi

79
Woman with bird, moulded terra-
cotta, H. 0.11 m., Śunga dynasty,
1st c. B.C.

80
Winged figure, terracotta, H. 0.155
m., Śunga dynasty, 1st c. B.C., Kau-
śambi

81
Statuette of a woman, terracotta,
Mauryan or Śunga dynasty, 3rd–1st
c. B.C.

82
Statue of a woman wearing a pannier,
Mauryan dynasty, 3rd–2nd c. B.C.,
Pāṭaliputra, Mus., Patna

83
Yaksha (mythical being), sandstone, H. 1.81 m., Mauryan dynasty, 3rd to 2nd c. B.C., Indian Mus., Calcutta

84
Head of a man, stone, head-dress typical of about the 1st c. A.D., Sāñcī

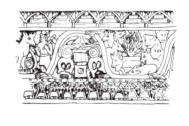

85
Yakshinī: tree-goddess, stone, 1st c. A.D., east gateway, Sāñcī, *in situ*

86
Detail of the handrail, stone, 2nd c. B.C., Bhārhut, Indian Mus., Calcutta

49

88
Head of an ascetic, stucco, 3rd c. A.D., Hadda, Afghanistan, Guimet Mus., Paris

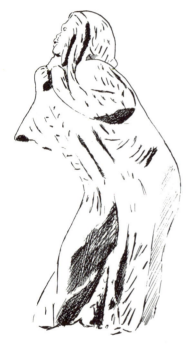

87
Demon wearing a fur cloak, stucco, 3rd c. A.D., Hadda, Guimet Mus., Paris

89
Head of an ascetic, stucco, 3rd c. A.D., Hadda, Afghanistan, Guimet Mus., Paris

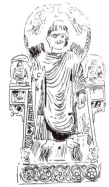

90
Monk and *devatā* (deity), fragment of a low relief, schist, 2nd c., Butkara, Swāt, M. N.A.O., Rome

91
Buddha of the Great Miracle of Sravasti, schist, 2nd c., Paitava, Guimet Mus., Paris

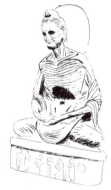

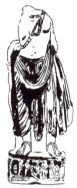

92
Emaciated Buddha, *c.* 2nd c., found only in the Gandhāran style, Lahore Mus., Pakistan

93
Standing Bodhisattva, *c.* 2nd c., Saharī Bahlol, Gandhāra, Rietberg Mus., Zurich

94
The 'Great Going-Forth', stucco, 4th c., Hadda, Afghanistan, Guimet Mus., Paris

95
Guardian Spirit with Flowers, stucco, 3rd c., Hadda, Afghanistan, Guimet Mus., Paris

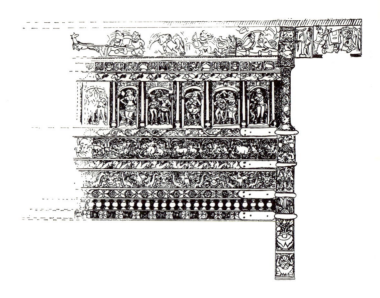

96 Reconstruction: back of a seat from Begrām (Afghanistan), panels of
 open-work executed in carved ivory, 2nd c., Kabul Mus.

97 Reconstruction: back of a chair with curved cross-bar from Begrām
 (Afghanistan), copper rivets and panels, ivory framework, 2nd c., Kabul Mus.

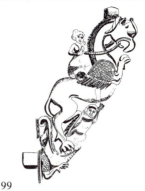

98
No. 97 continued: positions of consoles and copper panels supporting ivory panels from Begrām

99
Ivory console from No. 98, links back of chair to cross-bar, carved in the round, 2nd c., Begrām, Kabul Mus.

100 Scene in the women's apartments, panel of carved ivory, 2nd c., Begrām, Afghanistan, Kabul Mus.

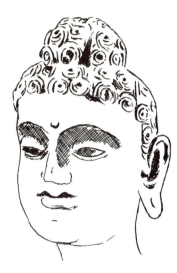

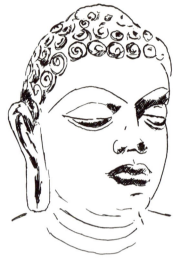

101
Head of the Buddha: hairstyle with large flattened curls, schist, Gandhāra, Belmont Coll., Basle

102
Head of the Buddha: refined physiognomy, sandstone, Gupta style, Arch. Mus., Mathurā

103
Figures under an arch, schist, 1st–2nd c., Butkara, Swāt, M. N. A. O., Rome

104
Women under an arch: style derived from those made of timber, ivory, Begrām, Kabul Mus.

105
Palace interior, marble medallion, 2nd c., Amarāvatī, Andhra Pradesh, Gov. Mus., Madras

106
Buddha represented by his throne, marble, 2nd c., Amarāvatī

107
Birth of the Buddha, part of a low relief, marble, 2nd c., Amarāvatī

108
A couple, detail from a handrail, stone, 3rd c., Nāgārjunakonda, Andhra Pradesh, *in situ*

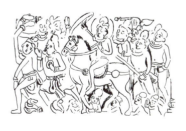

109
A couple, detail from a handrail, stone, 3rd c., Nāgārjunakonda, Andhra Pradesh, *in situ*

110
The 'Great Going-Forth', low relief, stone, 3rd c., Nāgārjunakonda

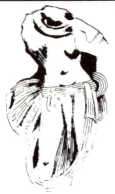

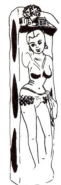

111
Nāgarāja, the 'snake-king', red sand-
stone, H. 1.16 m., 2nd c., Mathurā,
Madhya Pradesh, Guimet Mus., Paris

112
Woman, the upright of a *vedika*
(Buddhist balustrade), red sand-
stone, 2nd c., Mathurā

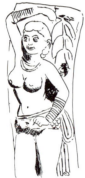

113
Yakshinī holding a branch of aśoka,
red sandstone, H. 0.52 m., 1st–2nd
c., Mathurā, V & A Mus., London

114
Female figure, 2nd c., Gandhāra

115
Woman under a tree, stone, 10th c.,
Mukteśvara Temple, Bhuvaneśvara,
Orissa, *in situ*

116
Yamunā, a river-goddess, terracotta,
5th–6th c., Ahichhatra, Bengal, Nat.
Mus. of India, New Delhi

117
Yamunā, a river-goddess, on a tor-
toise, stone, 7th c., Ratnagiri, Orissa,
in situ

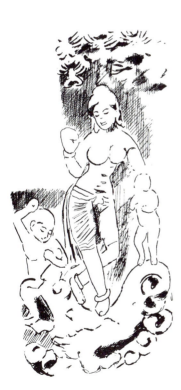

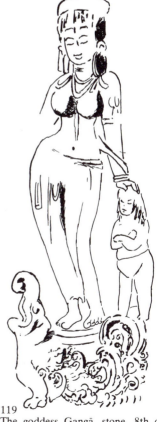

118
The goddess Gangā (the Ganges) on
a *makara*, stone, 7th c., Besnagar

119
The goddess Gangā, stone, 8th c.,
façade of the Ravana *kakhai* grotto,
Ellorā

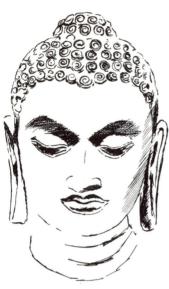

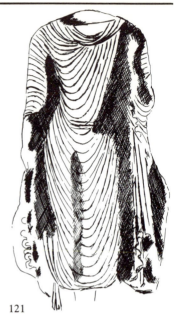

120
Head of gentle, spiritual Buddha, sandstone, Gupta, 5th c., Nat. Mus. of India, New Delhi

121
Standing Buddha in a transparent monastic robe with many folds, Gupta, 5th c., Arch. Mus., Mathurā

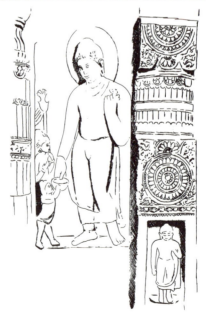

122 The offering of a handful of dust, Gupta, 6th c., façade of cave 19, Ajantā

123
A woman removing a thorn from her
foot, sandstone, 11th c., Dula Deo
Temple, Khajurāho

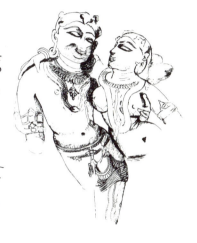

124
Divine couple, sandstone, H. 0.65 m.,
11th–12th c., Khajurāho, *in situ*

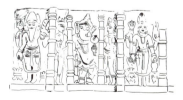

125
Loving couple *(mithuna):* style
typical of Khajurāho, sandstone,
11th c., *in situ*

126
Ganeśa between Śiva and Brahmā,
low relief, sandstone, 11th c., Khaju-
rāho Mus.

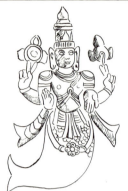

127
The fish: 1st avatar of Vishnu, stone, 14th–15th c., Varadarāja, Kāñcīpuram, *in situ*

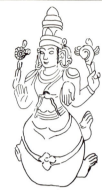

128
The tortoise: 2nd avatar of Vishnu, stone, 14th–15th c., Varadarāja, Kāñcīpuram, *in situ*

129
Narasimha or Vishnu punishing the infidel, stone, 8th c., cave 15, Ellorā, *in situ*

130
Vāmana or Trivikrama: the 6th avatar of Vishnu, stone, 6th c., Bādāmī, *in situ*

131
Krishna Govardana: a form of Vishnu, stone, 7th c., Suvali Temple, Bādāmī, *in situ*

132
Vishnu reclining on the snake of eternity, stone, 7th c., Aihole, Prince of Wales Mus., Bombay

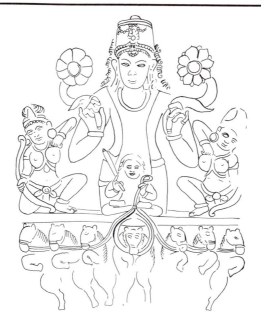

133 Sūrya, the sun-god riding on a chariot drawn by 7 horses, stone, 7th
 c., Vaitāl Deul, Bhuvaneśvara, *in situ*

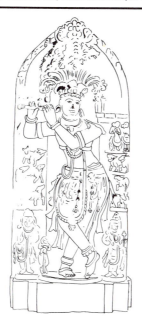

134 Krishnā playing the flute, stone, 15th c., Kesava Temple, Somnathpur,
 in situ

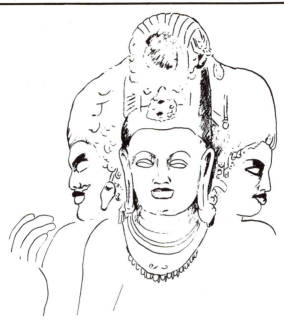

135 Maheśamūrti: 3 aspects of Śiva—terrible, peaceable, feminine, stone, 6th c., Elephantā

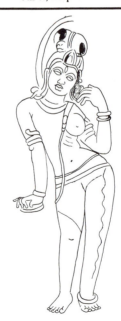

136 Śiva Ardhanarīśvara: androgynous form, stone, 7th–8th c., Mahākuteśvara, *in situ*

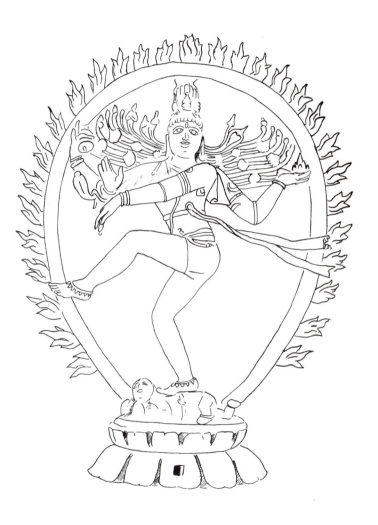

137 Śiva Natarāja or the cosmic dance of Śiva, bronze, 11th c., Guimet
Mus., Paris

138
Cāmunda: terrible emaciated form of
the goddess Kāli, stone, 12th c., Sena,
Nat. Mus. of India, New Delhi

139
Durgā slaying the buffalo-demon,
stone, 8th c., Śiśireśvara, Bhuvaneś-
vara, *in situ*

140 Mahishamardinī, stone, 11th c., Subrahmānyam, Tanjore, Tamil Nadu,
in situ

141
Medallion: decorative motif, sand-stone, 2nd c. B.C., Bhārhut, Indian Mus., Calcutta

142
Low relief: decoration of foliage, stone, 10th c., Mukteśvara Temple, Bhuvaneśvara, *in situ*

143 Low relief: dancing scene, marmoreal limestone, 3rd c., Amarāvatī

144 Column with decorative sculptures, Medieval Period, 8th–12th c., Rajim, *in situ*

145 Lintel: a human figure on a *makara,* Medieval Period, 9th–14th c., Kedareśvara, Halebīd, *in situ*

146 Panel: border set with semi-precious stones and carved flowers, marble,
Taj Mahal, 1632–54, *in situ*

Nepal

by Chantal Massonaud
Emeritus curator at the Guimet Museum, Paris

NEPAL

Nepal covers an area of 141,000 square kilometres (55,000 square miles); the country's length (west to east) is 900 kilometres (560 miles), but its average width is only 160 kilometres (100 miles).

The geomorphological divisions of the country fall into horizontal belts: in the south, the relatively low country known as the Teraï marks the boundary between India and Nepal; then come the Siwaliks, comparatively low mountains, the Mahabharat Lekh, the Nepalese plateau and the cradle of its civilization; then the central region dominated by the great Himalayan range, rising to heights in excess of 8000 metres (26,000 feet) and finally the northern border with Tibet in an area of high valleys and mountains.

Since, in the 6th century B.C., the Buddha was born at Lumbini in the Teraï, it may be said that Buddhism has its origins in Nepal.

The beginnings of Nepalese history are known only from epigraphy. The earliest inscription is dated 464. The Chronicles *(vamśāvalī)* are far more recent; the *Gopala-vamśāvalī,* generally considered to be the oldest Chronicle, was written late in the 14th century.

The development of Nepalese civilization was stimulated by the Newars, a people whose origin is obscure, but who are known to have been the rulers of the Katmandu valley for a long time.

One fact is certain: the Indian emperor Aśoka made a pilgrimage to Lumbini, and commemorative pillars were erected on his orders at the birthplace of the Buddha.

In 1896 at this site, Doctor Führer found the stump of a pillar bearing an inscription proving that Emperor Aśoka had been to Lumbini. Excavations carried out not far from that find have brought to light some terracottas representing human heads and animals that date from the 2nd and 1st centuries B.C.

Lastly, Nepalese archaeologists have discovered, near the Aśokan pillar, a sandstone low relief representing the birth of the Buddha. This sculpture is in the Mathurā style and can therefore be assigned to the 2nd or 3rd century A.D.

The Nepalese attribute to Emperor Aśoka the five stupas at Patan. However, although their shape was inspired by a Mauryan model, this fact alone does not prove their authenticity. According to tradition, Aśoka's daughter founded a monastery at Chabahil, not far from Katmandu, where to this day a stupa is still worshipped.

Firm evidence exists concerning the history of Nepal from the 5th century onwards; this period may be divided as follows: the Licchavi dynasty and its successors (400–750), the Thakuri dynasty and the first Malla rulers (750–1480), the three Malla kingdoms (1480–1768), the Gurkhas (1768 to the present day).

Nepal

The artistic development of Nepal is closely related to the country's political development. Nepalese art, in common with that of all the Himalayan kingdoms, is essentially religious, and the earlier Buddhist and the later Hindu philosophies are at times closely blended. There is no truly secular art. Rulers had fine palaces built, but all the decorative motifs used reaffirm the primacy of the spiritual over the temporal.

The earliest aesthetic influence in Nepal was that of Gupta India, as evidenced by the stone sculptures carved during the Licchavi era. During the 7th century, Nepal was ruled by Tibet whose king, Srong-btsan sgam-po, married the daughter of King Amśuvarman. Exchanges of artistic ideas between the two countries ensued.

In the 8th century, Nepal regained its independence. This is proved by an inscription of 736, but very little is known of the country's history from then until 879. This date marks the point of departure for a new chronology known as *Newari Samvat*.

The Malla dynasty seized the throne in 1082. From then onwards, Nepalese art flourished in all its originality and, along with the Kashmīrī influence, enriched the cultural life of Tibet. The abbots of the great Tibetan monasteries copied Nepalese manuscripts. At a later date, the members of the important Sa-skya-pa monastic order welcomed artists from Nepal. So great was the renown of these artists that the Moghul emperors called upon their services for the decoration of temples and palaces. The celebrated artist Anige (1243–1306) went to China after having been in Tibet.

The foundations of a new style were laid during the reign of Jayasthiti Malla (1350–95). The Golden Age, which lasted from the 14th century until the 17th, reached its zenith in the 15th century with the reign of Yaksha Malla (1428–80), who had the town of Bhatgaon (Bhaktapur) built. This king committed the error of dividing his kingdom among his three sons. The valley was divided between the kingdoms of Katmandu, Bhatgaon and Patan. These three capital cities provide a magnificent illustration of the achievements of Nepalese art: in each one a statue of the founding king looks down from the top of a column upon temples and palaces, of wood and pink brick, built around a central square. Mention should be made of the following kings who were particularly noteworthy: Narasimha Malla (1620–57), the king of Patan; Pratapa Malla (1639–89), the king of Katmandu, and Bhupatindra Malla (1696–1721), the king of Bhatgaon.

The division of the kingdom weakened it to such an extent that in 1768 Prithvi Narayan, the chief of the principality of Gurkha, was able to conquer it. Prithvi Narayan unified Nepal, which is ruled by his descendants to this day.

The Nepalese have displayed their most original talent in wooden architecture and wood-carving, but they have also been skilled adaptors of other artistic techniques for the purpose of decorating their buildings with a rich variety of bronzes, wall-paintings and stone low reliefs.

India provided the initial artistic stimulus for Nepal, as it did for Kashmīr and Tibet. The Newars, who established their supremacy over the valley in which they lived, derived their writing and culture from India but very soon developed their own language.

The stupas are the oldest form of Nepalese architecture, for example the stupa at Carumati and those of the Emperor Aśoka at Patan. Two great stupas, Svayambunath and Bodnath, are places of pilgrimage.

There are three distinct styles of temple architecture: the *śikhara,* the pagoda and the temple with a domed roof. The Nepalese *śikhara* is identical to its Indian counterpart. The Mahābuddha *bahal* at Patan was built in imitation of the Mahābodhi Temple at Gayā. The third tier of the temple dedicated to

Krishna at Patan reminds one of the Panchmahal at Fatehpur-Sikri. Unlike those in India, however, Nepalese temples with *śikharas* are not preceded by a *mandapa*. The pagoda is the commonest type of Nepalese temple. The basic structure of these tiered buildings is composed of interlocking members. Roofs, of which there may be one, two, three or five, are supported by a system of overhanging beams decorated with carved tantric motifs. The Hiranyavarna Mahāvira at Patan (a three-tiered pagoda), the Nyatapola at Bhatgaon (a five-tiered pagoda) and the Taleju at Katmandu are examples of this style. The domed roof is used for sanctuaries built as annexes to the main temple buildings.

Temples sometimes constitute a veritable holy city, for instance at Pashupatinath, built on both banks of the river Bagmati. The palaces inhabited by the kings (incarnations of the god Vishnu, who are protected by Taleju and guarded by Hanuman) are surrounded by temples—not inappropriately, since the palaces are the product of the same spirit as the rest of the architecture. There is no demarcation between the divine and the human.

MAJOR MUSEUMS

Belgium
Musées royaux d'art et d'histoire, Brussels

France
Guimet Museum, Paris

Great Britain
British Museum, London
Victoria and Albert Museum, London

Italy
Museo Nazionale d'Arte Orientale, Rome

Nepal
Nepal Museum, Katmandu
Bhaktapur Museum, Bhaktapur
Patan Museum, Patan

Netherlands
Rijksmuseum voor Volkenkunde, Leiden

Switzerland
Ethnographic Collection of the University of Zurich, Zurich

U.S.A.
Museum of Fine Arts, Boston
Museum of Art, Cleveland
Los Angeles County Museum of Art, Los Angeles

U.S.S.R.
Hermitage Museum, Leningrad

Nepal
CONCISE BIBLIOGRAPHY

BERNIER, R.M. *The Temples of Nepal.* Katmandu, 1970.

KRAMRISCH, S. 'Nepalese Paintings' in *Journal of the Indian Society of Oriental Art,* no. 2 I. London, 1933.

LEVI, S. *Le Népal.* 3 vols. Paris, 1905–8.

Nepalese Art. Exhibition catalogue. Guimet Museum, Paris, 1966.

PAL, P. *The Art of Nepal: Sculpture.* Leiden, 1974.

PETECH, L. *Medieval History of Nepal (750–1480),* Rome, 1958.

REGMI, D.R. *Medieval Nepal.* Katmandu, 1966.

SNELLGROVE, D.L. 'Shrines and Temples of Nepal' in *Arts Asiatiques,* no. 1–2 VIII. Paris, 1961.

UNESCO. *Kathmandu Valley.* Vienna, 1976.

WALDSCHMIDT, E. and R. *Nepal,* vol. I. London, 1969.

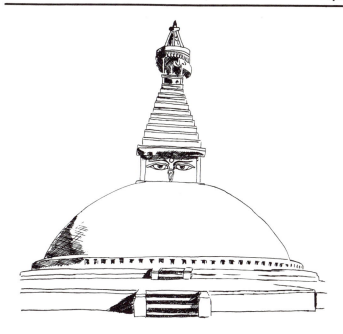

1 Stupa: a pair of eyes on each side, Bodhnath

2 *Caitya* (sanctuary): 4 diminishing tiers, Licchavi period, 5th–6th c., Chabahil

3
Silhouette of 5-tiered pagoda dedicated to Śiva, Kumbheśvara, 1392, Patan

4
Nyatapola: 5-tiered pagoda dedicated to the goddess Bhairavī, Bhaktapur

5 Portico with a bronze bell, Patan

6 Window: carved wooden open-work, typical of Nepalese houses, Katmandu

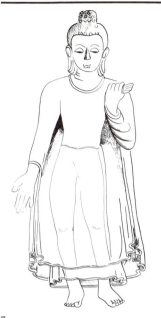 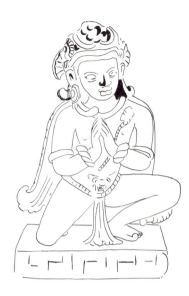

7
Buddha: similar to the Gupta Bud-
dhas at Sārnāth, stone, Licchavi, 6th c.

8
Garuda (mythical bird), 6th–7th c.,
Changu-Narayan

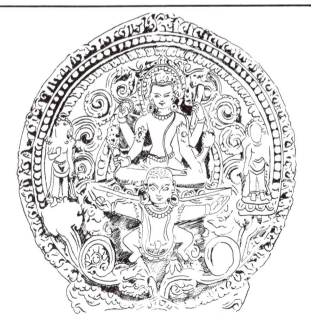

9 Vishnu on Garuda: sculpture from the Kumbheśvara Temple, Patan

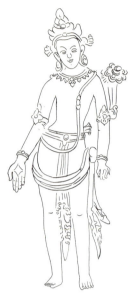

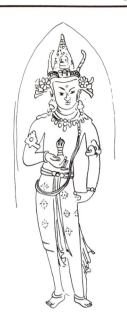

10
Mañjuśri or Mañjunātha, stone, 11th
c., Katmandu

11
Avalokiteśvara, bronze, 14th c.

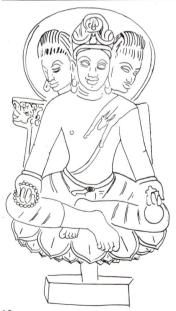

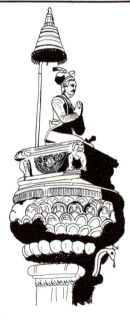

12
Brahmā: 2 arms instead of the usual
4, stone, 6th c., Chapagaon

13
Statue of King Bhupatindra Malla,
18th c., Bhaktapur

14
Tribhanga: triple flexion

15
Ardhaparyanka: relaxed pose

16
Mahārājalilāsana: attitude of royal ease

17
Pratyālīdha: leaning to the right with legs apart

18
Ardhaparyanka: dancing pose

19
Ālīdha: leaning to the left with legs apart

20
Vajrahūmkāra-mudrā

21
Prajñālinganābhinaya: gesture of embracing

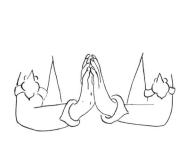

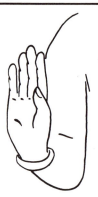

22
Añjali-mudrā: offering, greeting

23
Abhaya-mudrā: protection

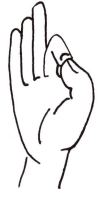

24
Bodhyagrī-mudrā: special gesture of the Buddha Vairocana

25
Vitarka-mudrā: argumentation

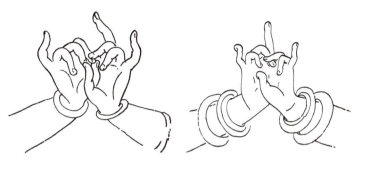

26 and 27 Two forms of the *Vajradhātu-mudrā*

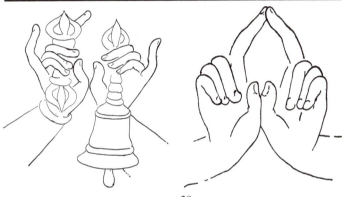

28
Dharmadhātu-mudrā

29
Mudrā attributed to the Buddha
Vairocana

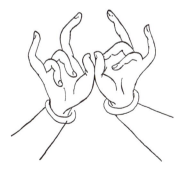

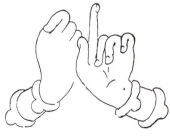

30
Vairocana-mudrā

31
Vairocana-mudrā of the 14th and
15th c. (?)

Tibet

by Chantal Massonaud
Emeritus curator at the Guimet Museum, Paris

TIBET

Tibet, with an area of some 1,217,250 square kilometres (470,000 square miles) and an average altitude of 4000 metres (13,000 feet), lies in the heart of the Himalayas and occupies the area separating the Indian world from the Chinese. The states bordering it to the south and west, the Gilgit group, Kashmīr, Ladakh, as well as Nepal, Sikkim, Bhutan and Assam, have for many centuries exchanged with Tibet not only artistic and philosophical ideas but also—more prosaically—commercial products.

The origins of Tibetan history are shrouded in uncertainty, and its development is substantiated by very few finds. Roerich discovered megalithic monuments in the region of the great lakes, and near the frontier with Ladakh missionaries found bronze and iron panels reminiscent of the nomadic art of central Asia. To the west of Tibet there was once a clearly independent country, Zhang-zhung, which was eventually annexed to its eastern neighbour. This country included Mount Kailāsa and Lake Manasarovara; its people spoke an Indo-European language. It would appear that we should seek here the origins of the Tibetan tradition. Access to Zhang-zhung from India was gained through Nepal, Kashmīr and Ladakh. Its precise limits are difficult to define. On the western side it had a common frontier with Khotan, Gilgit, Gandhāra and Swāt, regions through which elements of Greek and Iranian civilization found their way into Tibet. The first centralized political authority was established at Yar-klungs in central Tibet. According to legend, the first kings returned to heaven by a rope-ladder; they were buried, from the 7th century A.D. onwards, at Phyong-rgyas, not far from Yar-klungs. Their burial mounds can still be seen there. The history of Tibet emerges from obscurity with the reign of King Srong-btsan sgam-po, who is known to have died in 649 after embarking upon an expansionist policy. He is the first landmark in the history of the Tibetan civilization. The emperor of China and the king of Nepal each gave him the hand of a daughter in marriage. The two princesses brought with them effigies of the Buddha, thereby encouraging the introduction of a religion that was gradually to leave its mark on the history, art and thought of Tibet. The king adopted a script, which may have been modelled on the Kashmīri one, and had a corpus of grammatical rules drawn up. These rudiments enabled scholars to study the Indian religions. Buddhism was flourishing in central Asia, where the Tibetans occupied several oases, and Tantrism in Bengal. According to tradition, it was during this reign that Nepalese artists came to Tibet, some working in stone, others in bronze. The architects who built the temples also came from neighbouring countries.

Buddhism was recognized as the official religion during the reign of King Khri-srong lde-btsan (742–97). At this time, Padmasambhava, a Buddhist saint who is regarded as the founder of the order of Rnying-ma-pa, caused

the first monastery, Bsam-yas, to be built. The last Buddhist king, Ral-pa-can (Long-hair), reigned from 815 until 838. There is evidence that artists from Khotan worked in Tibet during his reign. His brother, Glang-dar-ma, persecuted Buddhists; with his assassination royal power came to an end. Antagonism between Buddhists and followers of the local shamanist religion, Bon, culminated in a civil war. The descendants of the kings took refuge in several small kingdoms in the west of the country.

Under the sovereigns of Guge—a kingdom ruled by descendants of Glang-dar-ma that played a transitional role in Tibet—a religious revival occurred. King Lha Bla-ma sent the monk Rin-chen bzang-po, the Great Translator, to Kashmīr three times. He brought back seventy-five artists with him. The temples of Tsha-pa-rong, Mtho-lding and Lta-bo provide ample evidence of their craftsmanship. King 'Od-lde brought in from India the Buddhist pandit Atīśa (982–1054), a great tantric master, who gave a fresh impetus to Buddhism in Tibet. The teaching of the Tantras resulted in the founding of large monasteries or lamaseries. In 1073, Dkon-mchong rgyal-po established the monastery of Sa-skya, whose priest-kings were to play a very influential role. Mar-pa (1012–96), the third guru in a line of descendants taught by the Buddha Vajradhara, founded the Bka'-brgyud-pa sect and was the teacher of Mi-la ras-pa (1040–1123) who, in turn, instituted the reformed sect of Bka'-gdams-pa (although the founder is sometimes given as 'Brom-ston [1005–64]). Mi-la ras-pa's disciples established other orders, spreading like twigs from the branch of a tree. Before long, there were many monasteries scattered all over Tibet, which soon came to play an important political role. Rivalry sprang up among them, and this rivalry was at its height when the Mongols appeared on the scene. In the 13th century, after one of their members converted Kublai Khan to Buddhism, the abbots of the Sa-skya-pa sect were appointed regents over the whole of Tibet, but rival monasteries were reluctant to accept their leadership. Reforms were carried out by the lama Tsong-kha-pa (1357–1419), who, after building his own monastery of dGa'-ldan (Ganden) in 1409, founded the Gelukpa sect ('the ones of the virtuous order'). Although Tsong-kha-pa's reputation spread as far as China, he declined an invitation to visit the court of Emperor Yung-lo in 1408, sending in his stead one of his pupils. His chief disciples founded great monasteries near Lhasa such as 'Bras-spungs and Sera.

In 1445, Dge-'dun-grub-pa, the third successor to Tsong-kha-pa, founded the monastery of Bkra-çis lhun-po. In 1578, Abbot Bsod-nams rgya-mtsho (1543–88) of the monastery of 'Bras-spungs, was granted the title of *Dalaï* ('ocean of wisdom') by Altan Khan, the chief of the Tümed Mongols. He was acknowledged as the reincarnation of the reformer Tsong-kha-pa. His two predecessors were accorded the title of Dalaï posthumously. The fifth Dalaï Lama, Ngag-dbang rgya-mtsho (1617–82) brought the Gelukpa sect to its apogee. After 1644 when the Manchus came to power in China, relations between the two countries improved. When the Emperor K'ang-hsi (1662–1722) intervened in Tibetan affairs in order to settle some disputes, he sent a number of Chinese citizens to take up residence in Tibet. The theocracy of the Dalaï Lamas continued into the 20th century. Since 1965, Tibet has been one of the two autonomous regions within the People's Republic of China.

In Tibet, religious feelings and artistic movements are closely allied. Tibet's monuments, monasteries or chorten *(mchod-rten),* serve as a framework for the paintings and sculptures within, which inspire meditation. Deities are represented in accordance with a strict code of iconographic and iconometric laws. The works of art are anonymous. The walls of religious buildings are decorated with frescoes or *t'ang-kas,* painted banners.

Specialists are endeavouring to draw up a classification of Tibetan art by 'schools', according to the geographical situation of the monuments and the stylistic details in which the influence of one or other of the neighbouring countries can be discerned. Thus, for example, one can acknowledge the existence of a school of western Tibetan art, influenced by India and Kashmīr, a school that grew up at Ngor in southern Tibet and was inspired by Nepalese art, and an eastern school, closely related to Chinese art. The same features can be observed when one studies the style of bronzes, created by various techniques ranging from chasing to the *cire perdue* ('lost wax') method of casting.

MAJOR MUSEUMS

Belgium
Musées royaux d'art et d'histoire, Brussels

France
Guimet Museum, Paris

Great Britain
British Museum, London
Victoria and Albert Museum, London

Italy
Museo Nazionale d'Arte Orientale, Rome

Nepal
Nepal Museum, Katmandu
Bhaktapur Museum, Bhaktapur
Patan Museum, Patan

Netherlands
Rijksmuseum voor Volkenkunde, Leiden

Switzerland
Ethnographic Collection of the University of Zurich, Zurich

U.S.A.
Los Angeles County Museum of Art, Los Angeles
Museum of Fine Arts, Boston
Museum of Art, Cleveland
Newark Museum, Newark, N.J.

U.S.S.R.
Hermitage Museum, Leningrad

CONCISE BIBLIOGRAPHY

Dieux et démons de l'Himalaya. Exhibition catalogue. Petit Palais, Paris, 1977.

MALLMANN, M. T. de. *Introduction à l'iconographie du tantrisme bouddhique.* Paris, 1975.

PAL, P. *The Art of Tibet.* New York, 1969.

SNELLGROVE, D. L. *Buddhist Himalaya.* Oxford, 1957.

——————————— and RICHARDSON, H. *A Cultural History of Tibet.* London, 1968.

STEIN, R. A. *Tibetan Civilization* (trs. by J.E.S. Driver). London, 1972.

TUCCI, G. *Tibetan Painted Scrolls.* 3 vols. Rome, 1959.

————— *Tibet, Land of Snows.* London, 1967.

————— *Tibet.* Archaeologia mundi series. Geneva, 1973.

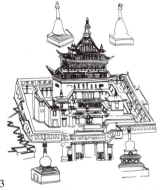

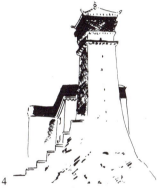

1
The Potala Palace: built around an earlier fortified palace, 17th c., Lhasa

2
Detail: timberwork, Potala Palace, Lhasa

3
Monastery of Bsam-yas, plan in the form of a *mandala* (magic circle), 8th–9th c., central Tibet

4
Yum-bu lha-mkhar: royal palace, with later alterations, 8th c., central Tibet

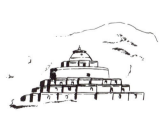

5
Wheel of the Law: detail of the roof of Jo-khang, the oldest temple in Lhasa

6
Stupa or chorten with many niches, built on the plan of a *mandala*

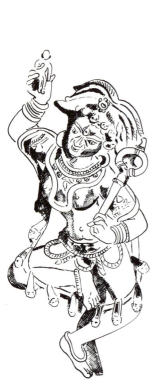

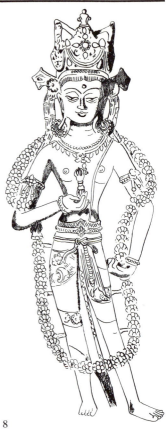

7
The *dākinī* Savarī: Tibetan: Indian prototype; Pāla-Sena dynasty, bronze, H. 8.7 cm., Guimet Mus., Paris

8
Vajrapāni, painted bronze with gems, Kashmīri model of the 9th c., western Tibet, Guimet Mus., Paris

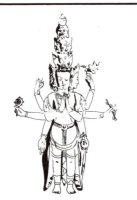

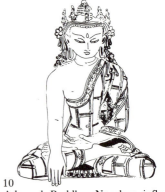

9
Avalokiteśvara: Nepalese influence, wood, H. 68 cm., Brooklyn Mus., N.Y.

10
Adorned Buddha: Nepalese influence, gilt silver with gems, 16th–18th c., Tibet, L.C.M.A., Los Angeles

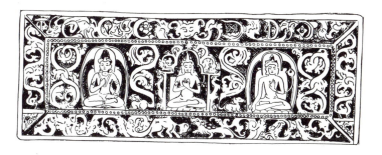

11 Book-cover, gilded and painted wood, 16th–17th c., southern Tibet,
B. M., London

12
The red *dākinī:* Nepalese influence,
gilt bronze, H. 52 cm., 18th c., Tibet,
private coll.

13
Vajravārāhī: painted silver inlaid with
gems, H. 32 cm., 17th–18th c., Tibet,
Newark Mus., N.J.

14
Lama, gilt bronze, H. 28 cm., 18th
c., Tibet, L.C.M.A., Los Angeles

15
Saint Padmasambhava, bronze inlaid
with gems, 17th c., Tibet

16
Vajradhara: Chinese influence, gilt copper inlaid with gems, 17th c., H. 47 cm., Tibet

17
Mahākāla, silver inlaid with gems, H. 15 cm., Tibet, L.C.M.A., Los Angeles

18
Dpal-ldan lha-mo, gilt silver, painted and inlaid with gems, H. 15 cm., Tibet, L.C.M.A., Los Angeles

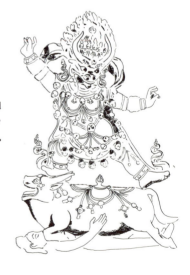

19
Hevajra: Nepalese influence, gilt bronze inlaid with gems, H. 29 cm., Tibet, Guimet Mus., Paris

20
Yama: style of northern China, painted gilt bronze, H. 37 cm., 17th–18th c., private coll.

21
Chopper, iron, H. 29 cm., Tibet

22
'Diamond-thunderbolt' or *vajra (rdo-rje)*, bronze, H. 17 cm., Tibet

23
Ritual dagger *(phur-bu)*, silver and copper, H. 38 cm., Tibet

24
Bell *(dril-bu)*, bronze, H. 24 cm., Tibet

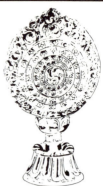

25
Decorative motif: awesome deity—
lama's apron for ritual dances, 19th
c., Tibet, Newark Mus., N.J.

26
Wheel of the Law, embossed silver,
H. 51 cm., 18th c., Tibet, Newark
Mus., N.J.

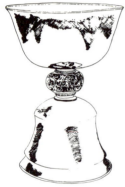

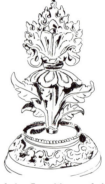

27
Butter-lamp, beaten silver, H. 40
cm., 18th–19th c., Tibet, Newark
Mus., N.J.

28
One of the 7 emblems of the Uni-
versal Monarch, gilt bronze, 18th–
19th c., Tibet, B.M., London

South-east Asia

by Professor Jean Boisselier

SOUTH-EAST ASIA

It is mainly on account of Sri Lanka's (Ceylon's) influence that the chapter devoted to that country has been placed as an introduction to the section of this book dealing with South-east Asia. Although the geography and, for many centuries, the history of that island seem to make it only natural to associate Sri Lanka with the nearby Indian subcontinent in any classification, the influence of Sinhalese Buddhism upon most of the Indo-Chinese peninsula has been so marked, especially since the 12th century, that it appears impossible to separate the two regions.

This influence, which was to result in extremely fruitful cultural exchanges, developed from the time when Sinhalese Buddhism became established on the peninsula, providing within a short time the main and, in many instances, the only source of inspiration for the literature and arts of Burma, Thailand, Cambodia and Laos. Even though this widespread and profound movement did not radically alter the local artistic taste and traditions that were generally born of a long past—a past during which Sri Lanka had in fact already often played a significant role—it did give the area a common vocabulary and, above all, a uniform conception of the world and of life. More than eight centuries have elapsed since the ancient Indian Buddhism, having disappeared from its place of origin, spread from the new capital of Theravāda Buddhism, Sri Lanka, to the Indo-Chinese peninsula, where it has gone from strength to strength, rapidly becoming the principal driving force behind an artistic activity of extraordinary intensity. On the other hand, on several occasions, the Buddhist communities in Burma and Thailand have provided Sri Lanka with the means of maintaining the purity of a doctrine threatened with debasement at the most crucial periods in Sinhalese history. It seems likely that Sri Lanka served as a link between India and South-east Asia during the very earliest centuries of Indian influence in that part of the world, and the development of the island's influence there has continued almost unbroken to this day. In so far as adherence to the beliefs of Theravāda Buddhism engenders a certain uniform conception of the order of the world and of society, Sri Lanka is helping to ensure the national unity of the countries of the Indo-Chinese peninsula.

The collections of most of the local museums listed at the end of each chapter consist, in the main, of works of art from the countries in which these museums are situated, but there are also many museums all over the world possessing collections of varying sizes composed of objects from the whole of South-east Asia. Some of these museums are listed below, together with a partial indication of which countries are most strongly represented in their collections.

South-east Asia

Belgium: Musées royaux d'art et d'histoire, Brussels

France: Guimet Museum (C. Ch. I. Th.), Paris; Guimet Museum (C. Ch.), Lyons; Georges Labit Museum (C. V.), Toulouse

Germany: Museum für Völkerkunde, Indian Department (C. Th.), Berlin; Museum für Ostasiatische Kunst, Cologne; Kunst- und Gewerbemuseum, Hamburg; Museum für Völkerkunde, Leipzig; Museum für Völkerkunde, Munich

Great Britain: British Museum, Department of Oriental Antiquities, London; Victoria and Albert Museum, London

Italy: Museo Nazionale d'Arte Orientale, Rome

Netherlands: Museum van Aziatische Kunst (I. C.), Amsterdam; Koninklijk Instituut voor de Tropen (I.), Amsterdam; Gemeentemuseum (I.), The Hague; Museum voor her Onderwijs (I.), The Hague; Rijksmuseum voor Volkenkunde (I.), Leiden; Museum voor Land- en Volkenkunde (I.), Rotterdam

Switzerland: Rietberg Museum, Zurich

Thailand: National Museum, Bangkok

Vietnam: Musée historique du Vietnam, Hanoi; Musée national, Saigon

U.S.A.: Museum of Fine Arts (SL), Boston; Museum of Art (C.), Cleveland; Institute of Arts, Detroit; Los Angeles County Museum of Art, Los Angeles; Metropolitan Museum of Art, New York; Museum of Art, Philadelphia; Asian Art Museum of San Francisco (Avery Brundage Coll.: C. Th.), San Francisco

SRI LANKA

The history of Sri Lanka, unusually well known from local Chronicles, is virtually inseparable from that of Buddhism, which became established on the island from the middle of the 3rd century B.C. onwards. Mahāyāna Buddhism played an important, and at times predominant, role from the 3rd century A.D. until the 12th century when Parākramabāhu I (1153–86) ensured the ultimate triumph of Theravāda Buddhism. Sinhalese art, when viewed in this context, ought not to be considered as a sort of regional school of Indian art, though it all too often is. Despite its close and often manifest affinity with the art of near-by south India, the art of Sri Lanka has always maintained in all its aspects an undeniable originality—an originality resulting not only from the action on the country's artistic sensibility of an essentially Buddhist inspiration, but also from local conditions and the Sinhalese character. Sinhalese art finds its fullest development in and around the sites of the ancient capitals and sometimes exhibits quite marked regional characteristics (particularly in the southern provinces, the ancient Rohana). Its history and development are best studied by being divided into long periods extending from a few centuries before the Christian era until early in the 19th century (fall of the kingdom of Kandy, the last independent kingdom, 1815).

ARCHITECTURE. Sinhalese architecture bears the imprint of the predominance of Buddhism. The stupas *(dagabas)* and monasteries are of prime importance; their designs show that the Sinhalese preoccupations were similar to those behind the medieval Christian monuments of the West. At a very early period, original types of stupa, often of enormous size, were developed: bases consisting of three high terraces, façades *(vāhalkada)* oriented towards the cardinal points and, particularly, rows of columns, the supports for roofs that have long since disappeared, surrounding the dome *(vatadāgē)*. It should be added that the reliquary stupas provide exceptionally interesting evidence concerning the development of both the Sinhalese stupa and also of the earlier ones.

The monasteries, often remarkably adapted to their sites, include the most varied of constructions, their designs depending on the intended purposes of their constituent elements. These purposes may be connected with worship ('House' of the Bodhi Tree, 'House' of the Image) or with the needs of the community (piscina, refectory, infirmary, etc.). The monasteries consisted of various buildings of composite construction, but all that remains of most of these are their platforms and the columns that supported their upper tiers; nevertheless, the great, brick viharas at Polonnaruwa (12th century) are among the finest buildings erected in Sri Lanka before the creation of more complex structures during the 13th and 14th centuries (Kandy

region). Despite the constant use of caves as shelters, the importance of forest-dwelling communities and sculptures carved out of rock, cave architecture has never played as important a role in Sri Lanka as it has in India.

Brahminic architecture is far less abundant on Sri Lanka than Buddhist architecture and exhibits a much closer affinity with Dravidian art (Polonnaruwa, 11th century); however, the importance of the cults worshipping deities supposed to protect the island ensures the existence within this type of architecture of original features (Kandy region, 14th century).

Concurrently with the religious architecture and in close alliance with it, a category of buildings developed, connected with the exercise of royal power and often constructed with the need for defence very much in mind. Veritable fortified cities (Sigiriya, 5th century; Yapahuwa, 13th century) were built around royal palaces. Great skill was displayed in the use made of the terrain, some of the cities being perched on summits of almost unscalable peaks, while the arrangement of perspectives was handled with a classical degree of assurance.

ARCHITECTURAL DECORATION. Sculpted or stuccoed architectural decoration plays an important role and demonstrates the originality of Sinhalese artists, whether their concern is merely with the proportions and outline of a building or with its ornamentation by the use of figures that are, generally, very attractive. Some of the most outstanding examples of Sinhalese art, by virtue of their beauty and the quality of their composition, are the friezes, the decorated columns and the ornamented staircases: string walls, stair-risers and, especially, moonstones, stone doorsteps with very elaborate symbolism, and guardstones, steles on the string walls adorned with auspicious figures (*gana,* Nāgarāja, etc.).

SCULPTURE. Sinhalese sculpture in the strict sense of the term consists largely of low reliefs and cave art, the latter being especially predominant and including colossal carvings (Buduruvegala, Gal Vihara). Some of them rank among Sri Lanka's truest masterpieces, such as the statue of Agastya, called Parākramabāhu I, at Polonnaruwa, 11th–12th century. Almost all of the sculpture in the round represents the Buddha (standing or seated in the Indian manner). The Buddha's gestures vary little in these images, and the manner of depicting his attire (especially on the standing figures) reveals a surprising fidelity to the old sculptural tradition of south India, the so-called Amarāvatī School. At least up to the 14th century, most of these images are of stone, and those that are of bronze are generally quite small. The Mahāyānist idols, few in number, emphasize the relative independence of the Sinhalese School. Of the sculptures commissioned by the Brahmins around the 11th century, the bronzes have survived in the largest numbers. The stylistic treatment of some of them is purely Indian, others are merely locally executed copies of these, faithful in varying degrees to their models.

Works of art made from wood or ivory, known mainly from relatively recent objects (14th century and later), have also played an important role and reveal very clearly the artistic taste of the Sinhalese people (wood-carving from Embekke *devāle*).

A BRIEF HISTORY OF SINHALESE ART

The history of Sinhalese art has been studied mainly in the light of information contained in the Chronicles which, some would argue, attribute too much importance to purely historical facts at the expense of stylistic evidence. As a result, the chronology of Sinhalese art has remained rather vague with

the exception of a few landmarks to which it has been possible to assign precise dates. The chronology is imprecise both with regard to architecture, in the study of which scholars have failed to give due consideration to successive restorations and alterations, and with regard to sculptural images, the study of which has too often been subjective.

After a prehistory about which little is known, but which appears not to have differed appreciably from the same period in south India and to have been characterized by the same sequence of events, Buddhism was introduced into Sri Lanka, about the 3rd century B.C., according to the earliest witnesses of Indianization: barely furnished cave shelters, with inscriptions in archaic characters at Mihintale. Although the Chronicles (the *Mahāvamsa,* for instance) provide valuable information concerning the foundation and the history of most of the great monuments, these have been so frequently enlarged and restored or so fundamentally altered that one would need to find architectural and sculptural remains dating back to the dawn of the Christian era to be able to assemble material capable of yielding evidence when studied exhaustively. Contacts with the Roman world are well recorded but do not seem to have left behind durable remains. On the contrary, and as one might expect in view of the inevitably close ties between the two areas, it is with the artistic schools of southern India (Āndhra—the art in the so-called Amarāvatī style—Pallava, Cola, Pandya) that the most constant and evident relations were established. It is, however, only during the very earliest centuries, then during the period of Cola rule (11th century) and finally during the period of political decline (14th century and later) that Indian influence becomes really noticeable, and even during these periods it is only very rarely that the purely Sinhalese tradition becomes eclipsed.

THE ANURADHAPURA PERIOD (*c.* 3rd century B.C. to A.D. 993). Apart from the fact that the site is of great antiquity, little is known as yet about Anuradhapura's history as the capital city prior to the introduction of Buddhism around the middle of the 3rd century B.C. Its history between that time and the year in which the site was abandoned (A.D. 993) can be divided into two phases:

The first phase lasted until 432, the year when the Hindu Tamils established their rule over the capital that remained in their grip for the next thirty years or so. This phase saw the foundation of the island's most venerable monasteries and stupas, all of which have been located but are altered to a greater or lesser degree. The ascendancy of the Mahāyāna Buddhists from the beginning of the 3rd century A.D. onwards and the subsequent arrival of the Relic of the Tooth (soon regarded as the kingdom's safeguard) were to exert an influence upon the earliest artistic trends by introducing a different iconography and stimulating the adoption of new architectural designs. The most immense Sinhalese stupas, on a far larger scale than any built in India during the same period, were constructed throughout the 3rd century A.D. The majority of the sculptures produced during this period are low reliefs, the oldest of which may have been carved as early as the period from the 2nd century B.C. to the 1st century A.D. They are quite closely related to the earliest sculptures from Amarāvatī. The oldest statues of the Buddha, all standing figures, do not appear to have been carved much before the 3rd or 4th century A.D., but they too bear a resemblance to the art of Amarāvatī.

The second phase (432–993) is widely regarded as having been a Golden Age in the history of Sinhalese art. Architecture evolved along original lines: this period saw the end of the immense stupas but a vogue for domes

(*vatadāgēs;* 7th–8th century), the development of a monastic architecture well suited to its purpose and to the requirements of the various sects, and the construction of the fortified palace at Sigiriya by Kassapa I (477–95), one of the finest examples of the utilization of the terrain for symbolic and defensive purposes. The Sinhalese sculpture of this period is generally of great beauty, and it was then that the classical themes (moonstones, guard-stones) were created. The advent (?) in Sinhalese sculpture of seated figures of the Buddha (some protected by the *nāga,* a serpent divinity) reveals for the first time the existence of several traditions that were destined to endure side by side for a long time.

The Polonnaruwa Period (993–1236) is also divided neatly into two phases: the Cola rule (993–1070) was characterized by the construction of a large number of Brahminic buildings and by the influence of contemporary Cola art (temples, bronzes); the phase following the Sinhalese Restoration (1070–1236, the year of the fall of the kingdom of Polonnaruwa) saw intense artistic activity that is reflected in the buildings founded by the great sovereigns of the period, especially Parākramabāhu I (1153–86) and his successor. This artistic activity brought about some real changes in architecture (designs, methods of construction, the importance of secular buildings). Although it also inspired sculpture, in which for the first time a greater degree of heaviness and certain tendencies towards stylization (above all of figures of the Buddha) can be observed, sculptors continued to be, by and large, faithful to the tradition of Anuradhapura.

The Period of Transient Capitals (1236–1505) extends from the fall of the kingdom of Polonnaruwa to the seizure of Kotte by the Portuguese—an event which marked the beginning of an oppressive colonial era for Sri Lanka. In the course of this period, disturbed by political instability, the Sinhalese turned to the Colas and the Pandyas for help in resisting the threats of Kalinga and were therefore subject to new influences. The influence of Pandyan architecture was to be particularly profound and durable, but unfortunately the capital cities and most of the historic buildings lie in ruins so that a true assessment of the extent of this influence is no longer possible. Be that as it may, the great traditions concerning the division of areas into rooms survived, at least during the earlier part of the period (royal residences: Yapahuwa, 13th century), and the plans of certain temples seem to show some Burmese influence (Vijayotpaya, Lankā-tilaka vihara at Gadaladeniya). The development of sculpture, mentioned as a feature of the previous period, continued unabated. The traditional symbolism of the moonstones and guardstones was abandoned, and the images of the Buddha reveal a profound change in artistic taste and the adoption of new attire. The figures carved in low relief are still invested with life but have become less graceful, wearing cumbersome and complex garments. These figures are direct precursors of those seen in the art of Kandy which, through its decorative and architectural accomplishments, was to keep alive the original creative genius of the Sinhalese people even after the island's annexation by the British in 1815.

MAJOR MUSEUMS

National Museum, Colombo
Archaeological Museum, Anuradhapura
National Museum, Kandy
Museum, Dedigama

CONCISE BIBLIOGRAPHY

BANDARANAYAKE, S. *Sinhalese Monastic Architecture.* Leiden, 1974.
BOISSELIER, J. *Sri Lanka.* Architecture Mundi series, Geneva, in preparation.
CAVE, H. W. *Ruined Cities of Ceylon.* Colombo, 1897; 3rd ed. London, 1904.
COOMARASWAMY, A. K. *Medieval Sinhalese Art.* Broad Campden, 1908; 2nd ed. New York, 1956.
DEVENDRA, D. T. *Classical Sinhalese Sculpture.* London, 1958.
GODAKUMBURA, C. E. *Art Series,* nos. 1–12. Arch. Dept., Colombo, n.d.
MODE, H. *Die buddhistische Plastik aus Ceylon.* Leipzig, 1963.
PARANAVITANA, S. *The Stūpa in Ceylon.* Colombo, 1947.
——————————— *Art and Architecture of Ceylon: Polonnaruwa Period.* Bombay, 1954.
——————————— *Art of the Ancient Sinhalese.* Colombo. 1971.
PARKER, H. *Ancient Ceylon.* London, 1909.

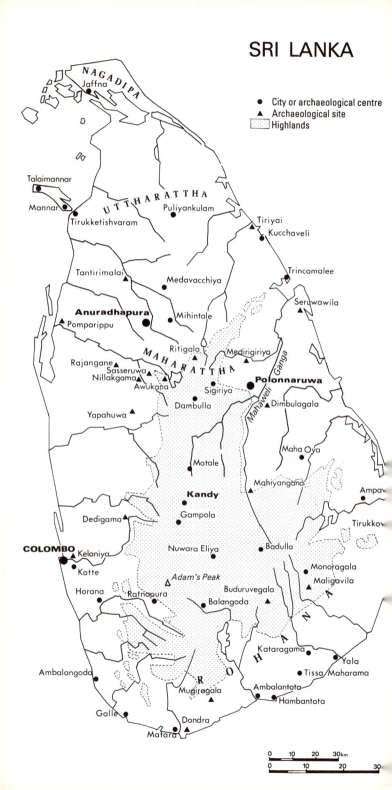

SRI LANKA

- ● City or archaeological centre
- ▲ Archaeological site
- ▢ Highlands

NAGADIPA

Jaffna

Talaimannar
Mannar
Tirukketishvaram

UTTHARATTHA

Puliyankulam

Tiriyai
Kucchaveli

Trincomalee

Tantirimalai
Medavacchiya

Anuradhapura
Pomparippu
Mihintale

Seruwawila

MAHARATTHA

Ritigala
Medirigiriya

Rajangane
Sasseruwa
Nillakgama
Awukana

Mahaweli Ganga

Polonnaruwa

Sigiriya
Dambulla
Dimbulagala

Yapahuwa

Maha Oya

Matale

Mahiyangana

Ampa

Kandy
Gampola

Dedigama

Tirukkov

COLOMBO Kelaniya
Kotte

Nuwara Eliya
Badulla

Horana
Ratnapura

Adam's Peak

Monoragala
Maligavila

Buduruvegala
Balangoda

R O H A N A

Ambalangoda

Kataragama

Yala
Tissa Maharama

Mugiragala
Ambalantota
Hambantota

Galle

Dondra
Matara

0 10 20 30km
0 10 20 30

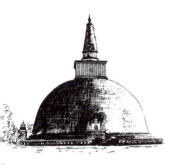

1
Ruvanveliseya *dagaba* or stupa, t. H.
91.50 m., 2nd c. B.C., restored in the
19th c., Anuradhapura, *in situ*

2
Votive stupa, dolomite, H. *c.* 1.30 m.,
c. 5th c., Ruvanveliseya *dagaba*,
Anuradhapura, *in situ*

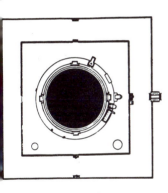

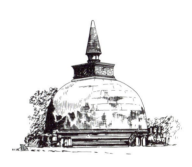

3
Plan of the Ruvanveliseya *dagaba*

4
Kiri-vehera, present H. 24.40 m.,
12th c., Polonnaruwa

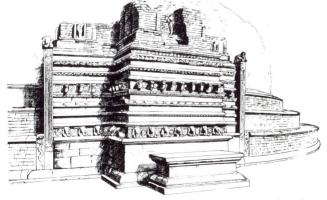

5 East *vāhalkada* (façade) of the Kantaka *cetiya*, stone, *c.* 2nd–3rd c.,
Mihintale

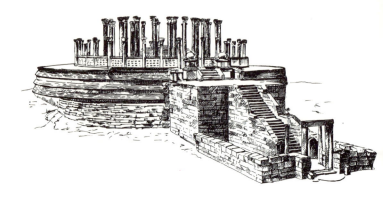

6 *Vatadāgē* (sanctuary), 7th c. and later, Medirigiriya

7 *Vatadāgē*, 11th–12th c., Polonnaruwa

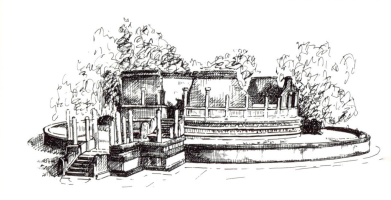

8
Plan of the *vatadāgē* at Polonnaruwa

9
Stupa: Indikatuseya monastery, stone, 8th–9th c., Mihintale

10
Reliquary stupa: found at Ruvanveliseya *dagaba,* gold, *c.* 1st–2nd c., Anuradhapura

11
Reliquary stupa, bronze, H. 36 cm., Papulpava, Nat. Mus., Kandy

12
Temple of Upulvan, stone. L. 7.92 m., 7th c., Dondra

13
Devāle (sanctuary) of Śiva no. 2, stone, L. 8.95 m., 11th c., Polonnaruwa

14
Sat Mahal Pāsāda, stuccoed brick, circum. 9.20 m., 12th c., Polonnaruwa

15
Tampita vihara, stone and wood, *c.* 16th–17th c., restored in 1963, Dorabavila

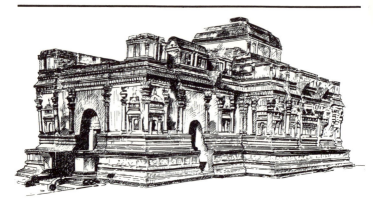

16 Thūpārāma, stuccoed brick, L. 22.70 m., 12th c., Polonnaruwa

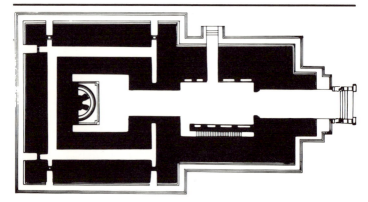

17 Lankātilaka vihara, stuccoed brick, L. 38.70 m., 12th c., Polonnaruwa

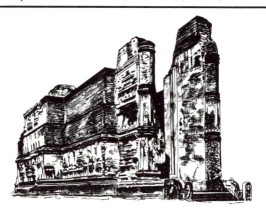

18 Plan of the Tivanka Pilimagē, stuccoed brick, L. 40.53 m., 12th c.,
 Polonnaruwa

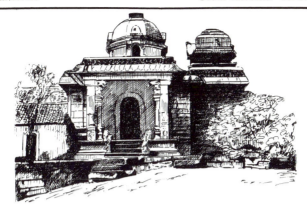

19 Gadalādeniya vihara, stone, stuccoed brick, L. 23.77 m., 1266, restored
 in the 15th c., Kandy Dist.

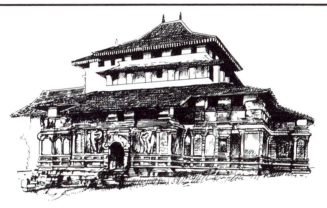

20 Lankātilaka vihara, stone, brick, L. 29.26 m., 14th c. but with later
 alterations, Kandy Dist.

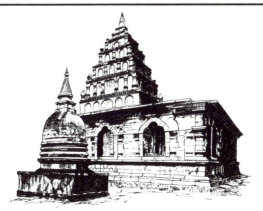

21 Galmaduva Temple, 18th c., Kandy

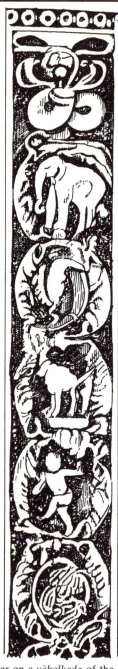

23
Upper part of pilaster: Kantaka *cetiya*, dolomite, 1st–2nd c., Mihintale, *in situ*

24
Guardstone: building near Ruvanveliseya *dagaba*, dolomite, *c.* 1st–2nd c. (?), Anuradhapura, *in situ*

22
Pilaster on a *vāhalkada* of the Kantaka *cetiya*, dolomite, *c.* 1st–2nd c., Mihintale, *in situ*

25
Guardstone: dolomite, H. 67 cm., *c.* 3rd–4th c., Anuradhapura

26
Detail: pilaster from the Abhayagiri *dagaba*, dolomite, *c.* 2nd c., Anuradhapura, *in situ*

27
Detail: pilaster from the Dakkhina Thūpa, dolomite, *c.* 2nd–3rd c., Anaradhapura, *in situ*

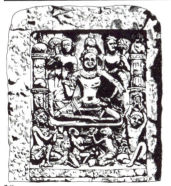

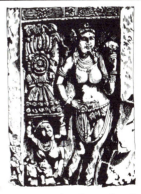

28
Upper part: pilaster from the Jetavana *dagaba*, dolomite, *c.* 2nd c., Anuradhapura, *in situ*

29
Lower part: stele of east façade of the Jetavana *dagaba*, dolomite, *c.* 2nd c., Anuradhapura, *in situ*

30
Side of pilaster (Fig. 27) from the Dakkhina Thūpa

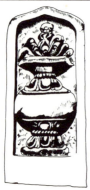

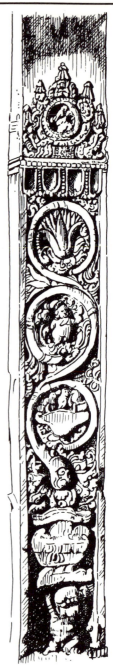

32
Guardstone, dolomite, H. 62 cm., *c.* 5th–6th c., Arch. Mus., Anuradhapura

31
Column from the Atadāgē, dolomite, 11th c., Polonnaruwa, *in situ*

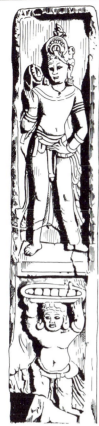

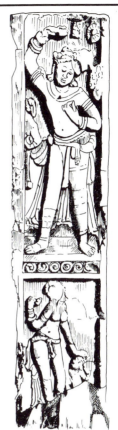

33
Stele from the Abhayagiri *dagaba,* dolomite, *c.* 3rd c., Anuradhapura, *in situ*

34
Stele from the Abhayagiri vihara: the Universal Monarch, dolomite *c.* 3rd c., Anuradhapura, *in situ*

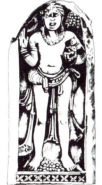

35
Stele from the Abhayagiri vihara: the Story of Alavaka (?), dolomite, 2nd–3rd c., Anuradhapura, *in situ*

36
Stele: east façade of the Jetavana *dagaba* (*Nāga*-king), dolomite, 3rd–4th c., Anuradhapura, *in situ*

37
Tutelary goddess: guardstone, dolomite, H. 1.17 m., 10th–11th c., Tissamahārāma, Sandagiri, *in situ*

38
Gana: guardstone, dolomite, H. 1.22 m., 7th–8th c., Magulmahā vihara, Ruhunumahā vihara, *in situ*

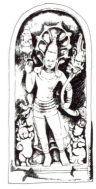

39
Nāga-king: guardstone, dolomite, H. 1.24 m., 7th–8th c., *vatadāgē*, Tiriyay, *in situ*

40
Nāga-king: guardstone, dolomite, H. 1.52 m., 8th–9th c., *vatadāgē*, Polonnaruwa, *in situ* (re-used)

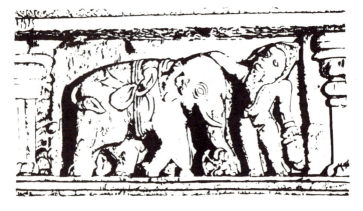

41 Detail: frieze, The Lion's Bath, dolomite, 10th c. (?), Mihintale, *in situ*

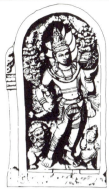

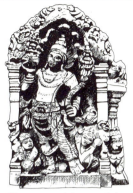

42
Nāga-king: guardstone, building near Thūpārāma, dolomite, 8th c., Anuradhapura, *in situ*

43
Nāga-king: guardstone, dolomite, H. 89 cm., 11th c., Kapārārāma, Anuradhapura, *in situ*

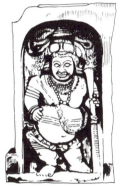

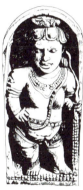

44
Gana: guardstone, dolomite, H. 99 cm., 7th–8th c., 'Vijayabāhu Palace', Anuradhapura, *in situ*

45
Gana: guardstone, dolomite, H. 1.30 m., 7th–8th c., Abhayagiri vihara, Anuradhapura, *in situ*

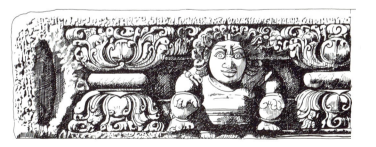

46 Decoration of a stair-riser, dolomite, 11th c., Ruvanveliseya *dagaba*, Anuradhapura, *in situ*

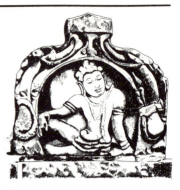

48
'Kudu': architectural fragment, dolomite, H. 35 cm., *c.* 8th c., Isurumuniya, *in situ*

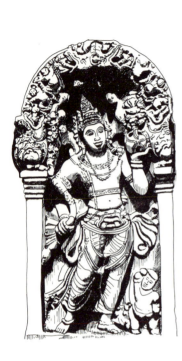

47
Nāga-king: guardstone, dolomite, H. 1.35 m., 8th c., Ratana Pāsāda, Anuradhapura, *in situ*

49
Gana: detail from a frieze, dolomite, *c.* 8th c., Isurumuniya, *in situ*

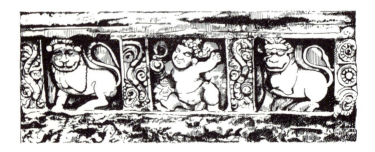

50 Lions and Bhairava: frieze from the Ruvanveliseya *dagaba,* dolomite, *c.* 8th c., Anuradhapura, *in situ*

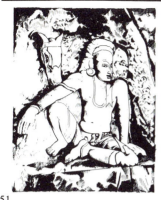

51
Aiyanār (called 'Kapila'): cave re-
lief, *c.* 9th c., Isurumuniya, *in situ*

52
Elephant: detail from a relief, *c.*
9th c., Isurumuniya, *in situ*

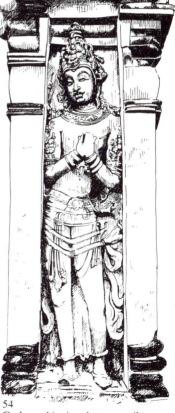

53
'The lovers': sculptured panel, dolo-
mite, H. 94 cm., *c.* 8th c., Isurumu-
niya, *in situ*

55
Lady playing a vina: figure from
string wall, dolomite, 13th c., Yapa-
huva, *in situ*

54
God worshipping: between pilasters,
stucco, H. 1.80 m., Tivanka Pilimagē,
12th c., Polonnaruwa, *in situ*

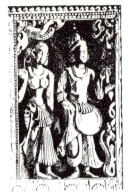

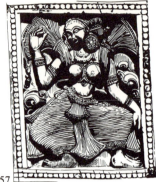

56
Detail: door-frame, wood, 14th c.,
Aludeniya vihara, Veligalla, *in situ*

57
Dancing woman, carved wood, H.
20 cm., 14th c., Embekke *devāle*,
Udunuwara, Kandy Dist., *in situ*

58
Frieze: Ruvanveliseya *dagaba,* dolo-
mite, 8th c., Nat. Mus., Colombo

59
Elephant, terracotta panel, H. 17
cm., 11th–12th c., Panduvasnuwara
Palace

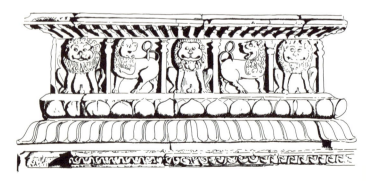

60 Plinth surrounding a bodhi tree, dolomite, *c.* 9th c., *bodhighara* at
Nillakgama, *in situ*

61
Lion, terracotta, H. 47 cm., 10th c.,
Polonnaruwa, Nat. Mus., Colombo

62
Lion, terracotta panel, H. 31 cm.,
10th c., Ambalantota

63
Lion on string wall: on a building
near Basavakkulam, dolomite, 8th to
9th c., Anuradhapura, *in situ*

64
Guardian-lion: top of string wall,
sculptured in the round, dolomite,
13th c., Yapahuwa, *in situ*

65
Gajasimha: on a string wall, dolomite,
Simhayāpitiya, 14th c., Gampola,
Nat. Mus., Kandy

66
Lion, carved wood, H. 20 cm., 14th
c., Embekke *devāle,* Udunuwara,
in situ

119

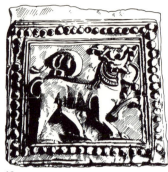

67
Ridge-tile, moulded terracotta, H.
40 cm., 18th c., Lankātilaka, Kandy
Dist.

68
Ridge-tile, moulded terracotta, H.
17 cm., 18th c. (?), Kandy region,
Nat. Mus., Colombo

69
Makara: fragment of decoration,
limestone, *c.* 2nd–3rd c., Abhayagiri
vihara, Anuradhapura, *in situ*

70
Hamsa, terracotta, H. 20 cm., 11th to
12th c., Panduvasnuwara

71 *Makara:* on sloping part of a string wall, west building of the Ruvan-
veliseya *dagaba,* Anuradhapura, *in situ*

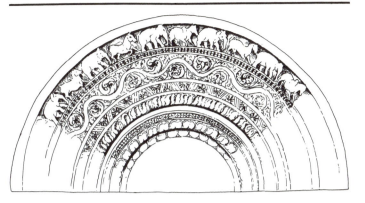

72 Moonstone, L. 2.42 m., *c.* 7th–8th c., Temple of the Bodhi Tree, Anuradhapura, *in situ*

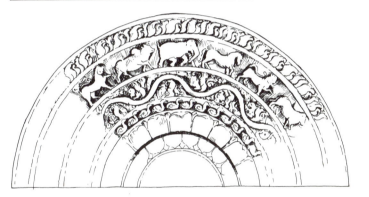

73 Moonstone: building near the Ruvanveliseya *dagaba*, L. 1.83 m., *c.* 7th–8th c., Anuradhapura, *in situ*

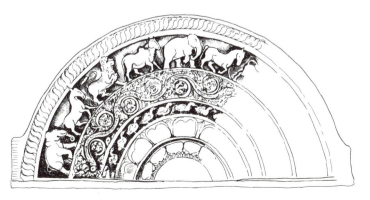

74 Moonstone: porch to the west of the Ruvanveliseya *dagaba*, L. 2.25 m., *c.* 8th–9th c., Anuradhapura, *in situ*

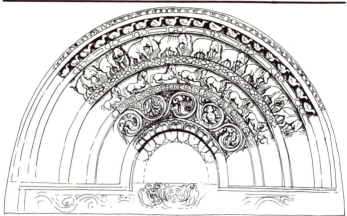

75 Moonstone, L. 2.28 m., 12th c., *vatadāgē,* Polonnaruwa, *in situ*

76 Moonstone, L. 1.47 m., 14th c., Horana Rājamahā vihara, Nat. Mus.,
 Colombo

77 Moonstone, L. 1.42 m., *c.* 16th c., Vishnu *devāle,* Kandy, Nat. Mus.,
 Kandy

78
Vajra capital: Dalada Maligava, dolomite, H. 60 cm., *c.* 7th–8th c., Anuradhapura, Nat. Mus., Colombo

80
Capital, dolomite, H. 73 cm., 8th–9th c., Anuradhapura, Nat. Mus., Colombo

81
Altar: lotus base, dolomite, H. *c.* 85 cm., 8th–9th c., Anuradhapura, Nat. Mus., Colombo

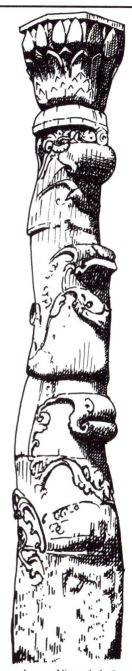

79
Lotus column: Nissamkalatā *mandapa,* dolomite, H. 2.70 m., late 12th c., Polonnaruwa, *in situ*

123

83
Kibini mūna or lion mask, wood, H. 19.5 cm., 14th c., Embekke *devāle, in situ*

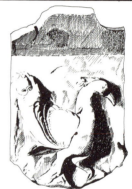

84
Hamsa: ridge-tile (rear side), mould-ed terracotta, H. 18 cm., 18th c., Temple of the Tooth, Kandy

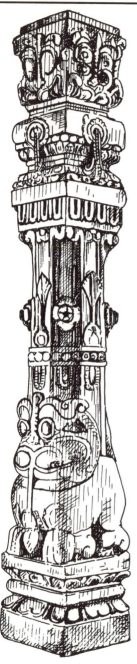

82
Column, dolomite, H. *c.* 2.60 m., *c.* 14th c., Medagoda *devāle,* Colombo Museum

85
Confronting *hamsas,* wood, H. 20.5 cm., 14th c., Embekke *devāle, in situ*

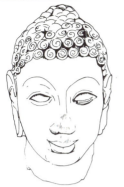

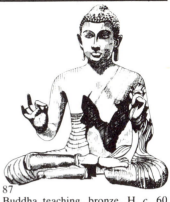

86
Head of the Buddha, limestone, *c.* 4th c., Ruvanveliseya *dagaba,* Nat. Mus., Anuradhapura

87
Buddha teaching, bronze, H. *c.* 60 cm., *c.* 5th c., Badulla, Nat. Mus., Colombo

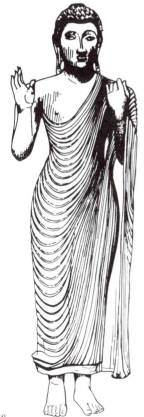

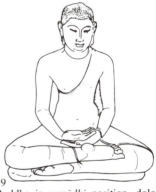

89
Buddha in *samādhi* position, dolomite, 5th–6th c., Puvarasankulam, Nat. Mus., Anuradhapura

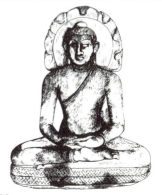

88
Standing Buddha, bronze, H. 45.5 cm., *c.* 4th c., Medavachchiya, Nat. Mus., Anuradhapura

90
Buddha protected by the Nagā, dolomite, *c.* 7th–8th c., Tirukkovil

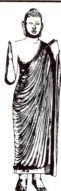

91
Standing Buddha: restored, lime-
stone, H. *c.* 2.40 m., *c.* 4th c., vihara:
Ruvanveliseya *dagaba, in situ*

92
Buddha in *samādhi* position, stone,
H. *c.* 1.20 m., *c.* 6th–7th c., Nat. Mus.,
Colombo

93
Buddha in *samādhi* position, cave
sculpture, H. 1.40 m., 12th c., Gal
vihara (vault), Polonnaruwa, *in situ*

94
Standing Buddha, cave sculpture,
H. 11.84 m., *c.* 9th c., Avukana,
in situ

95 Reclining Buddha, cave sculpture, L. 14.12 m., 12th c., Gal vihara,
Polonnaruwa, *in situ*

96
Standing Buddha called 'Ananda', cave sculpture, H. 6.93 m., 12th c., Gal vihara, Polonnaruwa, *in situ*

97
Standing Buddha: south Indian style, bronze, H. 60 cm., 14th c., Gadalā-deniya vihara, Kandy Dist., *in situ*

98
Buddha in *samādhi* position: south Indian style, bronze, 14th c., Tituk-kovil

99
Buddha in *samādhi* position, bronze, H. 24 cm., *c.* 18th c., Nat. Mus., Bangkok

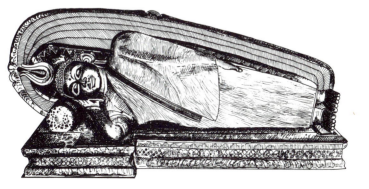

100 Reclining Buddha, bronze, L. 68 cm., *c.* 18th c., Kandy, Nat. Mus., Colombo

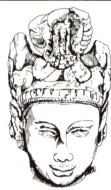

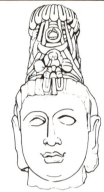

101
Bodhisattva (?): head, limestone, H.
c. 30 cm., c. 3rd c., Thūpārāma, Anu-
radhapura, Nat. Mus., Colombo

102
Head of Maitreya, dolomite, H. c.
45 cm., c. 7th–8th c., Thūpārāma,
Anuradhapura, Nat. Mus., Colombo

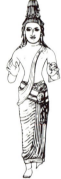

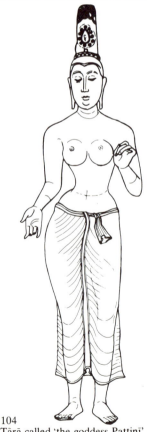

103
Standing Bodhisattva, bronze, H. c.
27 cm., c. 7th c., Giridara, Gampaha,
Nat. Mus., Colombo

105
Tārā, bronze, H. 17 cm., c. 8th c.,
Kurunegala, Nat. Mus., Colombo

104
Tārā called 'the goddess Pattinī', gilt
bronze, H. 1.45 m., c. 9th c., B.M.,
London

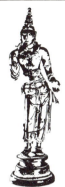

107
Standing Maitreya (?), bronze, 7th to 8th c., Anuradhapura, Nat. Mus., Colombo

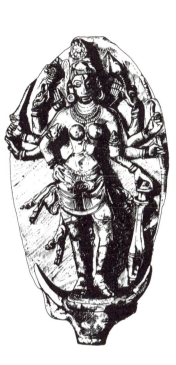

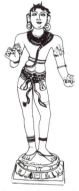

106
Mahishāsuramardini, granite, H. 73 cm., *c.* 10th–11th c., Cheddikulam, Nat. Mus., Colombo

108
Śivaite saint: Cola art, bronze, H. 37 cm., 11th c., Polonnaruwa, Nat. Mus., Colombo

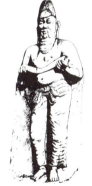

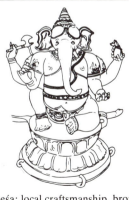

109
Agastya (?) or 'Parākramabāhu I', cave sculpture, H. 3.50 m., *c.* 11th to 12th c., Potgul vihara, Polonnaruwa

110
Ganeśa: local craftsmanship, bronze, t.H. 81 cm., 11th c., Polonnaruwa, Nat. Mus., Anuradhapura

111
Bālakrishna: Cola art, bronze, H. 7 cm., *c.* 11th c., Polonnaruwa, Nat. Mus., Colombo

112
Bālakrishna: local craftsmanship, bronze, t.H. 10 cm., *c.* 11th c., Polonnaruwa, Nat. Mus., Anuradhapura

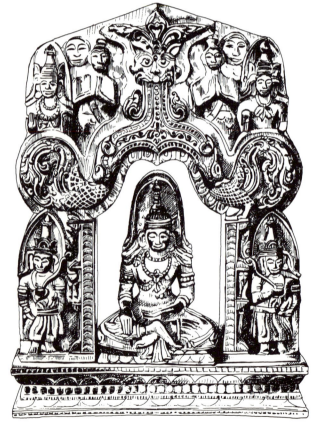

113 Adorned Buddha called 'Maitreya', bronze, 18th c., Kandy region (?), Nat. Mus., Colombo

BURMA

When compared with the art of the other Indianized countries in South-east Asia, Burmese art seems very original, and yet it remains one of the least studied areas, the brilliant Pagan period (1044–1287) having so far all but monopolized the attention of scholars. Various factors have perpetuated this regrettable state of affairs: the diversity of the population and the complex nature of Burma's historical development have encouraged the development of contemporaneous schools of art; the annexation of Burma to colonial India (1886–1947) diverted archaeological investigations to India; the isolationist policies often adopted by the Union of Burma in more recent years, and the publication of reports on the most important archaeological projects solely in the Burmese language have done nothing to improve the situation. Nevertheless, despite serious gaps in our knowledge about the very earliest period and the various local schools, some observations concerning the most notable features of Burmese art can be made.

ARCHITECTURE. Burmese architecture ranks among the most original types of architecture found anywhere in the Indianized world, whether one considers buildings in brick (preponderant at all times) or in wood, the material to which the art of Mandalay (1857–86) owes its well-deserved fame. Although the Burmese did not seek to create complexes on a vast scale emulating Cambodian and Indonesian achievements, their buildings attain a degree of intricacy not encountered elsewhere. Brick, the traditional building material, was used for the walls of the very earliest cities (Beikthano, Halin, Śrīkshetra) as well as for religious structures. Stone was employed only in isolated blocks or, since decoration was usually carried out in stucco, as a facing. Two main types of building can be distinguished: the stupa (often called pagoda) and the temple.

The stupas (cylindrical, pointed or slightly bulbous at first) evolved into structures with outlines that became progressively more bell-shaped, and this form was accentuated by the increasing size of the (square or polygonal) stepped bases and of the finials (hrāsa). The most recent stupas—of considerable size—have become the centres of highly intricate complexes (Rangoon: Shwe Dagon Temple). The temples adhere to two main plans that have been in use from the very earliest times (Śrīkshetra, formerly Prome): either a hall serving as the sanctuary, preceded in some cases by a projecting vestibule, or a nucleus (solid or with niches let into the walls) surrounded by a passage. The latter type was to undergo remarkable transformations during the Pagan Period: square or rectangular shapes with vestibules (Nagayon), cruciform temples (Ananda) and structures of diminishing tiers (Thatbyinnyu). The roofs formed by terraces are surmounted by śikharas reminiscent of the architecture of Orissa or, less commonly, by

131

stupas that are already found at Śrīkshetra (Bebe Paya). The construction of such original buildings necessitated the use of techniques hitherto unknown in South-east Asia: cloister and barrel-vaulting held in position by voussoirs.

ARCHITECTURAL DECORATION. Except in the case of the exuberant decoration on wooden buildings, the decoration of Burmese architecture is consistently restrained, conferring upon the buildings a certain bareness, and being confined to the mouldings, to the frames around openings and to pilasters. Mention should also be made of the importance of windows with tracery in the art of Pagan.

SCULPTURE. The predominantly Buddhist sculpture of Burma (stone, bronze, stuccoed brick, terracotta, wood) has received little attention from scholars. During the very earliest period, in Burma as throughout South-east Asia, the influence of the positions, dress and personal adornment typical of the southern Indian and Sinhalese artistic tradition was paramount; from the 8th or 9th century onwards, however, the Pāla style exerted the greater influence, supplanting the earlier tradition. The Pāla influence prevailed during the Pagan Period, although Burmese sculptors had elaborated an iconography of a richness and variety unsurpassed by any of the contemporary schools of art—as can be seen in their numerous carvings of scenes inspired by the *Jātaka* stories and by the Buddha's last existence. After the fall of Pagan, there developed a tendency towards stylization, while the regional schools, little known even today, seem to have become more individualized. At the same time there was a substantial increase in the number of adorned images, often with extravagant hairstyles; as time progressed, these images became further and further removed from the Pāla tradition. About the 18th or 19th century, a new iconography came to the fore; it manifested itself in figures with less naturalistic expressions and garments resembling Chinese robes (numerous alabaster statues, often partly lacquered and gilded, some of which may be regarded as the products of craftsmanship rather than of true artistry). The artistic quality of the bronzes and especially of the carved wooden figures is often much higher, e.g. images of the Buddha (usually standing) and of the great disciples. It should be noted that very few Mahāyānic or Brahminic images have survived; some of these (bronzes) are of a purely Indian character, while others provide evidence of local adaptation that the worship of *nats* (local gods) has kept alive up to the present day.

CERAMICS. Although a considerable number of wares from the earliest times (Beikthano) have survived, our knowledge of Burmese ceramics during the long interval between the early periods and the dawn of the modern era is quite sketchy. However, the importance of terracotta should be stressed in view of the abundance and quality of the Holy Images (Pagan) and of the major role played by terracotta plaques with moulded and glazed decoration in relation to architecture (*Jātaka* scenes from Pagan, 11th and 12th centuries; plaques decorated with coloured glazes from Pegu, 15th and 16th centuries and from Mingun, 18th and 19th centuries).

A BRIEF HISTORY OF BURMESE ART

There is no evidence to suggest that whatever artistic activity may have occurred in Burma during the prehistoric period bore fruit in the form of particularly original works of art, nor does there appear to be any evidence

to attest the creation of noteworthy works of art during the protohistory of the country before the earliest Indianized kingdoms came into being. Although it is conceivably correct, the Buddhist tradition according to which, as early as the 3rd century B.C., missionaries were sent to Burma and at the same time to Sri Lanka is unverified. Similarly, Chinese reports concerning an Indianized Pyu kingdom in existence as early as the 3rd century A.D. are not confirmed by local epigraphy or archaeological remains, which provide no evidence of this kingdom's having existed before about the 6th century.

THE EARLIEST INDIANIZED KINGDOMS. Before the rise of the kingdom of Pagan, from the middle of the 11th century onwards, the Pyu kingdom of the middle course of the Irrawaddy and the Mōn kingdom of Lower Burma played a decisive role in determining the course to be taken by Burmese art. For its part the province of Arakan, on account of its geographical situation, tended to promote links with north-east India.

The Pyu kingdom, to which in the 7th century the Chinese gave the name of Śrīkshetra ('Holy Place', 'Blessed Land'), is considered the forerunner of the Burmese nation. During the 7th and 8th centuries, the two main sects of the 'Lesser Vehicle' of Buddhism existed side by side: Theravāda Buddhism, whose language is Pāli, and Mūlasarvāstivāda Buddhism, whose language is Sanskrit. Several sites have yielded valuable information about creative activity during the Pyu dynasty's period of rule, which seems to have lasted from the 5th until the 9th century. Successive excavations at Beikthano, the 'City of Vishnu' and undoubtedly the Pyu's most ancient city, have revealed the existence, within the fortified enclosure of a large palace, stupas and monasteries with cells that show the influence of Āndhra (Amarāvatī, Nāgārjunakonda). No Buddhist images have been discovered, but interesting finds of pottery, including funerary urns, have been made. Halin, a site further north, experienced the same influences and has yielded some reliefs. Near Prome, at the ancient capital Śrīkshetra (Thayekhitteya, or Hmawza), other interesting monuments are preserved whose importance is in no way diminished by their being rather small, since they herald the two styles that were to be further developed at Pagan. The great stupas (cylindro-conical and pointed) are not completely solid. The sculpture carved during the early years of the Pyu kingdom reflects the influence of south India; later, the influence of north-east India can be recognized. This sculpture includes some Brahminic and Mahāyānic images.

The Mōn Kingdom (Ramaññadesa, capital Sudhammāvatī, modern Thaton) seems to have established relations with south India during its very earliest years, as one might expect in view of its geographical position. There is evidence to prove that Theravāda Buddhism was practised there as early as the 5th century. The long period of activity in this region, conquered by the Pagan kingdom but restored to independence when Pagan fell (Martaban, Pegu, founded in 825), has resulted in the restoration and alteration of most of the buildings so that it is now difficult to form an impression of their original condition. The sculpture, however, bears the imprint of the same waves of influence as that found in Śrīkshetra, with comparable evidence of the presence of Brahminism.

BURMA, THE KINGDOM OF PAGAN. There are indications that the site of Pagan was fortified as early as 849, but it is not until the 11th century, with the reign of Aniruddha (1044–77) that the Burmese kingdom can truly be said to enter the history books. Art historians distinguish two periods. The earlier of these is the Mōn Period (1044–1113), when the Mōns conquered

by Pagan introduced their art and and culture into the kingdom, although the affinity between Mōn and Pyu architecture ought not to be overlooked. Many buildings were erected during the reigns of Aniruddha and Kyanzittha; the architecture reflects the combined influence of the local tradition and that of north-east India (due, for instance, to the renown of the site at Bodh-Gayā): the erection of numerous stupas (cylindro-conical, rounded, the Sinhalese type and, above all, a type with high, wide terraces rising in a pyramid) and temples that are a development of styles first adopted at Śrīkshetra with a predilection for roofs surmounted by *sikharas* and for symmetrical shapes such as those found at Ananda.

The second period, known as the Burmese Period (1113–1287), consists of a transitional phase (1113–*c*. 60), during which the influence of the Mōn culture waned, followed by a phase characterized by the transformation of temples into tiered structures with halls and passages more open and airy than hitherto (Thatbyinnyu) and by the development of residential monasteries.

Although in its style the sculpture carved during the Pagan Period reflects the direct influence of Pāla-Sena art, it displays a far richer iconography, and by slow degress it moved towards the creation of a more authentically Burmese aesthetic, which is already clearly visible at Ananda in the Scenes from the Life of the Buddha. Images of deities are rare, and they bear a closer relationship to Buddhist cosmology and the worship of local deities than to Brahminism. (Nat-hlaung-gyaung is nonetheless a temple dedicated to Vishnu.) Though outside the scope of this survey, the important role played at Pagan by painting ought not to pass unmentioned.

FROM THE FALL OF PAGAN TO THE FOUNDING OF AMARAPURA (1287 to 1783). During the long period of political instability and the incessant struggles following the seizure of Pagan by the Mongols, art and architecture fell into a decline from which they did not emerge until the collapse of the kingdom of Ava (founded in 1636)—the event that ushered in the artistic renaissance of Amarapura and Mandalay. Despite the turbulence of this period, the capital cities, whether succeeding one another or coexistent, often witnessed considerable artistic activity. At Pegu, the inheritor of the kingdom of Thaton, a number of historic buildings founded in the 15th and 16th centuries still exist, though they have been continually enlarged and restored in an unending process lasting from the 15th century right up to the 20th. Mrohaung, which followed Wesali as the capital of Arakan, boasts many important buildings dating from the 15th, 16th and 17th centuries. At Sagaing, founded in 1315, the influence of Sri Lanka can be seen in some buildings of the 14th and 15th centuries; however, it was at Ava (Ratnapura, the 'Jewelled City', founded in 1364 and adopted as the capital in 1636) that the renaissance got under way. The layout of the town is evidently the result of rational development by clear-sighted planners, and the decoration of the architecture, indeed the architecture itself, tends to derive its inspiration from wood-carving, which plays an important role itself. At Mingun, a pagoda of sizeable proportions (it was to have been more than 150 metres high [492 feet]) was begun towards the end of the 18th century by the founder of Amarapura (the 'City of the Immortals', 'of the Gods').

THE ART OF AMARAPURA AND MANDALAY (1783–1885) forms, on the one hand a retrospective link with the glorious tradition of Pagan, whose most famous temples it occasionally copied, while, on the other hand, it developed timber architecture of outstanding richness and refinement.

(Many examples of this were destroyed during the Second World War.) The wood-carvings (statues and reliefs) are often gilded or painted in a variety of colours; they represent all that is best in the modern Burmese tradition. At Rangoon, founded in 1755 by renaming the town of Dagon, the Shwe Dagon Temple (continually enlarged and embellished through the centuries) illustrates the recent artistic trends by bringing them together in a single display.

MAJOR MUSEUMS

Field Museum, Hmawza
State Museum, Mandalay
Museum, Mrohaung
Archaeological Museum, Pagan
Museum of the International Library for Advanced Buddhist Studies, Rangoon
National Museum, Rangoon

CONCISE BIBLIOGRAPHY

BEYLIÉ, L. DE. *Prome et Samara.* Paris, 1907.
DONNISON, F. S. V. *Burma.* London, 1970.
GRISWOLD, A. B. 'Burma' in *Burma, Korea, Tibet.* London, 1964.
LOWRY, J. *Burmese Art.* (Victoria and Albert Museum) London, 1974.
LUCE, G. H. *Old Burma, Early Pagan.* 3 vols. (*Artibus Asiae* Suppl.) Ascona, 1969.
O'CONNOR, V. C. SCOTT. *Mandalay and Other Cities of the Past in Burma.* London, 1907.
THAW, AUNG. *Historical Sites in Burma.* Rangoon, 1972.
WIN, LU PE. *Pictorial Guide to Pagan.* Rangoon, 1955.

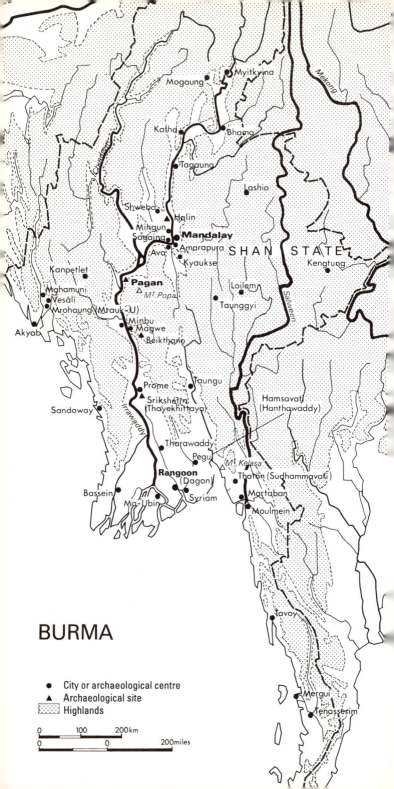

BURMA

- ● City or archaeological centre
- ▲ Archaeological site
- ░ Highlands

Mogaung
Myitkyina
Katha
Bhamo
Tagaung
Lashio
Shwebo
Halin
Mingun
Sagaing
Mandalay
Amarapura
Ava
Kyaukse
SHAN STATE
Kengtung
Kanpetlet
Loilem
Pagan
Mt. Popa
Mahamuni
Vesali
Taunggyi
Mrohaung (Mrauk-U)
Akyab
Minbu
Magwe
Beikthano
Taungu
Prome
Srikshetra
(Thayekhittaya)
Hamsavati
(Hanthawaddy)
Sandoway
Tharawaddy
Pegu
Mt. Kelasa
Rangoon
(Dagon)
Tharon (Sudhammavati)
Bassein
Ma-Ubin
Syriam
Martaban
Moulmein
Tavoy
Mergui
Tenasserim

Irrawaddy
Chindwin
Mekong
Salween

0 100 200km
0 200miles

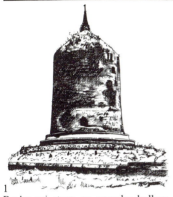

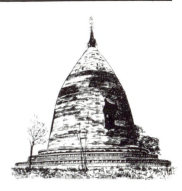

1
Bo-bo-gyi stupa or pagoda: hollow construction, H. 46.50 m., 6th–7th c., Śrīkshetra

2
Paya-gyi pagoda: restored, 6th–7th c., Śrīkshetra

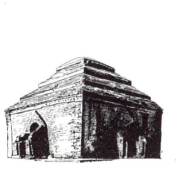

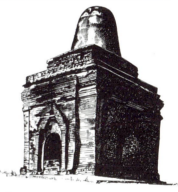

3
Lemyethna Temple, *c.* 5th–7th c., Śrīkshetra

4
Bebe Paya Temple, *c.* 6th–7th c., Śrīkshetra

5
Rounded stupas, H. 10.65 m., 8th c., near Thiripyitsaya, Pagan

6
Pebin-gyaung stupa, H. 12.50 m., 10th c., Pagan

137

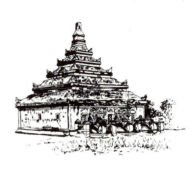

7
Paw-daw-mu stupa, H. 6.50 m., 11th c., near Nagayon, Pagan

8
Pitakat-taik Temple: library, Mōn style, after 1057 A.D., Pagan

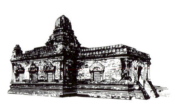

9
Shwe-hsan-daw (or Mahāpeinnè) pagoda, H. 41.30 m., after 1060 A.D., Pagan

10
Nanpaya Temple, 1060–70, Myin-pagan

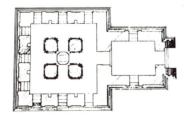

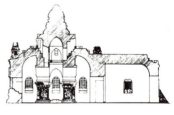

11
Nanpaya Temple: plan

12
Nanpaya Temple: longitudinal section

13
Nat-hlaung-gyaung Temple: temple
of Vishnu, after 1057, Pagan

14
Loka-hteikpan Temple: transitional
style, 12th c., Pagan

15 Pahtothamya Temple: Mōn style, *c.* 1080, Pagan

16 Nagayon Temple: Mōn style, *c.* 1090, Pagan

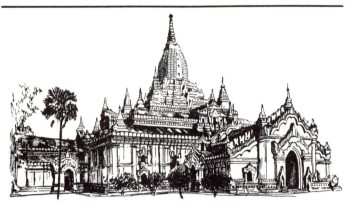

17 Ananda (or Nanda) Temple: Mōn style, H. 48.75 m., early 12th c.,
Pagan

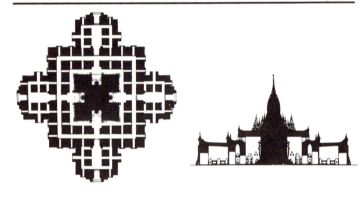

18
Ananda Temple: symmetrical plan

19
Ananda Temple: cross-section

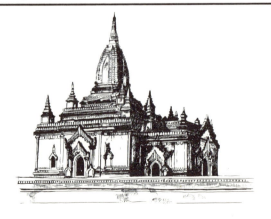

20 Shwegu-gyi Temple: transitional style, 1131, Pagan

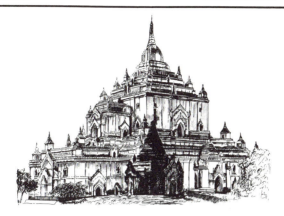

21 Thatbyinnyu Temple: Burmese style, H. 64 m., Pagan

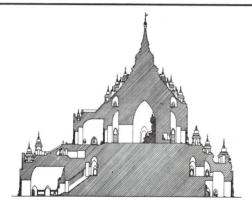

22 Thatbyinnyu Temple: cross-section

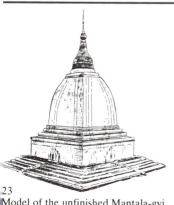

23
Model of the unfinished Mantala-gyi
pagoda: Pondaw, brick, H. 5 m.,
1790, Mingun

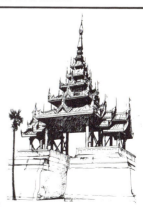

24
Pyathat: Mingalā Gateway, 19th c.,
Royal Palace, Mandalay

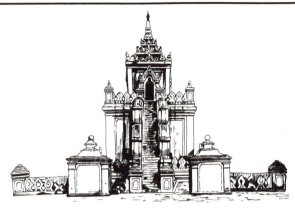

25 Sanctuary tower of the Relic of the Tooth, 19th c., Royal Palace, Mandalay

26
Window with tracery, stone, after 1057, Pitakat-taik Temple, Pagan

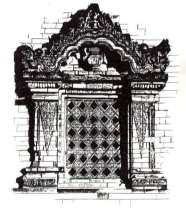

28
Window with tracery, brick, *c.* 1090, Nagayon Temple, Pagan

27
Window with tracery, stone, 1060–70, Nanpaya Temple, Pagan

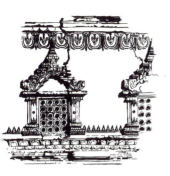

29
Window with tracery, stone and stuccoed brick, late 11th c., Mye-bontha Paya-hla, Pagan

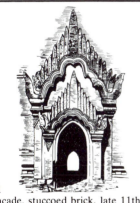

31
Façade, stuccoed brick, late 11th c., Hlaing-shè Gu Temple 251, near Nabedaw (east of Pagan)

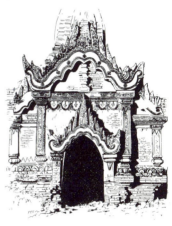

30
Side entrace, stuccoed brick, 12th c., Dhammayan-gyi Temple, Pagan

32
Detail: exterior frieze, carved stone, 1060–70, Nanpaya Temple, Pagan

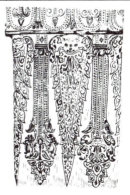

33
Detail: interior frieze, carved stone, 1060–70, Nanpaya Temple, Pagan

34 Exterior frieze, carved stone, 1060–70, Nanpaya Temple, Pagan

35
Detail: arch of the portico, stucco, late 11th c., Mon Gu Temple 418, near Lokananda (south of Pagan)

37
Detail: frieze on the Sō-min-gyi stupa, glazed terracotta, c. 12th c., Pagan, *in situ*

36
Corner pilaster, stucco, c. 1113 Kubyauk-gyi Temple, south of Pagan

144

38
Decorative plaque, terracotta, 8th to
9th c., Kyontu pagoda, Waw, Pegu,
in situ

39
Scene from a *Jātaka* story, terracotta,
H. 38 cm., 11th c., Hpetleik pagoda,
Pagan, *in situ*

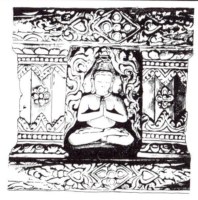

40 Detail: Brahmā's throne, stuccoed brick, late 11th c., Myebontha
Paya-hla Temple, Pagan, *in situ*

41
Scene: *Jātaka* story, glazed terracotta,
H. 37 cm., early 12th c., Ananda
Temple, Pagan, *in situ*

42
Scene: *Jātaka* story, glazed terracotta,
H. 37 cm., early 12th c., Ananda
Temple, Pagan, *in situ*

43
Detail: framework of a door, carved
wood, late 11th c., Shwé-zigōn pa-
goda, Pagan, *in situ*

44
Detail: west door, carved wood,
1131, Shwégu-gyi Temple, Pagan,
in situ

45 Door from the Zedawun-zaung, t.H. 4.15 m., 19th c., Royal Palace,
Mandalay

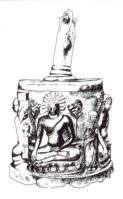

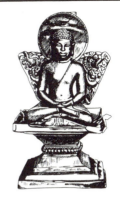

46
Reliquary, silver, 6th–7th c., Khin
Ba mound, Prome

47
Buddha in *samādhi* position, gold,
6th–7th c., Khin Ba mound, Prome

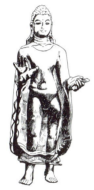

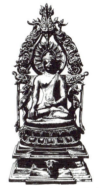

48
Standing Buddha, bronze, 7th–8th
c., Thaton

49
Buddha touching the Earth, bronze,
H. 36 cm., 11th–12th c., Arch. Mus.,
Pagan

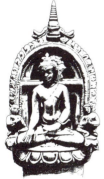

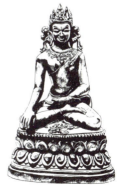

50
Buddha touching the Earth (1 of 4),
bronze, H. 14 cm., 11th c., Paw-daw-
mu, Arch. Mus., Pagan

51
Fully adorned Buddha touching the
Earth, bronze, 12th c., Thazi

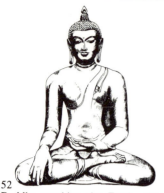

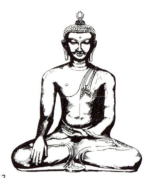

52
Buddha touching the Earth: Pāla-Mōn style, bronze, H. 43 cm., 11th to 12th c., Pagan

53
Buddha touching the Earth: Pāla-Mōn style, bronze, H. 31 cm., 11th to 12th c., Pagan

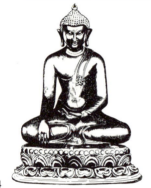

54
Buddha touching the Earth: Pāla-Mōn style, bronze, H. 32 cm., 11th to 12th c., Ngwezedi

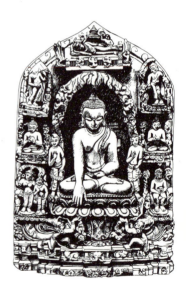

56
The Buddha Vessabhū: Pāla-Mōn style, inscribed terracotta, 11th–12th c., Pagan

55
8 Great Miracles: Pāla-Mōn style, soapstone, H. 13 cm., 11th–12th c., Upali Thein, Arch. Mus., Pagan

57
Head of an adorned Buddha (?),
stucco, H. 30 cm., 11th–12th c.,
Arch. Mus., Pagan

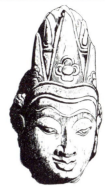

58
Head of an adorned Buddha (?):
shows Pāla-Sena influence, stone,
11th–12th c., Arch. Mus., Pagan

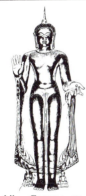

59
The Buddha Gotama or Gautama
standing, bronze, H. 3.80 m., c. 1080,
Shwé-zigōn pagoda, Pagan, *in situ*

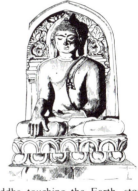

60
Buddha touching the Earth, stone,
H. 1.20 m., late 11th–early 12th c.,
Nagayon Temple, Pagan, *in situ*

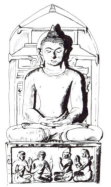

61
The Buddha Padumuttara, stone,
late 11th–early 12th c., Nagayon
Temple, Pagan, *in situ*

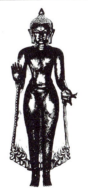

62
Standing Buddha, bronze, H. 1.12
m., c. 1100, Pagan

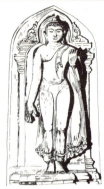

63
Buddha walking, stone, late 11th to early 12th c., Nagayon Temple, Pagan, *in situ*

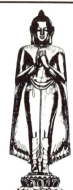

64
The Buddha Kāśyapa standing, wood, H. 9.80 m., early 12th c., Ananda Temple, Pagan, *in situ*

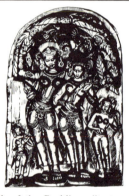

65
Birth of the Buddha, gilt stone, H. 1 m., early 12th c., Ananda Temple, Pagan, *in situ*

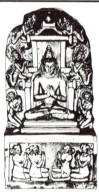

66
The Bodhisattva at Kapilavastu, gilt stone, H. 1 m., early 12th c., Ananda Temple, Pagan, *in situ*

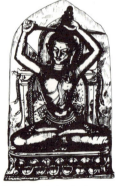

67
The Cutting of the Hair, gilt stone, H. 1 m., early 12th c., Ananda Temple, Pagan, *in situ*

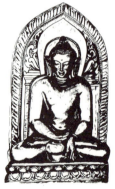

68
The Buddha taking a meal, gilt stone, H. 1 m., early 12th c., Ananda Temple, Pagan, *in situ*

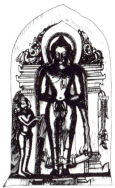

69
The offering of the bundle of grass, gilt stone, H. 1 m., early 12th c., Ananda Temple, Pagan, *in situ*

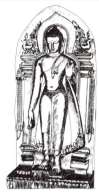

70
Buddha walking, gilt stone, H. *c.* 1 m., early 12th c., Ananda Temple, Pagan, *in situ*

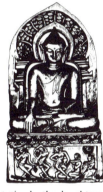

71
Temptation by the daughters of Māra, gilt stone, H. *c.* 1 m., early 12th c., Ananda Temple, Pagan, *in situ*

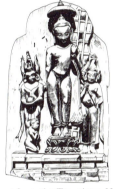

72
Descent from the Tāvatimsa Heaven, wood, H. 70 cm., *c.* early 12th c., Arch. Mus., Pagan

73
Adorned Buddha standing, H. 1.88 m., *c.* late 13th c., Arch. Mus., Pagan

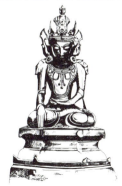

74
Adorned Buddha touching the Earth: early Ava style, bronze, *c.* 14th c., Thazi

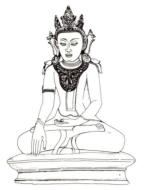

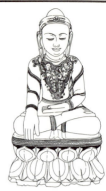

75
Adorned Buddha touching the Earth:
Ava style, bronze, *c.* 15th c., private
coll.

76
Adorned Buddha touching the Earth:
Ava style, bronze, *c.* 15th c., private
coll.

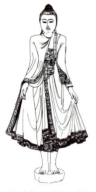

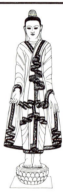

77
Standing Buddha: Mandalay style,
lacquered and gilt wood, H. *c.* 1.80
m., *c.* 19th c., private coll.

78
Standing Buddha: Mandalay style,
lacquered and gilt wood, H. *c.* 1.80
m., *c.* 19th c., private coll.

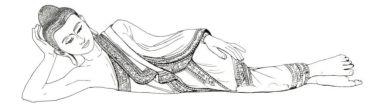

79 Reclining Buddha: Mandalay style, lacquered and gilt wood,
L. *c.* 1.70 m., *c.* 19th c., private coll.

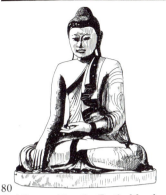

80
Buddha touching the Earth: Mandalay style, alabaster (partially gilt), H. 1.75 m., V. & A., London

81
Adorned Buddha: 'Shan' style, bronze, t.H. 37 cm., c. 17th c., private coll.

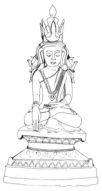

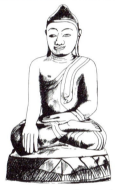

82
Adorned Buddha: 'Shan' style, bronze, c. 17th c., private coll.

83
Buddha touching the Earth, alabaster, H. 37.5 cm., 19th c., Mayong (Shan States), V & A., London

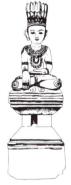

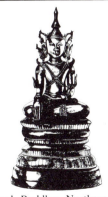

84
Adorned Buddha: Shan (?) style, wood, t.H. 33 cm., c. 19th c., private coll.

85
Adorned Buddha: Northern style, bronze, H. 46 cm., c. 18th c., Myothit region, V. & A., London

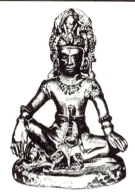

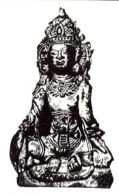

86
The Bodhisattva Maitreya (?), gilt
bronze, H. 18.5 cm., *c.* 8th–9th c.,
Pagan, V. & A., London

87
The Bodhisattva Maitreya (?),
bronze, *c.* 8th–9th c., Arch. Mus.,
Pagan

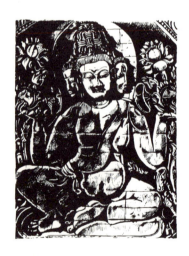

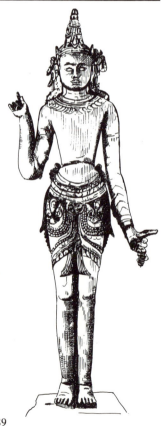

88
Brahmā, stone low relief, H. of figure
c. 1.20 m., 1060–70, Nanpaya Temple,
Pagan, *in situ*

89
Indra, gilt wood, H. 2.65 m., late
9th c., Shwé-zigōn pagoda, Pagan,
in situ

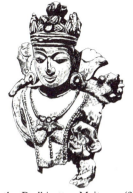

90
Bust: the Bodhisattva Maitreya (?),
bronze, *c.* 13th c., Office of Arch.,
Mandalay

91
Donor (King Kyanzittha), lacquered
and gilt, early 12th c., Ananda
Temple, Pagan, *in situ*

92
Donor (the Mahāthera Arahan),
lacquered and gilt, early 12th c.,
Ananda Temple, Pagan, *in situ*

93
The disciple Moggallana, lacquered
and gilt wood, H. 37 cm., *c.* 1850,
Mandalay (?), V & A., London

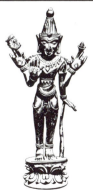

94
Padmapāni standing, bronze, H. *c.*
15 cm., 10th–11th c., Arch. Mus.,
Pagan

95
Vishnu standing, bronze, H. 33 cm.,
c. 13th c., Pagan, Office of Arch.,
Mandalay

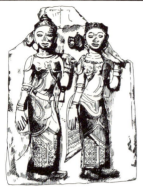

96
Goddesses, terracotta panel with 3-coloured glaze, H. 43.5 cm., late 15th c., Pegu, V. & A., London

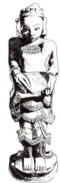

98
Matali holding a notice, sandstone, H. 67 cm., *c.* 17th c., Kyauksé, V. & A., London

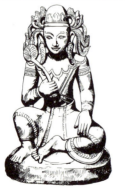

99
Lokanātha (?), alabaster, H. 61 cm., *c.* 17th–18th c., V. & A., London

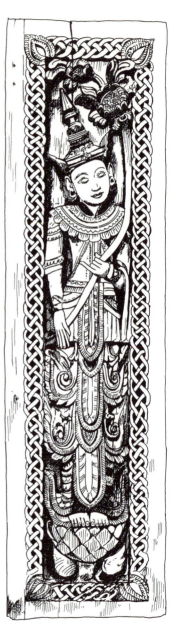

97
Door leaf, carved wood with traces of polychrome painting. H. 1.20 m., *c.* 1850, Mingun, V. & A., London

101
Votive stupa, bronze, H. 23 cm.,
11th–12th c. (?), Arch. Mus., Pagan

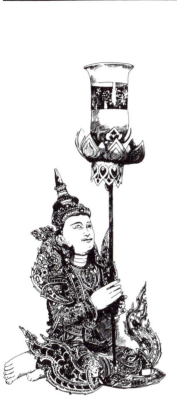

100
Deity as candle-holder, lacquered
and inlaid wood, H. 65 cm., c. 1850,
Mandalay (?), V. & A., London

102
Votive stupa, bronze, 11th–12th c.
(?), Pagan

103
Praying woman, glazed terracotta,
H. 31 cm., c. 16th–17th c., Prome,
V. & A., London

104
A *yaksha*, an assistant of the Buddha,
alabaster, H. 23 cm., c. 19th c., Ma-
yong (Shan States), V. & A., London

157

105
Lotus (open) decorated with the Eight Miracles: Pāla-Mōn style, bronze, *c.* 11th–12th c., Tuywindaung

106
Loom-pulley, wood, H. 16.5 cm., *c.* 19th c., Sagaing region, V. & A., London

107
Lamp, terracotta, 7th–9th c., Halin

108
Covered vase: stupa shape, terracotta, *c.* 9th c., Twanté, Pegu region, formerly in Shwe-hsan-daw Temple

109
Water-vessel, bronze, *c.* 10th–12th c., Thiripyitsaya, Arch. Mus., Pagan

110
Pitcher, glazed terracotta, H. 19 cm.,
c. 19th c., Lawsawk, V. & A., London

111
Water-cooler and stand, glazed terra-
cotta, H. 19 cm., c. 19th c., Lawsawk,
V. & A., London

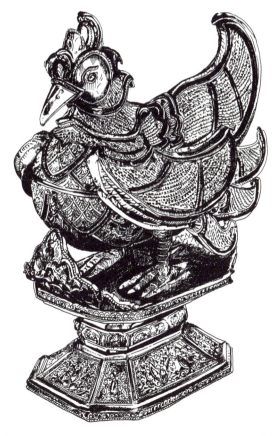

112 Betel-container, chased gold inlaid with precious stones, H. 41.5 cm.,
 c. 19th c., Mandalay (Regalia), V. & A., London

THAILAND

Geographical and, to an even greater extent, historical factors peculiar to Thailand make Thai art a meeting place for widely differing schools of art. The normally straightforward task of establishing a chronology is made very difficult for these schools on account of the fact that most of the schools did not succeed one another but were contemporaneous over considerable periods of time. Since, until the end of the 18th century at the earliest, no real unity can be perceived, most writers have distinguished seven main schools of art. Despite this diversity, which precludes an overall study of the art of Thailand, certain broad tendencies can be discerned. Resulting partly from local circumstances (for example, the relative scarcity of a type of stone suitable for dressing or for carving), partly from the permanence of certain traditions (ceramics, modelling) and partly from the constant predominance of Buddhism (particularly Theravāda Buddhism), these tendencies are often the only real links that exist between schools that grew up during two long periods. One of these periods extends from the beginning of the Indianization of the country in the earliest centuries of the Christian era to the founding of the first Thai kingdoms of central Indo-China in the second half of the 13th century; the other, truly Thai, began at that date and continues to this day.

It is after a rich and active prehistory, noted in particular for the original wares of its ceramic industry (Ban Kao, Neolithic; Ban Chieng, 1st millennium) and a period of Indianization (c. 3rd–6th century A.D.), which is well represented in the Malay peninsula and the south-west of the Menam basin, that the earliest schools can be distinguished.

THE DVĀRAVATĪ SCHOOL (7th–11th century). The artistic output of this school, which is named after a kingdom known to have existed in the late 7th century, should be regarded as a special form of art (primarily of Buddhist inspiration and very widespread), rather than as the art of a narrowly defined area. The Dvāravatī school grew up during a period when the Mōn culture was the main influence on Thailand. It is best-known for its sculpture, relatively little having survived of the buildings (especially the stupas), most of which were constructed of bricks bonded with unbaked clay and decorated with stucco or, less often, with terracotta: Nakhon Pathom, U Thong, Ku Būa, etc. Most of the sculpture falls into one of two categories: images of the Buddha (stone, bronze, stucco, terracotta) depicting him either seated in the Indian or European manner or standing (a type whose influence was to be widespread and long-lasting) and usually making the debating gesture; and, second, Wheels of the Law, descendant of Indian Buddhism's oldest iconographic tradition. However, as far as is known at present, the examples of these carved by sculptors of the Dvāravatī school were the only ones created during this period.

161

THE ŚRĪVIJAYA SCHOOL (8th–13th century). This school came into being as a result of the expansion of the Sumatran kingdom of Śrīvijaya into the Malay peninsula in the 8th century. During its early phase, the Śrīvijaya school was distinguished by its Mahāyānic or Brahminic inspiration and, in the field of sculpture, by the clear influence of contemporary Indonesian art. Although the few buildings that have survived (at Chaiya, for example) are unfortunately either in a ruinous state or too heavily restored, they do nevertheless reflect the same influence, albeit fused with borrowings from Champa (especially of construction techniques). The statuary (stone and bronze) is as noteworthy for the quality of its execution as for its iconography, and provides evidence of the expansion (definite but short-lived) of the Śrīvijaya school throughout the area dominated by the art of Dvāravatī, which was modified to some extent by the influence of the younger school. After the 10th century, however, the influence of the Śrīvijaya school seems to have come to an end. The importance of the Mahāyānic and Brahminic cults waned, and henceforth it was only in the peninsula that, as a result of the activities of local workshops such as that at Nakhon Si Thammarat, some vestiges of the school's originality lingered on.

THE LOPBURI SCHOOL (7th–14th century). Although the term 'Lopburi school' was at first used with reference only to the Khmer art produced in Lopburi and eastern Thailand between the 11th century and the 13th, the term seems appropriate for all the works of art that derived their inspiration either directly from a Khmer tradition or indirectly from a tradition which itself drew upon Khmer art. Such works of art were produced to the north of the Dangrēks and especially in the valley of the Mun, but it would be an over-simplification to regard these works as constituting some kind of regional prolongation of Khmer art. Except at the end of the 12th century and the beginning of the 13th when a truly Khmer style—that of the Bayon (see 'Cambodia'), even if it was adapted to the availability of local resources (rarity of sandstone, importance of stucco)—became established for a time, these works of art emanated from an original school having its own iconographical and technical traditions and its own regional workshops (in particular Si Tep, c. 8th–9th century). The architectural decoration (lintels) of the 7th to 9th centuries and the sculpture (especially the bronzes of the 8th and 9th centuries, of Mahāyānic inspiration and of outstanding quality) afford ample proof of this school's importance from its very beginnings. Moreover, after the middle of the 13th century, when Angkor's output ceased and its influence declined, it was in the region around Lopburi, once again independent, that the traditions inherited in the 12th century were not merely kept alive but actually developed. This development gave rise to the *prang* (Lopburi), a sanctuary tower soon to become a typical feature of Thai art, and to a prolific school of sculpture that was active right up to the flowering of the art of Ayuthia late in the 14th century.

THE THAI SCHOOLS. During the second half of the 13th century there came into being the schools, essentially Theravāda Buddhist in their inspiration, from which, after fusion and development, the truly indigenous art of Thailand was later to emerge.
The Sukhothai School (late 13th–15th century). Created by the overthrow of its Khmer suzerain towards the middle of the 13th century, the kingdom of Sukhothai, despite its short duration, was to give rise to a school of art that was extremely prolific and prodigiously original in every branch of artistic activity: architecture, sculpture and ceramics to name but a few. This school's influence over a large proportion of the Indo-Chinese penin-

sula was to prove profound and lasting. The artists of Sukhothai applied their remarkable sense of beauty to assimilating into their art extremely varied influences, creating an idealized image of the Buddha of unrivalled spirituality, this being particularly true in the case of the Buddha walking. These images, fashioned in bronze only, would suffice to ensure the school's reputation, but in addition this school produced highly original Brahminic idols. No less worthy of mention, in conclusion, are the Sukhothai school's contribution to and influence upon architecture and ceramics, the latter deriving considerable benefit from the teachings of Chinese potters.

The Lan Na school (c. 13th–20th century). A feature of the art of the northern provinces (the former kingdom of Lan Na, created by the overthrow of the ancient Mōn kingdom of Haripuñjaya—Lamphun—at the end of the 13th century) is its originality, which persisted until the early years of the 20th century. This school's output is often referred to either as the 'art of Chiang Sèn' (the city founded in 1327 being considered, on the basis of an unsubstantiated tradition, to have been built on what had been the site of an important Buddhist centre) or as the 'art of Chiang Mai' (from the name of the kingdom's capital, founded in 1296). The Lan Na school appears to have benefited during its early years from certain features of Pāla-Sena art transmitted by the Mōns of Burma, the kingdom of Haripuñjaya having probably acted as an intermediary by virtue of its dealings with the latter. From the second half of the 14th century onwards, the influence of Sukhothai made itself felt; this led to the formation of a hybrid style. Much of the sculpture (bronzes in the main, but also remarkable achievements in stucco) suffered a decline; few of the very large number of carvings produced were of the highest quality. The wide variety of architecture, on the other hand, while continually reflecting the influences acting upon it, consistently maintained a very high standard. Frequently in modern times, a very strong Burmese influence, the result of political developments, has come to the fore. The ceramics of the Lan Na school are heavily indebted to the wares of Sukhothai; indeed, the first kilns established in the Chiang Mai region employed craftsmen who had migrated from Sukhothai. It is interesting to observe that the later art of the Lan Na school, characterized by a large output of high-quality wood-carvings, has certain affinities with Laotian art.

The Ayuthia School (14th–18th century). The kingdom of Ayuthia, founded in 1350, was to achieve national unity and bring about the coalescence of the various artistic trends in existence at that time. The new kingdom's earliest art, produced more than a century after the end of the Khmer hegemony over the Menam basin, synthesized the artistic traditions surviving in the country: the continuation of the art of the Dvāravatī and Lopburi schools, sometimes in a decadent form, and the influence of Lamphun, the vehicle through which features of Pāla-Sena art were transmitted to Thai art. These varied currents gave birth to the 'style of U Thong' (13th–15th century), known only for its (Buddhist) sculpture, whose development reflects the growing influence of the art of Sukhothai. From the 15th century, this influence was the major force acting upon the art of the Ayuthia school, whose sculpture is distinguished by bearing the imprint of its heterogeneous inspiration and by being executed in a somewhat lifeless, classical style. Although Ayuthian architecture reflects the influence of the same currents, it attained distinction through its adoption and development of the shape of the *prang* (inherited from Lopburi), by its evolvement of the various types of stupa and by its elaboration of monastic buildings with classical naves *(vihān, ubosoth).* Although most of the buildings of this period were destroyed in 1767 when the Burmese sacked the capital, structures of the types described above have

fortunately been preserved in the great provincial monasteries (Phitsanulok, Phetburi, Nakhon Si Thammarat, etc.).

The Bangkok School (or *Ratanakosin* school, late 18th–early 20th century). It is this school, the direct heir of the Ayuthia school, which, more than any other, enables us to appreciate the quality, richness and refinement of the art of Thailand. The architecture of the great monasteries at Thonburi (18th–early 19th century) and at Bangkok (the capital from 1782) is a considerable artistic achievement, synthesizing the trends that developed over more than five centuries of evolution. In the early phase of this school's activity, its sculpture was a mere continuation of that of the Ayuthia school, but, from the second quarter of the 19th century (the reign of Rama III) onwards, the influx of a fresh iconographic repertoire and a certain fascination with Chinese art gave rise to a real stylistic regeneration. After the middle of the 19th century (the reigns of Rama IV Monkut and of Rama V Chulalongkorn), a desire for rationalism lessened the effects of the earlier tendencies, introducing an element of Western perspective into traditional art and giving rise to real museological preoccupations.

Although space does not permit a lengthy discussion of the interest and quality of lacquered ware, inlaid work and gold-work, these should be mentioned along with the Sino-Siamese polychrome ceramics (*Bencharong*, 'five-colours') that appeared at the very close of the Ayuthia period and are remarkable for their variety and beauty.

MAJOR MUSEUMS

Chandrakasem National Museum; Chao Sam Phraya National Museum, Ayuthia
National Museum, Bangkok
Museum of Wat Pra Mahāthat, Chaiya
National Museum, Chiang Mai
National Museum (Chiang Sèn District), Chiang Sèn
National Museum, Kamphèng Phèt
National Museum, Khon Ken
Museum Wat Pra That Haripunchai, Lamphun
Pra Narai Rajanivet National Museum, Lopburi
Pra Pathom Chedi National Museum, Nakhon Pathom
Maha Viravongsa National Museum, Nakhon Rachasima
National Museum, Nakhon Si Thammarat
Museum of the Department of Fine Arts, Phimai
Museum of Wat Machimawat, Songkhlà
Ram Khamheng National Museum, Sukhothai
National Museum, U Thong

CONCISE BIBLIOGRAPHY

BOISSELIER, J. and BEURDELEY, J.M. *The Heritage of Thai Sculpture* (trs. by James Emmons). New York and Tokyo, 1975.
——————— *Thai Painting* (trs. by Janet Seligman). Tokyo, 1976.
BOWIE, T., DISKUL, S. and GRISWOLD, A.B. *The Sculpture of Thailand.* New York, 1972.
CHAND, E. and YIMSIRI, K. *Thai Monumental Bronzes.* Bangkok, 1957.
CLAEYS, J.Y. 'L'archéologie du Siam' in *B.E.F.E.O.* no. 1 XXXI. Hanoi, Saigon, Paris, 1931.

COEDES, G. 'Les collections archéologiques du Musée National de Bangkok' in *Ars Asiatica* XII. Paris, Brussels, 1928.

——————— BOISSELIER, J. and DISKUL, S. *Trésors d'art de Thaïlande.* Paris, 1964.

DISKUL, S. *Art in Thailand: A Brief History.* Bangkok, 1970.

DÖHRING, K. *Buddhistische Tempelanlagen in Siam.* 3 vols. Berlin, 1920. Reissued as *Siam.* Darmstadt, 1923.

DUPONT, P. 'L'archéologie mône de Dvâravatî' in *Publ. E.F.E.O.* Saigon and Paris, 1959.

FOURNEREAU, L. *Le Siam ancien.* 2 vols. Annales du Musée Guimet series. Paris, 1895–1908.

GRISWOLD, A.B. *Towards a History of Sukhodaya Art.* Bangkok, 1967.

——————— LYONS, E. and DISKUL, S. *The Arts of Thailand: A Handbook.* Bloomington, 1960.

LE MAY, R. *A Concise History of Buddhist Art in Siam.* Cambridge, 1938.

LUNET DE LAJONQUIÈRE, E. 'Le domaine archéologique du Siam' in *B.C.A.I.* Paris, 1909.

——————— 'Essai d'inventaire archéologique du Siam' in *B.C.A.I.* Paris, 1912.

QUARITCH WALES, H.G. *Dvāravatī: The Earliest Kingdom of Siam.* London, 1969.

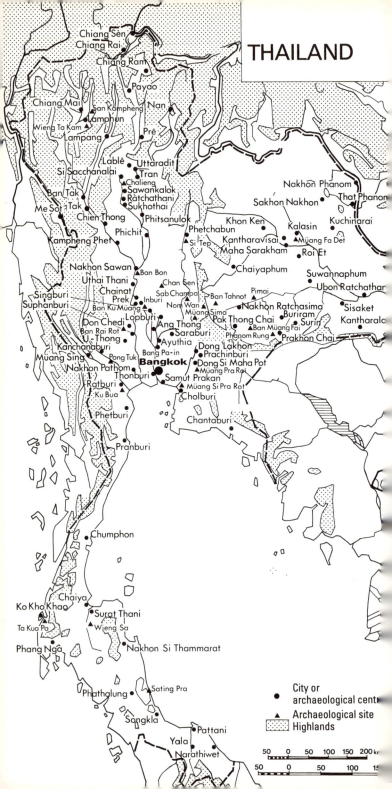

THAILAND

Chiang Sën
Chiang Rai
Chiang Ram
Payao
Chiang Mai
San Kampheng
Lamphun
Nan
Wieng Ta Kam
Prê
Lampang
Lablê
Uttaradit
Si Sacchanalai
Tran
Chalieng
Sawankalok
Ràtchathani
Sukhothai
Ban Tak
Me Sot
Tak
Chien Thong
Phitsanulok
Kampheng Phet
Phichit
Phetchabun
Nakhon Phanom
Sakhon Nakhon
That Phanom
Khon Ken
Kalasin
Kuchinarai
Si Tep
Kantharavisai
Müang Fa Det
Maha Sarakham
Roi Et
Nakhon Sawan
Ban Bon
Chaiyaphum
Suwannaphum
Uthai Thani
Chan Sen
Ubon Ratchathani
Chainat
Sab Champa
Ban Tahnot
Pimai
Prek
Inburi
Nom Wan
Sisaket
Singburi
Ban Ku Müang
Müang Sima
Nakhon Ratchasima
Kantharalo
Suphanburi
Lopburi
Pak Thong Chai
Buriram
Surin
Don Chedi
Ang Thong
Ban Müang Fai
Ban Rai Rot
Saraburi
Phanom Rung
Prakhon Chai
U-Thong
Ayuthia
Dong Lakhon
Kanchanaburi
Bang Pa-in
Prachinburi
Müang Sing
Pong Tuk
Bangkok
Dong Si Maha Pot
Nakhon Pathom
Müang Pra Rot
Thonburi
Samut Prakan
Ratburi
Müang Si Pra Rot
Ku Bua
Cholburi
Phetburi
Chantaburi
Pranburi

Chumphon

Chaiya
Ko Kho Khao
Surat Thani
Ta Kua Pa
Wieng Sa
Phang Nga
Nakhon Si Thammarat

Sating Pra
Phathalung

Sangkla
Pattani
Yala
Narathiwet

● City or
archaeological centr
▲ Archaeological site
⠿ Highlands

50 0 50 100 150 200 kr
50 0 50 100 15

1 *Chedi* (stupa) Chula Paton (state 1): elevation, *c.* 7th–8th c., Nakhon
Pathom

2
Reliquary stupa, limestone, H. 48 cm.,
c. 7th–8th c., Saraburi, Nat. Mus.,
Bangkok

3
Reliquary stupa: art of Lopburi,
bronze, H. 23 cm., *c.* 13th–14th c.,
Nat. Mus., Bangkok

4
Reliquary stupa, gold, H. 25.5 cm.,
before 1424, Ayuthia, Nat. Mus.,
Ayuthia

5
Reliquary stupa, bronze, *c.* 15th c.,
Ayuthia, Nat. Mus., Ayuthia

167

6
Wat Pra Mahāthat: *chedi* (restored in the late 19th c.), *c.* 8th c., Nakhon Si Thammarat

7
Chedi Ngam, 14th–15th c., Sukhothai

8 Wat Cham Lom, late 13th–early 14th c., Si Sacchanalai

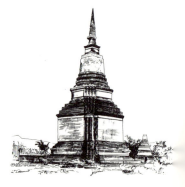

9
Wat Cham Rop: *chedi* (restored), 14th c., Sukhothai

10
Wat Chedi Sung: *chedi* (restored), 14th–15th c., Sukhothai

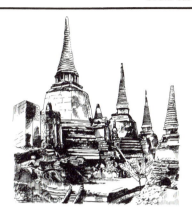

11 Wat Pra Si Sanpet, late 15th c., Ayuthia

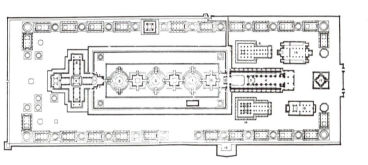

12 Wat Pra Si Sanpet: plan of the whole

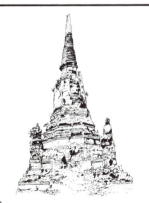

13
Wat Yai Chai Mongkoon: *chedi,*
after 1592, Ayuthia

14
Wat Chien Yan: *chedi* (restored),
c. 15th c., Lamphun

15 Wat Phu Khao Thong: *chedi*, 1745, Ayuthia

16
Wat Pa Sak: *chedi*, early 14th c., Chiang Sèn

17
Wat Pha Khao Pan: *chedi, c.* 15th c., Chiang Sèn

18
Wat Chiang Man: *chedi* (restored), 1296 (?), Chiang Mai

19
Wat Pra That Haripunchai: *chedi* (restored in the 19th c.), after 1445, Lamphun

20 Wat Chedi Chet Yot: *chedi, c.* mid-15th c., Chiang Mai

21 Wat Chedi Chet Yot: ground-plan of the *chedi*

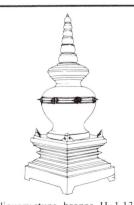

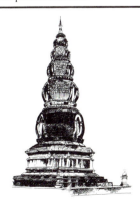

22
Reliquary stupa, bronze, H. 1.13 m., *c.* 15th c., Wat Pra That Haripunchai Mus., Lamphun

23
Wat Ku Tao: *chedi* (restored in the 19th c.), *c.* 1597, Chiang Mai

171

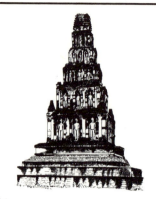

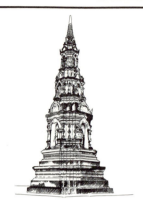

24
Wat Chamadevi (or Wat Kukut):
Ratanachedi, 12th–13th c., Lamphun

25
Wat Si Bun Rang: *chedi*, 19th c.,
Lamphun

26
Pra Boromathat Chaiya: (restored
in the 20th c.), 8th c., Wat Pra
Mahāthat, Chaiya

27
Wat Trapang Müang: 'lotus-bud'
chedi, 14th–15th c., Sukhothai

28 Wat Mahāthat: main group of buildings (restored), late 13th–14th c.,
Sukhothai

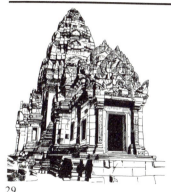

29
Pimai temple: central sanctuary (restored), sandstone, late 11th–early 12th c.

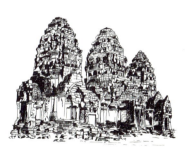

30
Pra Prang Sam Yot, stuccoed laterite, late 12th–early 13th c., Lopburi

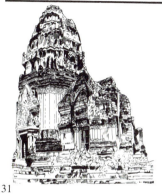

31
Wat Pra Ratana Si Mahāthat: *prang* (sanctuary tower), stuccoed brick, laterite, late 13th–early 14th c., Lopburi

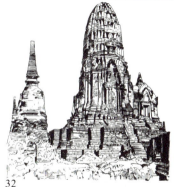

32
Wat Ratburana: *prang* and stupa, stuccoed brick and laterite, 1424, Ayuthia

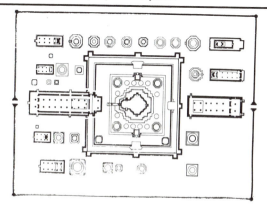

33 Wat Ratburana: plan of the whole complex

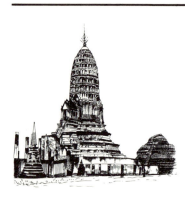

34
Wat Mahāthat: *prang,* 15th–16th c., Chalieng

35
Model of a *prang,* stucco, H. *c.* 60 cm., *c.* 17th c., Ayuthia

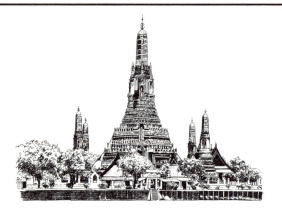

36 Pra Buddha *prang,* H. 67 m., 1842 and later, Wat Arun, Thonburi

37
Prāsāt Si Khara Phum: south-west sanctuary, 12th c. (the roof *c.* 15th to 16th c.), Surin region

38
Prāsāt Müang Ti: north-west sanctuary, *c.* 17th–18th c., Surin region

39
Model of a vihara (temple), terra-cotta, *c.* 18th c., Ayuthia

40
Model of a vihara, terracotta, *c.* 17th c., Wat Mahāthat, Phitsanulok

41
Vihān (temple), 2nd quarter of the 19th c., Wat Na Pra Men, Ayuthia

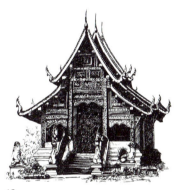

42
Lai Kham *vihān,* early 19th c., Wat Pra Singh, Chiang Mai

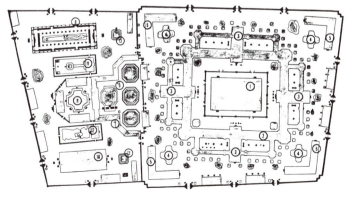

43 Wat Po (Wat Pra Chetubon): plan, late 18th–19th c., Bangkok

44
Fragment of slab, schist, L. 13 cm.,
3rd–5th c., Nat. Mus., U Thong

45
Decorative fragment, terracotta, H.
12 cm., *c.* 8th c., Kū Bua, Nat. Mus.,
Bangkok

46
Fragment of pilaster, terracotta, H.
45 cm., *c.* 8th c., Kū Bua, Nat. Mus.,
Bangkok

47
Fragment of pilaster, terracotta, L.
20 cm., *c.* 8th c., Kū Bua, Nat. Mus.,
Bangkok

48
Decorative plaque, terracotta, L.
10.4 cm., *c.* 8th c., Kū Bua, Nat.
Mus., Bangkok

49
Decorative plaque, terracotta, L.
7 cm., *c.* 8th c., Kū Bua, Nat. Mus.,
Bangkok

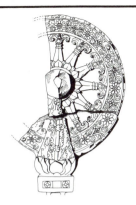

50
Wheel of the Law, limestone, *c.* 8th
c., Nat. Mus., U Thong

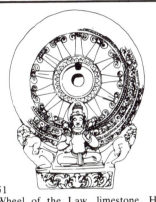

51
Wheel of the Law, limestone, H.
72 cm., 7th–8th c., Nakhon Pathom,
Nat. Mus., Bangkok

52
Column support for Wheel of the
Law, limestone, H. 1.85 m., 8th c.,
Nat. Mus., U Thong

53
Block support for Wheel of the Law,
limestone, L. 48.5 cm., 7th–8th c.,
Nat. Mus., U Thong

54
Block support for Wheel of the Law,
limestone, L. 67 cm., 7th–8th c.,
Nat. Mus., Nakhon Pathom

177

55
Running ornament: main sanctuary, sandstone, early 12th c., Pimai, *in situ*

56
Lotus: schist slab, L. 81 cm., 14th to 15th c., Wat Si Chum *(vihān),* Sukhothai, Nat. Mus., Bangkok

57
Running ornament, *c.* 1745, Wat Phu Khao Thong, Ayuthia, *in situ*

58
Corner pilaster, stucco, 14th c., Wat Pa Sak: *chedi,* Nat. Mus., Chiang Sèn

59 Frieze, stucco, *c.* 14th c., Wat Pa Sak: *chedi,* Nat. Mus., Chiang Sèn

60
Niche-arches, terracotta, L. 80 cm.,
c. 8th c., Kū Bua, Nat. Mus., Bangkok

61
Niche-surround, stucco, c. 13th c.,
Wat Chamadevī, Lamphun, *in situ*

62 Arch of a pediment: central sanctuary, stucco, c. 15th c., Wat Si Savai,
 Sukhothai, *in situ*

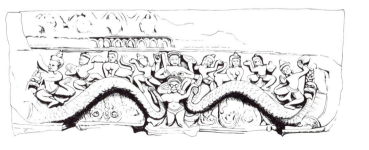

63 Lintel, red sandstone, late 9th–10th c., Pra Phanom Wan, Korat region

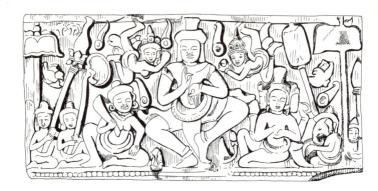

64 Lintel, sandstone, 12th c., Ku Svan Tèng, Buriram region, Mus., Pimai

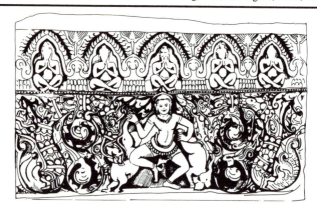

65 Lintel: at ground level, sandstone, 12th c., Pra Si Khara Phum, *in situ*

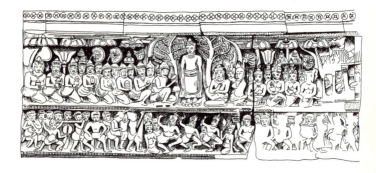

66 Lintel: main sanctuary, sandstone, 12th c., Pimai, *in situ*

67
Śivaite corner-stone, sandstone, H.
87 cm., 11th–12th c., Prāsāt Pra Narai,
Mus., Pimai

68
Pinnacle: enclosure around stupa,
stuccoed laterite, H. 1.60 m., late
13th/14th c.,Wat Mahāthat,Chalieng

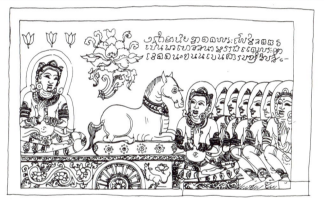

69 Carved panel: *mondop,* schist, L. 48 cm., 14th c., Wat Si Chum, Sukho-
thai, Nat. Mus., Bangkok

70 Carved panel: *mondop,* schist, L. *c.* 50 cm., 14th c., Wat Si Chum,
Sukhothai, *in situ*

71
Lion guardstone, stucco, H. *c.* 55 cm., *c.* 8th–9th c., Nat. Mus., Nakhon Pathom

72
Lion guardstone: fragment, stucco, H. *c.* 45 cm., *c.* 8th–9th c., Nat. Mus., Nakhon Pathom

73
Lion bracket, terracotta, H. 34 cm., *c.* 8th c., Kū Bua, Nat. Mus., Bangkok

74
Lion: on pilaster, 14th–15th c., Wat Mahāthat (secondary *chedi*), Sukhothai, *in situ*

75
Lion: art of Ayuthia, stucco, *c.* 17th c., Nat. Mus., Bangkok

76
Dragon *makara:* art of Sukhothai, glazed pottery, H. 51 cm., private coll.

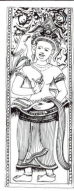

77
Devatā: main sanctuary, sandstone, 12th c., Pra Si Khara Phum, Surin region, *in situ*

78
Worshipping gods: *chedi,* stucco, H. 30 cm., 14th c., Wat Pra Pai Luang Nat. Mus., Sukhothai

79
Deva (god), stucco, H. *c.* 2.30 m., 15th c., Wat Chedi Chet Yot, Chiang Mai, *in situ*

80
Leaves of a door, wood, H. 2.30 m., 17th–18th c., Royal Chapel of Ayuthia, Nat. Mus., Ayuthia

81
Worshipping deity, stucco, H. *c.* 2 m., 15th c., Wat Chedi Chet Yot, Chiang Mai, *in situ*

82
Dancing figure, stucco, H. *c.* 40 cm., *c.* 15th c., Nat. Mus., Kamphèng Phèt

83
Leaves from a door, wood, *c.* 16th c., Wat Mahāthat, Chalieng, Nat. Mus., Sukhothai

84
Leaf of a door, wood, *c.* end of the 16th c., Wat Pra Si Sanpet, Nat. Mus., Ayuthia

85
Female musicians, stucco, H. 67.5 cm., *c.* 8th c., Kū Bua, Nat. Mus., Bangkok

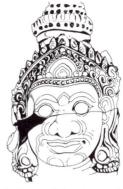

86
Head of a *yaksha,* terracotta, H. 27 cm., *c.* 15th c., Wat Chang Rop, Nat. Mus., Kamphèng Phèt

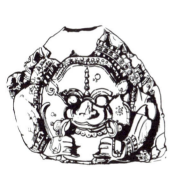

87
Kīrtimukha ('mask of glory'), H. 53 cm., *c.* 14th–15th c., Nat. Mus., Sukhothai

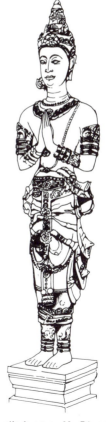

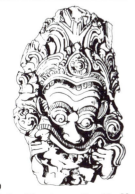

89
Kīrtimukha, terracotta, H. 52 cm., early 14th c., Wat Pa Sak: *chedi,* Nat. Mus., Chiang Sèn

88
Deva, gilt bronze, H. 74 cm., late 15th–early 16th c., Chiang Mai, Nat. Mus., Bangkok

185

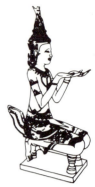

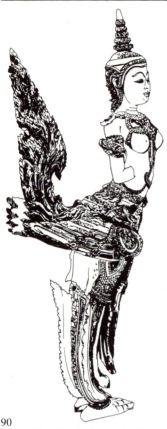

91
Bearer of offerings: art of Ayuthia, polychrome wood, H. 1.10 m., 18th c., Nat. Mus., Ayuthia

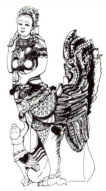

90
Kinnarī (mythical being): art of Bangkok, wood, H. 1.24 m., late 18th–early 19th c., Nat. Mus., Bangkok

92
Kinnarī: Sino-Siamese art, stone, H. *c.* 1.40 m., 19th c., Wat Arun, Thonburi, *in situ*

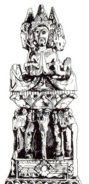

93
The Four Great Kings, wood, *c.* 18th c. (?), Wat Lampang Luang, Lampang

94
Console, wood, *c.* 18th c., Wat Luang Nai, Payao, *in situ*

95 Console: art of Chiang Mai, gilt wood, L. 99 cm., 18th–19th c., The
 Siam Society, Bangkok

96 *Ham Yon,* lintel: art of Chiang Mai, wood, L. 76 cm., 18th–19th c.,
 The Siam Society, Bangkok

97 Scene from the *Rāmayāna:* art of Chiang Mai, wooden panel, L. 1.05
 m., 18th–19th c., The Siam Society, Bangkok

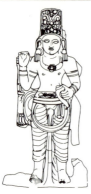

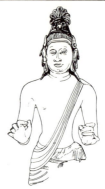

98
Vishnu, limestone, H. 69 cm., *c.* 5th
c., Chaiya, Nat. Mus., Bangkok

99
Avalokiteśvara: art of Śrīvijaya,
bronze, H. 22 cm., 8th c., Nat. Mus.,
Lopburi

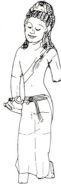

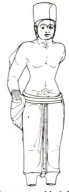

100
Avalokiteśvara, terracotta, H. 91 cm.,
8th c., Kū Bua, Nat. Mus., Bangkok

101
Vishnu, limestone, H. 1.70 m., 8th to
9th c., Dong Si Maha Pot, Nat. Mus.,
Bangkok

102
Vishnu: art of Śrīvijaya, sandstone,
H. 39 cm., 7th–8th c., private coll.

103
Vishnu, limestone, H. *c.* 1.30 m.,
8th–9th c., Dong Si Maha Pot, Nat.
Mus., Bangkok

104
Head of Vishnu, sandstone, t. H.
1.40 m., 8th c., Si Tep, Nat. Mus.,
Bangkok

105
Vishnu, sandstone, H. 2.09 m., 8th
c., Si Tep, Nat. Mus., Bangkok

106
Detail: Bodhisattva, bronze, t. H.
39 cm., 8th–9th c., Prakon Chai,
private coll.

107
Torso of Avalokiteśvara, bronze, H.
70 cm., 8th–9th c., Chaiya, Nat. Mus.,
Bangkok

108
Śiva, bronze, H. 36 cm., 8th–9th c.,
Sating Pra, Mus., Songkhlà

109
Head of a deity, stucco, H. 30 cm.,
c. 8th–9th c., Nat. Mus., U Thong

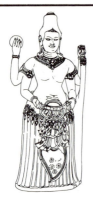

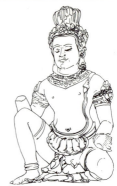

110
Vishnu: art of Lopburi, bronze, H. 49 cm., 13th c., Nat. Mus., Bangkok

111
Viśvakarman: art of Lopburi, bronze, H. 30 cm., 13th c., Nat. Mus., Bangkok

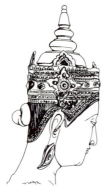

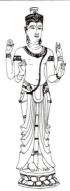

112
Head of Umā: art of Sukhothai, bronze, t. H. 1.55 m., 14th c., Nat. Mus., Bangkok

113
Harihara: art of Sukhothai, bronze, H. 1.54 m., 14th c., Nat. Mus., Sukhothai

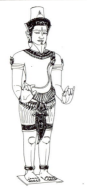

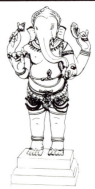

114
Śiva, bronze, H. 2.80 m., 1510, Kamphèng Phèt, Nat. Mus., Bangkok

115
Ganeśa, bronze, H. 65 cm., 16th to 17th c., Nat. Mus., Nakhon Si Thammarat

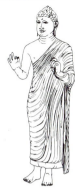

116
Buddha: Amarāvati style, bronze, H. 55 cm., *c.* 5th–6th c., Sungai Golok, private coll.

117
Buddha: Gupta style, sandstone, H. 17 cm., 5th–6th c., Wieng Sa, Nat. Mus., Bangkok

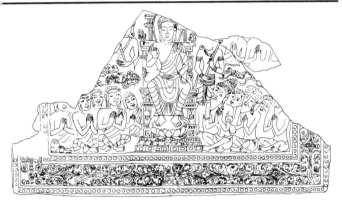

118 The First Sermon, limestone, L. 1.14 m., 8th c., Nat. Mus., Nakhon Pathom

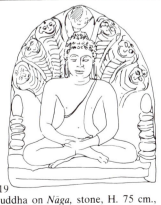

119
Buddha on *Nāga*, stone, H. 75 cm., 7th–8th c., Dong Si Maha Pot, Nat. Mus., Bangkok

120
Buddha 'on Panasbati', limestone, H. 47 cm., 8th–9th c., Müang Pra Rot, Panas Nikhom, private coll.

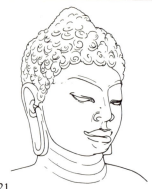

121
Head of a Buddha: style of Dvāravatī,
limestone, t. H. 1.45 m., 7th–8th c.,
Ayuthia, Nat. Mus., Bangkok

122
Buddha teaching: style of Dvāravatī,
quartzite, H. *c.* 3.70 m., 7th–8th c.,
Ayuthia, Nat. Mus., Bangkok

123
Buddha in *samādhi* position, terra-
cotta, H. 45 cm., 7th–8th c., U Thong,
private coll.

124
Buddha, bronze, H. 24 cm., 8th–9th
c., Nat. Mus., U Thong

125
Buddha in *samādhi* position, sand-
stone, H. 1 m., 12th–13th c., Lopburi,
Nat. Mus., Bangkok

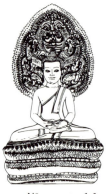

126
Buddha on *Nāga:* art of Lopburi
bronze, H. 52 cm., 13th–14th c.
private coll.

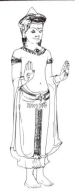

127
Adorned Buddha: art of Lopburi, bronze, H. 43 cm., 12th–early 13th c., private coll.

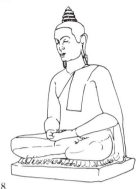

128
Buddha in *samādhi* position: art of Lopburi, sandstone, H. *c.* 2.10 m., 13th c., Nat. Mus., Ayuthia

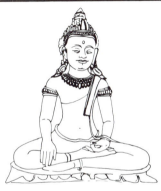

129
Adorned Buddha: art of Lopburi, bronze, 13th c., Nat. Mus., Ayuthia

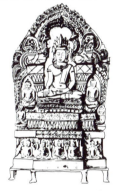

130
Buddha Māravijaya: art of Lopburi, bronze, H. 41.5 cm., 13th c., private coll.

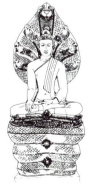

131
Buddha 'of Grahi', bronze, H. 1.62 m., late 12th–13th c., Chaiya, Nat. Mus., Bangkok

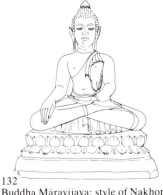

132
Buddha Māravijaya: style of Nakhon Si Thammarat, bronze, H. 34 cm., *c.* 15th c., private coll.

193

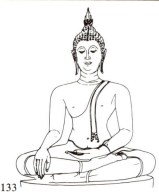

133
Buddha Māravijaya, bronze, H. 1.02 m., 14th–early 15th c., Sukhothai, Nat. Mus., Bangkok

134
Buddha walking, bronze, H. 2.20 m., 14th c., Wat Benchamabopit, Sukhothai, Bangkok

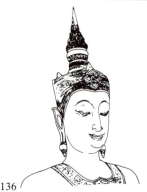

135
Pra Pim ('Holy Image'), tin, H. 32 cm., late 14th–early 15th c., Sukhothai, private coll.

136
Head: adorned Buddha: art of Sukhothai, gilt bronze, t. H. 1.53 m., c. 16th–17th c., Nat. Mus., Sukhothai

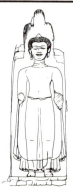

137
Head of a Buddha: art of Haripunjaya, terracotta, H. 24 cm., c., 13th c., Lamphun

138
Buddha, stuccoed terracotta, H. c. 2.30 m., c. 13th c., Wat Chamadevī, Lamphun, *in situ*

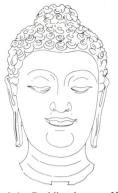

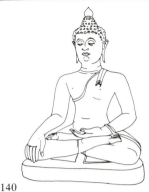

139
Head of the Buddha, bronze, H. 38 cm., 12th–13th c., Chiang Sèn, Nat. Mus., Bangkok

140
Buddha Māravijaya: art of Chiang Sèn, bronze, H. *c.* 60 cm., *c.* 14th c., private coll.

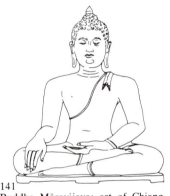

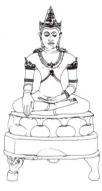

141
Buddha Māravijaya: art of Chiang Mai, bronze, H. *c.* 70 cm., *c.* 13th to 14th c., Lamphun

142
Buddha Māravijaya: art of Chiang Mai, bronze, H. 48 cm., 15th–16th c., Nat. Mus., Bangkok

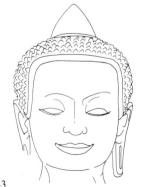

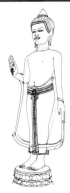

143
Head of a Buddha: 'U Thong' style A, bronze, H. 26 cm., 13th–14th c., Nat. Mus., U Thong

144
Buddha: 'U Thong' style A, bronze, H. 45 cm., 13th–14th c., Nat. Mus., Bangkok

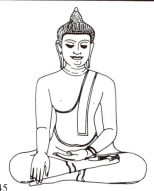

145
Buddha Māravijaya: 'U Thong' style A, bronze, H. 49 cm., 13th–14th c., Nat. Mus., Bangkok

146
Buddha Māravijaya: 'U Thong' style C, bronze, H. 55 cm., late 14th–early 15th c., Nat. Mus., Ayuthia

147
Head of Buddha: 'U Thong' style C, bronze, H. 52 cm., late 14th–early 15th c., Nat. Mus., Ayuthia

148
Head of Buddha, sandstone, H. 56 cm., c. 14th–15th c., Lopburi, Nat. Mus., Bangkok

149
Adorned Buddha: art of Ayuthia, bronze, H. 78 cm., c. 16th c., Nat. Mus., Bangkok

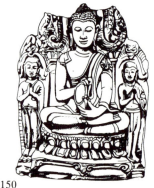

150
Buddha teaching: art of Ayuthia, sandstone, H. 40.5 cm., c. 17th c., private coll.

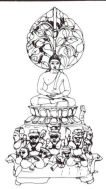

151
Buddha in *samādhi* position: art of
Ayuthia, bronze, H. 35 cm., 16th to
17th c., Nat. Mus., Bangkok

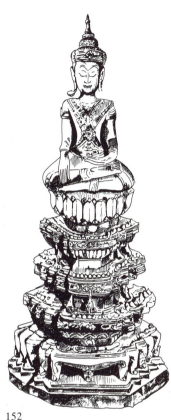

153
Buddha stilling the waves: art of
Bangkok, wood, t. H. 1.19 m., early
19th c., Nat. Mus., Bangkok

152
Buddha Māravijaya: art of Ayu-
thia, gilt wood, *c.* 17th–18th c., The
Siam Society, Bangkok

154
Pra Malai: art of Bangkok, gilt
bronze, H. 85 cm., 19th c., Nat. Mus.,
Nakhon Pathom

155
Worshipping disciple: art of Ayuthia,
bronze, *c.* 16th c., Nat. Mus., Bangkok

156
Cup in the form of a chalice, red earthenware, H. 28.3 cm., early Neolithic, Ban Kao, Nat. Mus., Bangkok

157
Vessel: funnel-shaped neck, brown earthenware, H. 30 cm., late Neolithic, Ban Kao, Nat. Mus., Bangkok

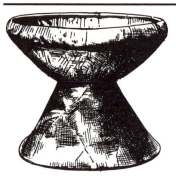

158
Cup, brown earthenware, H. 19.4 cm., early Neolithic, Ban Kao, Nat. Mus., Bangkok

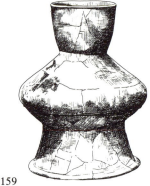

159
Vase with foot, brown earthenware, H. 34.2 cm., early Neolithic, Ban Kao, Nat. Mus., Bangkok

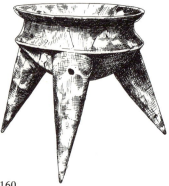

160
Tripod pot, brown earthenware, H. 34.5 cm., early Neolithic, Ban Kao, Nat. Mus., Bangkok

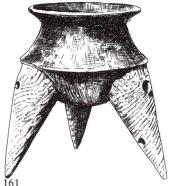

161
Tripod pot, black earthenware, H. 21.6 cm., early Neolithic, Ban Kao, Nat. Mus., Bangkok

162
Vase without foot, painted decoration,
H. 31 cm., *c.* 1st mil. B.C., Ban
Chieng, private coll.

163
Vase without foot, painted decora-
tion, H. 43 cm., *c.* 1st mil. B.C.,
Ban Chieng, private coll.

164
Vase without foot, painted decora-
tion, H. 36 cm., *c.* 1st mil. B.C.,
Ban Chieng, private coll.

165
Vase, painted decoration, H. 32 cm.,
c. 1st mil. B.C., Ban Chieng, private
coll.

166
Vase, painted decoration, H. 30 cm.,
c. 1st mil. B.C., Ban Chieng, private
coll.

167
Vase, painted decoration, H. 26 cm.,
c. 1st mil. B.C., Ban Chieng, private
coll.

168
Jar: art of Lopburi, glazed stoneware,
H. 53 cm., 11th–13th c., Nat. Mus.,
Bangkok

169
Anthropomorphous vase: Lopburi
art, stoneware, H. 26 cm., 11th–13th
c., Nat. Mus., Nakhon Rachasima

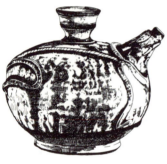

170
Zoomorphic vase with spout: art of
Lopburi, glazed earthenware, H. 12
cm., 12th–15th c., Nat. Mus., Ayuthia

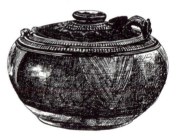

171
Vase with spout: art of Lopburi,
earthenware with brown glaze, H.
15 cm., 12th–15th c., private coll.

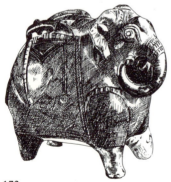

172
Elephant vase: Lopburi or Chalieng
art, earthenware: brown glaze, H. 17
cm., 12th–15th c., Nat. Mus., Ayuthia

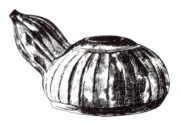

173
Kendi: art of Lopburi (?), glazed
earthenware, H. 8.5. cm., 14th–15th.
c., Nat. Mus., Ayuthia

174
Small jar, stoneware, H. 19 cm., *c.* 13th–14th c., Sukhothai, Nat. Mus., Bangkok

175
Pear-shaped vase, celadon, H. 20 cm., 14th–15th c., Sawankalok, Hist. Mus., Hanoi

176
Kendi, underglaze decoration, H. 14.5 cm., 14th–15th c., Sawankalok (?), Hist. Mus., Hanoi

177
Kendi, underglaze decoration, H. 29.2 cm., 14th–15th c., Sawankalok, private coll.

178
Jar, celadon, H. 17 cm., 14th–15th c., Sawankalok, private coll.

179
Lidded vessel, underglaze decoration, H. 12 cm., 14th–15th c., Sawankalok, private coll.

180
Dish, underglaze decoration, D. 25.7 cm., 14th–15th c., Sukhothai, private coll.

181
Bowl: interior, underglaze decoration, D. 21.6 cm., 14th–15th c., Sukhothai, Univ. of Singapore

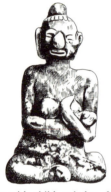

182
Mother with child, celadon, H. 9.5 cm., 14th–15th c., Sawankalok, Univ. of Malaya

183
Jar, brown-glazed earthenware, H, 15.7 cm., 14th–15th c., Chalieng, Univ. of Singapore

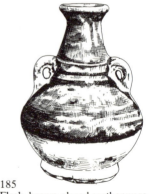

184
Pear-shaped vase, brown-glazed earthenware, H. 14.3 cm., 14th–15th c., Chalieng, Univ. of Singapore

185
Flask, brown-glazed earthenware, H. 6 cm., 14th–15th c., Chalieng, private coll.

186
Dish, underglaze decoration, D. 21 cm., 15th–16th c., Sankamphèng, Univ. of Singapore

187
Dish, underglaze decoration, D. 25 cm., 15th–16th c., Sankamphèng, private coll.

188
Bowl, underglaze decoration, H. 6 cm., 15th–16th c., Kalong, private coll.

189
Pear-shaped vase, underglaze decoration, H. 20 cm., 15th–16th c., Kalong, private coll.

190
Small jar, brown glaze, H. 21.5 cm., 15th–16th c., Sankamphèng, private coll.

191
Ewer, celadon type, H. 16 cm., 15th to 16th c., Sankamphèng, private coll.

192
Miniature stove, terracotta, Ayuthia period, Nat. Mus., Ayuthia

193
Model *kuti* (Skt: hut, cell), terracotta, Ayuthia period, Nat. Mus., Ayuthia

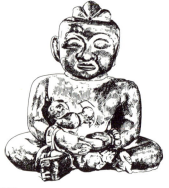

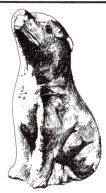

194
Mother with child, terracotta, H. *c.* 10 cm., Ayuthia period, private coll.

195
Dog, terracotta, H. *c.* 15 cm., Ayuthia period, Nat. Mus., Ayuthia

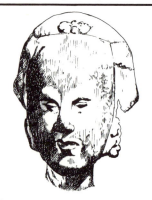

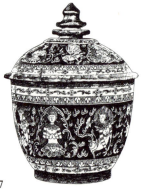

196
Head of a figurine, terracotta, Ayuthia period, Nat. Mus., Ayuthia

197
Lidded pot: Sino-Siamese art, 'five-colour' porcelain, H. 20.5 cm., late 18th–early 19th c., private coll.

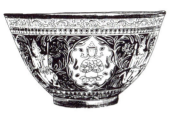

198
Bowl: Sino-Siamese art, 'five-colour' porcelain, H. 9.5 cm., late 18th–19th c., private coll.

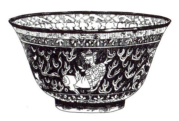

199
Bowl: Sino-Siamese art, 'five-colour' porcelain, H. 8.5 cm., late 18th–19th c., Hist. Mus., Hanoi

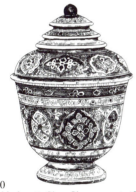

200
Lidded pot: Sino-Siamese art, 'five-colour' porcelain, H. 17 cm., 19th c., private coll.

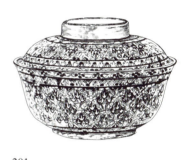

201
Covered bowl: Sino-Siamese art, 'five-colour' porcelain, H. 8.2 cm., 2nd half of the 19th c., Hist. Mus., Hanoi

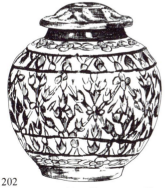

202
Ointment pot: Sino-Siamese art, 'five-colour' porcelain, H. 5.8 cm., 2nd half of the 19th c., Hist. Mus., Hanoi

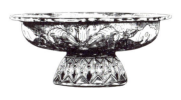

203
Stem-cup: Sino-Siamese art, 'five-colour' porcelain, D. 16.5 cm., 2nd half of the 19th c., Hist. Mus., Hanoi

LAOS

The art of Laos owes its reputation to its achievements in the field of the decorative arts. Most Laotian works of art are of comparatively recent date and have not yet received much attention from scholars. The kingdom of Lan Xang (the old name for Laos) has only been in existence since the middle of the 14th century, and Laotian art has been continually subjected to influences from its immediate neighbours and from other countries in South-east Asia. The very diversity of these influences has probably helped preserve a real originality in this art, which should not be considered as a kind of regional Thai school nor as a compound art, formed from a variety of traditions. In several respects, it plays the same role in the arts of the Indo-Chinese peninsula as baroque art does in relation to classicism in the West. It is, then, the expression of a highly original outlook, reflecting a whole range of distinctive concepts that have remained to this day but dimly perceived in the ethnological evidence. It is, in brief, rather perplexing. Although Laotian art first appeared only about six centuries ago, it possesses few readily discernible antecedents, in spite of the fact that the area was the scene of considerable activity as early as the prehistoric period and produced pottery and objects carved from stone during the Neolithic period that are regarded as being of remarkably fine quality. Mention should be made of a megalithic culture in the area, which is independent of that emanating from Dŏng-sön (late Bronze Age, see Vietnam): this is amply represented by the megaliths of Hua Phan province (late Bronze Age) and by the Field of Jars (monolithic urns) at Tran-ninh in Xieng Khuang province (Iron Age). Several centuries after this protohistoric phase, in about the 8th century A.D., Buddhism was introduced into the Vientiane area, an event for which there is no evidence except a very few rare images relating to the art of Dvāravatī (see Thailand). However, Brahminic art, predating the founding of Angkor, was also firmly established in the south in the region of Champassak where Wat Phu—later to be regarded as the most sacred shrine of pre-Angkorian Cambodia—was situated. Although some sculptures carved inside caves appear to date from about the 10th century, it was not until the reign of Jayavarman VII (1181– c. 1218) that the systematic diffusion of Khmer art as far north as Vientiane began. This movement, which went hand in hand with a more general Khmer expansion into the peninsula, may have been responsible for the introduction of Buddhism and Brahminism into the region of Luang Prabang. After this brief period, there is another gap in our present knowledge of the history of Laotian art—a gap of more than a century which is all the more inexplicable as it corresponds to the annexation of the area around Vientiane by the kingdom of Sukhothai (see Thailand). This is, however, in line with the general paucity of knowledge about Laos during the period. For instance, little more is known about the activity

of the kingdom founded around 1350 at Xieng Dong-Xieng Thong (the site of Luang Prabang) with the help of the court at Angkor (in all domains including that of art, according to texts of the period). All in all, right up to about the 16th century, the art of Laos is only known from a few surviving works that are quite inadequate to enable one to form a general opinion of Laotian art. Even the great buildings founded in the 16th century have frequently suffered damage in the course of history and have been repaired many times, so that it is now extremely difficult to gain an idea of their original state.

ARCHITECTURE. In Laos there is a wide variety of more or less original stupas (or *thats,* a word also used for reliquary towers, the Thai pronunciation of *dhātu* a 'relic' and by extension, a 'reliquary'). *Thats* occur in hemispherical, bell and baluster shapes—the latter being the commonest of all stupa shapes in Laos, and sometimes being called the 'carafe-shaped bulb'. Other buildings intended to house relics take the form of sanctuary towers of solid construction with terraces and high bases. They are surmounted either by a slender spire or by a stupa built in one of the styles described above.

The *vihān* (a Thai pronunciation of vihara [temple]) is the essential element of the monastic buildings (many of them rebuilt in recent times), which are of composite construction and erected in various styles. Differing in their plans and elevations, they reflect particular regional traditions and varying influences, and yet all styles may sometimes be found together on one site. Three types of plan can be distinguished: a simple nave, a nave preceded by a portico and a nave surrounded by an arcade. Three regional styles of elevation are generally discernible, the distinction between them being based on their different treatments of façades and roofs. The Luang Prabang style is characterized by huge saddleback roofs that descend very low. The Xieng Khuang style seems to go one step further, having roofs with overlapping sections, each of which corresponds to one of the longitudinal divisions of the ground-plan. The Vientiane style, with proportionately higher buildings and roofs that may be of a simple or an overlapping type (with sometimes, in addition, a lean-to roof consisting of four sloping sections), has side-walls that are the same height as the façade instead of lower ones as in the two styles already described. Generally speaking, the styles of Xieng Khuang and Luang Prabang tend to resemble the architecture of Lan Na (see Thailand), whereas the Vientiane style has more in common with the styles of Ayuthia and of Bangkok.

The libraries and chapels, that relate in differing degrees to the art of northern Thailand, give a greater importance than the *vihān* do to masonry, and many of them are very elegant structures. It is worth mentioning that a few buildings in a purely Burmese tradition were erected—a reminder of the wars of the 16th and 17th centuries and of the Laotian occupation of Burma.

ARCHITECTURAL DECORATION. The ornamentation of these buildings (where stucco predominates for the chapel, and wood for the pediments, consoles and doors of the *vihān*, with an ever-increasing use of pre-cast concrete nowadays) is of great richness and complexity. It makes use of motifs derived from (often superabundant) plants and of figures (mythical, borrowed from Buddhist cosmology or from epics, and also historical, with rather whimsical forms of local colour). The decoration of the temple furnishings (especially the pulpits and candle-holders) is more elaborate than that found on the architecture and displays the virtuosity of Laotian woodcarvers.

STATUARY. Despite the well-attested presence of Khmer art in Laos—at least as far north as Vientiane—in the 12th and 13th centuries, and in spite of the fact that the Pra Bang, the kingdom's palladium, is an image in the Khmer style, the Thai art of Sukhothai appears to have exerted the predominant influence on the earliest figure-sculptures from Lan Xang. The only plausible explanation is that this is due to the political role played by the kingdom of Sukhothai in the Vientiane region up to the middle of the 14th century. At about the same period, however, at Luang Prabang, the influence of the (Thai) Lan Na style—or rather of its most classical form known as the Chiang Sèn style—was at first paramount. Soon afterwards, a hybrid style evolved, and it was on the basis of this that a truly Laotian school of statuary was established. Interpreting the Sukhothai aesthetic along original lines and going beyond it in the direction of hieratic stylization, the Laotian Buddha in the 17th and 18th centuries reveals a lack of sensitivity that quite frequently detracts from the beauty of its features. This all too prevalent tendency makes it difficult to date such works of art, since it cannot be regarded as a positive sign of development. Nonetheless, it would seem that one workshop (Luang Prabang) did produce, in about the 18th century, a whole gamut of small images illustrating the life of the Buddha with a most unexpected degree of charm and refinement. It should be stressed that Burmese statuary appears to have exerted no influence on that of Laos, whereas Laotian architecture was, as we have seen above, modified by contact with Burma.

MAJOR MUSEUMS

Royal Palace (formerly Royal Collection), Luang Prabang
Wat Vixun Collection, Luang Prabang
Wat Xieng Thong Collection, Luang Prabang
Wat Phra Kèo Collection, Vientiane
Wat Sisakhet Collection, Vientiane

CONCISE BIBLIOGRAPHY

BOUN SOUK, THAO. *Louang Phrabang*. Paris, 1974.
——————————— *L'image du Buddha dans l'art lao*. Vientiane, 1971.
COLANI, M. *Mégalithes du Haut-Laos*. 2 vols. Publ. E.F.E.O. Paris, 1935.
GITEAU, M. *Laos, Etude de collection d'art bouddhique*. UNESCO (limited ed.) Paris, 1969.
MARCHAL, H. 'L'art décoratif au Laos' in *Ars Asiatiques* (special issue) no. 2 X. Paris, 1964.
PARMENTIER, H. *L'art du Laos*. 2 vols. Publ. E.F.E.O. Hanoi, 1954.
——————————— *L'art du Laos*. Paris, 1925.
PHOU, THIT. *Motifs d'art décoratif laotien*. Vientiane, n.d.

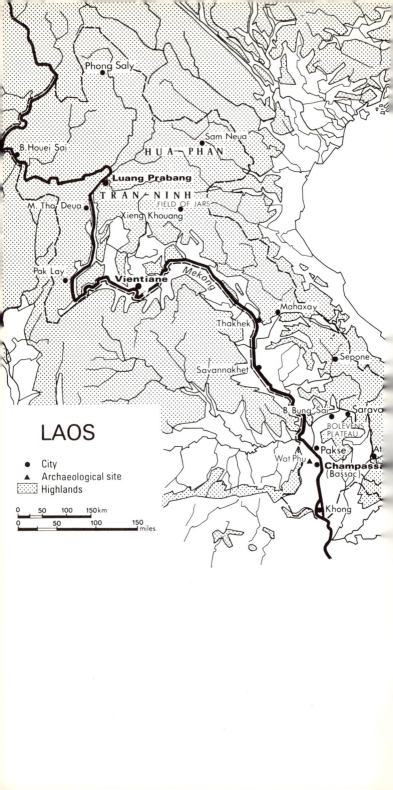

LAOS

- ● City
- ▲ Archaeological site
- ░ Highlands

0 50 100 150km
0 50 100 150 miles

Phong Saly

B. Houei Sai

HUA PHAN

Sam Neua

Luang Prabang

TRAN NINH

M. Tha Deua

FIELD OF JARS

Xieng Khouang

Pak Lay

Vientiane

Mekong

Mahaxay

Thakhek

Sepone

Savannakhet

B. Bung Sai

Sarava

BOLEVENS PLATEAU

Wat Phu ▲

● Pakse

At

Champassa (Bassac)

Khong

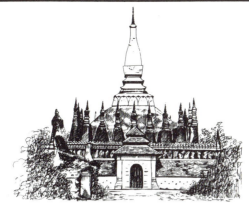

1 That Luong, Vientiane, founded in 1566, restored between 1931 and
1935

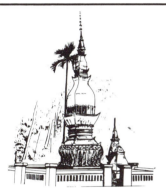

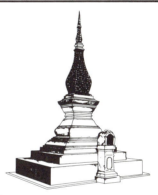

2
That (or stupa) of Tham Wat Tha
(Tha Khèk region)

3
That, Wat Xieng Thong: west of the
vihara, Luang Prabang

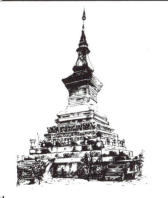

4
That Luang: built in 1818, restored,
Luang Prabang

5
That Mak Mo, founded in 1504,
rebuilt in 1932, Wat Vixun, Luang
Prabang

7
Library of Wat Sisaket, 1820, Vientiane

6
That of Wat Sop, founded in 1480,
Luang Prabang

8
*Library of Wat In Peng, 19th c.,
Vientiane*

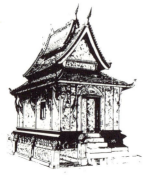

9
'Red Chapel', founded in the 16th
c. (restored), Wat Xieng Thong,
Luang Prabang

10
Miniature temple with altar, stuccoed
brick, Wat Na Hua, Muong Khang

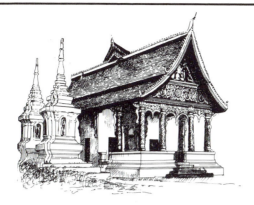

11 Wat Pa Fai: vihara (Vientiane style), founded in 1815, rebuilt, Luang Prabang

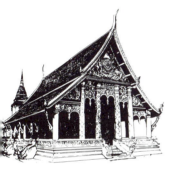

12
Wat That: vihara (Luang Prabang style), founded in 1548, rebuilt, Luang Prabang

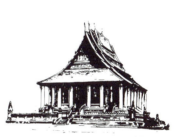

13
Wat Ho Pra Kèo: vihara (Vientiane style), founded c. 1565, restored, Vientiane

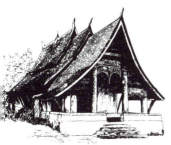

14
Wat Xieng Ngam: vihara (Xieng Khuang style), founded in 1799, Luang Prabang

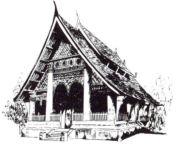

15
Wat Sieng Mouane: vihara (Xieng Khuang style), founded in 1853, Luang Prabang

16 Pediment, carved wood, Wat Sisaket, Vientiane, *in situ*

18
Horn-shaped finial for a vihara, wood, from a Laotian treatise on design

19
Horn-shaped finial for a vihara, wood, from a Laotian treatise on design

17
Door leaf, carved wood, 1904, Wat Savankalok, Luang Prabang, *in situ*

20 Pediment: Xieng Khuang style, carved wood, from a Laotian treatise on design

21
Horn-shaped finial for a vihara, wood, from a Laotian treatise on design

23
Horn-shaped finial for a vihara, wood, from a Laotian treatise on design

22
'Dutch' door leaf, carved and lacquered wood, c. 1861, Wat Pa Khè, Luang Prabang, *in situ*

24
Pediment: Vientiane style, carved wood, from a Laotian treatise on design

25
Pediment: Xieng Khuang style, carved wood, from a Laotian treatise on design

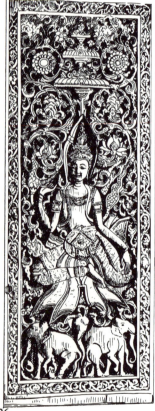

27
Capital: column for a vihara, from a Laotian treatise on design

26
Door leaf, carved wood, lacquered and gilt, 1898, Wat Vixun, Luang Prabang, *in situ*

28
Capital: column for a vihara, from a Laotian treatise on design

29
Capital: column for a vihara, from a
Laotian treatise on design

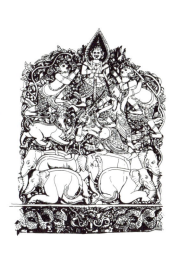

31
Capital: column for a vihara, from a
Laotian treatise on design

30
Candle-holder, carved and gilt wood,
c. 1915, Wat That Luang, Luang
Prabang, *in situ*

32
Decorative panel, carved wood, Wat
Sisaket, Vientiane, *in situ*

33
Mythical lion, carved wood, H. 68
cm., Wat Vixun Mus., Luang Pra-
bang

34
Console: roof of a vihara, Wat That
type, wood, Luang Prabang

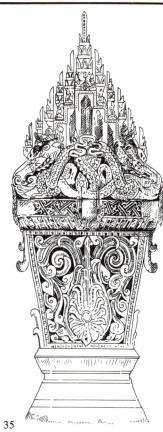

36
Console: roof of a vihara, wood,
from a Laotian treatise on design

35
Candle-holder, carved and painted
wood, 19th c., Wat Ban Phong,
Muong Suoi (Xieng Khuang)

37
Console: roof of a vihara, wood, late
18th c., Wat Khili, Luang Prabang

38
Console: roof of a vihara, wood,
from a Laotian treatise on design

39
Detail: door frame, restored, plaster,
18th c., Wat Sene, Luang Prabang

41
Detail: surround of pediment, plaster, altar: Wat That Noi chapel (destroyed), Luang Prabang

40
Candle-holder, fretted and carved
wood, Wat Ban Mang, Muong Sui
(Trà-ninh)

42
Detail: border of ornamental front of pulpit, carved wood, Wat Xieng Thong, Luang Prabang

43
Detail: door frame (modern), plaster, Wat Xieng Men, Luang Prabang

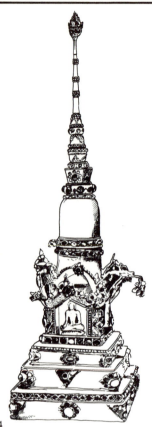

45
String-wall: foot, stuccoed masonry,
from a Laotian treatise on design

44
Reliquary stupa, gold and precious
stones, H. 59 cm., c. 16th c. (?),
Wat Vixun, R.C., Luang Prabang

46
Console: base, carved wood, Wat
Vixun, Luang Prabang

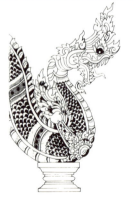

47
String-wall: foot, stuccoed masonry,
from a Laotian treatise on design

48
String-wall: foot, stuccoed masonry,
from a Laotian treatise on design

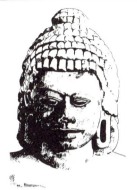

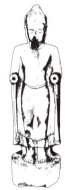

49
Head of standing deity, sandstone, t.H. *c.* 60 cm., 7th–8th c., Wat Phu, Champassak, private coll.

50
Standing Buddha, sandstone, t.H. 1.91 m., *c.* 8th c., Ban Thalat (Vientiane)

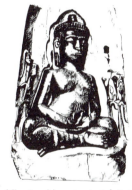

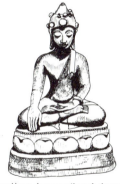

51
Buddha teaching, cave sculpture, H. 4.80 m., *c.* 9th–10th c., Vang Sang (Vientiane)

52
Māravijaya, bronze (head-dress: gold and gems), t.H. 34 cm., *c.* 14th c., Wat Vixun, R.C., Luang Prabang

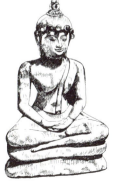

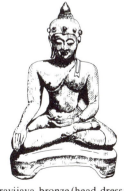

53
Buddha in *samādhi* position, bronze (head-dress: gold and gems), t.H. 35 cm., *c.* 14th c., Wat Vixun, R.C.,

54
Māravijaya, bronze (head-dress: gold and gems), t.H. 32.5 cm., *c.* 14th c., Wat Vixun, R.C., Luang Prabang

221

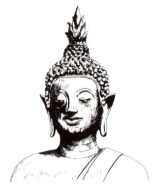

55
Head of the Buddha Māravijaya,
No. 59

57
Head of a Buddha, bronze, Wat
Vixun Mus., Luang Prabang.

56
Buddha Māravijaya, bronze, *c.* 17th
c., Ban Sai Fong, *in situ*

58
Buddha Māravijaya, bronze, *c.* 16th
c., Xieng Khuang, *in situ*

59
Buddha Māravijaya, bronze, H. 37
cm., *c.* 15th c., Wat That Luang,
Wat Vixun, Luang Prabang

60
Standing Buddha, bronze, H. 1.70
m., *c.* 17th–18th c., private coll.

61
Detail: adorned Buddha, wood, *c.*
18th c., Wat Vixun Mus., Luang
Prabang

62
Walking Buddha, bronze, *c.* 15th c.,
Wat Xieng Thong, Luang Prabang,
in situ

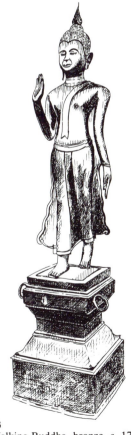

64
Standing Buddha, bronze, *c.* 17th c.,
Ban Sai Fong, *in situ*

63
Walking Buddha, bronze, *c.* 17th c.,
Ban Sai Fong, Hist. Mus., Hanoi

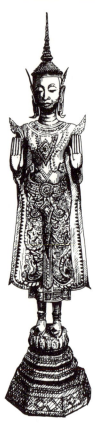

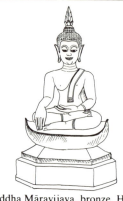

66
Buddha Māravijaya, bronze, H. 54.5
cm., *c.* 16th c., R.C., Wat Vixun,
Luang Prabang

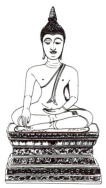

65
Adorned Buddha, bronze, 18th c.,
Wat Pa Fai, Luang Prabang, *in situ*

67
Buddha Māravijaya, gold, t.H. 24
cm., *c.* 16th c. (?), R.C., Wat Vixun,
Luang Prabang

68
Buddha Māravijaya, bronze, t.H.
29 cm., *c.* 16th c., R.C., Wat Vixun,
Luang Prabang

69
Buddha Māravijaya, bronze, t.H.
20.5 cm., *c.* 17th–18th c., R.C.,
Wat Vixun, Luang Prabang

70 Reclining Buddha, bronze, 1569, Wat Xieng Thong: Red Chapel, Luang Prabang, *in situ*

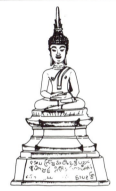

71
Buddha on the *Nāga*, lacquered wood, t.H. 53 cm., *c.* 18th c. (?), R.C., Wat Vixun, Luang Prabang

72
Buddha Māravijaya, bronze, t.H. 33 cm., *c.* 17th c., R.C., Wat Vixun, Luang Prabang

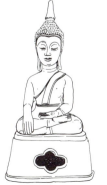

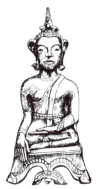

73
Buddha Māravijaya, bronze, t.H. 25.5 cm., *c.* 18th c. (?), R.C., Wat Vixun, Luang Prabang

74
Buddha Māravijaya: aberrant type, copper, t.H. 27 cm., *c.* 19th c., R.C., Wat Vixun, Luang Prabang

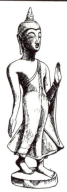

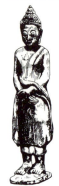

75
Walking Buddha, bronze (head-dress: gold), H. 30.5 cm., 15th c., R.C., Wat Vixun, Luang Prabang

76
Walking Buddha, bronze, H. 22 cm., 18th c. (?), Wat That Luang, R.C., Wat Vixun, Luang Prabang

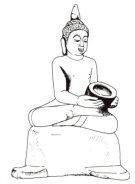

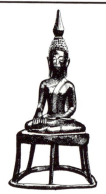

77
Buddha with bowl, bronze, t.H. 17 cm., 18th c. (?), Wat That Luang, R.C., Wat Vixun, Luang Prabang

78
Buddha Māravijaya, bronze, t.H. 30.5 cm., c. 18th–19th c., R.C., Wat Vixun, Luang Prabang

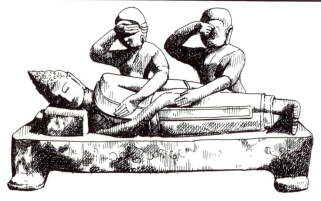

79 The *Mahāparinirvāna*, bronze, L. 24.5 cm., c. 18th c. (?), Wat That Luang, R.C., Wat Vixun, Luang Prabang

CAMBODIA

Khmer art—the art of Cambodia—is undoubtedly one of the most prestig-ious and most systematically studied in the whole of South-east Asia, but the constant interest that it has aroused for over a century and the well-deserved fame of great complexes such as the site of Angkor do not by themselves account for this. The study of Khmer art has been greatly facili-tated by an exceptional development that encountered few set-backs. As long ago as 1927 it became possible to establish the chronology of a succes-sion of styles and to define these styles. Using this early work as a starting-point, scholars have since succeeded in reconstructing the history of Khmer art. The typical features of these styles have gradually been more precisely described and more readily recognized, until today we are in a position to date Khmer works of art to within fifty years and can look forward to a time when we shall be able to date them with a margin of error of as little as ten years. Since space does not permit us to give a detailed description of all the various styles, we shall confine ourselves to giving an account of Cambodian art during each of the three main periods into which, on the basis of political history, it may be divided and to summarizing its essential characteristics.

ARCHITECTURE. The buildings—even those that appear to have a purely utilitarian character—are all of an essentially religious inspiration. None of those known today was erected before the beginning of the 7th century. Ever since that time, the basic element of every religious foundation has been the temple tower (prāsāt) covered with a varying number of terraces. The groups of religious buildings of which the temple towers formed a part soon became increasingly complex, and their constituent elements were generally disposed according to a geometrically conceived plan: several sanctuaries might be built on a common platform in a single or double row or in quincunxes, but they were most frequently constructed on the top of terraced pyramids called 'mountain temples'. The complexes just described are directly linked to the worship of royalty and reveal a symbolism that is often extremely intricate (Phnom Bakhèng). They are further complicated by the addition of long halls and arcades, which the architects, by remarkable feats of design, used to the fullest advantage. This formula, progressively developed and yet always conforming to the same basic model, culminated in the celebrated complex of Angkor Wat (first half of the 12th century). The temples were at first constructed in brick bonded (as in Champa) with a binding material of vegetable origin that gave them remarkable strength and solidity. It was not until the latter part of the 10th century that sand-stone (sporadically replaced by laterite) began to replace brick as the most favoured building material; during the 11th century its use became general. The face-towers, inspired by Buddhist cosmology and among the most orig-

inal creations of Khmer art, belong solely to the style of the Bayon (reign of Jayavarman VII, 1181– c. 1218). After this style, which was characterized by a spate of activity that often detracted from the unity of the various elements of the buildings, and well before the abandonment of Angkor (1431), traditional architecture fell into disuse. Although the work of Jayavarman VII—intended to be perfect in its royal symbolism—could hardly be completed by his successors, the rise of Theravāda Buddhism was soon to introduce another ideal that was more in keeping with the spirit of Buddhist doctrine and less concerned with durability. Except for brick, henceforth bonded with mortar, the techniques of building in stone continued to be employed for the few buildings erected during the 16th and 17th centuries, and it was only gradually that composite construction, so well suited to monastic architecture, came into vogue and made necessary the adoption of the constructional techniques used in Thailand and Laos.

ARCHITECTURAL DECORATION. It is by studying architectural decoration, which has constantly played such a vital role, that scholars have been able to unravel the development of Khmer art and distinguish features by which the historic buildings of Cambodia can be dated with a high degree of accuracy. Carved traditionally from sandstone (lintels, small columns) or from other building materials such as brick or stone (pilasters, pediments), and employing a wide variety of foliated scrolls, usually in conjunction with figures, Khmer architectural decoration forms an essential element in the originality of Khmer art. From a very early period and in a steady progress up to 13th century, the importance of the means of access to large complexes was emphasized by paths, steps and terraces. These are punctuated by carved guardstones (lions and also, from the 11th century onwards, statues of dvārapālas) and by decorative corner-posts and are given special prominence by means of the beautifully constructed balustrades terminating in multi-headed, hooded nāgas (late 9th–12th century, Garuda in the style of the Bayon).

STATUARY. The images of deities and temple-guardians (dvārapālas in low relief or carved in the round, devatās in low relief alone) and the rarer narrative low reliefs also show the development of Khmer sculpture. Most of the statues are of sandstone; large bronze images are uncommon, and the use of wood-carving did not really become widespread until after the 13th century. The statues carved during the 7th and 8th centuries are not only the most realistic but are among the most beautiful too, despite almost always being provided with supports (for safety's sake) in the form of struts and arches. From the early 9th century on, a certain tendency towards conventionality and stylization can be observed. Although it was moderated by a growing confidence in the handling of sculpture carved completely in the round, this tendency became more marked until early in the 10th century, affecting the carving of anatomy and clothing alike. During the second quarter of the 10th century (Koh Ker), the hieratic style was tempered by a certain degree of sensitivity; technical mastery made possible the carving of images and groups in dynamic poses, often on a colossal scale. After a period displaying a new and somewhat exceptional taste for a measure of sensuous beauty—a taste nurtured, it would seem, by Indonesian influence (Banteay Srei, 967)—there developed, over more than a century, a style of art more concerned with gracefulness than with the cold grandeur that the age of Angkor Wat (first half of the 12th century) was to reintroduce. Such ideals, which scarcely affected low reliefs but had much in common with the ideals of the late 9th and early 10th century, were to disappear with the advent

of the style of the Bayon—infused with compassion, animated with inner life and rendered justly famous by the 'Bayon smile'. After this veritable golden age in the history of Khmer sculpture, stone images became increasingly rare, and sculpture, consisting by now almost exclusively of figures of the Buddha, became primarily the province of the wood-carver. Most of the numerous images that were produced are of fully adorned, standing figures. Although they do not bear comparison with the earlier works, they nonetheless preserve their traditional qualities in large measure and are often possessed of true originality.

CERAMIC WARES. Though neither as varied nor as consistently abundant as those of Thailand, Cambodian ceramic wares are not without interest. This is especially true of those produced from the 11th century to the 13th. Cambodian ceramics are mostly made of stoneware, and the potters employed surprisingly classical shapes ('baluster' types) that coexist with others exhibiting a bold zoomorphism and with wares of a more obviously utilitarian nature.

A BRIEF HISTORY OF KHMER ART

After a prehistoric period about which little is as yet known, and a proto-historic period when objects similar to those produced in Indonesia and at Dōng-sön (Vietnam) during the late Bronze Age were created, there existed in the south of the peninsula, in the very earliest centuries of the Christian era, an Indianized kingdom called Fu-nan, mentioned in Chinese texts. Almost nothing is known about the art of this kingdom to which a mere handful of objects (seals, some gems) found at Oc-èo can be attributed with certainty. For a while it was thought possible that another, larger group of objects might be from Fu-nan, but this theory has been disproved by the most recent excavations in Thailand (especially by those at U Thong), which show that the objects in question cannot have been made earlier than the 7th or 8th century. In any case, it is incorrect to regard Khmer culture has having been inherited directly from that of Fu-nan, since the Khmers, advancing from the middle reach of the Mekong River, began by robbing Fu-nan of its independence and then embarked upon the total destruction of the kingdom.

THE PRE-ANGKORIAN PERIOD (2nd half of the 6th century—beginning of the 9th). It is generally accepted that this period begins with the fall of Fu-nan and ends, not with the founding of Angkor, which did not take place until the last years of the 9th century, but with the introduction (in the first half of the 9th century) of the rites upon which the kingship of Angkor was to be based. The oldest (Buddhist) images are no earlier than the middle of the 6th century. The somewhat later (early 7th century and the period following) Brahminic monuments already exhibit some of the traditional features of Khmer architecture: e.g. the same general arrangement in the plans of the buildings, and the same quality and richness in the decorative sculpture (Sambor Prei Kuk). The statuary produced during this period includes some real masterpieces but also some sculptures of undeniable mediocrity that were turned out by provincial workshops of minor importance.

THE ANGKORIAN PERIOD (9th century—1431). The productions of the first half of the 9th century (Kulēn style) mirror the transition from pre-Angkorian to Angkorian art very faithfully. The latter was soon dominated by royal

patronage, which inspired the building of great complexes even before the founding of Angkor (Preah Kō, 879; Bàkong, 881) and imposed a particular style upon most of the buildings founded during this period. These observations apply with equal validity to structures that may properly be described as Angkorian, to those of a short-lived capital (Koh Ker, 921–44), to those at the kingdom's shrines (Wat Phu, *c.* 7th–12th century, Preah Vihear, 11th–12th century, Phnom Chisor, 11th century, etc.) and to those belonging to the great fiefs. Although the construction on the site of Angkor of Angkor Wat (Sūryavarman II, 1st half of the 12th century) marked the climax of 'classical' architecture, the seizure of the capital by the Chams in 1177 was to impose—with the building of a new city (Angkor Thom, centred on the Bayon)—a political and religious reconstruction of the kingdom that was to be the work of Jayavarman VII. Popularized under the name of 'style of the Bayon', this considerable entreprise, extending far beyond the traditional limits of the kingdom, tended to make the capital city the terrestrial counterpart to the City of the Gods in a Cambodia that epigraphy identifies with the City of Indra, the Heaven of the Thirty-three Gods. After the accomplishment of this immense undertaking, intended to perpetuate the power of the rulers of Angkor by making it universal, artistic activity declined considerably. The spread of Theravāda Buddhism, less concerned with acquiring prestige than with gaining authentic merits, coupled with growing difficulties abroad (the independence of the Kingdom of Sukhothai followed by the threat presented by the Kingdom of Ayuthia) turned the attention of the Khmers from the ideals of the preceding centuries. An ever-increasing proportion of the sculpture was carved in response to Buddhist commissions. Sculptors forgot the lesson of the Bayon, and their work became increasingly lifeless and academic, while wooden statues (some of which were very tall) were already becoming more numerous. At Angkor, the only architectural activity was the construction of a few small sanctuaries and of vast terraces intended for buildings of composite construction that have not survived.

THE POST-ANGKORIAN PERIOD (1431—the present). For a short while, after the abandonment of Angkor in 1431, the art and aesthetic of the Thai kingdom of Ayuthia predominated in the former Khmer capital; however, when Khmer royalty reoccupied the site briefly towards the middle of the 16th century, the renewal of artistic activity at Angkor Thom (the region round the Royal Palace) and especially at Angkor Wat showed that, inspite of there being a certain degree of hastiness in the execution of the work, the essence of the great traditions had not been forgotten. From the 17th century onwards, the architecture of Cambodia differed little from that of contemporary Thailand, though its sculpture (wooden images of the Buddha for the most part) retained a real measure of independence from the schools of Ayuthia and Bangkok.

MAJOR MUSEUMS

Archaeological Repository of Angkor, Angkor (Siem Reap)
Musée Nationale du Cambodge, Phnom Penh
Museum of Wat Po Veal, Battambang

CONCISE BIBLIOGRAPHY

BOISSELIER, J. *Le Cambodge* (Manuel d'Archéologie de l'Asie du Sud-Est series, no. 1) Paris, 1966.

───────── *La statuaire khmère et son évolution.* 2 vols. Publ. E.F.E.O. Saigon, 1955.

───────── *Tendances de l'art khmer.* Publ. Musée Guimet, Paris, 1955.

COEDES, G. *Pour mieux comprendre Angkor.* Publ. Musée Guimet, Paris, 1947.

───────── 'Bronzes khmers' in *Ars Asiatica* V. Paris and Brussels, 1923.

───────── *Angkor: An Introduction* (trs. by Emily Floyd Gardiner). Hong Kong, 1963.

CORAL-REMUSAT, G. DE. *L'art Khmer, les grandes étapes de son évolution.* Paris, 1940.

DUPONT, P. 'La statuaire préangkorienne' in *Artibus Asiae* Suppl. Ascona, 1955.

GITEAU, M. *The Civilization of Angkor* (trs. by Katherine Watson). New York, 1976.

───────── *Iconographie du Cambodge post-angkorien.* Publ. E.F.E.O Paris, 1975.

───────── *Khmer Sculpture and the Angkor Civilization* (trs. by Diana Imber). London, 1965.

GLAIZE, M. *Les monuments du Groupe d'Angkor: Guide.* 3rd ed. Paris, 1964.

GROSLIER, B. P. *Angkor, hommes et pierres.* Paris, 1956.

───────── *Angkor, Art and Civilisation* (trs. by Eric Ernshaw Smith). Rev. ed. London, 1966.

GROSLIER, G. 'Les Collections khmères du Musée Albert-Sarraut à Phnom-Penh' in *Ars Asiatica* XVL. Paris and Brussels, 1931.

───────── *Recherches sur les Cambodgiens.* Paris, 1921.

LUNET DE LAJONQUIERE, E. *Inventaire descriptif des monuments du Cambodge.* 3 vols. Publ. E.F.E.O. Paris, 1902–11.

MARCHAL, H. *Nouveau Guide d'Angkor.* Phnom Penh. 1961.

───────── *Les temples d'Angkor.* Paris, 1955.

───────── *Le décor et la sculpture khmers.* Paris, 1951.

PARMENTIER, H. *L'art khmer classique: Monuments du Quadrant Nord-Est.* 2 vols. Publ. E.F.E.O. Paris, 1939.

───────── *L'art khmer primitif.* 2 vols. Publ. E.F.E.O. Paris, 1927.

STERN, P. *Les Monuments khmers du style du Bayon.* Publ. Musée Guimet. Paris, 1965.

───────── *Le Bayon d'Angkor et l'évolution de l'art khmer.* Publ. Musée Guimet. Paris, 1927.

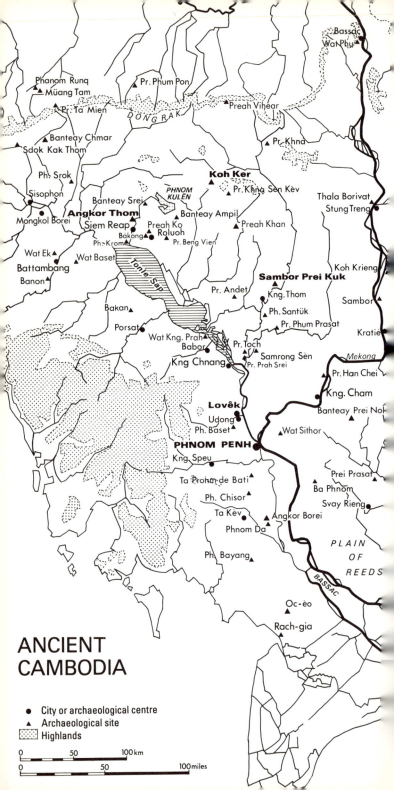

Bassac
Wat Phu

Phanom Runq
Müang Tam
Pr. Phum Pon
Preah Vihear

Pr. Ta Mien
DONG RAK
Pr. Khna

Banteay Chmar
Sdok Kak Thom
Koh Ker
Pr. Khna Sèn Kèv

Ph. Srok
PHNOM KULÈN
Thala Borivat
Stung Treng

Sisophon
Banteay Srei
Banteay Ampil

Angkor Thom
Preah Khan
Mongkol Borei
Siem Reap
Preah Ko
Roluoh
Bakong
Ph. Krom
Pr. Beng Vien

Wat Ek
Wat Baset
Koh Krieng

Battambang
Tonlé Sap
Sambor Prei Kuk

Banon
Pr. Andet
Kng. Thom
Sambor

Bakan
Ph. Santük
Kratie

Porsat
Pr. Phum Prasat
Mekong

Wat Kng. Prah
Pr. Toch
Babor
Pr. Han Chei

Kng Chnang
Pr. Prah Srei
Samrong Sèn
Kng. Cham

Lovêk
Banteay Prei Nok

Udong
Ph. Baset
Wat Sithor

PHNOM PENH

Kng. Speu
Prei Prasat

Ta Prohm de Bati
Ba Phnom

Ph. Chisor
Svay Rieng

Ta Kèv
Angkor Borei

Phnom Da
PLAIN

Ph. Bayang
OF

REEDS

BASSAC

Oc-èo

Rach-gia

ANCIENT
CAMBODIA

● City or archaeological centre
▲ Archaeological site
▨ Highlands

0 50 100 km

0 50 100 miles

1
Prāsāt (or temple tower) Preah Theat Toch, brick, *c.* 7th c.

2
Prāsāt Preah Theat Thom, brick, *c.* 7th–8th c.

3
Prāsāt Prei Chek: side view, brick, 7th–8th c.

5
Prāsāt Kompong Preah: side view, brick, 8th c.

4
Prāsāt Damrei Krap, brick, 1st half of the 9th c., Phnom Kulēn

6
Bàkong: N. W. sanctuary, 881

7
Prāsāt Phnom Krom: central sanctu-
ary, sandstone, late 9th–early 10th c.

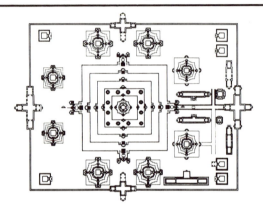

8 Bàkong: plan, 881 (additions dating from the 12th c.)

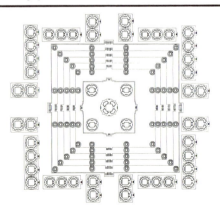

9 Prāsāt Phnom Bàkheng: plan, late 9th–early 10th c., Angkor

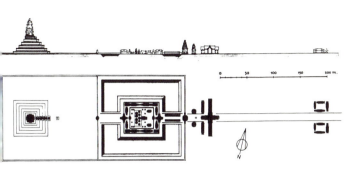

10 Prāsāt Thom: elevation and plan, 921–c. 45, Koh Ker

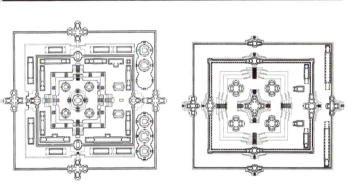

11
Pré Rup: plan, 961, Angkor

12
Tà Kèv: plan, early 11th c., Angkor

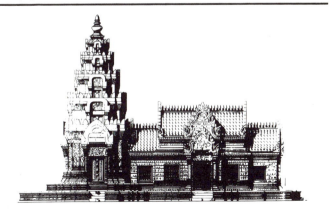

13 Prāsāt Khna Sen Kèv: side view (restoration), 11th c.

235

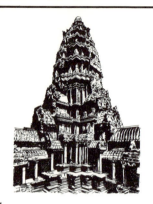

14
Angkor Wat: central sanctuary, sandstone, 1st half of the 12th c.

15
The Bayon: face-tower, sandstone, late 12th–early 13th c., Angkor

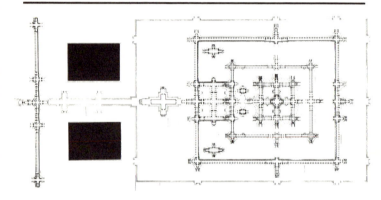

16 Angkor Wat: plan, 1st half of the 12th c.

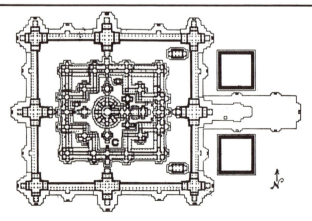

17 The Bayon: plan, late 12th–early 13th c.

18
Votive stupa, sandstone, H. 2.30 m., 2nd half of the 10th c., Phnom Srok, Guimet Mus., Paris

19
Stupa, brick faced with stone, *c.* 16th–17th c., Wat Tarey, Srei Santhor

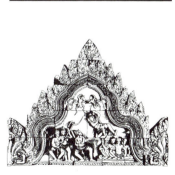

21
Multifoil pediments, sandstone, 967, Banteay Srei

20
Gopura (monumental door): triangular pediment, sandstone, 967, Banteay Srei

22
Scene: *Mahābhārata,* sandstone pediment, H. 1.89 m., 967, Banteay Srei, Mus. Nat., Phnom Penh

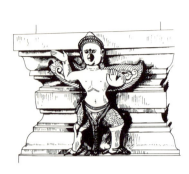

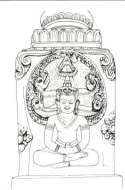

23
Pedestal with garuda, sandstone, *c.* mid–10th c., Mus., Battambang

24
Buddhist corner-stone, sandstone, H. 65 cm., 13th–14th c., Bos Preah Nan, Mus. Nat., Phnom Penh

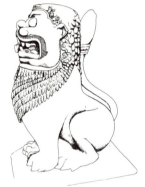

25
String-wall spirit: lion, sandstone, H. *c.* 80 cm., late 9th c., Preah Kō, *in situ*

26
Nāga: end of balustrade, sandstone, H. *c.* 1 m., 12th c., Banteay Samré, *in situ*

27
Garuda: end of balustrade, sandstone, H. *c.* 80 cm., late 12th–early 13th c., Banteay Chhmar, *in situ*

28
Garuda, wood, H. 1.50 m., early 20th c., Mus. Nat., Phnom Penh

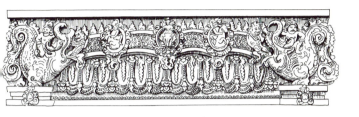

29 Lintel, sandstone, *c.* 2nd quarter of the 7th c., Sambor Prei Kuk, near site S. 7, *in situ*

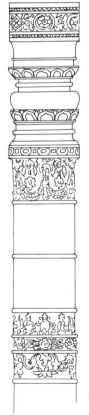

30
Colonnette: upper section, sand-stone, *c.* 2nd half of the 7th c., Prāsāt Prei Kmeng, *in situ*

31
Pilaster: decoration, sandstone, 2nd quarter of the 7th c., Sambor Prei Kuk site S. 2, *in situ*

32
Pilaster: decoration, sandstone, 2nd quarter of the 7th c., Sambor Prei Kuk site N. 17, *in situ*

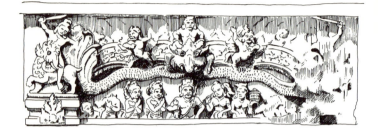

33 Lintel, sandstone, *c.* 2nd quarter of the 7th c., Sambor Prei Kuk site
S. 1, *in situ*

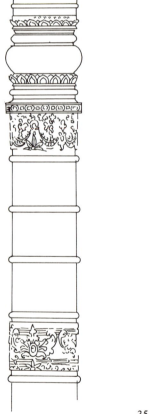

34
Colonnette: upper section, sand-
stone, late 7th–8th c., Prāsāt Tra-
peang Phong site S. 4, *in situ*

35
Pilaster: decoration, sandstone, *c.*
late 7th c., Han Chei, aedicule B,
in situ

36 Lintel, sandstone, 716, Prāsāt Preah Theat Kvan Pir, *in situ*

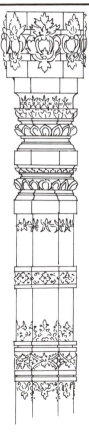

38
Pilaster: decoration, brick, 706, Prāsāt Phum Prāsāt, *in situ*

37
Colonnette: upper section, 8th c., Sambor Prei Kuk site C. 1, *in situ*

39
Pilaster: decoration, brick, 8th c., Prāsāt Kompong Preah, *in situ*

40 Unfinished lintel, sandstone, *c.* 2nd half of the 7th c., Sambor of
the Mekong, Mus. Nat., Phnom Penh

41 Lintel, sandstone, 8th c., Wat Kompong Chnang, Mus. Nat.,
Phnom Penh

42 Lintel, sandstone, 1st half of the 9th c., Prāsāt Or Pong, Phnom
Kulēn, Mus. Nat., Phnom Penh

43 Lintel, sandstone, 2nd quarter of the 10th c., Prāsāt Damrei, Koh Ker
in situ

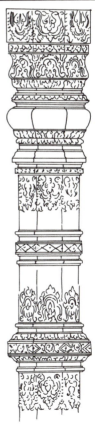

44
Colonnette: upper section, sandstone,
3rd quarter of the 9th c., Prāsāt
Trapeang Phong site S. 1, *in situ*

45
Colonnette: upper section, sand-
stone, 879, Preah Kō, *in situ*

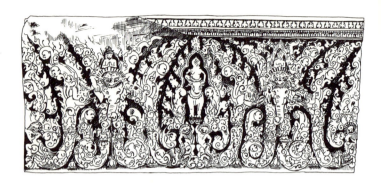

46 Lintel, sandstone, 967, Banteay Srei, *in situ*

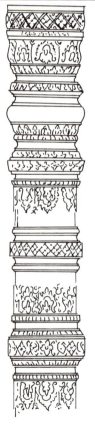

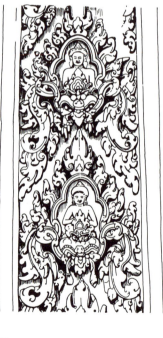

47
Colonnette: upper section, sand-
stone, 881, Bàkong, *in situ*

48
Pilaster: decoration, sandstone, late
9th–early 10th c., Phnom Bàkheng,
in situ

49 Lintel, sandstone, *c.* 3rd quarter of the 10th c., R.P., Angkor Thom,
in situ

51
Pilaster: decoration, sandstone, 967,
Banteay Srei, *in situ*

50
Colonnette: upper section, sand-
stone, 2nd quarter of the 10th c.,
Prāsāt Kraham, Koh Ker, *in situ*

52
Pilaster: decoration, sandstone, 967,
Banteay Srei, *in situ*

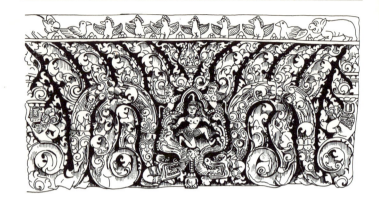

53 Lintel, sandstone, 11th c., Prāsāt Pem Chun, Mus. Nat., Phnom Penh

55
Pilaster: decoration, sandstone, 1st half of the 12th c., Angkor Wat, *in situ*

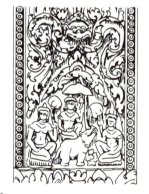

56
Pilaster: decoration, sandstone, 12th c., Banteay Samrè, *in situ*

54
Pilaster: decoration, sandstone, 12th c., Beng Mealea region, Guimet Mus., Paris

57 Lintel, sandstone, after 1191, Preah Khan, Angkor, *in situ*

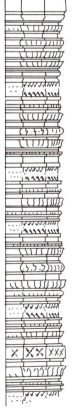

58
Colonnette: upper section, sandstone, 11th c., Prāsāt Khnà Sen Kèv, *in situ*

59
Pilaster: decoration, sandstone, late 12th c., Preah Khan, Kompong Svay, *in situ*

60 Lintel, sandstone, late 12th–early 13th c., Banteay Kdei, *in situ*

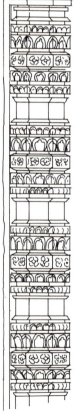

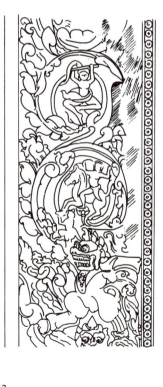

61
Colonnette: upper section, sand-
stone, after 1191, Preah Khan,
Angkor, *in situ*

62
Pilaster: decoration, sandstone, after
1186, Tà Prohm, Angkor, *in situ*

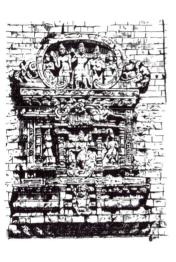

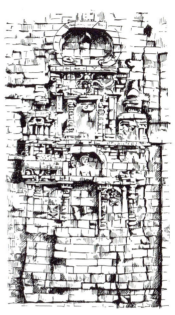

63
Scaled-down model: building, brick,
c. 2nd quarter of the 7th c., Sambor
Prei Kuk site N. 16, *in situ*

64
Scaled-down model: building, brick,
c. 2nd quarter of the 7th c., Sambor
Prei Kuk site N. 14, *in situ*

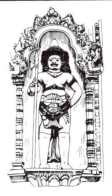

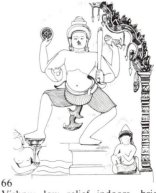

65
Dvārapāla, sandstone, 879, Preah
Kō, *in situ*

66
Vishnu: low relief indoors, brick,
2nd quarter of the 10th c., Prāsāt
Kravan, Angkor, *in situ*

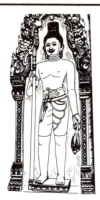

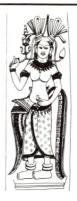

67
Dvārapāla, sandstone, 967, Banteay
Srei, *in situ*

68
Devatā, sandstone, 1st half of the
12th c., Angkor Wat, *in situ*

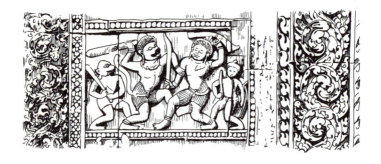

69 Scene from the *Rāmāyana:* low relief, sandstone, 11th c., Baphuon,
in situ

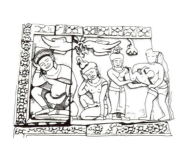

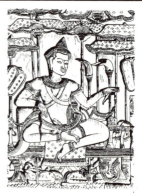

70
Scene from the *Rāmāyana:* low relief,
sandstone, 11th c., Baphuon, *in situ*

71
Low relief: King Sūryavarman II,
sandstone, 1st half of the 12th c.,
Angkor Wat, *in situ*

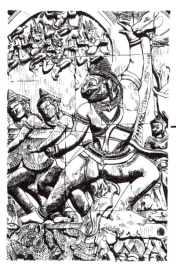

73
Detail: low relief, sandstone, late 12th–early 13th c., the Bayon, *in situ*

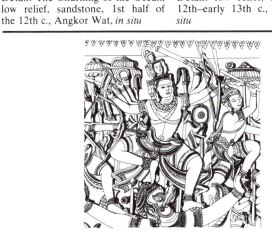

72
Detail: The Churning of the Ocean, low relief, sandstone, 1st half of the 12th c., Angkor Wat, *in situ*

74
Detail: low relief, sandstone, late 12th–early 13th c., the Bayon, *in situ*

75 Detail: Krishna, low relief, sandstone, 16th c., Angkor Wat, *in situ*

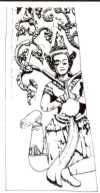

76
Fragment: pediment, wood, 17th to 18th c., Babor, Mus. Nat., Phnom Penh

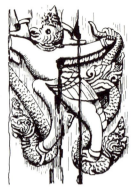

77
Detail: carved panel, wood, 17th to 18th c., Babor, Mus. Nat., Phnom Penh

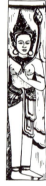

78
Detail: carved panel, wood, 17th to 18th c., Babor, Mus. Nat., Phnom Penh

79
Rājasīha: pulpit, lacquered and gilt wood, 19th c., Buddhist Institute, Phnom Penh

80
Deity on a cock, painted wood, 19th c., Wat Kompong Preah, *in situ*

81
Kinnarī (mythical being), loom-pulley, wood, 19th c., private coll.

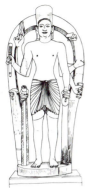

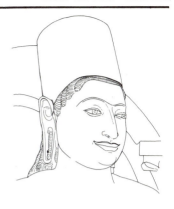

82
Vishnu, schist, H. 2.87 m., 7th to
8th c., Phnom Da, Mus. Nat.,
Phnom Penh

83
Detail: Vishnu (head), Phnom Da

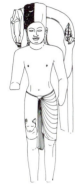

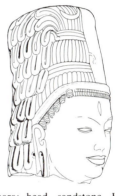

84
Harihara, sandstone, H. 1.75 m.,
7th–8th c., Asram Maha Rosei,
Guimet Mus., Paris

85
Harihara: head, sandstone, H. 42
cm., 7th–8th c., Phnom Da, Mus.
Nat., Phnom Penh

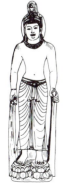

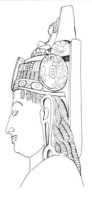

86
Avalokiteśvara, sandstone, H. 1.88
m., 7th–8th c., Rach-gia, private
coll.

87
Detail: Avalokiteśvara (head), Rach-
gia

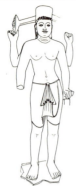

88
Vishnu, sandstone, H. 1.83 m., 7th c., Tūol Dai Buon, Mus. Nat., Phnom Penh

89
Lakshmī (?), sandstone, H. 1.27 m., 7th c., Koh Krieng, Mus. Nat., Phnom Penh

90
Vājimukha (?), sandstone, H. 1.35 m., 7th–8th c., Kuk Trap region, Kandal, Mus. Nat., Phnom Penh

91
Sūrya, sandstone, H. 63 cm., 8th c., Prāsāt Pram Lovēng, Saigon Mus.

92
Harihara, sandstone, H. 1.94 m., 2nd half of the 7th c., Prāsāt Andèt, Mus. Nat., Phnom Penh

93
Detail: Harihara (head), Prāsāt Andèt

94
Devī, sandstone, H. 84 cm., 8th c.,
Bos Prah Nan, Mus. Nat., Phnom
Penh

95
Skanda, sandstone, H. 80 cm., 8th
c., Kdei Ang Chumnik, Guimet
Mus., Paris

96
Harihara, sandstone, H. 86 cm.,
8th c., Kompong Speu, Mus. Nat.,
Phnom Penh

97
Lakshmī (?), sandstone, H. 1.05
m., 8th c., Popel, Guimet Mus.,
Paris

98
Vishnu, sandstone, H. 1.80 m., 9th
c., Prāsāt Damrei Krap, Phnom
Kulēn, Mus. Nat., Phnom Penh

99
Detail: Vishnu (head), Prāsāt
Damrei Krap

100
Śiva, sandstone, H. 1.87 m., 881, Bàkong, Mus. Nat., Phnom Penh

101
Śiva: head, sandstone, H. 42 cm., 879, Preah Kō, Mus. Nat., Phnom Penh

102
Rishi, sandstone, H. 50 cm., late 9th c., Prāsāt Ak Yum, Mus. Nat., Phnom Penh

103
Male body, sandstone, H. 1.52 m., late 9th–early 10th c., Phnom Bàk-heng, Mus. Nat., Phnom Penh

104
Brahmā: head, sandstone, H. 52 cm., late 9th–early 10th c., Phnom Bok, Guimet Mus., Paris

105
Ascetic, sandstone, H. 1.27 m., 2nd quarter of the 10th c., Prāsāt Thom, Koh Ker, Mus. Nat., Phnom Penh

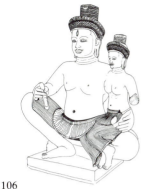

106
Umāmaheśvara, sandstone, H. 60
cm., 967, Banteay Srei, Mus. Nat.,
Phnom Penh

107
Avalokiteśvara, sandstone, 3rd quar-
ter of the 10th c., Saigon Mus.

108
Male deity, sandstone, H. 79 cm.,
11th c., Prāsāt Beng, Mus. Nat.,
Phnom Penh

109
Female deity: head, sandstone, H.
24 cm., 11th c., Bàsak, Mus. Nat.,
Phnom Penh

110
Male deity, sandstone pedestal, H.
61 cm., 11th c., Prāsāt Trapeang
Phong, Hist. Mus., Hanoi

111
Female deity, sandstone, H. 75 cm.,
11th c., Wat Maha, Mus. Nat.,
Phnom Penh

112
Śiva: head, sandstone, 1st half of
the 12th c., private coll.

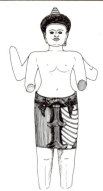

113
Vishnu, sandstone, H. 101 cm., 1st
half of the 12th c., Wat Khnàt,
Mus. Nat., Phnom Penh

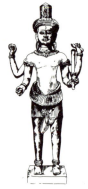

114
Harihara, bronze, H. 38 cm., 12th
c., Angkor region, Mus. Nat., Phom
Penh

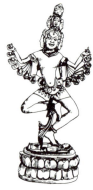

115
Hevajra, bronze, H. 30.5 cm., 2nd
half of the 12th c., Banteay Kdei,
Mus. Nat., Phnom Penh

116
Avalokiteśvara, sandstone, H. 1.16
m., late 12th–early 13th c., Angkor
region

117
Avalokiteśvara: Angkor Thom, sand-
stone, t.H. 2.12 m., late 12th–early
13th c., Mus. Nat., Phnom Penh

118
Jayavarman VII (?): head, sandstone,
H. 41 cm., late 12th–early 13th c.,
Preah Khan, Kompong Svay

119
Giant: head, sandstone, H. c. 60 cm.,
late 12th–early 13th c., Gateway of
the Dead, Angkor Thom, in situ

120
Prajñāpāramitā, sandstone, t.H. 1.10
m., late 12th–early 13th c., Preah
Khan, Angkor, Guimet Mus., Paris

121
Female body, sandstone, H. 71 cm.,
late 12th–early 13th c., Banteay
Chhmar, Mus. Nat., Phnom Penh

122
Female deity, sandstone, H. 86 cm.,
13th c., Prāsāt Srangé, Arch. Rep.,
Angkor

123
Male deity, sandstone, c. 14th to
15th c., Srei Santhor, in situ

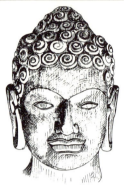

124
Buddha: head, sandstone, H. 25 cm., *c.* 5th–6th c., Wat Romlok, Mus. Nat., Phnom Penh

125
Buddha: head, sandstone, H. 32 cm., 7th–8th c., Mus. Nat., Phnom Penh

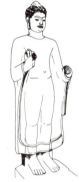

126
Standing Buddha, sandstone, H. 90 cm., *c.* 7th–8th c., Tūol Preah Theat, Guimet Mus., Paris

127
Standing Buddha, sandstone, H. 46 cm., *c.* mid–10th c., Prāsāt Beng Vien, Mus. Nat., Phnom Penh

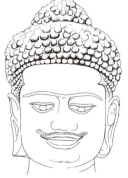

128
Buddha: head, sandstone, 3rd quarter of the 10th c., near Preah Pithu, Angkor Thom (lost)

129
Buddha: head, sandstone, 3rd quarter of the 10th c., Angkor Thom, R.P., Phnom Penh

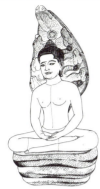

130
Buddha on *Nāga,* sandstone, H. 1.15 m., 11th c., Peam Cheang, Mus. Nat., Phnom Penh

131
Adorned Buddha on *Nāga,* sandstone, H. 87 cm., 1st half of the 12th c., Mus. Nat., Phnom Penh

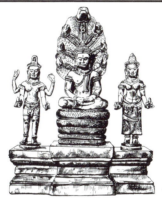

132 The Buddhist triad, bronze, H. 18.5 cm., late 12th–early 13th c., Mongkol Borei region, Mus. Nat., Phnom Penh

133
Buddha on *Nāga,* bronze furnishing, H. 16.5 cm., 12th–13th c., Chong Prei region, Mus. Nat., Phnom Penh

134
Buddha on *Nāga,* sandstone, H. 3.60 m., late 12th–early 13th c., the Bayon, Angkor Thom, *in situ*

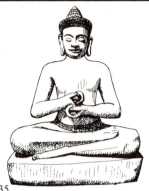

135
Vajradhara, sandstone, H. 85 cm., late 12th–early 13th c., Arch. Rep., Angkor

136
Standing Buddha, sandstone, H. 1.78 m., 13th c., Preah Khan, Angkor, Guimet Mus., Paris

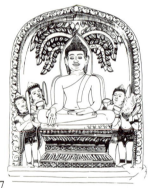

137
Stele: offering of the Four *Lokapāla,* sandstone, H. *c.* 80 cm., 13th c., the Bayon, Mus. Nat., Phnom Penh

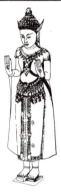

138
Adorned Buddha, lacquered wood, H. 1.15 m., *c.* 17th c., Wat Preah Einkosei, Siem Reap, *in situ*

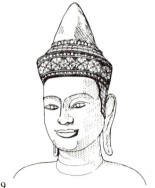

139
Adorned Buddha: head, wood, H. (statue) 2.11 m., *c.* 18th c., Angkor Wat, *in situ*

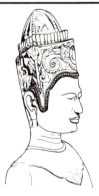

140
Adorned Buddha: head, wood, H. (statue) 1.77 m., *c.* 18th c., Angkor Wat, *in situ*

141
End of a (wagon) tongue, bronze, H. 28 cm., 1st half of the 12th c., Banteay Srei, Guimet Mus., Paris

142
Supporting foot, bronze, H. 21 cm., late 12th–early 13th c., Chau Say, Angkor, Mus. Nat., Phnom Penh

143
Mirror-handle, bronze, H. 16 cm., 12th c., Wat Phu, Guimet Mus., Paris

144
Hook from litter (?), bronze, late 12th–early 13th c., Mongkol Borei region, Mus. Nat., Phnom Penh

145
Candle-holder, bronze, H. 24.5 cm., 12th–13th c., Mongkol Borei region, Mus. Nat., Phnom Penh

146
Vessel for lustral water, bronze, H. 29 cm., 19th c. (?), Lovea Em, Hist. Mus., Hanoi

263

147
Lime-container, bronze, H. 16.5 cm., 17th c. (?), Hist. Mus., Hanoi

148
Lime-container, bronze, H. 16.5 cm., 17th c., Angkor region, Hist. Mus., Hanoi

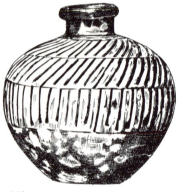

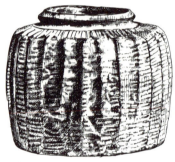

149
Jar, glazed stoneware, H. 11 cm., Angkorian period, private coll.

150
Jar, glazed stoneware, H. 9.8 cm., Angkorian period, Mus. Nat., Phnom Penh

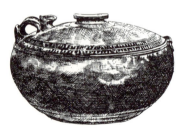

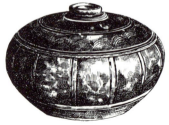

151
Vessel with spout, brown-glazed earthenware, D. 20 cm., 12th–15th c., Siem Reap, Hist. Mus., Hanoi

152
Jar, brown-glazed earthenware, D. 13.5 cm., 12th–15th c., private coll.

264

153
Incense-burner (?), brown-glazed earthenware, H. 9.8 cm., 12th–13th c., Univ. of Singapore

154
Vessel with spout, brown-glazed earthenware, D. 18 cm., 12th–15th c., Mus. Nat., Phnom Penh

155
Elephant jar, glazed earthenware, H. 16 cm., 12th–13th c., Angkor region, Hist. Mus., Hanoi

156
Lidded vase, stoneware, H. 27 cm., Angkorian period, Mus. Nat., Phnom Penh

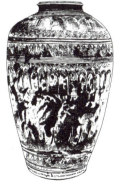

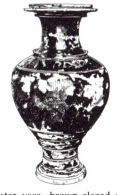

157
Large jar, brown-glazed stoneware, H. 45 cm., 11th–12th c., Ubon, Nat. Mus., Bangkok

158
Baluster vase, brown-glazed stoneware, H. 54 cm., Angkorian period, Hist. Mus., Hanoi

INDONESIA

Although Indonesian art is usually described as being first and foremost 'Indo-Javanese', it should be borne in mind that it cannot be characterized accurately merely by employing this term. On the other hand, to claim a solely Javanese origin for Indonesian art is equally misleading, although Java was its most prolific and renowned centre. The earliest traces of Indian influence on an area of the Indonesian archipelago date from the 4th or 5th century A.D., but well before that, around the 5th to the 2nd century B.C., during Indonesia's protohistory, a splendid bronze civilization had flowered. Despite its close links with Dŏng-sön in north Vietnam, this civilization was original. It was rooted in a megalithic culture that flourished during the 1st millennium B.C. and lasted far longer in certain remote regions. Typical of this civilization were tombs, sanctuaries with statues of 'ancestors' and low reliefs and (in southern Sumatra and eastern Java) large earthworks.

The earliest examples of Indian influence so far discovered are a few Sanskrit inscriptions (Borneo, c. end of the 4th century) and some bronze figures of the Buddha (Celebes, Java, Sumatra) that date from the 4th and 5th centuries and appear to be of south Indian or Sinhalese origin. Indonesian art, inspired by religion—sometimes Buddhist, sometimes Hindu and (especially in the 13th century) sometimes with strong tantric undercurrents—began its most prolific period, which lasted for some seven centuries, at the end of the 7th century or at the beginning of the 8th. In spite of political changes, which have in fact given an impetus to the development of Indonesian art and caused it to flower during certain periods (particularly from the 8th to the 10th century on the Malaysian peninsula and in Champa), architecture and sculpture have nearly always maintained that very high quality to which they owe their reputation. The disappearance in the 15th century of the last Indianized kingdoms as a result of the steady encroachment of Islam (Bali alone remaining faithful to Hinduism) brought about a resurgence of the native beliefs of earlier times and the development of an epic literature from which the plastic arts, including the theatre (shadow theatre, masked theatre, etc.), were to draw their favourite themes. Islam, far from discarding Indonesia's artistic tradition, adopted most of the architectural shapes and decorative motifs created by Hindu culture. It is because Indonesian art was so profoundly influenced by Indian art that it is often described as 'Indo-Javanese'. It sometimes reflects the influence of the Pallava art of southern India and sometimes that of the post-Gupta and Pāla tradition of northern India (especially in Buddhist commissions). Nevertheless, Indonesia retained a corpus of traditions peculiar to itself. Although many of these are rooted in the country's protohistory, they were to acquire a new lease on life when the Indian characteristics of Indonesian art became blurred.

ARCHITECTURE. Most of the historic buildings on Java are constructed of stone, whereas the few that have survived on Sumatra and those on Bali are of brick. The stones and bricks, usually of moderate size, are laid without mortar in very regular courses. Corbelling was the only method of roof construction employed, and covered galleries were unknown. Pre-eminent among these buildings is the *candi,* a square sanctuary erected on a large, terraced platform. The stepped roof and its corners are surmounted by miniature buildings (often stupas on Buddhist sanctuaries such as Sewu Candi). More complicated sanctuaries, with chapels opening off each side, were developed from this simple type, and some are very elaborate (main sanctuary, Lara Janggrang Candi). In certain instances, large complexes, some consisting of several hundred identical small temples, are arranged on concentric terraces around the central *candi* or a group of them (Sewu Candi, Lara Janggrang Candi). This is a feature of Buddhist and Hindu architecture alike, but Buddhism also employed structures peculiar to itself (Sari Candi). Naturally stupas are found among these structures. Although stupas were only erected in large numbers on Sumatra, it was at Borobodūr on Java (constructed at the end of the 8th century or during the 9th) that the stupa reached its greatest and richest development and was invested with its full cosmic symbolism.

In the 10th and 11th centuries, the evolution of religion and the development of funerary cults brought about the introduction of new constructions, in particular the piscinae, where the holy waters collected from the mountain were redistributed by divinities shaped like water spouts (Belahan). The funerary temples of sovereigns also underwent changes in design, becoming higher (Kidal Candi) and sometimes being built on a stepped pyramid (Singasari Candi). In about the 14th century, temples consisting of a succession of enclosures were built (Panataran Candi), and the gates of these enclosures became increasingly plain until they reverted to the original type known as the *candi bentar:* a sort of opening produced by omitting horizontal rows of brick or stone in a high façade. With the demise of the Indianized kingdoms in the 15th century, the sanctuaries appear to have reverted to megalithic forms: mountainside terraces, pyramids, menhirs (Mt. Lawu: Sukuh Candi). The converts to Islam were content to adopt the forms of traditional buildings for their mosques. The *candi* was the model for the minaret, and the monumental entrances were derived from the *candi bentar.* Some of the brick or wooden sanctuaries *(meru)* on Bali are curious examples of composite construction, being covered with high thatched roofs rising in tiers (Mengwi).

ARCHITECTURAL DECORATION. On Indonesian buildings architectural decoration often assumes such importance and is so loaded with meaning that it is practically impossible to consider the decorative detail separately from the buildings themselves. Embellishment for its own sake is never found in art of Indian inspiration; on Java, however, the symbolism of decorative features is richer than anywhere else. Four main categories of decoration may be distinguished: (1) narrative low reliefs, depicting events in the life of the Buddha and scenes from the legends of the gods or from the epics—themes that have always played a major role in Indonesian art and constitute some of its most successful illustrative art; (2) large figures of tutelary deities (bodhisattvas, guardians of the cardinal points, etc.), usually carved in niches or between the pilasters of *candi;* (3) decoration mainly inspired by plant life, in which ornamental foliage, lotus, trees that 'grant desires', vases 'of plenty' and auspicious symbols inherited from India are frequently used (especially during the period from the 8th to the 10th cen-

turies); and (4) a motif that enjoyed exceptional popularity, the *Kāla,* a symbolic guarantee of protection for porches and niches. The *Kāla,* which is the head of a horned monster with staring, protruding eyes, is similar to the 'mask of glory' *(kīrtimukha)* of Indian iconography and was placed at the summit of an arch, each end of which was decorated (up to the 13th century) with the head of a *makara*—a sea-monster with an elephant's trunk. *Kāla* and *makara* heads often served as gargoyles, being modelled in the round when they were so used.

SCULPTURE. Low reliefs illustrating narrative scenes were so popular at all times that they can be regarded as the Indonesian sculptor's favourite means of expression. Although certain free-standing sculptures are unquestionably masterpieces, it would appear that Indonesian artists preferred to carve images either on steles or as solid masses (seated or kneeling figures in various postures are common) rather than as standing figures with no vertical or horizontal means of support. From the 13th century onwards, there was an increasing tendency to treat funerary statues as standing statues, a tendency which was not initially accompanied by a deterioration in quality; and, later on, images of the epic heroes developed into a kind of synthesis of a statue and a menhir.

BRONZES. In addition to the stone sculptures discussed above, examples of the art of bronze-casting have survived in considerable numbers. These show a remarkable mastery of technique and seem to have contributed in no small measure to the strengthening of the art of the Indo-Chinese peninsula in the 8th and 9th centuries. Although only a few fragments have survived from large-scale bronzes, smaller images and ritual objects (bells, hand-bells, lamps, etc.) have fortunately come down to us in large numbers. The influence on Buddhist images of the Indian art of Nālandā is often clearly visible; at a later date, the quality of the bronze objects deteriorated as it did with statuary. Images of plated or inlaid gold and silver, many fashioned as skilfully as the finest bronzes, are also known. Indonesian craftsmen also produced exquisite jewellery (faceted gemstones and embossed ornaments).

CERAMICS. Although terracotta is represented by some objects modelled with great sensitivity, there is scarcely any evidence relating to the art of pottery, which does not appear to have been widely practised. Indeed, it is interesting to note in this connection that a great deal of pottery from Sukhothai in Thailand was imported into Indonesia during the 14th and 15th centuries.

A BRIEF HISTORY OF INDONESIAN ART

Clearly defined styles, such as those referred to in discussions of Khmer and Cham (Champa) art, have not been distinguished by students of the considerably more complex art of Indonesia. Most scholars resort to a division of the subject into long periods, corresponding to the historical evolution, by which centres of artistic activity moved from western towards eastern Java. In spite of affirmations to the contrary, no work of art can at present be attributed to the earliest period of 'western Java', and it is with the 8th-century 'Indo-Javanese' art of central Java that the history of Indonesian art really begins.

THE CENTRAL JAVANESE PERIOD (*c.* 8th–late 9th century) was a period of intense artistic activity inspired by Śivaism (the Dieng plateau, Gedong Sanga) and, under the patronage of the Śailendra dynasty, by Buddhism (the Kedu plain). Styles vary considerably according to the region concerned and to religious beliefs, and these variations sometimes foil attempts to date and to carry out a comparative study of works of art. The sculpture carved during this period is of a very high quality. The influence of Indian sculpture of the post-Gupta period on it is visible in varying degrees. Several examples of free-standing sculpture have survived (Banon Candi), but Indonesian sculptors already preferred to carve plain-backed statues that were meant to lean against walls (Mendut Candi). During this period they favoured narrative low reliefs above all else. A taste for the picturesque prevailed everywhere, whether in the form of the judiciously balanced rhythms and calm grandeur of the Buddhist scenes at Borobodūr or of the more animated compositions illustrating events from the *Rāmāyana,* such as those carved somewhat later at Lara Janggrang Candi. This period was also characterized by compositions inspired by plant forms. During these two centuries, more directly than at any other time, Indonesian bronzes, especially Buddhist ones, reflected the influence of India (Nālandā).

THE EASTERN JAVANESE PERIOD (10th–15th century). It was around 930 that the political centre of Java shifted to the east. Buddhism had by this time declined in importance. In the 10th and 11th centuries, during the reign of Airlanga, the son of a king of Bali, sanctuaries were built with piscinae, incorporating gargoyles of great originality. Some works of art of this period are realistic, while others are stiff and have a somewhat lifeless grandeur. Little evidence remains of the artistic activity of the kingdom of Kediri (11th–12th century), far more having survived from the kingdoms of Singasari and of Majapahit (13th–14th century). Changes in decorative features are no less important than the development of architectural forms we have mentioned: the disappearance of *makara,* alteration of the *Kāla*'s head, compositions being treated as medallions, etc. Narrative low reliefs, inspired by the epics, assumed new characteristics: a preference for representation in silhouette, for stylized figures and animated landscapes (Panataran) and, on the other hand, for a heightened feeling of intimacy (Surawana Candi). Most of the statuary of the period is marked by a progressive loss of naturalism and grace, although this criticism cannot be levelled against the outstanding statues carved at Jago Candi and Singasari Candi. Images, whether carved on buildings or free-standing, became overloaded with ornament, some of which reveals a marked taste for the macabre—a taste linked to some extent to the development of certain tantric forms of worship that are known to have existed in Sumatra at this time. Funerary statues became increasingly stiff and hieratic from the reign of King Majapahit onwards, until they became as it were mere lifeless symbols, the life they lack having passed, it would seem, into low reliefs such as those at the sites at Penanggungan. The art of Bali alone kept alive the traditions of Brahminism in their full vigour and with undiminished originality.

THE ISLAMIC PERIOD (after the 15th century) preserved the kernel of the earlier traditions as has been mentioned, but the decorative motifs were radically transformed. Although landscapes continued to be represented (Mantingan), great care was henceforth taken to exclude living creatures from them. As time went on, Indonesian art came to rely increasingly on popular traditions for its subject-matter, with the result that much of it is of greater interest to the ethnologist than to the art historian.

MAJOR MUSEUMS

Bali Museum, Denpasar (Bali)
Archaeological Institute of Indonesia, Djakarta
Central Museum of the Institute for Indonesian Culture (Museum Pusat), Djakarta
Modjokerto Municipal Museum, Modjokerto (Java)
Archaeological Institute (Prambanan Branch Office), Prambanan (Java)
Radyo Pustaka Museum, Surakarta (Java)
Sana Budaja Museum, Jogjakarta (Java)
as well as museums mentioned at the end of the introduction to the Southeast Asia section

CONCISE BIBLIOGRAPHY

BERNET-KEMPERS, A.J. *Ancient Indonesian Art.* The Hague, 1957.
BODROGI, T. *L'art de l'Indonésie.* Paris, 1972.
FONTEIN, J., SOEKMONO, R. and SULEIMAN, S. *Ancient Indonesian Art.* New York, 1971.
HOLT, C. *Art in Indonesia: Continuities and Change.* Ithaca, N.Y., 1967.
KROM, N.J. *Inleiding tot de Hindoe-Javaaansche Kunst.* The Hague, 1923.
——————'L'art javanais dans les musées de Hollande et de Java' in *Ars Asiatica* VIII. Paris and Brussels, 1926.
LE BONHEUR, A. *La sculpture indonésienne au Musée Guimet. Catalogue et étude iconographique.* Paris, 1971.
LOEB, E.M. *Sumatra: Its History and Peoples.* 2nd ed. London, 1972.
RAMSEYER, U. *The Art and Culture of Bali* (trs. by E. Walliser-Schwarzbart). Oxford and London, 1977.
WAGNER, F.A. *Indonesien: die Kunst eines Inselreiches.* Baden-Baden, 1959.
—————— *Indonesia: The Art of an Island Group.* (trs. by Ann E. Keep). London, 1962.

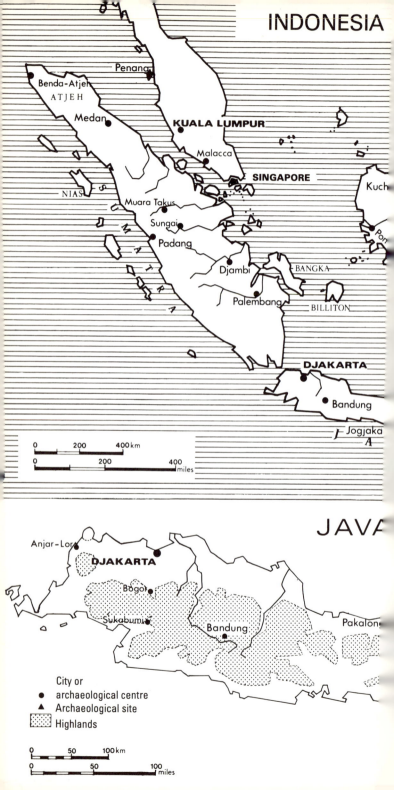

INDONESIA

Penang
Benda-Atjeh
ATJEH
Medan
KUALA LUMPUR
Malacca
SINGAPORE
Kuch
NIAS
Muara Takus
Sungai
Padang
Djambi
BANGKA
Palembang
BILLITON
DJAKARTA
Bandung
Jogjaka

| 0 | 200 | 400 km |
| 0 | 200 | 400 miles |

JAVA

Anjar-Lor
DJAKARTA
Bogor
Sukabumi
Bandung
Pakalong

City or
● archaeological centre
▲ Archaeological site
Highlands

| 0 | 50 | 100 km |
| 0 | 50 | 100 miles |

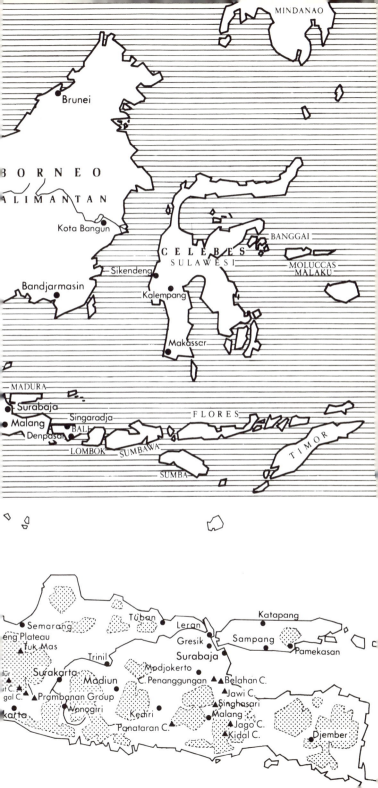

MINDANAO

Brunei

B O R N E O
K A L I M A N T A N

Kota Bangun

C E L E B E S
S U L A W E S I

BANGGAI

Sikendeng

MOLUCCAS
MALAKU

Bandjarmasin

Kalempang

Makassar

MADURA

Surabaja

Malang

Singaradja

BALI

Denpasar

FLORES

LOMBOK

SUMBAWA

T I M O R

SUMBA

Semarang

Tuban

Leran

Katapang

eng Plateau

Tuk Mas

Gresik

Sampang

Surakarta

Trinil

Surabaja

Pamekaran

ur C.

Madiun

Modjokerto

C. Penanggungan

Belahan C.

gal C.

Prambanan Group

Jawi C.

karta

Wonogiri

Kediri

Singhasari

Malang

Panataran C.

Jago C.

Kidal C.

Djember

1
Ceremonial (?) urn, bronze, H. 70 cm., *c.* 5th–2nd c. B.C., Makassar (Celebes)

2
Ceremonial (?) urn, bronze, H. 50 cm., *c.* 5th–2nd c. B.C., Keritji (Sumatra), Cen. Mus., Djakarta

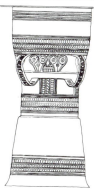

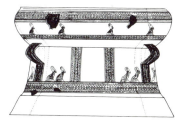

3
Ritual 'Moko' drum, bronze, H. 62 cm., *c.* 5th–2nd c. B.C., Alor Island

4
Ritual drum, bronze, H. 46 cm., *c.* 5th–2nd c. B.C., Babaka (western Java), Cen. Mus., Djakarta

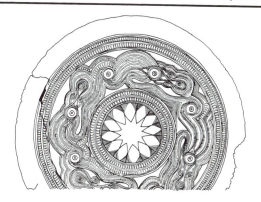

5 Ritual drum, bronze, D. 51.5 cm., *c.* 5th–2nd c. B.C., Tanureja (central Java), Cen. Mus., Djakarta

6
Ceremonial (?) axe, bronze, L. 44 cm., *c.* 5th–2nd c. B.C., eastern Java, Cen. Mus., Djakarta

7
Ceremonial axe, bronze, L. 89 cm., *c.* 5th–2nd c. B.C., Roti Island, Cen. Mus., Djakarta

8
Figurine, bronze, Bronze Age, Bankinang (Sumatra), Cen. Mus., Djakarta

9
Couple of figurines, bronze, Bronze Age, Bankinang (Sumatra), Cen. Mus., Djakarta

10 Statuette of a man, bronze, H. 25 cm., Bronze Age, Bogor, Cen. Mus., Djakarta

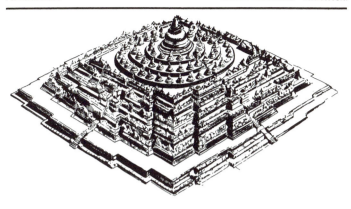

11 Borobodūr: aerial view from S.E., stone bonded with mortar, 8th–9th c.

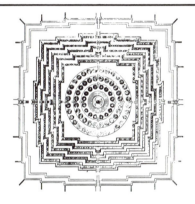

12 Borobodūr: plan of the whole structure, 8th–9th c.

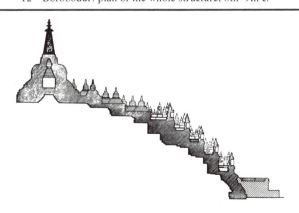

13 Borobodūr: half-section of the monument, 8th–9th c.

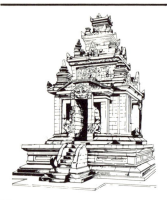

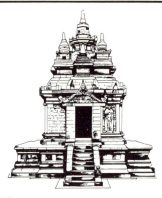

14
Gedong Sanga: temple no. 2, stone bonded with mortar, *c.* 7th–8th c.

15
Pawon Candi, stone bonded with mortar, 8th–9th c.

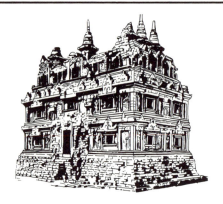

16 Sari Candi, stone bonded with mortar, 9th c.

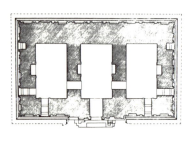

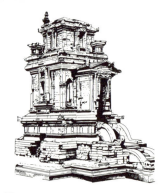

17
Sari Candi: plan of the whole, 9th c.

18
Puntadewa Candi (Dieng plateau), stone bonded with mortar, *c.* 8th c.

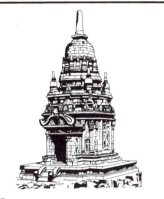

19
Sewu Candi: one of the small temples, stone bonded with mortar, 9th c.

20
Sewu Candi: plan of the whole, 9th c.

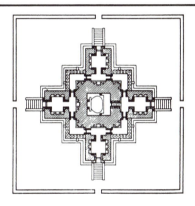

21 Sewu Candi: plan of the central sanctuary, 9th c.

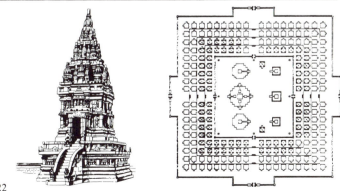

22
Lara Jonggrang Candi: south sanctuary, stone bonded with mortar, late 9th–10th c., Prambanan

23
Lara Jonggrang Candi: plan of the whole, late 9th–10th c.

279

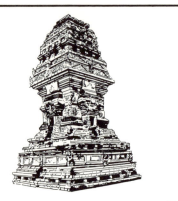

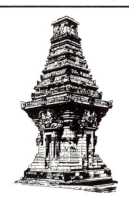

24
Kidal Candi, stone bonded with mortar, mid-13th c.

25
Panataran Candi: 'dated' temple, stone bonded with mortar, A.D. 1369

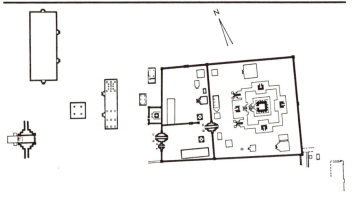

26 Panataran: plan of the entire complex, 12th–15th c.

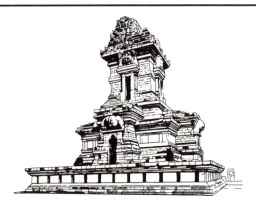

27 Singasari Candi, stone bonded with mortar, c. A.D. 1300

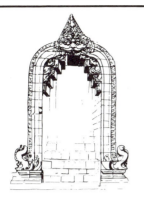

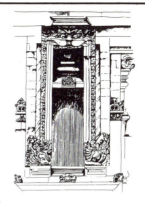

28
Borobodūr: one of the porches giving access to the 3rd terrace, 8th–9th c.

29
Puntadewa Candi: ornamental niche, *c.* 8th c. *in situ*

30
Makara (gargoyle), stone, H. 155 cm., 8th–9th c., Borobodūr, *in situ*

31
Kāla (gargoyle), stone, H. 80 cm., 8th–9th c., Borobodūr, *in situ*

32 Mendut Candi: north string-wall, 8th–9th c., *in situ*

33
Makara head, stone, H. 97 cm., *c.* 9th c., Bubrah Candi, Asia. Mus., Amsterdam

34
Nāgarāja, stone, H. 65 cm., *c.* 8th to 9th c., Ungaran, Cen. Mus., Djakarta

36
'Prambanan motif', base of monument, late 9th–10th c., Lara Jong-grang Candi

35
Ornamental niche, stone, 9th c., Kalasan Candi, *in situ*

37
Makara, stone, H. 145 cm., 11th c., Solok, Jambi (Sumatra), Cen. Mus., Djakarta

38 Lingam on a pedestal, stone, *c.* 10th c., Nagasari Candi (?), Tanjong-
tirta

39
Kāla: head, stone, H 114 cm.,
2nd half of the 13th c., Jago Candi,
in situ

40
Kāla: head, stone, *c.* 1300, Singasari
Candi, *in situ*

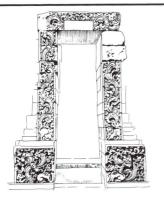

41
Jago Candi: entrance to the cella,
2nd half of the 13th c.

42
Lion, brick, H. 57 cm., 11th–12th
c., Bahal, base: Padang Lawas
(Sumatra), *in situ*

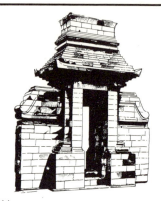

43
Stylized head: *Kāla,* stone, 14th to
15th c.

44
Gateway: Plumbangan, stone bonded
with mortar, 1390

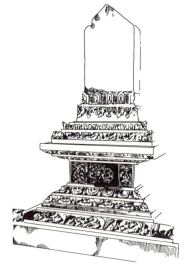

45
Ratu Kalinjamat's tomb, 16th c.,
Mantingan, *in situ*

46
Islamic funerary stele, stone, 1457,
Tralaja, Mun. Mus., Modjokerto

47 Decorative panel, stone, L. 120 cm., *c.* 8th c., Mendut Candi, *in situ*

48

Decorative panel: base of monument, stone, H. 94 cm., *c.* 8th c., Mendut Candi, *in situ*

49

Pilaster with foliated scrolls, 8th to 9th c., Borobodūr, *in situ*

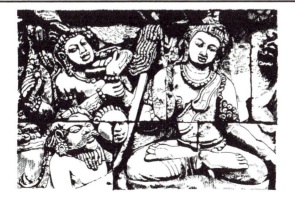

50 Detail: low relief, 8th–9th c., Borobodūr: terraces, *in situ*

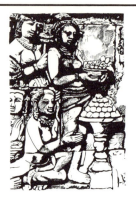

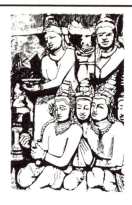

51
Detail: low relief, 8th–9th c., Boro-bodūr: terraces, *in situ*

52
Detail: low relief, 8th–9th c., Boro-bodūr: terraces, *in situ*

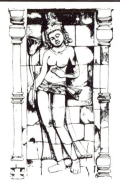

53
Tārā: statue in niche, 9th c., Sari Candi, *in situ*

54
Decorative panel with *kinnari*, H. 70 cm., late 9th–10th c., Lara Jong-grang Candi, *in situ*

55 Decorative panel, stone, L. 120 cm., 9th c., Kalasan Candi, *in situ*

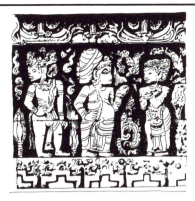

56 Scene from an epic, relief, H. *c.* 75 cm., 2nd half of the 13th c., Jago
Candi, *in situ*

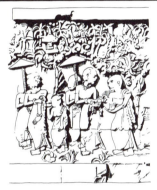

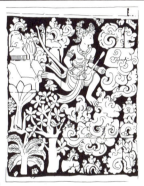

57
Low relief: base, stone, *c.* 1300,
Jawi Candi, *in situ*

58
Scene from the *Rāmāyana,* low
relief, *c.* 14th c., Panataran Candi:
main sanctuary, *in situ*

59
Hamsa (mythical goose), D. 35 cm.,
c. 14th c., Panataran Candi: main
sanctuary (1st terrace), *in situ*

60
Scene from an epic, low relief, *c.*
late 14th c., Surawana Candi, *in
situ*

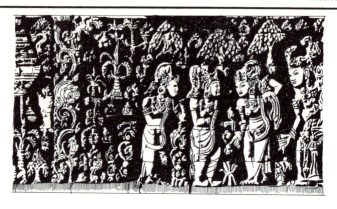

61 Scene from an epic, low relief, *c.* late 14th c., Surawana Candi, *in situ.*

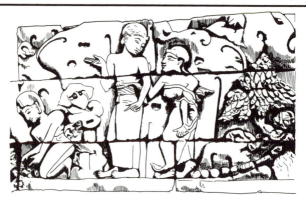

62 Low relief, 15th c., Penanggungan: site LXV, *in situ*

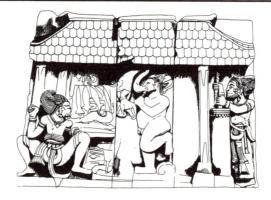

63 Ganeśa and blacksmiths, low relief, H. 160 cm., 15th c., Sukuh, *in situ*

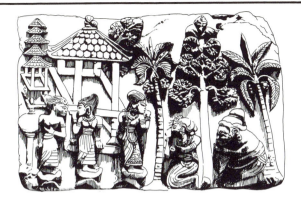

64 Scene from an epic, low relief, H. 105 cm., 15th c., Sukuh, *in situ*

65
Garuda (mythical bird) greeting his
mother, low relief, *c.* 14th c., Keda-
ton Candi, *in situ*

66
Decorative panel, H. 59 cm., 1599,
Mantingan: former mosque, *in situ*

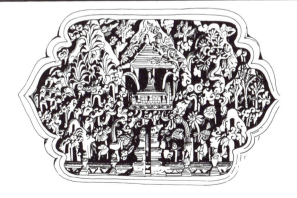

67 Decorative panel, H. 30 cm., 1559, Mantingan: former mosque, *in situ*

289

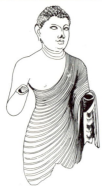

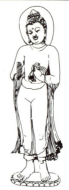

68
Standing Buddha: body, bronze, H. 75 cm., *c.* 4th–5th c., Celebes, Cen. Mus., Djakarta

69
Detail: standing Buddha, low relief, H. 72 cm., 8th–9th c., Borobodūr, *in situ*

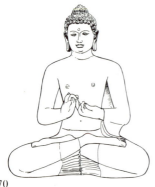

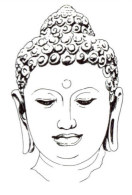

70
Buddha teaching: from a fenestrated stupa, stone, 8th–9th c., Borobodūr, *in situ*

71
Buddha: head, stone, 8th–9th c., Borobodūr, in situ

72
Buddha teaching, stone, 9th c., Sewu Candi, *in situ*

73
Disciple meditating, stone, H. 104 cm., Plaosan Candi, *in situ*

74
Buddha teaching, bronze, H. 37 cm., 8th–9th c., R.v.V., Leiden

75
Buddha teaching, bronze, H. 37 cm., *c.* 9th c., Palembang area, Cen. Mus., Djakarta

76
Avalokiteśvara, stone, H. 3 m., *c.* 8th c., Mendut Candi, *in situ*

77
Detail: Avalokiteśvara, *c.* 8th c., Mendut Candi

78
Agastya, stone, H. 196 cm., *c.* 9th c., Banon Candi, Cen. Mus., Djakarta

79
Vishnu, stone, H. 206 cm., *c.* 9th c., Banon Candi, Cen. Mus., Djakarta

80
Ganeśa, stone, H. 148 cm., *c.* 9th
c., Banon Candi, Cen. Mus., Dja-
karta

81
Temple guardian, stone, H. 2.50 m.,
9th c., Sewu Candi, *in situ*

82
Temple guardian, stone, H. *c.* 190
cm., 9th c., Kalasan Candi, *in situ*

83
The bodhisattva Kshitigarbha, stone,
H. *c.* 170 cm., 9th c., Plaosan
Candi: north sanctuary, *in situ*

84
Avalokiteśvara, silver-plated bronze,
H. 89 cm., 8th–9th c., Tekeran,
Surakarta, Cen. Mus., Djakarta

85
The bodhisattva Mañjuśrī, silver,
H. 28 cm., 8th–9th c., Ngamplak
Semongan, Cen. Mus., Djakarta

86
Avalokiteśvara, bronze, 7th–9th c.,
Guimet Mus., Paris

87
Regent of a cardinal point: relief,
H. 70 cm., late 9th–10th c., Lara
Jonggrang Candi, *in situ*

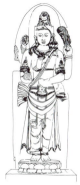

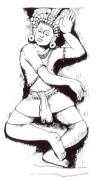

88
Śiva, stone, H. 3 m., late 9th to
10th c., Lara Jonggrang Candi:
central sanctuary, *in situ*

89
Dancer: relief on balustrade, H.
53 cm., late 9th–10th c., Lara
Jonggrang Candi, *in situ*

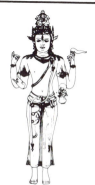

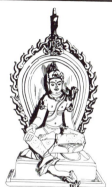

90
Śiva, bronze, gold and silver inlay,
H. 96 cm., 8th–9th c., Tegal area,
Cen. Mus., Djakarta

91
Syāmatārā, bronze, H. 15 cm., 8th
to 9th c., Wassaba, Cen. Mus.,
Djakarta

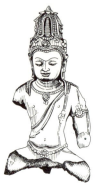

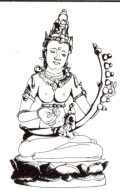

92
The bodhisattva Maitreya, bronze, H. 28.5 cm., *c.* 9th c., Palembang, Cen. Mus., Djakarta

93
A *tārā* as a musician, bronze, H. 8 cm., 10th–11th c., Nganjuk (Kediri), Cen. Mus., Djakarta

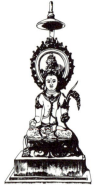

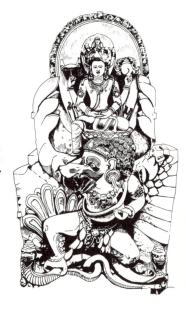

94
Śrī, bronze, H. 20.5 cm., *c.* 10th c., on loan to S.B. Mus., Jogjakarta

95
Female figure from a fountain, stone, H. 72 cm. Goa Gajah, Budulu, Bali

96
Vishnu on Garuda: statue from Airlanga, tufa, H. 190 cm., *c.* 1050 (?), Mun. Mus., Modjokerto

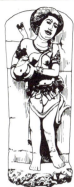

97
Female figure: spout from a foun-
tain, stone, H. 72 cm., 11th c.,
Cen. Mus., Djakarta

98
Male figure: spout from a fountain,
stone, H. 72 cm., 11th c., destroyed
in 1931

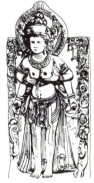

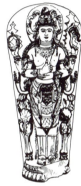

99
Feminine deity: spout from a foun-
tain (N. niche), H. 195 cm., 11th
c. (?), Belahan, *in situ*

100
Śiva: funerary statue, stone, H. 123
cm., 13th c., Kidal Candi (?), Trop.
Inst., Amsterdam

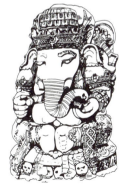

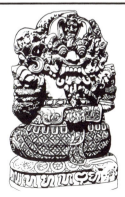

101
Ganeśa, stone, H. 150 cm., 1239,
Bara, Blitar

102
Ganeśa from Bara (no. 101): back
view

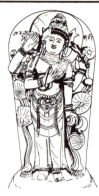

103
Bhrikutī, stone, H. 138 cm., 13th
c., Jago Candi, Cen. Mus., Djakarta

104
Detail: Sudhanakumāra, stone, t.H.
114 cm., 13th c., Jago Candi, Cen.
Mus., Djakarta

105
Temple guardian, stone, H. 3.70 m.,
early 14th c., Singasari, *in situ*

106
Ganeśa, stone, H. 154 cm., early
14th c., Singasari Candi, R.v.V.,
Leiden

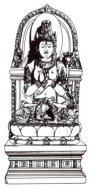

107
Mahishāsuramardini, stone, H. 157
cm., early 14th c., Singasari Candi:
north sanctuary, R.v.V., Leiden

108
Prajñāpāramitā, stone, H. 126 cm.,
late 13th–early 14th c., Singasari,
R.v.V., Leiden

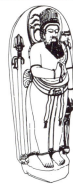

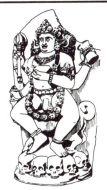

109
The sage Trinavindu, stone, H. 153 cm., mid-14th c., Singasari, destroyed in 1931

110
Cakracakra, stone, H. 167 cm., 13th c., Singasari area, R.v.V., Leiden

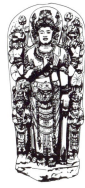

111
Funerary stele: king of Mojopahit, stone, H. 2 m., 14th c., Suberjati Candi, Cen. Mus., Djakarta

112
Funerary stele: queen of Mojopahit, stone, H. 2 m., early 14th c., Rimbi Candi, Cen. Mus., Djakarta

113
Stele of Amoghapaśa, stone, H. 163 cm., late 13th c. (?), Rambahan (Sumatra), Java, Cen. Mus., Djakarta

114
Bhairava, stone, H. 4.41 m., 13th
c. (?), Padang Roro (Sumatra),
Cen. Mus., Djakarta

115
Śiva: funerary statue, stone, H.
84.5 cm., c. 15th c., Mun. Mus.,
Modjokerto

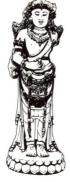

116
Funerary statue, stone, H. 160 cm.,
c. 14th c., Jebuk, Tulung Agung,
Cen. Mus., Djakarta

117
Funerary statue from Jebuk (no.
116): back view

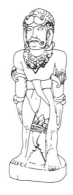

118 Hero of the romance of Pañji, stone, H. 68 cm., 15th c., Penang-
gungan, Cen. Mus., Djakarta

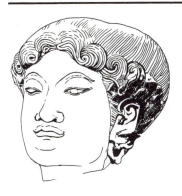

119
Female head, terracotta, H. 8.5 cm., 14th c., Mus., Trawulan

120
Female figure, terracotta, H. 37 cm., 14th c., Mus., Trawulan

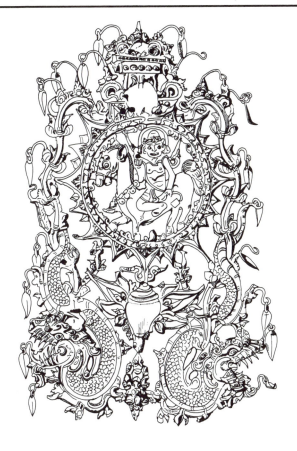

121 Pendant, embossed gold, H. 13 cm., *c.* 14th c., Cen. Mus., Djakarta

122
Bell, silver-plated bronze, H. 58 cm.,
c. 9th c., Kalasan Candi, S.B. Mus.,
Jogjakarta

123
Ritual bell, bronze, H. 18.5 cm.,
8th–9th c., Asia. Mus., Amsterdam

124 Garuda: lamp-holder, bronze, H. 31.5 cm., *c.* 9th–10th c., Cen.
Mus., Djakarta

125
Lamp, bronze, H. 38 cm., *c.* 8th to
9th c., Wassaba (on loan to S.B.
Mus., Jogjakarta)

126
Cakra (coronation attribute), bronze,
H. 30 cm., 12th–13th c., Selumbung,
Blitar, Cen. Mus., Djakarta

127
Ritual bell, bronze, H. 19.5 cm., *c.* 13th–14th c., Cen. Mus., Djakarta

128
Ritual ewer, bronze, H. 27 cm., *c.* 13th–14th c., Cen. Mus., Djakarta

129
Cup: Signs of the Zodiac, bronze, H. 11 cm., 14th–15th c., Tengger Mountains, Cen. Mus., Djakarta

130
Rakshasa (demon), bronze, H. 26.5 cm., 14th–15th c. (?), Babadan, Malang, Cen. Mus., Djakarta

131
Hamsa, bronze, H. 8 cm., 11th to 12th c. (?), Kediri, Cen. Mus., Djakarta

132
Ritual ewer, bronze, H. 34 cm., 11th–12th c., Kediri (?), Cen. Mus., Djakarta

133
Warrior as lamp-holder, bronze, H. 25 cm., 14th–15th c. (?), Tretes Panggung, Malang, Cen. Mus., Djakarta

134
Lamp, bronze, H. 14 cm., 14th to 15th c., Malang, Cen. Mus., Djakarta

135
Figurine: atlante, bronze, H. 10 cm., 14th–15th c., Cen. Mus., Djakarta

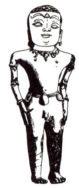

136
Small boy, bronze, H. 21.5 cm., 14th–15th c. (?), Sido Kampir, Jombang, Cen. Mus., Djakarta

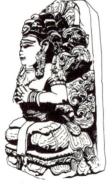

137
Funerary statue, tufa, H. 70 cm., 13th–14th c., Kutri (Bali)

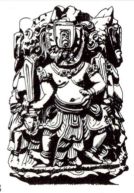

138
Kārtikeya (4 aspects of Śiva): tufa, H. 37 cm., 13th–14th c. (?), Penjeng (Bali)

139 Royal tombs carved out of rock, 11th c., Tampaksiring (Bali),
Gunung Kawi

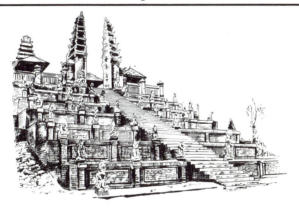

140 Entrance to the great temple *(candi bentar),* early 14th c., Pura
Besakih (Bali)

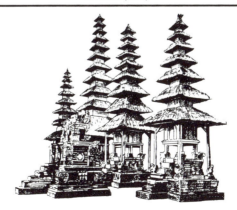

141 'Meru' sanctuaries and throne of deified ancestors, *c.* 17th c., Mengwi
(Bali)

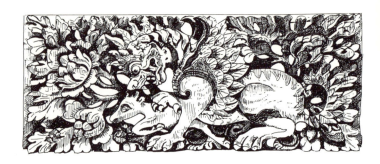

142 Polychrome wood-carving: traditional art, L. 54 cm., north Bali, K.I.v.T. Amsterdam

143
Human figure as candle-holder: traditional art, sandstone, H. 70 cm., Bali, M.v.L.V., Rotterdam

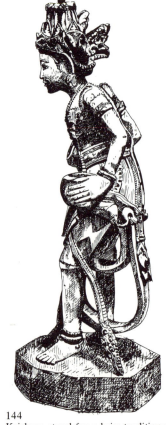

145
Śivaite priest: stand for a kris: traditional art, polychrome wood, H. 77 cm., Bali, M.v.L.V., Rotterdam

144
Krishna: stand for a kris: traditional art, polychrome wood, H. 78 cm., south Bali, M.v.L.V., Rotterdam

146
Statuette of an ancestor, bronze, H. 26.5 cm., 11th–13th c., Bali, Leiden

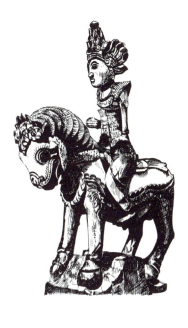

148
Figure of a female ancestor, terracotta, H. 61 cm., Bali, private coll., The Hague

147
Horseman: traditional art, polychrome wood, H. 46 cm., Bali, K.I.v.T. Amsterdam

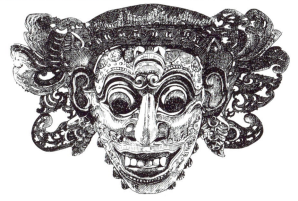

149 Ravana, *wayang* (puppet-theatre) mask: polychrome leather, H. 26 cm., Bali, private coll., Amsterdam

305

CHAMPA

The ancient kingdom of Champa was situated in the central area of the eastern coast of the Indo-Chinese peninsula. Ever since it was Indianized in the 4th or 5th century, Champa was constantly engaged in wars with its neighbours, especially those to the north. Finally, early in the 19th century after nearly nine centuries of unbroken struggle, it was absorbed by Vietnam, a country of Chinese culture. Although the prehistory of Champa is closely linked to that of Vietnam, it must be stressed that, contrary to opinions held by some people, Champa should in no way be considered as having inherited the culture of Dōng-sön (*c.* 5th–2nd century B.C.), which properly belongs to the history of Vietnam (see the following chapter).

In spite of its undeniable and unfailing originality, the art of Champa was deeply influenced by the kingdom's political development, which was marked, from the 13th century onwards, by an ever accelerating decline. After 1822, the date of the final annexation of the little that remained of the ancient kingdom, it was only in small enclaves of the region around Phan-ri and in Champa's mountainous hinterland that vestiges of Cham culture and artistic traditions survived. While Champa's firm resistance to Chinese influence should not be overlooked (unobtrusive borrowings, always completely assimilated, can be detected only rarely: e.g. in the last quarter of the 9th century—during the last phase of Cham art), its receptiveness to influences from other Indianized kingdoms (ancient Cambodia, Indonesia) is no less noteworthy. Appearing in Cham art in successive waves, these influences made little impression on architecture, which displays a clear continuity. Such foreign influences are far more discernible in architectural decoration, but it is in the field of statuary that they are most noticeable, giving rise to truly imaginative and varied shapes that are one of the main features of Cham art.

ARCHITECTURE. Cham architecture is essentially an architecture of brick, in which stone never plays more than a minor role, even in the 11th and 12th centuries when, because of Khmer influence, it was accorded a somewhat greater importance. The bricks are of excellent quality and, after being rubbed smooth, are always bonded by means of a mortar of vegetable origin, thereby rendering the joints almost invisible and producing surfaces that readily lend themselves to sculpture. Apart from the great Buddhist temple of Dōng-düöng (A.D. 875), large complexes on the scale of those found in Java and, above all, Cambodia do not exist in Champa. Cham temples consist merely of a sanctuary tower (the *kalan*) together with a few outbuildings, and at many sites one finds an assemblage of buildings dating from different periods (Po Nagar at Nha-trang, for example). Temples with a row of three sanctuary towers are not uncommon (Khüöng-My).

The Chams did not know how to construct galleries and used only two methods of roofing: courses of corbelled bricks for covering small areas, and tiles on a timber framework for larger buildings. As a rule, the sanctuary towers are characterized by a relative lack of embellishment as well as by their graceful proportions. These square buildings derive their proportions from their pilasters and projections and usually have a large entrance-hall. The high roofs consist—except in some very rare instances (for example, Bang-an, which has an octagonal plan)—of progressively smaller stories forming the basic shape of the building. Apart from the occasional lodge and small temple with a layout similar to that of the *kalan,* the secondary buildings are of two types: the 'library', of oblong shape, most frequently comprising two rooms under a curved roof of corbelled brick, and the 'hall', a larger building with thinner walls pierced by balustraded windows. The 'halls' have roofs of tiles on a timber framework and are sometimes divided by massive pillars into three naves. The decoration of these buildings normally takes the form of carved reliefs on brick, but for the decoration of sanctuaries, tympana, metopes, antefixes and certain other features, carved sandstone was generally used.

SCULPTURE. Cham sculpture, unlike the architecture that is conservative in its designs and methods, is marked by continual changes, reflecting new influences rather than a natural evolution. Although it cannot be denied that there were occasions when Cham art reached heights of pure, classical beauty (Mi-sön E. 1, Trà-kiêu), sculpture seems for the most part to have expressed contradictory tendencies: conventionality and innovation, a lack of decorative detail and an excess of it, both realism and fantasy. There is more and more an aversion to sculpture in the round until, finally, carving in high relief became the only means of expression, and a certain disregard for natural poses resulted in a loss of balanced proportions. It should be stressed that, in view of the constant and profound changes in Cham art, it is the study of costume, hairstyles and, above all, personal ornaments that gives the most reliable stylistic evidence for dating sculptures.

In spite of the fact that sufficient examples of bronzes and terracottas have survived to demonstrate that these two techniques were important at all times, too many have been destroyed for us to be able to trace their development satisfactorily. Some detachable ornaments from idols (headdresses, bracelets, necklaces, etc.) of chased gold or silver dating from the end of the 9th century or the beginning of the 10th have been found. The only other known ornaments (the regalia of the Cham kings) are not earlier than the 17th century. The visual evidence relating to personal ornaments in the intervening period is limited to that provided by sculpture.

A BRIEF HISTORY OF THE ART OF CHAMPA

The development of Cham art between the end of the 6th century and the 17th is classified according to a chronology. Although the task of describing in detail the various styles that have been identified as a result of the study of architectural decoration that was carried out in 1942 (a study extended in 1963 to the field of sculpture) cannot be undertaken here,

these styles can be regrouped within longer periods that correspond more or less directly to the main events in Champa's history.

There was widespread destruction of buildings during Champa's exceptionally turbulent history, which saw the provinces of the north frequently in conflict with those of the south, as we have mentioned. That probably accounts for the fact that none of the few ruined buildings that remain seem earlier than the second half of the 7th century. The earliest existing evidence for the period before this is provided by Chinese sources, but there are also a few local inscriptions (at first in Sanskrit only, but later also in Old Cham) and some sculptures (bronzes from southern India or Ceylon, locally carved reliefs of uncertain date).

EARLY PERIOD (mid-7th–mid-9th century). This period begins shortly after 650. A collection of sculptures that were inspired for the most part by Śivaite models (as is most of Cham art), comes from Mi-sön, one of the most venerated temples in ancient Champa. The group of sculptures enables us to define a style of Mi-sön E. 1 (the site where these sculptures were found), a golden age for Cham sculpture, even if it was influenced by pre-Angkorian Khmer art. A century later, when the leadership passed to the southern provinces, artistic activity seems to have declined. It was at about this time that the Indonesian attacks on the peninsula stimulated the growth of Buddhism in Champa and revitalized its iconography. Some monuments such as Hoa-lai, dating from about the beginning of the 9th century, testify to the birth of traditional Cham architecture and the appearance of a new style.

THE PERIOD OF INDRAPURA (2nd half of the 9th century—end of the 10th). Around the year 850, power once again passed to the northern provinces, and for a century and a half Indrapura was to be the capital of the kingdom. Though typified by two quite opposite tendencies, the period was one of intense artistic activity. As early as 875, the founding of the great Mahāyāna Buddhist complex of Dōng-düöng led to the flowering of a vigorous style that was much more concerned with grandeur than with human beauty, and yet welded together with a surprising degree of originality the most varied borrowings from Indonesia and China. A quarter of a century later, with the decline of Buddhism, sculpture became progressively more human and decoration more delicate (Khüöng-my). When, towards the middle of the 10th century, architecture achieved a classical balance (Mi-sön, group A), sculpture moved into its second golden age with the style of Mi-sön A. 1 and Trà-kiêu (the names of the sites that have yielded the most numerous and spectacular remains). This sculpture shows a strong Indonesian influence, which succeeded the short-lived influence of Angkor. It is imbued with a subtle sensuality and appears to be the very antithesis of the ideals of Dōng-düöng. By the end of the 10th century, when the kingdom was engaged in hostilities with a now independent Vietnam, its art had already lost many of its finest qualities, especially with regard to the rendering of the human figure (Chanh-lô).

THE PERIOD OF VIJAYA (1000–1471). As a result of attacks by Vietnamese forces, Indrapura, which lay too far to the north, was evacuated in favour of Vijaya, a capital further to the south. Vijaya underwent many changes of fortune before it too was abandoned. Even though the kingdom was threatened from all sides, the region around Vijaya (the present-day Binh-dinh) was to witness much artistic activity during the 11th and 12th centuries. The sculptures discovered at Thāp-mām exhibit such decorative inventiveness that we are justified in naming the style that was to

be the final summit of Cham art after this site. Growing tension between Cambodia and Champa led to the introduction of some new borrowings from Khmer art (Hüng-thanh); however, the worsening of political relations culminated in the occupation of Champa by forces from Angkor (1181 to 1220). All Cham artistic activity ceased, and the kingdom was to emerge much the poorer from the experience. Once set in motion, the decline was accelerated by the invincible onslaught of Vietnam and then, at the end of the 13th century, by the Mongol threat. The few buildings erected in the 15th century in the less harassed regions are of heavier proportions and became progressively less and less ornamented (Po Klaung Garai). It is in the field of sculpture that the decline appears to have been most rapid, affecting technique as well as decoration. The stylization and distortion that characterize the decoration are often bewildering (Yang-mum).

LATE PERIOD (after 1471). This began with the capture of Vijaya by the Vietnamese—an event that hastened Champa's downfall. Po Romē, probably built in the 16th century, was the last sanctuary of the traditional type. Those that followed it (the *bumongs* of hybrid construction) were to be influenced by Vietnamese architecture. Religious images became mere steles *(kut)*, thus completing a backward-looking development that had been going on for a considerable time. These *kut* are characterized by the progressive effacement of the human physiognomy, until only attributes of rank (especially head-dresses) remain as a reminder of them. Yet, although these sculptures reveal a continuous decline, they do manage to retain something of the profound originality that is the only truly constant feature of the art of Champa.

MAJOR MUSEUMS

Museum, Dà-nang
Historical Museum of Vietnam, Hanoi
Musée Khai-dinh, Hué
National Museum, Saigon

CONCISE BIBLIOGRAPHY

BOISSELIER, J. *La statuaire du Champa.* Publ. E.F.E.O. Paris, 1963.
CLAEYS, J. Y. *Introduction à l'étude de l'Annam et du Champa,* Hanoi, 1934.
LEUBA, J. *Un royaume disparu: Les Chams et leur art.* Paris, 1923.
PARMENTIER, H. 'Les sculptures chames du Musée de Tourane' in *Ars Asiatica* IV. Paris and Brussels, 1922.
————————— *Inventaire descriptif des monuments chams de l'Annam.* 2 vols. Publ. E.F.E.O. Paris, 1908–18.
STERN. P. *L'art du Champa (ancien Annam) et son évolution.* Toulouse, 1942.

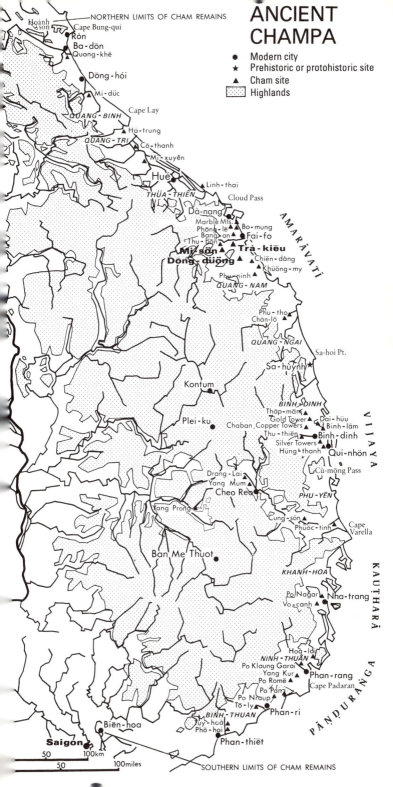

ANCIENT CHAMPA

- ● Modern city
- ★ Prehistoric or protohistoric site
- ▲ Cham site
- ⬡ Highlands

NORTHERN LIMITS OF CHAM REMAINS

Hoành Son
Cape Bung-qui
Rôn
Ba-dôn
Quang-khê
Dông-hói
Mi-dúc

QUANG-BINH

Cape Lay

Hà-trung
QUANG-TRI
Cô-thanh
Mi-xuyên
Huế

THÚA-THIÊN
Linh-thai
Cloud Pass

Dà-nang
Marble Mts.
Phông-lê
Bo-mung
Bang-an
Fai-fo
Thu-bôn
Mi-sơn
Trà-kiêu
Dông-dương
Chiên-dàng
Khüöng-my
Phu-ninh

AMARĀVATĪ

QUANG-NAM

Phú-tho
Chàn-lô

QUANG-NGAI
Sa-hoi Pt.
Sa-huỳnh ★

Kontum

BINH-DINH
Tháp-mâm
Gold Tower
Dai-hūu
Chaban Copper Towers
Binh-lām
Plei-ku
Thu-thiên
Binh-dinh
Silver Towers
Hùng-thanh
Qui-nhön

VIJAYA

Drang-Lai
Yang Mum
Cheo Reo
Yang Prong
Cù-mông Pass

PHU-YÊN

Cung-sön
Phước-tinh
Cape Varella

Ban Me Thuot

KHANH-HOA

Po Nagar
Vo-canh
Nha-trang

KAUTHĀRĀ

Hoà-lai
NINH-THUÂN
Po Klaung Garai
Yang Kur
Phan-rang
Po Romê
Cape Padaran
Po Pam
Po Nraup
Tö-ly
Phan-ri
BINH-THUÂN
Tuy-hoà
Phö-hai

PĀNDURANGA

Biên-hoa
Phan-thiêt

Saigon
50 100km
50 100miles
SOUTHERN LIMITS OF CHAM REMAINS

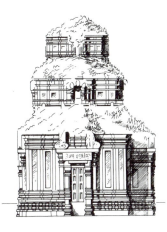

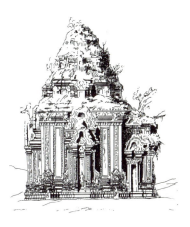

1
Phō-hai: main sanctuary (south front), brick, *c.* 8th c.

2
Hoa-lai: north sanctuary (south front), brick, 9th c.

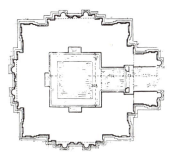

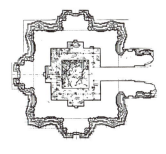

3
Plan: main sanctuary, Phō-hai

4
Plan: north sanctuary, Hoa-lai

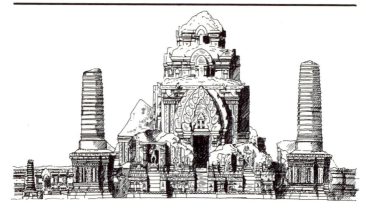

5 Dōng-düöng: precinct 1 of the temple (exterior façade), brick, 875 and later

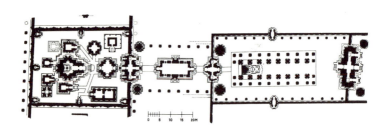

6 Dōng-düöng: the three precincts

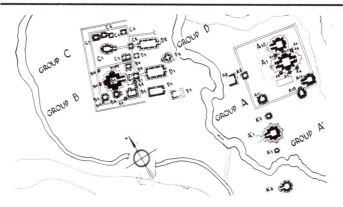

7 Plan of site (groups A, A', B, C, D): Mi-sön

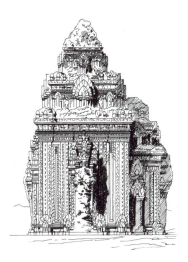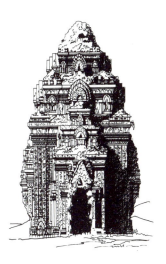

8
Khüöng-my: south sanctuary (south front), brick, early 10th c.

9
Khüöng-my: south sanctuary (east front)

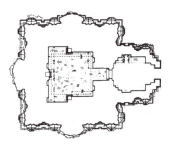

10 Plan: south sanctuary, Khüöng-my

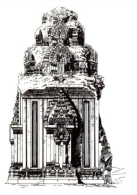

11
Binh-lam: sanctuary (south front), brick, late 10th–early 11th c.

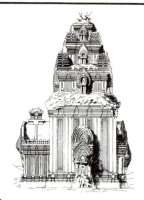

12
Silver Towers: main sanctuary (side view), brick, 11th c.

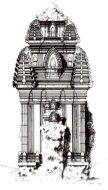

13
Copper Towers: south sanctuary (south front), brick faced with sandstone, 12th c.

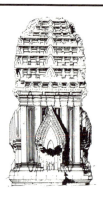

14
Hüng-thanh: north sanctuary (east front), brick, 12th c.

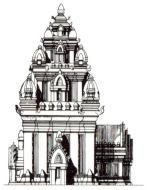

15
Po Klaung Garai: main sanctuary (south front), brick, c. 15th c.

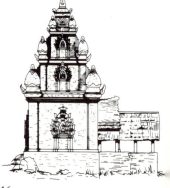

16
Po Romē: sanctuary (south front), brick, c. 16th c.

17 Lintel, re-used, sandstone, *c.* 8th c., Mi-sön A'. 1, *in situ*

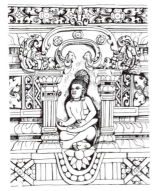

18
Detail: pedestal, sandstone, 7th c.,
Mi-sön E. 1, Mus., Dà-nang

19
Detail: pedestal (corner pilaster),
sandstone, *c.* 8th c., Mi-sön F. 1,
in situ

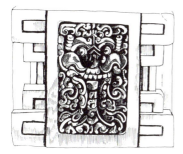

20
Pedestal for a *dikpāla* (guardian),
sandstone, 3rd quarter of the 9th
c., Dōng-düöng, Mus., Dà-nang

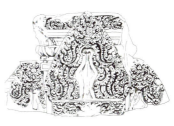

21
Decorative detail: altar, sandstone,
3rd quarter of the 9th c., Dōng-
düöng, Mus., Dà-nang

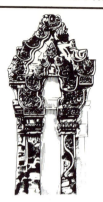

23
Detail: arcatures, carved brick, early
10th c., Khüöng-my, *in situ*

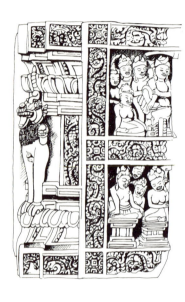

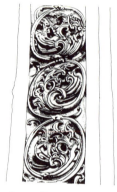

22
Detail: altar, sandstone, 3rd quarter
of the 9th c., Dōng-düöng, Mus.,
Dà-nang

24
Decoration: pilaster, carved brick,
early 10th c., Khüöng-my (south
sanctuary), *in situ*

25
Niche: decoration of the base,
carved brick, 10th c., Mi-sön A. 1,
in situ

26
Pedestal 'with dancing-girls' (frag-
ment): base, sandstone, 10th c.,
Trà-kiêu, Mus., Dà-nang

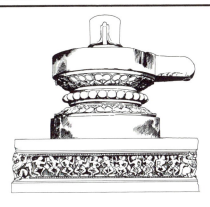

27 Pedestal 'of the Bhāgavata Purāna' and lingam, sandstone, 10th c., Trà-kiêu, Mus., Dà-nang

29
Makara (mythical animal): corner ornament, sandstone, H. 92 cm., 11th c., Chành-lô, Guimet Mus., Paris

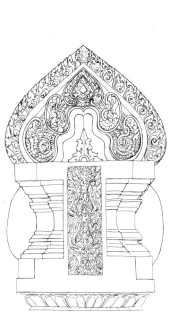

28
Rear view of the back of the statue of Bhāgavatī, sandstone, late 10th c., Po Nagar, Nha-trang, *in situ*

30
Tympanum, sandstone, 11th–12th c., Thāp-mām, Mus., Dà-nang

319

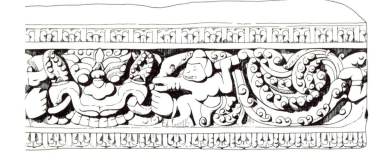

31 Detail: lintel, sandstone, 11th–12th c., Thāp-mām, Mus., Dà-nang

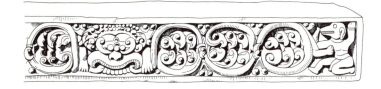

32 Detail: lintel, sandstone, 11th–12th c., Thāp-mām, Mus., Dà-nang

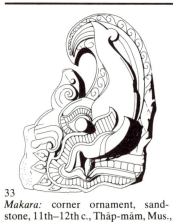

33
Makara: corner ornament, sand-
stone, 11th–12th c., Thāp-mām, Mus.,
Dà-nang

34
Makara: corner ornament, sand-
stone, *c.* 13th c., Mi-sön G. 1,
Mus., Dà-nang

35
Bust, terracotta, *c.* 6th c. (?), Cung-sön, Hist. Mus., Hanoi

36
Bust, sandstone, *c.* 6th c. (?), Phu-ninh or Tam-ky, Hist. Mus., Hanoi

37
Yaksha (mythical being), sandstone relief, *c.* 6th c. (?), Trà-kiêu, Mus., Dà-nang

38
String-wall: pedestal, sandstone, 7th c., Mi-sön E. 1, Mus., Dà-nang

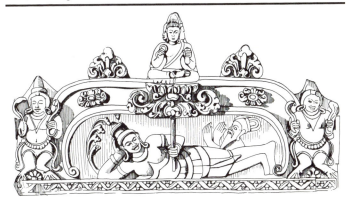

39 Birth of Brahmā: pediment, sandstone, 7th c., Mi-sön E. 1, Mus., Dà-nang

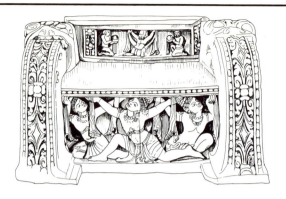

40 Detail: pedestal (risers), sandstone, 7th c., Mi-sön E. 1, Mus., Dà-nang

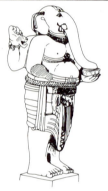

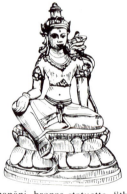

41
Ganeśa, sandstone, 7th c., Mi-sön E. 5, Mus., Dà-nang

42
Padmapāni, bronze statuette, 8th to 9th c., central Vietnam, Hist. Mus., Hanoi (?)

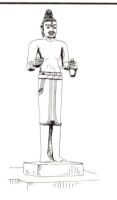

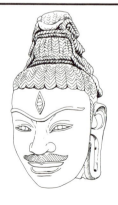

43
Śiva, sandstone, c. 8th c., Mi-sön A'. 4, Mus., Dà-nang

44
Detail: head of Śiva (No. 43)

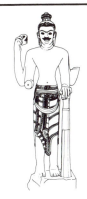

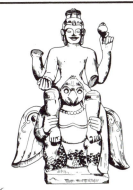

45
Vishnu, sandstone, *c.* 8th c., Da-nghi, Mus., Dà-nang

46
Vishnu on garuda (mythical bird), sandstone, *c.* 8th c., Marble Mountains (?), Guimet Mus., Paris

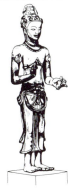

47
Avalokiteśvara, bronze statuette, 8th–9th c., central Vietnam, Nat. Mus., Saigon

48
Avalokiteśvara, bronze statuette, *c.* 9th c., central Vietnam, Hist. Mus., Hanoi

49
Pilaster and *dvārapāla* (guardian), carved brick, 9th c., Hoa-lai: central sanctuary, *in situ*

50
Dvārapāla, sandstone, 3rd quarter of the 9th c., Dōng-düöng, Mus., Dà-nang

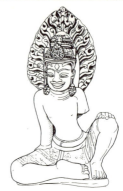

51
Dharmapāla (?), sandstone, 3rd quarter of the 9th c., Dōng-düöng: vihara, Mus., Dà-nang

52
Seated deity, sandstone, 3rd quarter of the 9th c., Dōng-düöng: vihara, Mus., Dà-nang

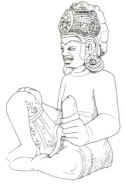

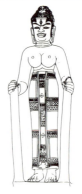

53
Dikpāla, sandstone, 3rd quarter of the 9th c., Dōng-düöng: enclosure 1, Mus., Dà-nang

54
Prajñāpāramitā, sandstone, *c.* late 9th c., Dai-hüu, Mus., Dà-nang

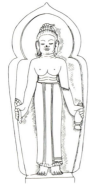

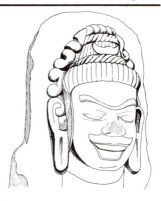

55
Lakshmī (?), sandstone, late 9th to early 10th c., Phu-nhan, Mus., Dà-nang

56
Śiva: head, sandstone, *c.* late 9th c., Qua-giäng, Mus., Dà-nang

324

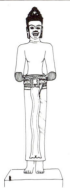

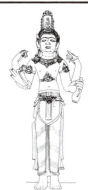

57
Avalokiteśvara, sandstone, late 9th
to early 10th c., Mi-dúc, Mus.,
Dà-nang

58
Avalokiteśvara, bronze, H. 53.5
cm., 9th–10th c., central Vietnam,
Hist. Mus., Saigon

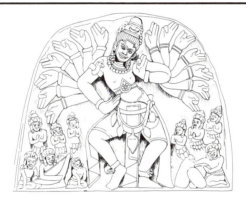

59 Tympanum: Śiva dancing, sandstone, early 10th c., Phōng-lē, Mus.,
Dà-nang

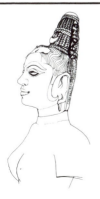

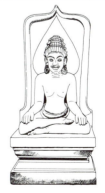

60
Devī: bust, sandstone, early 10th
c., Hüöng-quē, Hist. Mus., Saigon

61
Dikpāla, sandstone, 10th c., Mi-sön
A: small temple, Mus., Dà-nang

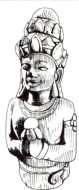

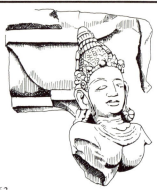

62
Praying figure: antefix from top of a building, sandstone, 10th c., Trà-kiêu, Mus., Dà-nang

63
Pedestal 'with dancing-girls': fragment, sandstone, 10th c., Trà-kiêu, Mus., Dà-nang

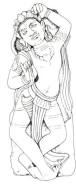

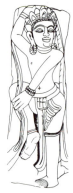

64
Dancer, sandstone relief, 10th c., Trà-kiêu, Mus., Dà-nang

65
Dancer, sandstone relief, 10th c., Trà-kiêu, Hist. Mus., Saigon

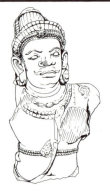

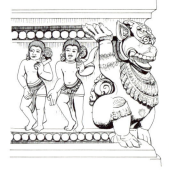

66
Dvārapāla: bust, sandstone, 10th c., Trà-kiêu, Mus., Dà-nang

67
Detail: base of the 'Bhāgavata Purāna' pedestal, Trà-kiêu, cf. No. 27

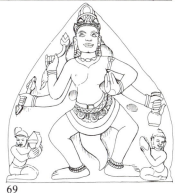

68
Deity: head, sandstone, 11th c.,
Chành-lō, Hist. Mus., Saigon

69
Tympanum, sandstone, 11th c.,
Chành-lō: hall of enclosure II, *in
situ* (?)

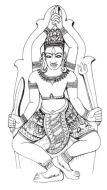

71
Śivaite deity: high relief, sandstone,
11th–12th c., Tháp-mām, Mus.,
Dà-nang

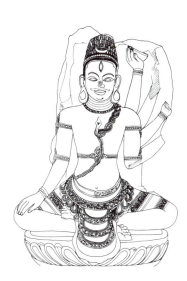

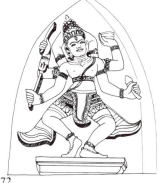

70
Śiva: sanctuary: Silver Towers,
sandstone, H. 165 cm., 11th–12th c.,
Guimet Mus., Paris

72
Tympanum (re-used), sandstone,
11th–12th c., Po Klaung Garai,
in situ

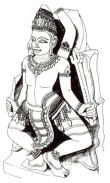

73
Śivaite deity: high relief, sandstone, 11th–12th c., Thāp-mām, Mus., Dà-nang

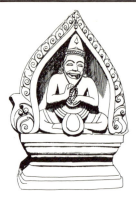

74
Ascetic: antefix, sandstone, 11th to 12th c., Thāp-mām, Mus., Dà-nang

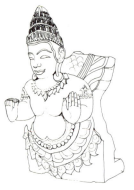

75
Kinnara (mythical being): corner ornament, sandstone, 11th–12th c., Thāp-mām, Mus., Dà-nang

76
Dvārapāla: bust, sandstone, 11th to 12th c., Thāp-mām, Mus., Dà-nang

77
Tympanum, terracotta, *c.* 13th c., Mi-sön G. 1, Mus., Dà-nang

78
Female deity, sandstone, *c.* 13th c., Xuān-my, Mus., Dà-nang

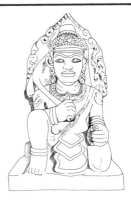

79
Śiva, sandstone, c. 15th c., Yang-mum, Mus., Dà-nang

80
Paraśurāma (?), sandstone, c. 15th c., Xuân-my, Mus., Dà-nang

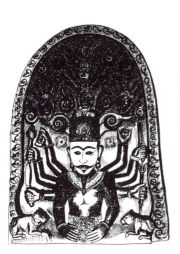

82
Idol called 'Po Biā Sucih', sandstone, 17th c., Po Romē: pagoda, *in situ*

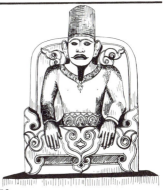

81
Śiva: main image in the sanctuary, sandstone, c. 16th c., Po Romē, *in situ*

83
Statue called 'Po Klaung Gahul', sandstone, 16th–17th c., Tō-ly, *in situ*

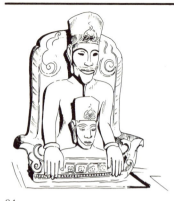

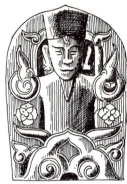

84
Statue called 'Po Nraup', sandstone, 16th–17th c., Bah Plom, *in situ*

85
'Po Panraung Kamar' stele, sandstone, *c.* 17th c., Phan-ri area, *in situ*

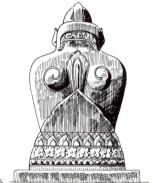

86
Kut (stele) with human shape, sandstone, *c.* 17th c. (?), Thanh-hiêu, *in situ*

87
Kut with human shape, sandstone, *c.* 17th c. (?), Thanh-hiêu, *in situ*

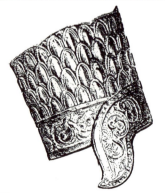

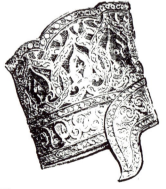

88
Royal tiara, gold, *c.* 17th c. (?), Treasury of Tinh-my

89
Royal tiara, gold, *c.* 17th c. (?), Treasury of Tinh-my

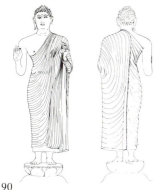

90
Standing Buddha: style of Amarā-
vatī, bronze, H. 108 cm., Dōng-
düöng, Nat. Mus., Saigon

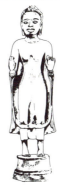

91
Standing Buddha, bronze statuette,
c. 8th c., Dang-binh, Nat. Mus.,
Saigon

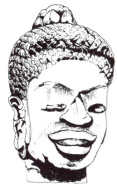

92
Buddha Vairocana (?), sandstone, H.
70 cm., 3rd quarter of the 9th c.,
Dōng-düöng, Guimet Mus., Paris

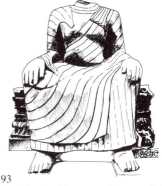

93
Seated Buddha, sandstone, 3rd
quarter of the 9th c., Dōng-düöng,
Mus., Dà-nang

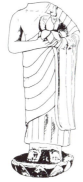

94
Monk with lotus, sandstone, 3rd
quarter of the 9th c., Dōng-düöng,
Mus., Dà-nang

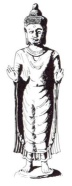

95
Standing Buddha, bronze, H. 44.5
cm., *c.* late 9th c., Dai-hüu, Hist.
Mus., Hanoi (?)

96
Lion: corner of a pedestal, sandstone, 10th c., Trà-kiêu, Mus., Dà-nang

97
Elephant: metope, sandstone, 10th c., Trà-kiêu, Nat. Mus., Saigon

98
Head of Garuda: antefix, sandstone, 10th c., Trà-kiêu, Mus., Dà-nang

99
Garuda and *nāga* (mythical being), tympanum, sandstone, 10th c., Trà-kiêu, Nat, Mus., Saigon

100
Garuda: metope, sandstone, 11th to 12th c., Thăp-măm, Mus., Dà-nang

101
Garuda as an atlante: corner of a pedestal, sandstone, 11th–12th c., Thăp-măm, Mus., Dà-nang

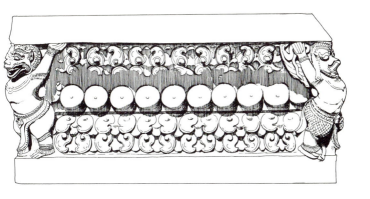

102 Pedestal, sandstone, 11th–12th c., Thāp-mām, Mus., Dà-nang

103
Gajasimha, sandstone, 11th to
12th c., Thāp-mām, Mus., Dà-nang

104
Lion: decoration of a pedestal,
sandstone, 11th–12th c., Thāp-
mām, Mus., Dà-nang

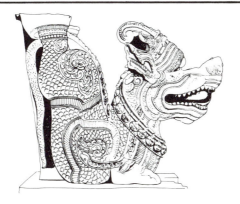

105 Dragon from string-wall, sandstone, 11th–12th c., Thāp-mām, Mus.,
Dà-nang

VIETNAM

It is undoubtedly the case that less is known in the West about the art of Vietnam than about that of any other South-east Asian country. Vietnamese art is also the least studied, except for its earliest phase—the Dōng-sön civilization. For a long time, attention has been paid only to the most recent Vietnamese works of art and that by people somewhat prejudiced against them, while most craftsmen's productions have gained notice less for their deeper qualities than for the virtuosity displayed in their making. The reputation of Vietnamese art has also suffered through its being regarded by many as a mere offshoot of Chinese art. There should be no need to stress that these judgements are unsound and unwarranted. Although Vietnamese iconography is at times confusing and exaggeration of gestures and excessive realism in the use of various colours are common, Vietnamese works of art frequently display qualities such as accuracy of observation and expressiveness that make them unique. Moreover, the architecture is admirably adapted to the terrain. It should be added that many of the recent works of scholarship that have been devoted to Vietnamese art have been published in the Vietnamese language alone and cannot therefore be read by the majority of those interested in the subject.

Initially it is rather difficult to perceive the link between the earliest works of art and those of the historical period, but in actual fact there are interconnections forming a very real continuity. It is the excessive emphasis on the long period of Chinese occupation (43 B.C.–A.D. 905) that has caused this continuity to be obscured and overlooked. In reality the Chinese annexation did not stifle either the artistic creativity of the Vietnamese people or their national pride. What is more, the spread of Vietnamese art into the eastern part of the peninsula was the direct outcome of historical developments and resulted in a gradual supplanting of the Indianized traditions of Champa and southern Cambodia by the Vietnamese tradition, which was of Chinese derivation (c. 980 until the mid-19th century). It follows that the greatest concentration of ancient monuments is in the northern part of the country. Finally it should be emphasized that by far the greatest influence on Vietnamese art since about the 2nd or 3rd century A.D. has been Buddhism—more specifically, Mahāyāna Buddhism. It was probably imported as a complete corpus of doctrine from China (the contemplative sect introduced by Bodhidharma, the 28th Indian and the 1st Chinese patriarch, who is represented in all Vietnamese temples) and from India, and was very different from the type of Buddhism practised in the rest of the peninsula. Mahāyāna Buddhism has imposed a special layout on Vietnamese temples and is characterized by a rich pantheon, which in addition to the transcendent Buddhas, the bodhisattvas and the historic

Buddhas (the successive Buddhas), employs the gods of Buddhist cosmology, Buddhist saints *(arhats)*, Taoist saints, spirits and heroes (both real and legendary).

ARCHITECTURE. The oldest remains—objects decorated with figures (bronze drums)—prove the importance of the tradition of building in brick and in light plasterwork at a very early date. Scaled-down models found in tombs (3rd–5th century) reveal the existence of an advanced architecture, often of a defensive character. Although some large hypogea, constructed of brick, vaulted and with plans of varying degrees of complexity, have survived from the period of Chinese occupation, nothing is known about the earliest temples mentioned in the texts. The oldest stupa-towers known (Binh-sön, model buildings) do not seem earlier than the 11th to 12th century, and the remains of buildings discovered on the ancient site of Hanoi appear to date from the same period. There is also a dearth of evidence for the art of the 14th and 15th centuries (the royal tombs at Lam-sön: vast complexes of temples, pavilions, steles and statues built on the basis of geomantic considerations). The buildings erected during the 17th century and later represent the 'classical' types of Vietnamese architecture: *chua* (pagodas), *dinh* (temples of tutelary dieties) and *dēn* (national or regional temples), whose roofs and carved timbers confer on them an originality free from Chinese influence. Unfortunately, it remains difficult to trace the development of these buildings, since they have frequently been rebuilt or altered. Military architecture is better known (17th–18th century; wall of Dōng-hoi, citadels). It should be observed that the connections between architecture and the sites (decisive as early as the period of building at Lam-sön) have never ceased to preoccupy Vietnamese architects, who are real lovers of landscape, motivated as much by philosophical as by aesthetic intentions.

SCULPTURE. A complete account of the development of Vietnamese sculpture cannot be given because of the gaps in our present knowledge. Although the images of the Buddha have a predominant and fairly constant Chinese influence, the originality displayed in the modelling of other figures of the pantheon (*arhats*, guardian spirits and various tutelary deities) is much greater. This is especially true of the figures produced after the end of the 16th century; most of these are of wood, lacquered and painted in several colours, and some are outstandingly beautiful. Some of the plant motifs and the real or mythical figures on the stone sculptures that decorate temples and large tombs reflect Chinese or Cham influence (the latter, c. 11th century) in varying degrees according to their period, while others exhibit diverse features of greater originality. Architectural tiles, used either for roofs or for wall facings, were important in all periods. There is evidence that bronze-castings of high quality were produced as early as prehistoric times, but only those objects that were created during the proto-historic and the most recent periods are well known, above all those intended for ritual use (dynastic urns, bells, bowls) and for warfare (cannons).

CERAMICS have formed a major part of Vietnam's output of works of art from the very earliest times. Most of the objects are either of earthenware (modelled or moulded, glazed or unglazed) or of porcelain, or are celadon wares. Some were intended to be used in the home (everyday or special wares) or in places of worship, while others were incorporated into buildings. These different uses account for the wide variety of wares produced. Except for the 'blues of Hué', produced during the 19th century,

the ceramic wares are almost totally free from Chinese influence and display considerable originality in composition, shape and decoration. Around the 15th century, part of the output of Vietnamese ceramics supplied a flourishing export trade.

A BRIEF HISTORY OF VIETNAMESE ART

Although it is not possible to give a detailed description here of those successive dynasties to which accounts of a country's art usually refer (recent research even tempts us to assign to the Bronze Age those dynasties formerly considered to be legendary), it is helpful to distinguish at least three major periods in Vietnam's historical development.

PROTOHISTORY. The Bronze Age was well represented in the north as early as the beginning of the 2nd millennium B.C., this being due, it would seem, to the bronze-working of the kingdom of Van-lang (the 'Country of Tattooed Men') mentioned in the Annals. It was not, however, until about the 5th century B.C. that the 'Dōng-sön civilization' came into being. It is named after the site where the earliest objects from this civilization were found (late Bronze Age and early Iron Age) and is distinguished by its technique of bronze-working, the quality and originality of its works of art and its prolific output of ceramics. This culture, during which iron and lacquer came into use, developed in ancient Vietnam itself, where its remains today are extremely widely distributed. The claim that it is a proto-Cham culture is totally without foundation. There is evidence to suggest that before the sinicization of the area, the influence of the Dōng-sön civilization had extended over much of South-east Asia. From 111 B.C. onwards, the area was a province of the Chinese empire under the rulers of the Han dynasty, but it was not until 43 B.C., after the quelling of the revolt led by the Trüng sisters, that the process of sinicization began.

THE SINO-VIETNAMESE PERIOD (43 B.C.–A.D. 905). This period was marked from its very beginning by a massive influx of Han culture and art, imported by Chinese immigrants who were encouraged by the Chinese authorities. Vietnamese art created during the period is a blend of local traditions and borrowings from China (Confucianism, Taoism and Buddhism with contributions also coming across the sea from India). Nothing remains of the temples built in the Sino-Vietnamese period; however, the brick Han and T'ang tombs (there are none from the Sung dynasty, contrary to what is often asserted) have yielded a large number of possessions (terracotta, bronze, iron or wood) buried alongside their deceased owners. Surprisingly, figures representing servants are totally lacking. Mention should also be made of the importance of ceramics, much of it glazed during this period.

NATIONAL ART (905–the present). Even in an account giving only the bare essentials, mention should be made of a feature of the first phase of the art of Dai Viēt (11th–early 13th century)—the country called Dai Cö Viēt in 968 took the name of Dai Viēt in 1069 and was replaced by Vietnam in 1804—that is, the abandonment of brick hypogea in favour of simple pits and the building of fortified castles and monasteries. (Buddhism had by then become the state religion.) The stupa-tower at Binh-sön and remains (architectural ceramics for the most part) found on the ancient

site of Hanoi have survived from this time. The sculptures assembled in the Phat-tich Monastery reflect Cham influence in varying degrees; they should be considered in relation to the first steps that were taken towards the conquest of Champa. Much pottery of great beauty (with painted or incised underglaze decoration) has come down to us. The sculpture carved during the period lasting from the early 13th century up to the beginning of the 15th (the Trān dynasty) had a more rough-hewn appearance than that of the preceding period, but at the same time the decoration of pottery became more varied.

The beginning of the 15th century (dynasty of the later Lys) witnessed a veritable renaissance with the art of the royal tombs at Lam-sön, a different style of decoration and, in ceramics, the production of blue-and-white wares 'with a chocolate-coloured body' that were exported to countries as distant as Japan, where they were highly esteemed.

The Art of the Trinhs (1533–1789) is characterized, especially after the end of the 16th century, by an increased interest in buildings erected in honour of ancestors or national heroes. This interest engendered considerable activity in the sphere of architecture—the construction of new buildings and the restoration of historic ones. Generally speaking, a more truly national inspiration was the predominant influence, although some of the more restrained buildings still remained faithful to the sinicizing tradition (Ninh-phuc Monastery). In the fields of decorative design and sculpture, the 'national' tendency led to the abandonment of themes derived from Chinese art in favour of a more original sense of beauty, informing a style in which more complicated shapes often bear symbolic devices. The statuary (especially wood lacquered or painted in several colours) is of a very high quality and includes masterpieces whose unrivalled realism and spirituality is still all too frequently unrecognized. The production of ceramics continued to be copious, and the wares are notable both for the quality of their craftsmanship and for the variety of their decoration. The main centres of production were Bat-tràng, where the industry was probably founded in the 15th century, and Thō-hà, which produced somewhat cruder wares.

The Art of the Nguyēns (17th–early 20th century), running for a century or so parallel to that of the Trinhs, from which it is derived, is the transplantation and adaptation of that art to the more southerly regions. Unfortunately, its earliest works of art, badly damaged by the wars at the end of the 18th century, have either been lost or altered beyond recognition by heavy restoration. Up to the Second World War, however, two buildings of the early 19th century—the Imperial Palace at Hué and the citadel (with a plan of French inspiration but constructed in accordance with Vietnamese tradition)—stood as remarkable examples of the art of this period. The designs of these buildings, admirably suited to their sites, were the work of architects imbued with the notion that topography and architectural style are indissolubly linked. The art of bronze-casting was widely practised, and the continued use of an excellent technique, inherited from secular traditions (dynastic urns from the Imperial Palace, bell from the Thiēn Mu Monastery, Hué), ensured a consistently high standard of craftsmanship. Besides the celebrated 'blues of Hué' (1810 and after), produced at first by craftsmen from China in fulfilment of orders received from the Imperial Palace, the ceramics include a large output of lacquered and glazed wares intended for structural and decorative purposes (the ceramics from Long-tho, near Hué).

MAJOR MUSEUMS

Historic Museum of Vietnam, Hanoi
Khai-dinh Museum, Hué
National Museum, Saigon
Temple-Museum of Lé-Loy, Thanh-hoa

CONCISE BIBLIOGRAPHY

BERNANOSE, M. *Les arts décoratifs au Tonkin.* Paris, 1922.

BEZACIER, L. *Le Viêt-Nam.* Manuel d'Archéologie de l'Asie du Sud-Est, II, no. 1. Paris, 1972.

———————— *L'art viêtnamien.* Paris, 1955.

CADIERE, L. 'L'art à Hué' in *Bullétin des Amis du Vieux Hué I.* Hué, 1919.

CLAEYS, J.Y. *Introduction à l'étude de l'Annam et du Champa.* Hanoi, 1934.

GOURDON, H. *L'art de l'Annam.* Toulouse, 1932.

NGUYÊN PHUC LONG. 'Les nouvelles recherches archéologiques au Viêt-Nam' in *Arts Asiatiques,* special issue XXXI. Paris, 1975.

PATKO, I. and REV, M. *L'art du Viêt-Nam.* Paris, 1967.

TRAN-VAN-TÔT. 'Introduction à l'art ancien du Viêt-Nam' in *Bullétin de la Société des Etudes indochinoises,* no. 1. XLIV. Saigon, 1969.

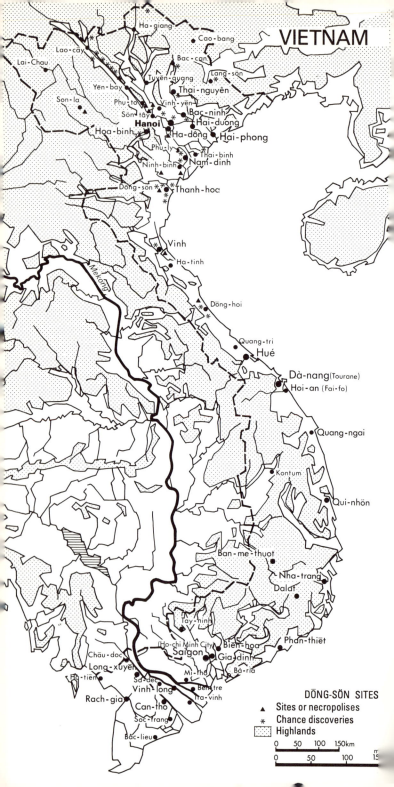

DŌNG-SŌN SITES

▲ Sites or necropolises
* Chance discoveries
▦ Highlands

1 Foot-shaped axe, 5th–3rd c. B.C., Dōng-sön, Hist. Mus., Hanoi

2
Halberd, bronze, 5th–3rd c. B.C., Nui Voi, Hist. Mus., Hanoi

3
Drum (type 1), bronze, 5th–3rd c. B.C., Sōng Dà, Hist. Mus., Hanoi

4 Drum (type 1): top, bronze, D. 87 cm., 5th–3rd c. B.C., Ngoc-lu, Hist. Mus., Hanoi

5
Cover called 'gong', bronze, 5th to
3rd c. B.C., Ngoc-lu, Hist. Mus.,
Hanoi

6
Covered urn, bronze, 5th–3rd c.
B.C., Dao-thinh, Hist. Mus., Hanoi

7
Dagger, bronze, 5th–3rd c. B.C.,
Thäi-nguyên, Hist. Mus., Hanoi

8
Dagger, bronze, 5th–3rd c. B.C.,
Sön-täy, private coll.

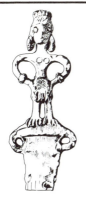

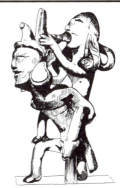

9
Dagger handle, bronze, 5th–3rd c. B.C., Dōng-sön, Hist. Mus., Hanoi

10
Group with musician, bronze, H. 9 cm., *c.* 4th–3rd c. B.C., Dōng-sön, Hist. Mus., Hanoi

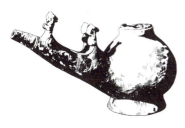

11
Oil lamp with bird-shaped spout, bronze, *c.* 3rd–1st c. B.C., Dōng-sön, Hist. Mus., Hanoi

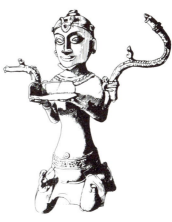

13
Lamp-holder (?), bronze, H. 17 cm., *c.* 3rd c. B.C., Dōng-tac, Guimet Mus., Paris

12
Lamp-holder, bronze, H. 33 cm., *c.* 3rd c. B.C., Lach-rüöng, Hist. Mus., Hanoi

14
Model of a well, terracotta, 1st–5th c., Nghi-vē, Hist. Mus., Hanoi

15
Model of a house, terracotta, c. 3rd c. (?), Nghi-vē, Hist. Mus., Hanoi

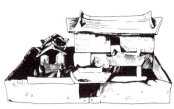

16
Model of a house, terracotta, c. 3rd–5th c., Van-phuc. Hist. Mus., Hanoi

17
Model of a house, terracotta, c. 3rd–5th c., Hoà-chung, Hist. Mus., Hanoi

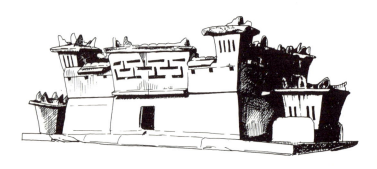

18 Model of a fortified castle, terracotta, c. 3rd–5th c., Nghi-vē, Hist. Mus., Hanoi

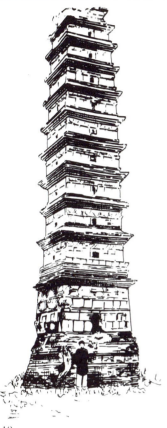

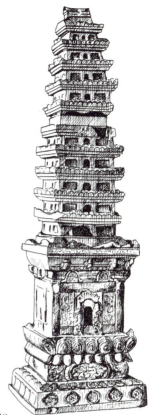

19
Stupa-tower, brick faced with stone, 11th–12th c., Binh-sön

20
Votive stupa, earthenware from Bat-tràng, H. 1.05 m., 16th–17th c., private coll.

21
Votive stupa, terracotta, H. c. 10 cm., c. 13th c., Hon-gay

22
Stupa of the Ninh-phuc Monastery, 17th c., But-thap

24
Small model of a building, terracotta, 16th–17th c. (?), Hüu-tiẽp, Hist. Mus., Hanoi

23
Bao-nghiẽm stupa-tower, stone, H. *c.* 13 m., 1647, But-thap

25
Portico of the *dinh* (temple of tutelary diety), 17th c., Cô-loa

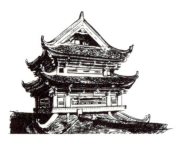

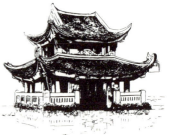

26
Belfry of the Chùa Keo, 17th–18th c., Thai-binh region

27
Dẽn (national or regional temple) of Phu-dõng, 17th–18th c., Bacninh region

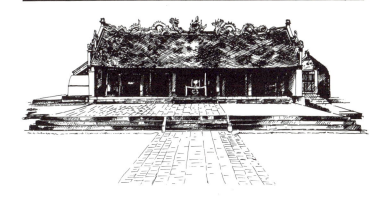

28 *Dinh* of Yēn-sö: main building, 18th c., Ha-dōng region

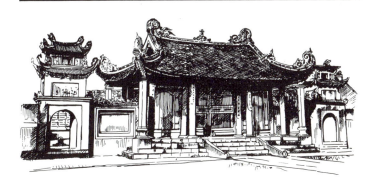

29 *Dinh* of Yēn-sö: main entrance

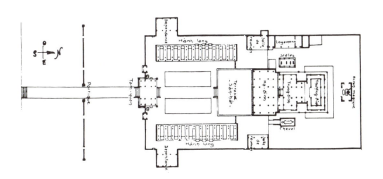

30 *Dinh* of Yēn-sö: plan

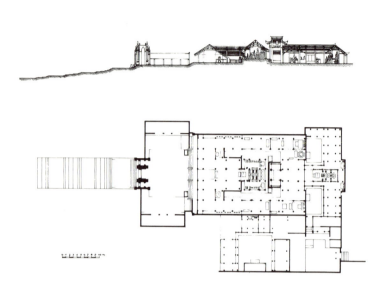

31 Buddhist temple Cam-üng: elevation and plan, Tam-sön

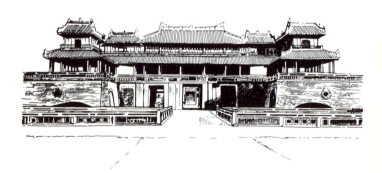

32 Imperial Palace at Hué: South Entrance (Ngo Môn), early 19th c.

33
Tile, impressed terracotta, 34.5 cm., Hoa-lü (?), late 10th–13th c. (?), Hist. Mus., Hanoi

34
Tile, impressed terracotta, 34.5 cm., Hoa-lü, late 10th–13th c. (?), Hist. Mus., Hanoi

35
Tile, impressed terracotta, 33 cm., Mi-düc, Hist. Mus., Hanoi

36
Base of stupa: decoration, late 13th c., Phō-minh, *in situ*

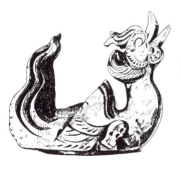

37
Decorative tile for roof ridge, terracotta, 11th–12th c. (?) Hist. Mus., Hanoi

38
Dragon: architectural decoration, terracotta, Kim-ma, Hist. Mus., Hanoi

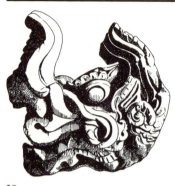

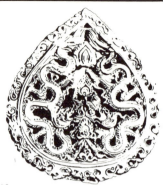

39
Dragon-*makara*: decorative tile for roof ridge (?), terracotta, 11th–12th c., Giang-vu, Hist. Mus., Hanoi

40
Pierced antefix, terracotta, H. 22 cm., 11th–12th c., Hist. Mus., Hanoi

41
String-wall, stone, L. 2.50 m., 17th c., Thai-phuong Temple, *in situ*

43
Decorative tile for roof ridge, faience, H. 20 cm., *c.* 15th–16th c., Hist. Mus., Hanoi

42
Capital of a pilaster, late 18th c., Van-miêu at Hanoi, *in situ*

44 Low relief: balustrade, L. 1.20 m., 1646–7, Ninh-phuc Monastery,
But-thap, *in situ*

45
Low relief: balustrade, H. 30 cm.,
1646–7, Ninh-phuc Monastery, *in situ*

46
Low relief: balustrade, H. 30 cm.,
1646–7, Ninh-phuc Monastery, *in situ*

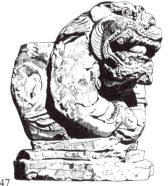

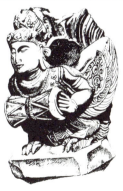

47
Lion: tile for roof ridge, terracotta,
H. 16 cm., late 10th–12th c., Hoc-
dōng, Hist. Mus., Hanoi

48
Thān-diêu or *kinnara:* acroter, sand-
stone, late 10th–11th c., Phat-tich,
Hist. Mus., Hanoi

351

49
Thiēn-vüöng or *Lokapāla,* sandstone, H. 1.10 m., late 10th–11th c., Phattich, Hist. Mus., Hanoi

50
Hō-phap or Dharmapāla, lacquered wood, H. 2.20 m., 17th c., Thaiphuong Temple, *in situ*

51
Dvārapāla (guardian): high relief, H. *c.* 80 cm., 16th c., Hist. Mus., Hanoi

52
Martial guardian, stone, H. 1.80 m., 16th–17th c., Tomb of Gal. Do, *in situ*

53
Warrior, stone painted in several colours, H. *c.* 60 cm., 18th c., cave temple: Chua-tay, *in situ*

54
An official, stone, H. *c.* 70 cm., 18th–19th c., cave temple: Chuatay, *in situ*

56
Arhat (Buddhist saint), lacquered wood, H. *c.* 40 cm., 18th c. (?), Thong Temple, Thanh-hoa, *in situ*

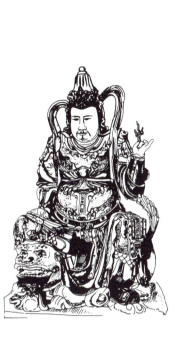

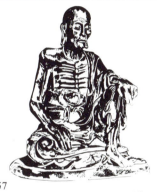

55
Hō-phap, lacquered wood, 17th to 18th c., Ninh-phuc Temple, But-thap, *in situ*

57
Arhat, lacquered wood, H. 1.40 m., *c.* 17th c., Thai-phuong Temple, *in situ*

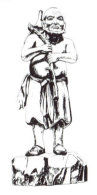

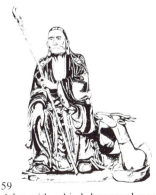

58
Pilgrim, lacquered wood, H. 45 cm., 18th–19th c., Nam-dinh (?)

59
Arhat with a hind, lacquered wood, H. *c.* 1.70 m., 17th c., Thai-phuong Temple, *in situ*

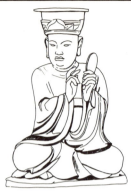

60
King of the Underworld, lacquered and gilt wood, H. 50 cm., 17th–18th c., Ninh-phuc Temple, *in situ*

61
Praying woman, lacquered and gilt wood, H. 35 cm., 17th–18th c. (?), Ninh-phuc Temple, *in situ*

62
Buddhist dignitary, lacquered and gilt wood, t.H. 70 cm., 17th–18th c., Ninh-phuc Temple, *in situ*

63
Van-thù or Mañjuśrī, lacquered and gilt wood, H. 1.15 m., *c.* 17th c., Van-phuc Temple, Phat-tich, *in situ*

64
Pho-hiēn or Samantabhadra, lacquered and gilt wood, H. 1.15 m., *c.* 17th c., Van-phuc Temple, *in situ*

65
Van-thù, lacquered wood, *c.* 17th to 18th c., Van-lai (My-hao) Temple, Hist. Mus., Hanoi

66
Quan-ām or Avalokiteśvara, lac-
quered wood, H. 80 cm., 17th–18th
c., Van-phuc Temple, *in situ*

67
Di-lac or Maitreya, wood, 17th to
18th c., Van-phuc Temple, *in situ*

68
Di-lac, stone, H. *c.* 50 cm., 17th to
18th c., cave temple: Chua-tram,
in situ

69
Deified princess, lacquered wood,
H. *c.* 1 m., 17th c., Temple-Museum
Lé-Loy, Thanh-hoa

70
Deified princess, lacquered wood,
H. *c.* 1 m., 17th c., Temple-Museum
Lé-Loy, Thanh-hoa

71
Quan-ām, polychrome wood, H.
35 cm., Hist. Mus., Hanoi

72
The Buddha being born, lacquered
wood, 17th–18th c. (?), Van-phuc
Temple, *in situ*

73
Emaciated Buddha, lacquered wood,
H. 1.40 m., 17th c., Ninh-phuc
Temple, *in situ*

74
Adorned Buddha on a Lotus Throne,
lacquered wood, *c.* 18th c., Hist.
Mus., Hanoi

75
Adorned Buddha standing, lacquered
wood, H. 2.18 m., *c.* 17th c., Thān-
tiēn Temple, Hoi-hōp, *in situ*

76 Reclining Buddha, lacquered wood, L. *c.* 1.60 m., *c.* 17th c., Hanoi,
Hist. Mus., Hanoi

77
Head-rest, wood, H. 18 cm., late 18th–early 19th c., Hist. Mus., Hanoi

78
Incense-burner, lacquered wood, H. 35 cm., *c.* 19th c., Cong-Cüöng Temple, Vinh region, *in situ*

80
Lion, wood, H. 40 cm., 17th c., Temple-Museum Lé-Loy, Thanh-hoa

79
Candelabrum, bronze, H. 40 cm., late 18th c., Hist. Mus., Hanoi

81
Throne, bronze, H. 1 m., 18th c., Hist. Mus., Hanoi

82
Zoomorphic cooking-pot, bronze,
H. 14 cm., 15th–16th c., Hist. Mus.,
Hanoi

83
Ewer, damascened copper, H. 23
cm., 18th c., Hist. Mus., Hanoi

84
Zoomorphic ewer, bronze, H. 22
cm., 17th–18th c., Hué, Hist. Mus.,
Hanoi

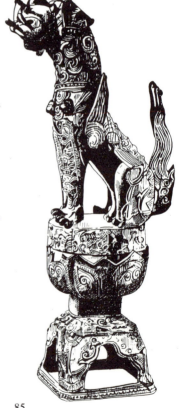

86
Tea-caddy, bronze, H. 11 cm., 18th
to 19th c., Hist. Mus., Hanoi

85
Lion-shaped altar-guardian, bronze,
H. 38 cm., 18th c., Hist. Mus.,
Hanoi

87
Water-vessel, glazed earthenware, c. 3rd c. A.D., Thanh-hoa, Hist. Mus., Hanoi

88
Tripod vessel with cock's head, glazed earthenware, c. 3rd c., Lach-trüöng, Hist. Mus., Hanoi

89
Lamp, earthenware, H. c. 30 cm., 3rd–2nd c. B.C. (?), Hist. Mus., Hanoi

90
Jar: relief decoration, stoneware, c. 10th c., Bac-ninh, Hist. Mus., Hanoi

91
Covered pot, brown glaze on cream ground, 11th–early 13th c., Hist. Mus., Hanoi

92
Urn, brown glaze on cream ground, H. 25 cm., 11th–early 13th c., Thanh-hoa, Hist. Mus., Hanoi

93
Urn (incomplete), brown glaze, cream
ground, H. 75 cm., 13th–14th c.,
Yēn-Lăng, Hist. Mus., Hanoi

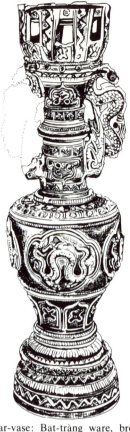

95
Jar, brown glaze on cream ground,
H. 20 cm., 13th–14th c., Hist. Mus.,
Hanoi

94
Altar-vase: Bat-tràng ware, brown
glaze, H. *c.* 60 cm., 16th–17th c.,
Hist. Mus., Hanoi

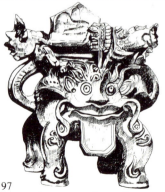

96
Incense-burner, coloured enamels on
white ground, H. 36 cm., 16th–17th
c. (?), Hist. Mus., Hanoi

97
Incense-burner, red earthenware,
H. 24 cm., 16th–17th c. (?), Thō-
hà, Nat. Mus., Saigon

98
Incense-burner: Bat-tràng ware, bluish-white glaze, H. 35 cm., 16th to 17th c.

100
Candelabrum: Bat-tràng ware, blue-and-white glazes. H. 41 cm., 16th to 17th c.

99
Altar-vase: Bat-tràng ware, coloured enamels, cream ground, H. 88.5 cm., 16th–17th c., Khai-dinh Mus., Hué

101
Vase, blue-and-white glazes on chocolate-brown body, H. 33 cm., 14th–15th c., Hist. Mus., Hanoi

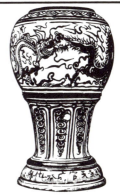

102
Altar-vase, blue-and-white glazes on chocolate-brown body, H. c. 40 cm., 15th–16th c., Hist. Mus., Hanoi

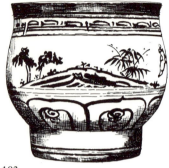

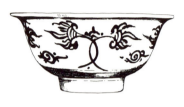

103
Bowl, blue-and-white glazes on chocolate-brown body, H. 18.5 cm., 14th–16th c., Hist. Mus., Hanoi

104
Bowl, blue-and-white glazes on chocolate-brown body, H. 6 cm., 14th–16th c., Hist. Mus., Hanoi

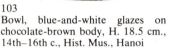

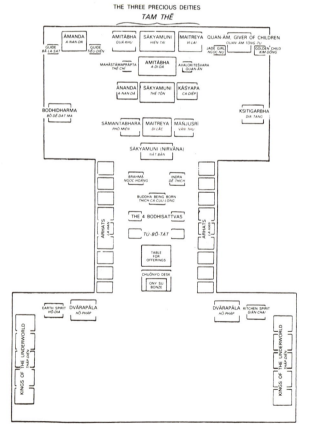

105 The Vietnamese Buddhist pantheon: a diagrammatic presentation after L. Bezacier, *L'art vietnâmien*

The Buddha's Gestures

by Professor Jean Boisselier

THE BUDDHA'S GESTURES

Buddhism seems to have inherited an acute sense of the sanctity of images of the Blessed One from the long period during which his followers refused to produce any images portraying their master in human form. This refusal is responsible for Buddhism's rich, and frequently very clever, aniconic imagery. In all Buddhist sects, the sacred character with which the painted or carved figures of the Buddha were invested, inspired respect for a whole body of precise rules governing not only the methods of making these images, but also the manner in which the Buddha should be portrayed.

Generally speaking, the image of the Buddha (or Buddhas)—the historical Buddha, the Buddhas of the Past and even the transcendent Buddhas peculiar to Mahāyāna Buddhism—is made up of elements consisting of original physical characteristics, a particular monastic attire, displaying considerable stylization, and postures and gestures that are all codified in varying degrees. The physical characteristics of a Buddha, which are apparent from his birth though not all of them are expressible in physical terms, are to be found in some of the marks *(lakshana)* of the Great Man, the pre-eminent man standing above all others, the predestinate man distinguished from common mortals and ordained to become, by virtue of the righteousness accumulated during countless previous existences (a righteousness of which the *lakshana* provide additional proof) either a universal monarch or a Buddha. Although the rendering of these marks varies according to period and artistic school, some of them have acquired a truly descriptive value (for example, the cranial protuberance or *ushnīsha* and the hairstyle with evenly spaced identical curls). Virtually the same physical characteristics are used for the Jaïn images of the Tīrthankaras and of Mahāvira for images of the Buddhas.

The same monastic attire is worn by the Buddha and by the members of the religious communities. It was chosen by the Blessed One himself and usually comprises three articles of clothing *(tricīvara)*, although the method of draping and wearing them varies considerably according to the climatic conditions and customs of dress in the various countries involved, to the traditions of the different sects, and finally to stylistic conventions that are as much a matter of artistic interpretation as of historical evolution. It is worth noting here that the supernatural characteristics of Buddhahood have gradually given birth to a certain number of conventions that evoke these characteristics: diaphanous robes that suggest the light radiating from the body of a Buddha 'through all his pores' on each occasion of significance, and clothing of a weightlessness which (artists seem gradually to have realized) enabled a Buddha's garments to remain correctly draped without imposing on him the constraints suffered by mere monks, since these would be inappropriate to the Buddha's exalted position.

365

The Buddha's Gestures

Postures and gestures are normally inseparable, since only a certain number of gestures can be made in a specific posture. No account will be given of the conventional gestures of the transcendent Buddhas that occur within the context of Tantrism and play such an important role in Tibeto-Himalayan iconography—copulation *(prajñālingana)* with the *Prajñā* (Knowledge, Wisdom; a transcendent Buddha's female counterpart), or handling the *vajra* (thunderbolt) and the *ghantā* (ritual bell). This survey will only deal with the four sacred postures in which a Buddha can be portrayed. These are the postures in which he appeared on the occasion of the Great Miracle in the pavilion at Śrāvastī: he made symmetrical images of himself—the Double Apparition—appear in the postures. The Miracle was intended to silence the sceptics of heterodox sects. The four sacred postures are the only poses considered decorous for monks: standing, walking, sitting and lying down.

The walking posture has not often been employed in Buddhist sculpture, except in an idealized manner in Thai sculpture by the school of Sukhothai and, in a more stylized manner, in Burmese sculpture by the school of Pagan.

The lying-down posture has been chiefly reserved for representations of the 'Final Blowing-out' *(Mahāparinirvāna)*.

The standing and sitting postures play a far more important role. There are various sitting positions: e.g. the Indian posture with legs crossed in several different ways, and the 'European' posture with both legs hanging down. The only attitude in which a sitting Buddha cannot be represented, although it is frequently employed for figures of Brahminic deities and Bodhisattvas, is one of relaxation—one leg bent while the other hangs down. These postures, which are associated with a group of appropriate gestures that are more or less invariable, make it possible for artists to represent, or at any rate to evoke, the majority of the most important events in the life of the Buddha, from his renunciation of the worldly life (the Great Going-forth and casting-off of his princely garb) and his search for Enlightenment to the 'Final Blowing-out', *Mahāparinirvāna.* In theory, a range of well-defined gestures should enable one to recognize which of the most noteworthy events in the Buddha's life is depicted in a painted or carved narrative scene, or even in a single image. Unfortunately, however, a miracle can always be more easily and more certainly identified if the artistic representation is in a figurative context—that is to say, in a narrative scene rather than a single statue. (The exceptional iconographic interest of Gandhāran imagery is due in large measure to the fact that it is so often set in a narrative context.) Moreover in the Buddhist context the gestures do not have the rigidly fixed character all too frequently attributed to them in books whose authors either extrapolate the very general facts given in various Indian treatises or adduce in support of their opinion the prescribed rituals of esoteric or tantric Buddhism. Indian artists, especially those working during and after the classical period, had at their disposal a complete and properly systematized range of gestures and postures that made it possible for them (especially in the theatre) to represent all kinds of action and even to portray feelings. However, this conventional vocabulary, reserved for those initiated into its symbolism, never gained universal acceptance among Buddhists.

Quite apart from their very clear and constant development of the art of mime, most of the schools accorded special importance to one particular gesture that was always employed in conjunction with the same posture, thus assuming exceptional prominence in that school whilst the other gestures were considered less important. Although the choice of the pre-eminent

gesture varied according to the period and the artistic school concerned, in Pāla art and, to an even greater extent, in the art of all the schools influenced either directly or indirectly by it, the gesture of 'touching the Earth' (see below), associated with the Victory over Māra, became the gesture that was truly characteristic of the Buddha, while in Sinhalese art the greatest importance was accorded to the *samādhi* position that depicts the Buddha sitting cross-legged with his hands in his lap and calls to mind his attainment of Full Enlightenment.

Despite these reservations to which others could be added, certain gestures have come to be defined and reserved for the representation of particular miracles performed by the Buddha, or for remarkable aspects of his behaviour. This list of generally accepted gestures is useful, since it enables most images, from whatever school they may have come, to be described as succinctly as possible. Nonetheless, it is essential to remember that these convenient definitions are fully applicable only to the classical period of Indian sculpture. In fact, up to the dawn of the Gupta period, they are not sufficiently in accordance with the known facts concerning ancient iconography and do not, to any appreciable extent, reflect artistic developments emanating from the schools of the Far East and South-east Asia. In the context of Mahāyāna Buddhism, on the other hand, the vocabulary of gestures assumes a special significance, since it makes possible (in theory) the identification of the most important transcendent Buddhas. Although these Buddhas are all basically alike, they can be distinguished from one another by particular gestures that may sometimes be related to their names. In tantric Mahāyāna Buddhism, the gesture helps the worshipper to conjure up in his mind an image of a certain deity of the pantheon whom he wishes to summon, using set words and descriptions given to him by the *sādhanas* (spiritual guides whose precise rubrics were intended to enable deities of any rank to be effectively called forth).

Although the list of gestures (*mudrā* in Sanskrit) and the significance attached to each of them remains unchanged in spite of sectarian differences, it should be pointed out that Theravāda Buddhism—otherwise known, not without a hint of disparagement, as the Lesser Vehicle, as opposed to Mahāyāna Buddhism or the Greater Vehicle—has constantly refused to accept not only the meanings associated with the specific gestures, but also the term *mudrā* itself (*muddā* in Pāli). One should also note that the role played by the *mudrā* and the purpose the gestures serve differ greatly depending on whether a gesture is used to evoke a more or less precise event in the life of the historical Buddha or to distinguish one of the transcendent Buddhas in Mahāyāna Buddhism.

THE TRADITIONAL LIST OF *MUDRĀ*

The word *hasta* (hand, forearm) is usually reserved for Brahminic iconography, whereas *mudrā* (mark, seal—meanings that underline the importance of the term for Mahāyāna Buddhism, in which a particular hand-gesture is designated as the 'mark' of a specific transcendent Buddha) is employed above all for Buddhist iconography. Without overlooking the need for reservations as to the importance and real significance of the *mudrā* and their interest for a number of schools (considered from a chronological as well as a regional point of view) we can accept the list of gestures that is normally published as a kind of universal terminology, though we should bear in mind that such a list is an aid to the definition of the images rather than to a real understanding of them.

The Buddha's Gestures

From a much longer list, which enables Bodhisattvas and deities of all ranks to be described, as well as important religious figures, six *mudrā* that are gestures used specifically by the Buddhas have been selected for discussion below. If one's judgement is based on the evidence of art alone, this list will seem surprisingly restricted, but such selectivity is necessary, since only two gestures can be positively identified as referring to specific miracles. Here is the list popularized by all the textbooks:

1) *Dhyāna mudrā:* 'seal' of meditation, of mental concentration (also referred to as the *samādhi* position, *samādhi* being the culminating stage in disciplining the mind). In the *samādhi* position the Buddha is usually shown seated in the Indian manner with his body bolt upright and his hands resting flat in his lap one on top of the other. In theory, this is the posture reserved for representations of the Attainment of Enlightenment, but in fact the *dhyāna mudrā* is the only gesture that can be used to represent the Buddha in meditation. (In Japanese Buddhist iconography, particular significance is attached to each change in the positions of the fingers.)

2) *Varada mudrā:* 'seal' of charity; gifts or favours, granted or received (also referred to as *vara mudrā, vara* meaning choice or the object chosen). The right arm is hanging down with the right hand in supination, the palm facing forwards and the fingers pointing downwards in a more or less straight line. This gesture is mainly (though not exclusively) reserved for standing figures.

3) *Abhaya mudrā:* 'seal' of the absence of fear (*bhaya* means fright, fear, terror or peril; *a* is a privative prefix). In accordance with the etymology of its name, this gesture can mean 'he who fears not' (for example, on the occasion of the attack by the demon hosts of Māra) and 'he who pacifies or calms' (for example, on the occasion of the dispute between the Koliyas and the Śākyas). The right forearm is bent at a right angle and the right hand is in supination, the palm facing forwards and the fingers pointing straight up. Most of the figures depicted in *abhaya mudrā* are standing, though some seated figures making this gesture do exist. In Thai art this gesture may be made with the left hand or with both hands (as in No. 9), a special meaning being attached to each of these variations.

4) *Vitarka mudrā:* 'seal' of reasoning, of exposition (also referred to as *vyākhyāna°*: exposition, narration; *cin°*: thought, reflection). Although in theory the right forearm is bent as in the preceding gesture, it sometimes tends to be held nearer to the body than in the *abhaya mudrā,* and although the position of the right hand is similar to that adopted in the *abhaya mudrā,* three fingers are slightly bent, while the thumb and forefinger are curled and touching. When making this gesture, the Buddha may be represented either seated (in the Indian or the European manner) or standing. The left hand of standing images holds a flap of the robe or, from the Pāla-Sena period onwards, executes the same gesture as the right hand; but with the fingers pointing downwards. (Six possible combinations, involving different positions of the fingers, are distinguished in Japanese Buddhist esoterism.) This gesture was used with particular frequency in Thai art of the Dvāravatī school, and from this period (*c.* 8th century) onwards, the *vitarka mudrā* was executed in Thailand in exactly the same way by the left hand as it had always been by the right. In the art of south India and in that of all the schools influenced by it, the *vitarka mudrā* is frequently substituted for the *dharmacakra mudrā* (see below).

5) *Dharmacakra mudrā:* 'seal' of the Wheel of the Law (or, more correctly, *dharmacakra pravartana mudrā:* seal of the setting in motion of the Wheel of the Law). This gesture as its name implies, symbolizes above all the First Sermon ('The Turning of the Wheel of the Law') preached at Sārnāth, near

Benares on the site of Rishipatana (Isipatana in Pāli) in the Deer Park, but it can also represent the Great Miracle of Śrāvastī. For this reason it is necessary for artists to make clear, by the narrative or symbolic context, the event represented by the *dharmacakra mudrā*. The gesture is made by bringing both hands together to a position in front of the chest, each hand held in the same position as in the *vitarka mudrā* but with the difference that the ends of the fingers of the left hand rest against the palm of the right hand. There are several variations of this gesture, one being reserved exclusively for representations of one of the most celebrated of the transcendent Buddhas, Vairocana (see below). At first this *mudrā* was executed only by figures seated in the Indian manner; later it came to be used in representations of the Buddha seated in the European manner and even, though far more rarely, for standing Buddhas.

6) *Bhūmisparśa mudrā:* 'seal' of touching the Earth (also known as *bhūsparśa°; bhū* means earth), more frequently described as the gesture of 'calling the (goddess) Earth to witness', a reference to the miracle that set the seal on the defeat of Māra, or as the 'gesture of the *Māravijaya*' (the Victory over Māra), which is the precise meaning of the gesture, embodying the concept of imperturbability. This *mudrā*, which is made only by figures seated in the Indian manner, consists in touching the throne lightly with the fingertips of the right hand, that rests on the right thigh in the vicinity of the knee; the left hand stays in the Buddha's lap.

THE *MUDRĀ* IN THE CONTEXT OF MAHĀYĀNA BUDDHISM

It was stated above that the *mudrās* assumed their meaning within the context of Mahāyāna Buddhism—no fewer than five of the gestures described on the preceding pages are used in Mahāyāna Buddhism as the 'mark' or 'seal' of a particular Buddha—and that they played a vital role in a ritualism totally unknown in Theravāda Buddhism.

No summary will be attempted here of the many problems raised by the notion of transcendent Buddhas, who are, according to some of the most famous texts, innumerable. They are usually referred to by the name of *Jina* (Conqueror); *Tathāgata* ('Went thus'), the historical Buddha himself; or *Dhyāni*-Buddha (Buddha of meditation, of contemplation, as distinct from the 'human Buddhas' such as the historical Buddha and the Buddhas of the Past), a name that is found only in late texts but which has for a long time been popularized in a number of works of scholarship produced in the West. Theories that evolved gradually from the Buddhist conception of the Universe and from notions such as that of the 'bodies of Buddha'—spectral body, body of enjoyment or beatitude, body of the Law—tend not to supplant but rather to complement the ideas from which they are derived, and have led Buddhist thinkers to postulate the existence of transcendent Buddhas belonging to other universes. All these universes are, by definition, similar to ours and affect our own world to the extent that the glory of one of these Buddhas illuminates every universe.

From among a vast number of Buddhas, most of whom are hardly more than names that one comes across in the course of reading Buddhist texts, there are five—or six for certain schools of belief—that have acquired a special importance in late and tantric Mahāyāna Buddhist thought. While the sixth Buddha plays a pre-eminent role that puts him in a class above all the others, the respective domains of the first five Buddhas are clearly related

to localities in space; each Buddha corresponds to one of the five 'human' Buddhas whose saving presence has graced, and will continue to grace, the great cosmic period in which we live (the historical Buddha Śākyamuni, his three immediate Predecessors and Maitreya, the future Buddha), a conception of time that has the effect of incorporating them into the Buddhist cosmology.

Three of the transcendent Buddhas have a particular importance already discernible in the very earliest years of Mahāyāna Buddhism: the Buddha of the East, the Buddha of the Zenith and the Buddha of the West, the latter being by far the most popular and the most venerated. Although they are naturally similar to the historical Buddha—the true archetype of all the Buddhas—they differ from him (in Tantrism) by virtue of their capacity for appearing in superhuman forms, having several heads and pairs of arms. They are distinguished by their names, by their different positions in space that cause each to be associated with a particular element and a distinctive colour, by a *mudrā* peculiar to each Buddha, by a symbolic attribute, by riding different animals *(vāhana)*—or, frequently, a pair of animals—and, lastly, by a condensed formula of invocation that is intoned during rituals: a letter or a syllable *(bīja,* 'germ-syllable').

Akshobhya, the 'Steadfast', resides in the east. He is blue in colour and represented making the *bhūmisparśa mudrā,* a gesture obviously appropriate to his name. Ratnasambhava, 'born of the Jewel', is in the south. He is yellow and shown making the *varada mudrā,* the same gesture mentioned above but with his hand in supination with the palm facing outwards. Sukhāvatī (the 'Blessed'), a land or 'field' belonging to the Far East's most popular transcendent Buddha, Amitābha (Immeasurable Glory) or Amitāyus (Immeasurable Age), stretches out to the west. He is red and depicted in the *samādhi* position (or *dhyāna mudrā*). Amoghasiddhi, 'unfailing Success' is green in colour and sits in the *abhaya mudrā* posture, with his right hand drawn across his chest. Finally, at the zenith, sits Vairocana, the 'Illuminator', who is white. He is represented making the *dharmacakra mudrā* or, to be more precise, a variant of that gesture known as *bodhyagrī mudrā* (or *bodhyangī°*). Derived from a form of the *dharmacakra mudrā,* which Gandhāran imagery appears at times to foreshadow, this gesture is regarded as symbolizing the 'ultimate stage' of the Enlightenment; the gesture is executed by raising both hands to chest-height and gripping with the right hand the raised index-finger of the left. Except in the case of Vairocana whose *mudrā* would seem to be sufficiently distinctive to apply to him alone, it would be unwise to suppose that one can identify an image of one of these transcendent Buddhas with a sufficient degree of certainty on the basis of its hand-gesture alone. Not every Buddha in *samādhi* position is necessarily Amitābha, and the large number of Buddhas 'touching the Earth' cannot, in the absence of additional evidence, be positively identified as portrayals of Akshobhya. Unless the context makes it certain that the image under consideration is a Mahāyāna Buddhist figure of a transcendent Buddha, it would be prudent to confine oneself to identifications of a most general nature, such as 'Buddha in *samādhi* position', 'Buddha making the *bhūmis-parśa mudrā*', thus avoiding the pitfalls of excessively limited identifications.

In Tantrism, these Buddhas can be depicted embracing or clasping their *Prajñā,* the female counterpart with whom they form a divine couple. This copulation, either realistically represented or symbolized by the gesture of arms folded across the chest with the fists clenched, distinguishes these Buddhas from the properly human ones. With these latest developments all possibility of direct comparison with the historical Buddha disappears, as

in the case of Vajrasattva, '[he] who has the Thunderbolt (or the diamond) as essence' or Vajradhara, 'Thunderbolt-bearer', often regarded as the sixth of the transcendent Buddhas and superior to the preceding five. On the other hand, Bhaishajyaguru, the 'Master of remedies', who can serve as a substitute for Akshobhya and sometimes even for Vairocana and who, as supreme therapeutist, has enjoyed immense popularity in the Far East and even in South-east Asia (12th and 13th centuries), often bears a much closer resemblance to the archetypal Buddha. Indeed, the only major difference between them is that Bhaishajyaguru is sometimes depicted holding a begging-bowl (*pātra*) or a bowl containing remedies and a myrobalan fruit (*āmalaka*) famous for its healing properties. However, it is important to keep it in mind that one cannot positively identify all the Buddhas holding a bowl in their lap (so numerous in Pāla-Sena art) as representations of Bhaishajyaguru, unless additional evidence confirms the identification.

THE GESTURES UP TO THE ADVENT OF GUPTA ART

A study of the art of the earliest schools that allowed the Buddha to be depicted in human form yields no evidence of a systematic use of the *mudrā* described above. It is not until the 4th or the 5th century, at the very earliest, that such evidence begins to appear. Even in the Gupta and post-Gupta styles, and at least until the 6th century, unexpected (though by no means exceptional) gestures reveal a chronic inconsistency in matters relating to iconography. An example is the Buddha represented making the *varada mudrā* on the occasion of the Attack by Māra in a painting in cave 1 and a low relief in cave 26 at Ajantā. This inconsistency can be accounted for by the fact that gestures with the left hand were forbidden, or at least discouraged until a later period when artists were finally no longer obliged by convention to portray the Buddha holding one of the flaps of his robe in his left hand.

The earliest schools that depicted the Blessed One in human form were all faced with the same problems, which were solved at first by adopting a general-purpose gesture with no precise meaning—a kind of benediction given with the right hand raised to shoulder-height, the palm facing outwards and the fingers slightly bent. This gesture was much more frequently used in the earliest centuries A.D. than the *dhyāna mudrā* and is common in the art of Mathurā and in the far more varied art of Andhradeśa (Amarāvatī). Mistaken by some authors—unmindful of the narrative context—for the *abhaya mudrā*, it has been used for representing all the incidents in the life of the Buddha, for Buddhas both standing and seated (in the Indian or European manner) and for Buddhas in circumstances as diverse as sermons, conversions and the reception of Rāhula coming to claim his inheritance. Although artists of the Mathurā school often portrayed the Buddha in an attitude that seems heroic and majestic (with his left hand clenched at hip level or with a hand resting on his thigh), the main purpose of such a gesture was to keep the drapery of his robe in position. The artists of the Amarāvatī school, finding a way of releasing the left hand, chose to wrap the fabric around the left shoulder, so that the hand could now rest freely in the Buddha's lap. It was not, however, until a fairly late phase of the Amarāvatī style that the *samādhi* position became truly established.

In comparison with this very limited vocabulary, Gandhāran imagery shows exceptional richness, employing as it does almost all the gestures of classical

iconography. Despite a marked predominance of the general-purpose gesture of the Mathurā and Andhradeśa schools, one can observe a distinct tendency towards specialization in the use of gestures to which specific meanings began to be attached. With the exception of the *vitarka mudrā,* all the *mudrā* described above can be recognized in Gandhāran art. A number of occasional gestures devised for use in representations of various special miracles are added to these, and some interesting variants, such as the *samādhi* position with the hands buried in the folds of the clothing, also occur. Why, in view of this surprising iconographic richness and the fact that the school of Gandhāra was the creator and propagator of the image of the Buddha in human form, did its vocabulary of gestures have so little impact on the school of Mathurā, whose artists remained virtually uninfluenced by it? The question becomes all the more pertinent when one bears in mind Gandhāra's relations with the Mathurā region and the political links between the two areas. It would, in the circumstances, be wise to re-examine the still problematical chronology of the Gandhāran school in the light of evidence provided by the development of mime. Without underestimating the importance of all the other stylistic data, the present writer is inclined to believe that the artists who produced the earliest Gandhāran sculpture knew only the same general-purpose gesture as those working at Mathurā and Amarāvatī, and that it was not until the differentiated *mudrā* became established in the Indian schools during the Classical period that the same tendency became common in the Gandhāran school.

The Sinhalese school has always displayed extreme restraint, employing a very limited range of gestures, all of which were to a greater or lesser extent inherited from the earliest tradition. This restraint was exercised in spite of the important and, at times, predominant role played by Mahāyāna Buddhism in Sri Lanka during the period from the 3rd century to the 12th. The attitude of meditation was virtually the only one in which seated figures were represented. The general-purpose gesture of Andhradeśa was eminently suited to depicting standing figures whose left hand, at shoulder-height, gripped the robe that was held in position by the bend in the arm. This gesture gradually lost its suppleness, becoming a hieratic gesture in which the edge of the outstretched hand faces forwards—a position sometimes termed *āśīsha mudrā* (gesture of benediction). This term is of modern coinage and only of typological interest, since it incorporates a word from Sanskrit, a language hardly used in Sri Lanka, and introduces the idea of *mudrā,* a notion foreign to Theravāda Buddhism. Medieval and modern Sinhalese art exhibits a slightly greater variety in the field of painting, but the statuary is scarcely more varied than during the early period. The posture of meditation continues to be predominant, and the only perceptible development is that the gesture signifying the absence of fear *(abhaya mudrā),* represented in a stiff and lifeless manner with the left arm hanging down against the body, has tended to supplant the gesture of benediction.

THE GESTURES IN POST-CLASSICAL ICONOGRAPHY

At about the end of the 6th century, during the post-Gupta period, especially in the art of Magadha and of the north-east (Bihār, Orissa, Bengal), began the process that was to culminate in the creation of a more varied and more

systematic iconography within which gestures at last started to acquire their function as precise symbols. The great and influential monastic universities played a major part in this process, since it was from these secular centres that new doctrines and the new iconography spread to South-east Asia (where they were superimposed upon older traditions mostly of south Indian or Sinhalese origin) and the Himalayan regions. It would appear that a decisive role was played in the Himalayan regions by monasteries such as those at Vikramaśīla (a tantric centre founded around the beginning of the 9th century) and at Nālandā (a centre that was converted to Tantrism).

Just as Sinhalese art showed a preference for the *samādhi* position and for representations of the Full Enlightenment (a preference that Sinhalese artists have retained up to the present day), the Gupta school and, to some extent, the post-Gupta schools, showed real interest in certain gestures only: standing figures making the *varada mudrā* or the *abhaya mudrā*, figures seated (in the Indian or the European manner) making the *dharmacakra mudrā*, this gesture being employed, as in Gandhāran imagery, for representations of the First Sermon and also for the Great Miracle of Śrāvastī. Indeed, it is not unreasonable to claim that only those compositions depicting the four or the eight Great Miracles (Sārnāth school) display a slightly greater variety. These compositions also helped to popularize a gesture that was to grow in favour for a number of schools until it became the gesture particularly associated with the Buddha—the *bhūmisparśa mudrā*, symbolizing his victory over Māra.

The trends first seen in the art of the post-Gupta period and, above all, in that of the Sārnāth school were further developed by the artists of the Pāla and Pāla-Sena schools. In addition, the reliefs representing the eight Great Miracles and the imagery of *Mahābodhi* (*Bodh Gayā;* where the Blessed One attained Full Enlightenment) underline the predominance of the Victory over Māra and his hosts through the large size and prominent positions of the numerous representations of these themes. It was at this time that the gestures at last merited the name of '*mudrā*'. In so far as images henceforth expressed the facts provided by the spiritual guides called *sādhana,* as was demonstrated early in this century by A. Foucher, the *mudrā* were able to assume their true signification, at any rate within the context of Tantrism. The enrichment of the iconography and the appearance of new gestures were encouraged, at least in the case of standing figures, by a considerable artistic development—the gradual realization by artists that it is possible to adapt the manner in which the Blessed One wears his monastic robe in such a way as to free him from the constraints imposed by tradition upon ordinary mortals, even those belonging to a religious order. This iconographic and gestural development would appear to indicate that scholars and image-makers alike finally realized that the Buddha's garment, already made transparent by the brilliance of the light radiating from his very being on so many occasions, could not be a burden and a source of constraint to him, just as dust and sweat—all the texts emphasize this—could not adhere to his skin. This conception of the Buddha's garment being weightless, which was clearly conveyed at an early date in the Gandhāran school's portrayals of the Buddha lying down *(Mahāparinirvāna),* enabled his left hand, now freed, to be used for new iconographic purposes. The acceptance by artists of this quality of the Buddha's robe does much to explain the popularity, from India to the Far East, of images of standing Buddhas, executing the same or complementary gestures with each hand; however, this explanation should not cause us to overlook an essential element of the Buddha's character: that he alone—having 'within him no impurity'—is able to act with perfect ambidexterity.

THE GESTURES IN THE BUDDHIST ART OF SOUTH-EAST ASIA

It is a curious fact that the richest and most varied iconographical vocabu-laries were developed within the very schools that had no notion of *mudrā* whatsoever—those adhering to Theravāda Buddhism. The explanation seems to be that these schools, following Sinhalese Buddhism's example of sobriety and reserve, felt obliged to exercise a similar restraint with regard to gestures. An evident desire, however, to represent without ambiguity an ever-increasing number of the noteworthy events in the Buddha's life appears to have caused a change of policy. Although it was above all in the first half of the 19th century, with the Thai school of *Ratanakosin* (Bangkok), that this tendency became consolidated, the beginnings of the process can be seen in the art of the school of Pagan, some seven centuries earlier. Before a brief account of these interesting, and at times bizarre, developments is given, it may be worthwhile to describe in some detail the major trends characterizing the main schools of art in South-east Asia.

It was at a very early date (certainly before the 7th century) that the whole of South-east Asia succumbed to the influence of south India and also, in all probability, Sri Lanka. The whole area, with the exception of Burma and Indonesia, was to retain a constant fidelity to representations of figures seated in the *vīrāsana* posture (the right leg bent and positioned over the left leg and not in the *vajrāsana* posture in which the legs are tightly crossed in such a way as to render the soles of both feet visible) and an equally constant aversion to the *dharmacakra mudrā*, the *vitarka mudrā* being em-ployed exclusively. The school of Dvāravatī (*c.* 7th–9th century), whose widespread and lasting influence was felt over most of central and eastern Indo-China, was responsible for developing and disseminating a special form of the *vitarka mudrā*, executed with both hands positioned symmetrically. This variant, adopted particularly for standing images, probably inspired the double *abhaya mudrā* which became established in about the 16th century and achieved immense popularity in more recent times.

During its earliest centuries, Khmer Buddhist art faithfully followed the example of Dvāravatī, but it tended to neglect the art of Dvāravatī during the Angkorian period, when its artists found themselves serving a country almost all of whose inhabitants were by then of the Mahāyāna Buddhist persuasion. Those artists produced very few images representing figures in attitudes other than the *samādhi* position, and they usually chose to depict the figures sitting on the coils of the *nāga*-king, Mucilinda. According excep-tional importance to the miracle that occurred during the weeks of medita-tion following the Buddha's achievement of Full Enlightenment, the Khmer artists drew their inspiration from examples derived from the art of Dvāra-vatī (which were themselves influenced by the iconography of south India and Sri Lanka). They succeeded in creating images of superlative decorative and aesthetic quality. In comparison with these works of art, so numerous and often of such great beauty, Tantrism appears to have exerted only a very limited influence on the iconography of the Buddha, although the existence of the tantrist movement is well attested at the end of the 12th century and the beginning of the 13th. With the exception of some statues of this period representing Vajrasattva holding the thunderbolt and the bell, little variety was to become apparent until the time when Cambodia, forsak-ing Mahāyāna Buddhism in favour of Theravāda Buddhism, adopted an iconography that became increasingly similar to the one prevailing in central Indo-China.

To begin with Indonesian art responded to the same trends as the rest of South-east Asia; from the middle of the 8th century onwards, it moved intentionally towards esoteric Mahāyāna Buddhism and was receptive to influences from the art of west Bengal. Although the Buddha is depicted in a wide variety of postures in the narrative compositions at Borobudūr, it is usually only by contemplating the whole scene, as in the case of Gandhāran art, that one can determine the precise meanings of these attitudes. The statues at Borobudūr show the *mudrā* used in strict accordance with the precepts of the spiritual guides *(sādhana)*. This trend continued in spite of the changes that Buddhism underwent and, towards the end of the 13th century, in the face of a development towards tantric syncretism. If we consider its purely iconographic aspect, Indonesian art emerges as the art that was most obviously influenced by the traditions of north-east India.

The problem is quite different in the case of Burma (Pagan school). Here too, the influence of Pāla-Sena art replaced that of a group of traditions inherited principally from south India or Sri Lanka, but it affected only art in the strict sense of the word; the overwhelming majority of the images derived their inspiration from Theravāda Buddhism. What is more, the artists of the 12th century were no longer satisfied with merely copying gestures and postures, but adapted them in order to extend their range of meaning. Whereas the artists of central Java (Borobudūr), like the image-carvers of Andhradeśa and Gandhāra, had attempted to clarify their illustrations of particular events in the Buddha's Life by having recourse to narrative scenes, the artists of Pagan (Ananda especially, and Nagayon) strove, by selecting certain typical ways of representing the Buddha, to make their depictions equally explicit, while reducing to a minimum the number of figures in each scene. This practice gave rise to a wide variety of figures that included Buddhas standing (making the *dharmacakra mudrā,* the *dhyāna mudrā* and the double *varada mudrā,* holding the begging-bowl, the handful of plants, etc.), walking (right arm dangling, with the hand making the *varada mudrā),* seated either in the European manner or in *vajrāsana* (in the *samādhi* position, teaching, holding or shaping the begging-bowl, with the right hand on the chest, etc.), or lying down. This wide choice of gestures and postures enabled sculptors to represent episodes in the Buddha's Life with the least possible ambiguity; additional clarification of the context is sometimes present in the form of praying figures, carved on the predella of statues in high relief, who provide further clues to the meanings of the sculptures. It would appear that these compositions are among the earliest reflections of preoccupations present in Thailand at least as early as the 17th and 18th centuries and especially prominent during the reign of Rāma III (1824–51). They resulted in the compilation of a veritable treatise on iconography. The originality of this iconography lies in its revelation of these preoccupations and of the manner in which they have been interpreted. Before we turn our attention to the imagery of Thailand, however, we should mention that Burmese artists in the 19th century seem to have derived inspiration from the tradition of the master craftsmen of Pagan. For their statues the 19th-century artists of Mandalay devised postures, shown by the wood-carvings, which enjoyed immense popularity despite their having played no more than a purely local role. Most of these represent a standing Buddha with arms outstretched, draped in a thick and sumptuous robe whose flaps are drawn aside by the ends of his fingers. Many such statues depict the Buddha holding in his right hand not only a flap of his robe but also a fruit; it is positioned between his thumb and middle finger and recalls the Burmese legend according to which a gall-nut was offered by a god to the Buddha when he ended his seven weeks of fasting. Another type of image is rarer

and even more curious; it represents the Buddha with his right arm out-stretched, his forefinger pointing, so it is supposed, to the site of the Royal Palace at Mandalay.

Probably indirectly influenced by the art of Pagan, artists from all the schools of art in Thailand showed a marked preference, from the second half of the 13th century onwards, for images depicting the Buddha 'victorious over Māra'. This was the period during which the truly Thai schools (Sukhothai, Chiang Mai or Lan Na, Ayuthia) were established. Although extraordinarily idealized representations of the Buddha walking were accorded a degree of importance unique in Buddhist art by the artists at Sukhothai, one cannot justifiably claim that this art really constituted a school, since its influence was of an aesthetic rather than a truly iconographic nature. It seems, in fact, that the wish to further differentiate the gestures and postures of the Buddha, which grew up around his 2000th anniversary (1457), may have originated at Chiang Mai, at a time when a replica of the famous sanctuary at Bodh Gayā was being built. Artists hoped that by creating distinctive images they would be able to represent the occupations of the Blessed One during the seven weeks which followed the attainment of Full Enlightenment. As a result, we find that many of the paintings and Holy Images *(Phra Pim)* produced by the school of Ayuthia during the 17th and 18th centuries depict the eight Great Miracles and the Wonders of the seven weeks of the *Mahā-bodhi* cycle in a manner that is not entirely new (the examples from Pagan), but does, however, help to establish a real classification of the gestures. It was above all at Bangkok (the *Ratanakosin* period) during the 19th century that this tendency came to the fore through the definition and execution of specific, narrow and precise images. As early as the First Reign (1782–1809), the Buddha Gandhārarattha ('invoking the rains') was represented with his right hand upraised, the fingers curved at shoulder-height and his left hand cupped 'as if to collect the rain' (a reference to the agrarian ceremonies in connection with the First Ploughing and with the Invocation of the Rains). Finally, during the Third Reign (1824–51), at the personal instigation of the sovereign, forty different images of the Buddha were identified, de-scribed and represented in an illustrated manuscript. These depictions, later cast in bronze, associate various other occurrences with the Great Miracles; the former are obviously much less well known, e.g. 'the gift of a single hair regarded as a relic' (the gift made to the merchants Trapusha and Bhallika) or 'the threading of a needle'—a reference to this edifying observation: 'his senses were heightened, and when he was making up his robe by joining together rags picked up from the dust, he acquired with each stitch made by his needle the eight means of deliverance (the eight means of liberation from life's sufferings—the noble Eightfold Path)....'

Such iconographic developments are far removed from the restrictive list of the *mudrā* that writers are so apt to popularize, and yet they remain within the mainstream of all that is most traditional in Buddhist art.

1 Detail: Buddha lying down *(Mahāparinirvāna)*, relief, 5th c., Sārnāth

2
Detail: Buddha walking, relief, 8th
to 9th c., Borobudūr

3
Buddha seated 'in the European
manner', 8th–9th c., Mendut Candi,
in situ

4
Buddha seated in *vajrāsana, c.* 6th c.,
Ajantā: cave 1, *in situ*

5
Buddha seated in *virāsana*, bronze, *c.*
10th c., Nāgapattinam

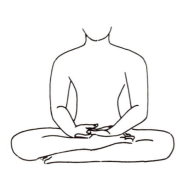

6
Dhyāna mudrā: Lan Nà school, bronze, *c.* 15th c.

7
Varada mudrā, bronze, 9th–10th c., Kurkihar

8
Abhaya mudrā: Ayuthia school, bronze, *c.* 15th c.

9
Abhaya mudrā: the so-called 'stilling the waves' gesture, Ayuthia school, bronze, 16th–17th c.

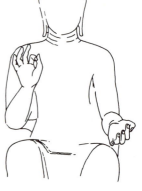

10
Vitarka mudrā: south Indian tradition, bronze, *c.* 6th c.

11
Vitarka mudrā: Dvāravatī school, quartzite, *c.* 8th c.

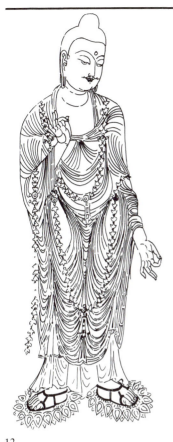

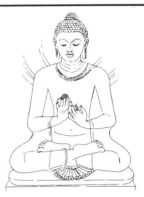

12
Vitarka mudrā: cave painting, *c*. 8th c., Bezeklik

13
Vitarka mudrā: Dvāravatī school, bronze, 8th–9th c.

14
Dharmacakra mudrā, stone, 5th c., Sārnāth

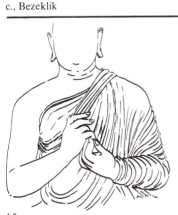

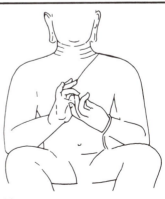

15
Dharmacakra mudrā: Gandhāra school, schist, *c*. 4th c.

16
Dharmacakra mudrā, stone, 8th to 9th c., Mendut Candi, *in situ*

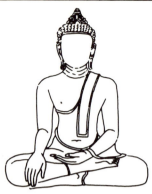

17
Bhūmisparśa mudrā: U Thong school, bronze, *c.* 14th c.

18
Bhūmisparśa mudrā: Lan Na school, bronze, *c.* 14th c.

19
Primitive (general-purpose) gesture: Mathurā school, stone, *c.* 2nd c., Kātrā

20
Primitive (general-purpose) gesture: Āndhra school, limestone, *c.* 3rd c., Nāgārjunakonda

21
Bodhyagrī mudrā, wood, Kōnin period (*c.* 9th c.), Japan

22
'*Aśisha mudrā':* Sinhalese school, *c.* 9th c., Avukana, *in situ*

China

by Michel Beurdeley

CHINA

It is difficult to summarize within the space of a few pages the general outlines of a civilization as ancient and complex as that of China. For three thousand years, Chinese art has been in a perpetual state of evolution. It has reflected changes in Chinese society and the contributions made by the civilizations that have succeeded each other on this vast continent. There has never been any real break in the evolutionary process. For those thirty centuries there has been an undeniable 'Chinese constant', creating a particular artistic taste which can be classed among the three or four major traditions that have determined the cultural development of mankind.

The Chinese Neolithic period is characterized by the 'painted pottery culture', which lasted from the end of the third millennium B.C. until the first half of the second. The finest examples dating from this era are the red pottery discovered at Yangshao and the black pottery from Lungshan. However, the history of Chinese civilization did not really begin until the Shang dynasty (1523–1028 B.C.), sometimes known as the Yin dynasty. The skill of the Shang bronze-casters was unsurpassed, and during this period ritual vessels were made in a wide variety of shapes and designs.

The Shang dynasty was followed by that of the Chou kings (1027–256 B.C.). A notable feature of these two civilizations is their complex funeral rites (including human sacrifice). Most of the pottery and bronze vessels of these periods have been found in tombs. During the Chou period, several clans spread throughout the Chinese territory: thus we have the periods of the Western Chou (1027–771 B.C.), of the Eastern Chou (770–256 B.C.); and we also have the period of the 'Spring and Autumn Annals' (722–481 B.C.) and the period of the 'Warring States' (480–221 B.C.). In addition to vases, many other bronze objects from this dynasty have been found: bells, mirrors, clasps and daggers.

Objects made of jade, which in the Chinese context refers to nephrite of various colours, played a major role, too, in the ceremonial rites of the antique period. They represent all sorts of symbols, from the circular *p'i* (a symbol of Heaven) to the square *tsung* (symbol of the Earth). There are also numerous miniature animals, birds, insects, fish, etc. and mythical monsters (*k'uei*).

China was united under the Ch'in rulers whose dynasty was short-lived (221–207 B.C.). The first Ch'in emperor, Shin Huang-ti had the Great Wall built as a frontier between the Chinese world and that of the 'barbarians'. The Han dynasty (206 B.C.–A.D. 220) ushered in an era of moral and political thinking under the aegis of Confucianism. It was a period of expansion, of external trade (exported silks) and of technical progress. The first capital of the Han kings was Ch'ang-an (present-day Hsien), but,

later on, Lo-yang became the capital city. The art of the Hans is best known for its terracotta funerary statuettes (the *ming ch'i*) in the shape of human figures, animals or domestic objects; these were buried together with the deceased and were probably at first substitutes for human victims. Though the *ming ch'i* are generally small, recent excavations (1974) near Hsien have brought to light life-sized statues of more than 6,000 warriors, some with their horses. The bronzes of this era were richly inlaid with gold and hardstones, and small figures of animals were modelled with humour and realism.

Between the fall of the Han dynasty and the formation of the T'ang empire there was a troubled period that was nevertheless beneficial to the intellectual development of China. During the period of the Six Dynasties (A.D. 220–581) and the Sui dynasty (581–618), society underwent many changes: the growth of Buddhism in the 3rd century A.D. and later led to the appearance of innumerable monasteries and new religious images, and the cave-temples of T'un-huang, Yünkang, Lung-men and Maichishan enable us to assess the merits of this statuary.

The accession of the first ruler of the T'ang dynasty (618–906) ushered in an epoch of exceptional prosperity. The extension of China's frontiers as far as southern Annam (present Vietnam) and to the west of the Caspian Sea opened the way to stimulating foreign ideas and influences. The splendours of the court in the capital Ch'ang-an were to attract a cosmopolitan society of brilliant and refined people. Buddhism flourished, and sculptures on a monumental scale were created to decorate the Buddhist caves at Lung-men. Metalwork (in gold and jewels in particular) was influenced by the Sassanians of Persia, though it retained a very Chinese style. The terracotta tomb figurines became more graceful and realistic and were sometimes enhanced by a new combination of yellow, brown and green glazes known as *san-ts'ai* (three-colour) glaze. These colours are also found on wares intended for everyday use, which occur in a wide variety of shapes and decorative designs. Both fantasy and naturalism can be seen in the designs of bronzes—in particular, mirrors that display an exuberant decoration of either flowers or animals or of arabesques and tracery. The two T'ang capitals of Ch'ang-an and Lo-yang benefited from the grandiose schemes of urban development executed by the rulers of this dynasty. The towns had a chequer-board layout, tree-lined avenues, canals, markets, gardens and administrative complexes adjoining the Imperial palaces. Many temples were built, serving worshippers from a wide range of religions: Buddhism, Taoism, Manicheism, Mazdaism and Zoroastrianism. It was during the T'ang period that the Buddhist Ch'an sect (which gave rise to the Japanese Zen school) first appeared.

The T'ang dynasty was followed by a period of anarchy, and for a century after it ended China was divided into independent kingdoms, each ruled by short-lived dynasties. Nevertheless, during this period, called the Five Dynasties (907–60), a valuable contribution was made to the cultural life of China. The output of artists and craftsmen, who worked under the protection of the local courts, was prolific; the introduction of printing made it possible for the classics to be read by a great number of people. China was once again to be unified under the great Sung dynasty, which is divided into two periods: the emperors of the Northern Sung period (960–1126) made K'ai-feng their capital, and those of the Southern Sung period (1127–1279) ruled from Hangchou. Repeated attacks by aggressive barbarian tribes forced the Chinese to fall back upon their own thoughts and to develop their native traditions. If metaphysics became an integral part of every aesthetic creation, at the same time, artists strove to

achieve the technical perfection exalted in various manuals and encyclo-
paedias. The influence of Ch'an Buddhism was particularly noticeable in
paintings, and landscapes painted in India ink tended to express the 'soul
of nature'—its spiritual rather than its physical aspects. In ceramics, a
greater emphasis was placed on materials and the subtlety of the colour-
ing of glazes than on the actual decoration. It was the age of the finest
tings and *chüns* ever produced and of the famous northern celadons.

The Yüan rulers (1260–1368), of Mongol extraction, made Tatu (present-
day Peking) their capital. The first emperor, Kublai Khan, a descendant of
Genghis Khan, transformed it into 'the most beautiful city in the world'.
The accounts of Marco Polo, the Venetian explorer who was received at
the court, are full of praise for the 'Khan's city' (called Cambaluc or
Khanbaliq). The traditions of Chinese art were continued by the Mongol
conquerors, but they also made some contributions of their own. The
Persian technique of decorating pottery with underglaze painting in cobalt-
blue was introduced, and a copper-red glaze, fired at a high temperature,
appeared at the same time. The technique of lacquering benefited from
the introduction of new processes such as inlay using mother-of-pearl,
while the great painters of the age excelled in landscape painting and
'portraits of horses'.

In 1368 the Mongols were driven back beyond the Chinese frontiers. They
were succeeded by the Chinese Ming ('brilliant') dynasty (1368–1644).
The third emperor, Yung-lo, rebuilt Tatu and gave it the name Peking
and also the layout that it has retained to this day. Peking (the northern
capital) was adorned with palaces and monuments, some of which such as
the Temple of Heaven are still standing. The famous Ming tombs to the
north of Peking are proof of the ostentatious tastes of the Ming rulers.
Artistic taste was influenced by Timurid and Safavid Iran; the polychrome
porcelain of Persian origin competed with Chinese blue-and-white ware.
An Imperial factory was founded at Ching-te-chen on the site of older
kilns, and Ming craftsmen were also skilled in the techniques of lacquering
and cloisonné enamelling.

When the Ming dynasty fell, it was followed by a Manchu dynasty (the
Ch'ing rulers), who reigned over China for three centuries (1644–1911).
Three famous emperors stand out in this long line of descendants: K'ang-
hsi (1662–1722), Yung-cheng (1723–35) and Ch'ien-lung (1736–95).
The Jesuits and other European missionaries now helped to open China
to the Western world. In the field of the decorative arts, technical perfec-
tion took precedence over inventiveness, and the development of ceramics
was accelerated by orders from European buyers that were conveyed by
the many East India Companies. Two types of ceramics were extremely
popular: *famille verte* wares during the reign of K'ang-hsi and *famille rose*
wares during that of Ch'ien-lung.

Increased pressure from Europeans and from China's domestic trou-
bles—the Opium War (1840–42), the Taiping Revolt (1848–64) and
the Boxer Rebellion (1900)—led to a weakening of the power of the
Ch'ing rulers. Despite attempts to assert their influence, the emperors
could not prevent anarchy from prevailing in the 20th century. The Ch'ing
dynasty was overthrown by Sun Yat-sen, the founder of the Kuomintang,
in 1911. Then after a period of internal disputes and the Sino-Japanese
War (1937–45), China was finally unified once again under the government
of Mao Tse-tung.

Since 1949, the leaders of the People's Republic of China have wisely
banned the export of all works of art. At the same time, the scientific exca-
vation of a number of archaeological sites has brought to light other

China

beautiful objects of types never seen before. The exhibitions 'The Genius of China' (London, 1973) and 'Unearthing China's Past' (Boston, 1973) gave us an opportunity of admiring some of these remarkable discoveries.

It has been considered unnecessary to state the provenance of some of the objects illustrated in the following pages since they are archetypes for the various shapes and styles of decoration adopted during particular periods. In this category, for example, are the drawings illustrating the development of the covered jar (pages 462 and 463).

MAJOR MUSEUMS

Austria
Museum für Völkerkunde; Österreichisches Museum für angewandte Kunst, Vienna

Belgium
Musées royaux d'art et d'histoire, Brussels

Canada
Royal Ontario Museum, Toronto

People's Republic of China
Nanking Museum of Historical Arts, Nanking
Peking Historical Museum; Peking Palace Museum, Peking
Shanghai Museum of Historical Arts, Shanghai

Republic of China, Taiwan
Exhibition Hall, Institute of History and Philology, Academia Sinica;
National Palace Museum, Taipei

East Germany
Staatliche Kunstsammlungen, Dresden (ceramics)

France
Musée des Arts Décoratifs; Musée Cernuschi; Musée Guimet, Paris

Great Britain
City Art Gallery, Bristol
Fitzwilliam Museum, Cambridge
British Museum, London
Percival David Foundation of Chinese Art, London
Victoria and Albert Museum, London
Ashmolean Museum of Art and Archaeology, Oxford

Iran
Archaeological Museum (with Collection of the Ardebil Shrine), Teheran

Japan
Atami Art Museum, Atami
Hakone Art Museum, Hakone
Kyoto National Museum; Suitomo Collection, Kyoto
Nezu Institute of Fine Arts; Tokyo National Museum, Tokyo

The Netherlands
Rijksmuseum; Museum van Aziatische Kunst, Amsterdam
Gemeentelijk Museum 'Het Princessehof', Leeuwarden
Rijksmuseum voor Volkenkunde, Leiden

Portugal
Museu das Janelas Verdes, Lisbon

Sweden
Museum of Far Eastern Antiquities (Östasiatiska Museet), Stockholm

Switzerland
Collections Baur; Musée Ariana, Geneva
Museum Rietberg, Zurich

Turkey
Topkapu Sarayi Müzesi, Istanbul

U.S.A.
Museum of Fine Arts, Boston
Buffalo Museum of Science, Buffalo, New York
Fogg Art Museum, Cambridge, Mass.
The Art Institute of Chicago, Chicago
The Cleveland Museum of Art, Cleveland
Honolulu Academy of Art, Honolulu
W.R. Nelson Gallery of Art and Atkins Museum of Art, Kansas City
The Metropolitan Museum of Art, New York
Asian Art Museum (Avery Brundage Collection), San Francisco
Seattle Art Museum, Seattle
The Freer Gallery of Art, Washington, D.C.

U.S.S.R.
Hermitage Museum, Leningrad

West Germany
Museum für ostasiatische Kunst, Berlin
Museum für Kunsthandwerk, Hamburg
Museum für ostasiatische Kunst, Cologne
Staatliches Museum für Völkerkunde, Munich

CONCISE BIBLIOGRAPHY

BEURDELEY, C. and M. *Chinese Ceramics* (trs. by Katherine Watson). London, 1974.
BEURDELEY M. *Chinese Furniture* (trs. by Katherine Watson). Tokyo and New York, 1979, in preparation.
───────── *Porcelain of the East India Companies* (trs. by Diana Imber). London and New York, 1962.
BRANKSTONE, A.D. *Early Ming Wares of King-tö tchen.* Peking, 1938.
CHENG, TE-K'UN. *Chu China.* Cambridge, 1963.
───────── *Shang China.* Cambridge, 1960.

China

DOHRENWEND, D. *Chinese Jades in the Royal Ontario Museum.* Toronto, 1971.

ECKE, G. *Chinese Domestic Furniture.* Peking, 1944; reprint, Tokyo and Rutland, Vt., 1962.

FONTEIN, J. and WU, TUNG. *Unearthing China's Past.* Exhibition catalogue: Museum of Fine Arts, Boston, 1973.

GARNER, SIR HARRY. *Chinese Lacquer.* London, 1979.

———————————— *Chinese and Japanese Cloisonné Enamels.* London, 1962; 2nd edn. 1970.

———————————— *Oriental Blue and White.* London, 1954; 3rd edn. 1970.

GOIDSENHOVEN, J.P. VAN. *Héros et divinités de la Chine.* Brussels, 1971.

———————————— *La céramique chinoise.* Brussels, 1953.

GOMPERTZ, G. ST. G.M. *Chinese Celadon Wares.* London, 1958; 2nd edn. 1980.

GYLLENSVÄRD, B. *Chinese Gold and Silver in the Carl Kempe Collection.* Stockholm, 1953.

JENYNS, R. SOAME. *Later Chinese Porcelain.* London, 1951; 4th edn. 1971.

———————————— and WATSON, W. *Chinese Art—IV: The Minor Arts II.* Fribourg, 1965.

———————————— *Chinese Art—II: The Minor Arts.* London, 1963.

KARLGREN, B. and WIRGIN, J. *Chinese Bronzes.* London, 1969.

LEE, YU-KUAN, *Oriental Lacquer Art.* Tokyo, 1972.

LEFEBRE-D'ARGENCE, R.Y. *Chinese, Korean and Japanese Sculpture.* The Avery Brundage Collection, Asian Art Museum, San Francisco, 1974.

LION-GOLDSCHMIDT, D. *Ming Porcelain* (trs. by Katherine Watson). London, 1978.

———————————— *Les poteries et porcelaines chinoises.* Paris, 1957.

———————————— and MOREAU-GODARD, J.C. *Chinese Art—I: Bronze, Jade, Sculpture, Ceramics* (trs. by Diana Imber). Foreword by G. Savage. London, 1960; reprinted London, 1966; New York, 1971.

LOEHR, M. *Ancient Chinese Jades.* Cambridge, 1975.

MEDLEY, M. *Yüan Porcelain and Stoneware.* London, 1974.

PIRAZZOLI-T'SERSTEVENS, M. and BOUVIER, N. *Living Architecture: Chinese* (trs. by Robert Allen). London, 1971.

POPE, J.A. *Chinese Porcelains from the Ardebil Shrine.* Washington, D.C., 1956.

———————————— *Fourteenth-century Blue and White: A Group of Chinese Porcelains in the Topkapu Sarayi Müzesi, Istanbul.* Washington, D.C., 1952.

RIDDELL, S. *Dated Chinese Antiquities, 600–1650.* London, 1979.

SIREN, O. *History of Early Chinese Art.* London, 1975.

———————————— *Chinese Sculpture from the Fifth to the Fourteenth Centuries.* 4 vols. London, 1975.

SPEISER, W., GOEPPER, R. and FRIBOURG, J. *Chinese Art—III: Painting, Calligraphy, Stone Rubbing, Wood Engraving* (trs. by Diana Imber). London, 1964.

SUGIMURA, YUZO. *Chinese Sculpture, Bronzes and Jades in Japanese Collections.* Tokyo, 1966.

TREGEAR, M. *Arts of China: Recent Discoveries.* London, 1968.

WATSON, W. *Archaeology in China.* London, 1960.

———————— *Ancient Chinese Bronzes.* London, 1962; 2nd edn. 1977.

———————— *Handbook to the Collections of Early Chinese Antiquities.* London, 1962.

———————— *The Genius of China.* Exhibition catalogue. London, 1973.

Wen Wu (Archaeological magazine published by the People's Republic of China). Peking.

WILLETTS, W. *Foundations of Chinese Art.* London, 1965.

WILLIAMS, C. A. S. *Encyclopedia of Chinese Symbolism and Art Motives.* London, 1961.

———————— *Outlines of Chinese Symbolism.* Peking, 1931.

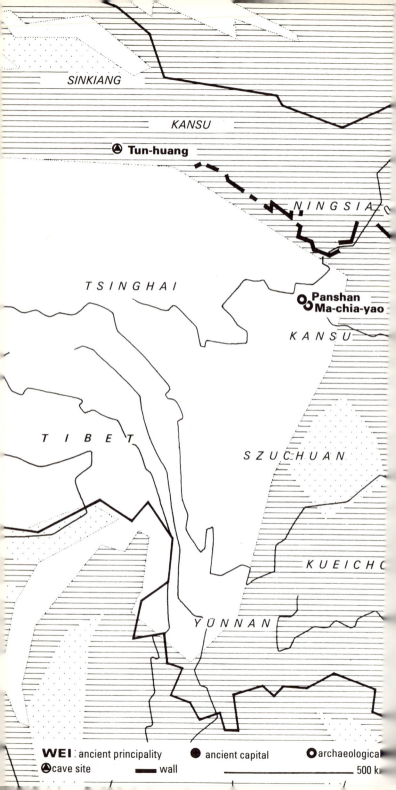

SINKIANG

KANSU

⚫ Tun-huang

NINGSIA

TSINGHAI

◎ Panshan
◎ Ma-chia-yao

KANSU

TIBET

SZUCHUAN

KUEICHO

YÜNNAN

WEI : ancient principality　　● ancient capital　　◐ archaeologica
◭ cave site　　━━ wall　　━━━━━━━━━━ 500 k

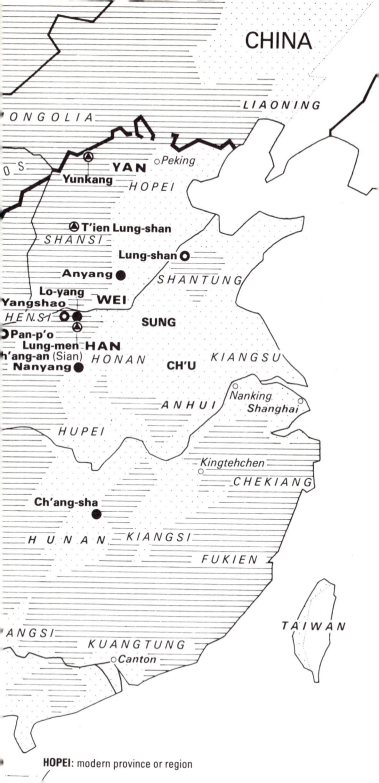

CHINA

LIAONING

MONGOLIA

OS

▲ YAN ○ Peking

Yunkang

HOPEI

▲ T'ien Lung-shan

SHANSI

Lung-shan ◎

● Anyang

SHANTUNG

Lo-yang

WEI

Yangshao ◎─

HENSI ●▲

SUNG

○ Pan-p'o Lung-men HAN

Ch'ang-an (Sian) *HONAN* CH'U

● Nanyang

KIANGSU

ANHUI ○ Nanking

Shanghai ○

HUPEI

○ Kingtehchen

CHEKIANG

● Ch'ang-sha

HUNAN *KIANGSI*

FUKIEN

TAIWAN

ANGSI

KUANGTUNG

○ Canton

HOPEI: modern province or region

China

CHRONOLOGY

Neolithic period	*c.* 7000–*c.* 1750 B.C.
Shang dynasty	*c.* 1750–1028
Chou dynasty	1027–221
Warring States period	481–221
Ch'in dynasty	221–206
Han dynasty	206 B.C.–A.D. 220
'Six Dynasties':	220–581
– Three Kingdoms	220–280
– Chin dynasty	265–419
– Tartar Wei dynasty	386–534
– Northern Ch'i dynasty	550–577
Sui dynasty	581–618
T'ang dynasty	618–906
'Five Dynasties'	906–960
Sung dynasty:	960–1279
– Northern Sung	960–1127
– Southern Sung	1127–1279
Mongol Yüan dynasty	1279–1368
Ming dynasty	1368–1644
Manchu Ch'ing dynasty	1644–1911
Republic of China	1911
People's Republic of China	1949

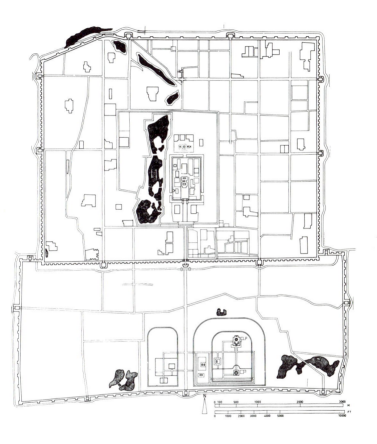

1 Peking with city walls during Ming and Ch'ing dynasties: (centre)
 Imperial Palace, (north) Coal Hill, (south) Temple of Heaven

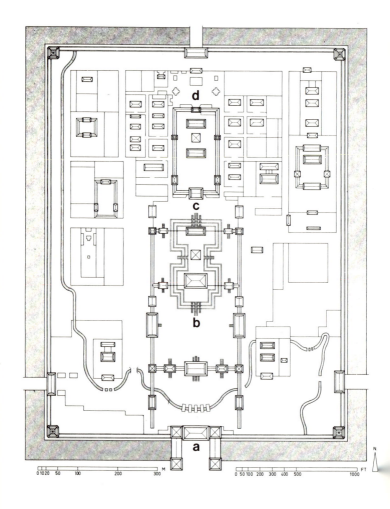

2 The Forbidden City or Imperial Palace: a) Southern entrance-gate, River of Golden Water b) Pavilion of Supreme Harmony and Pavilion of Protecting Harmony c) Gate of Celestial Purity d) Garden and Imperial Pavilion

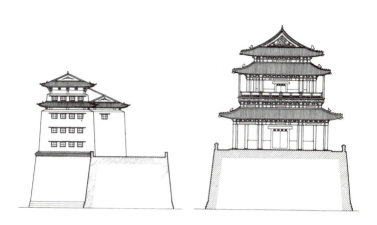

3–4 Inner tower, P'ing-tzu (now Fu Ch'eng-men) Gate, from M. Pirazzoli-
 t'Serstevens and N. Bouvier, *Living Architecture: Chinese*

5 Outer tower, Ch'ien-men (before restoration): main gateway of Peking
 in the south, in line with the Imperial Palace

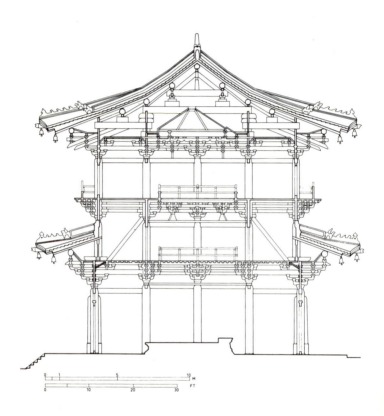

6 Kuan-yin Temple: Liao, 984, Chi-hsien, Hopei (90 km./56 miles from Peking), in the centre: terracotta statue of the goddess Kuan-yin, H. 15 m.

7–8 Various methods of arranging stones in the construction of bridge
arches

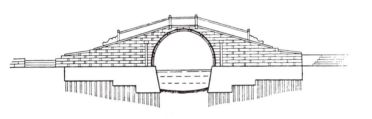

9 Elevation of a single-arched bridge, stone, from W. Willetts, *Foundations
of Chinese Art*

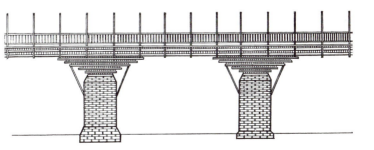

10 Part of the Liling cantilever bridge, Hunan, from W. Willetts, *Founda-
tions of Chinese Art*

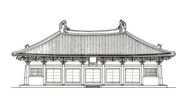

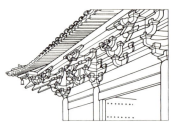

11
Main hall of the Fo Kuang-ssu,
850–60, Wu-t'ai Shan, Shansi

12
Detail of the system of corbelling:
Fo Kuang-ssu, 850–60, Wu-t'ai
Shan, Shansi

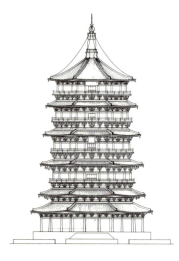

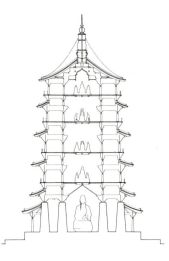

13
Shin-chia pagoda, 1056, Fo Kuang-
ssu, Wu-t'ai Shan, Shansi

14
Cross-section of the Shin-chia
pagoda, with large statue of the
Buddha

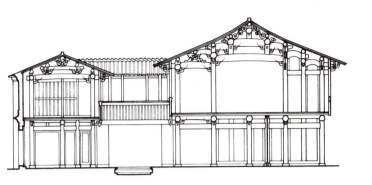

15 Plan: ground floor and first floor of a Ming house, Hsi-chinan, Huichou, Anhui

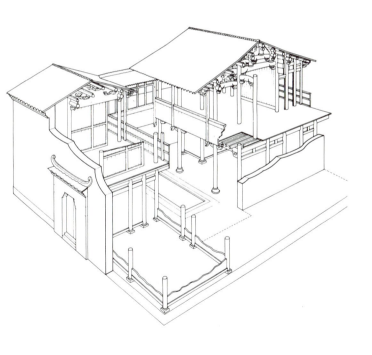

16 Axonometric plan: interior of a house in a Ming village

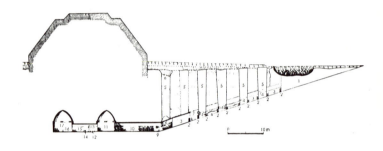

17 Tomb of Princess Yung T'ai, T'ang, A.D. 706, Ch'ien-hsien, Shansi:
1) entrance-passage 3) outer corridor 5) supporting columns 11) ante-
chamber 14) stone gateway 15) Empress's corridor 17) Empress's chamber
18) stone coffin

18 Plan: some caves in the Yunkang group, 2nd half of the 5th c.

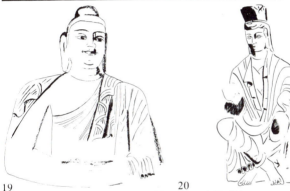

19
Seated Buddha, sandstone, H.
(visible part) 7.90 m., Northern
Wei, 386–543, Yunkang, *in situ*

20
Seated Bodhisattva, sandstone, H.
1.43 m., Northern Wei, 386–543,
Yunkang, *in situ*

21 Buddha and assistants, sandstone, Northern Ch'i, 550–77, T'ien-lung
Shan, Shansi, *in situ*

22 Horse trampling a barbarian, H. 1.88 m., Western Han, tomb of Ho
 Ch'ü-p'ing, *in situ*

23 'The red bird', low relief, L. 50 cm., Eastern Han, 1st–2nd c., Sichuan,
 in situ

24 Camel: from avenue leading to the tombs of the Ming rulers, stone,
 15th c., *in situ*

25 Female celestial musician, grey limestone, H. 64 cm., Northern Wei, Lung-men caves, Honan, *in situ*

26
Dvarapāla (guardian) and Avaloki-teśvara on a bull, Northern Wei, late 5th c., Yunkang, *in situ*

27
Bodhisattva on lotus-shaped plinth, stone, H. 63 cm., 2nd half of the 6th c., T'ien-lung Shan

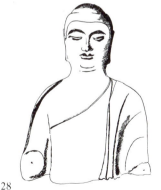

28
Bust: priest, dark grey limestone, H. 47 cm., T'ang, early 7th c., Lung-men caves, formerly Kelekian Coll.

29
Guardian-king, late 7th c., Lung-men caves, Honan, *in situ*

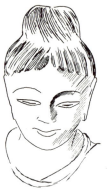

30
Earliest representation of the Buddha found in China, dated A.D. 338

31
Buddha: head, hairstyle influenced by Mathurā art, Northern Wei, 477

32
Bodhisattva: head, grey limestone, early 6th c., Lung-men caves, Honan

33
Avalokiteśvara with the effigy of Amitābha, grey limestone, Northern Ch'i, 550–70

34
Buddha: head, micaceous marble, Sui, dated 585, found in Hopei

35
Buddha: head, dry lacquer on wood, T'ang, early 7th c., Hopei

36
Buddha: close, stylized folds, Northern Wei, late 5th–early 6th c.

37
Seated Buddha: wide curvilinear, falling folds, Northern Wei, 6th c.

38
Standing Buddha adorned with jewels: 'moulded' robe, Sui, late 6th c.

39
Seated Buddha: with more regular folds, Sui, late 6th–early 7th c.

40
Seated Buddha: pleats close to the body, curved folds at the knee, late 7th c.

41
Standing Buddha: folds inspired by Indian Gandhāran art, T'ang, 8th c.

42
Standing Buddha: headless, softer Gandhāran folds, T'ang, c. 670, private coll., Paris

43
Bodhisattva: torso, triple flexion inspired by Indian art, 9th c., A.A. Mus., San Francisco

44
Kuan-yin in posture of royal ease: looser folds, Sung, 12th c., A.A. Mus., San Francisco

45
Bodhisattva P'u-hsien on an elephant: many gold ornaments, 14th c., A.A. Mus., San Francisco

46
Buddha on lotus-shaped plinth: folds arranged in regular fashion, Ming, 16th c., A.A. Mus., San Francisco

47
Standing Kuan-yin, loosely arranged folds, late Ming, 17th c., private coll., Paris

48
Warrior, terracotta, H. 1.84 m., Ch'in dynasty, 221–207 B.C., Museums, P. Rep. China

49
Man: bust, on top of pillar, grey terracotta, H. 1.30 m., Han period, A.A. Mus., San Francisco

50
Warrior, clay with straw-yellow glaze, H. 83 cm., early T'ang period, 7th c., A.A. Mus., San Francisco

51
Dvarapāla in armour, polychrome wood, 9th–10th c., Tun-huang, Kansu, Guimet Mus., Paris

52
Dancer, terracotta, H. *c.* 38 cm., Yüan, 1260–1367; discovered: 1963 at Honan, Museums, P. Rep. China

53
Officer: from avenue leading to tombs of Ming emperors, stone, H. *c.* 3 m., 15th c., *in situ*

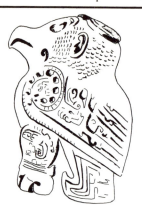

54 Stylized owl, white marble, H. *c.* 40 cm., Anyang: capital of Shang
 dynasty, Academia Sinica, Taipei

55 Small stylized bear, white marble, H. *c.* 40 cm., Anyang, Shansi,
 Academia Sinica, Taipei

56 Unicorn, painted wood, L. 59 cm., later Han dynasty, Wu-wei, Kansu,
 Museums, P. Rep. China

57
Winged lion guarding tomb, grey limestone, L. 3.60 m., early 6th c., near Nanking, *in situ*

58
Chimera: one horn, grey limestone, H. 86 cm., Liang period (?), 502 to 527, A.A. Mus., San Francisco

59
Seated lion: unferocious, typical of Sui period, 589–618, limestone, H. 44 cm., A.A. Mus., San Francisco

60
Chimera: guardian against spirits, glazed terracotta, H. 1 m., mid-T'ang period, A.A. Mus., San Francisco

61
'Dog of Fo', sandstone, green and amber glaze, H. 1.06 m., Ming period, 15th c., A.A. Mus., San Francisco

62
Lion guarding doorway, white marble, H. 80 cm., Ch'ing dynasty, 18th to 19th c., A.A. Mus., San Francisco

63
Chen kuei: symbol of Imperial power, dark green jade, H. 30 cm., Chou period

64
Ku kuei: plaque with 'grain' pattern, green jade, Chou period

65
Reverse of No. 64. showing decoration of lozenges

66
Kuei: plaque, jade, early Chou period

67
Yen kuei: pointed plaque, black jade, Chou period

68
Ya chang: plaque, jade, H. 43 cm., late Chou period

69
Fish-shaped pendant (?), Chou period or earlier

70
Silkworm, greyish-green jade, and doe, greenish-white jade, Han period

71
Bird-shaped harpin, ivory jade, traces of painting, Shang period (?)

72
Hare, Shang or early Chou period

73
Kuei dragon, green jade, traces of painting, early Chou

74
Cicadas: funerary jades, light green, Han period

75 *Pi* disc, white, decalcified jade with 'grain' pattern, D. 12 cm., Shang
period (?)

76 *Pi* disc with scrolls, greyish-green jade, D. 15 cm., Warring States
period

77
Ts'ung: symbol of the earth, brown jade, H. 10 cm., Chou period

78
Large *ts'ung:* grooves and volutes, dark green jade, D. 19 cm., Chou period

79 Plaque: 2 dragons, L. 30 cm., Chou period, discovered at Hopei

80 Princess Tou Wan: funeral suit of armour, 2,156 plaques of green jade sewn with gold thread, L. 1.72 m., discovered: 1968 at Man ch'eng (near Peking), Western Han period, Museums, P. Rep. China

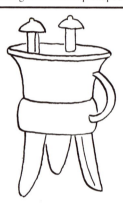

81
Hu: ritual wine vase

82
Ku: wine goblet with cup-shaped rim

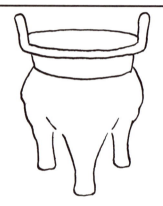

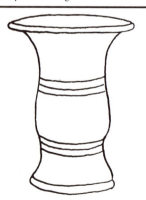

83
Li: tripod cooking vessel

84
Chia: ritual tripod wine vessel

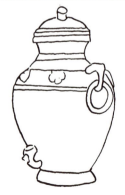

85
Tsun: round or square wine vessel

86
Lei: wine vessel, more rounded than the *hu*

87
Chüeh: tripod wine goblet with pouring lip

88
Huang: wine vessel

89
Ting: tripod cooking vessel

90
Kuei: ritual food vessel (for grain)

91
Yu: ritual wine bucket

92
Fu: ritual food vessel

93
Hsü: ritual food vessel

94
P'an: ritual basin (used with No. 96)

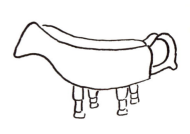

95
Chih: covered goblet for table-wine

96
Yi: vessel for water used in ritual ablutions (with No. 94)

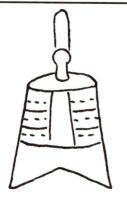

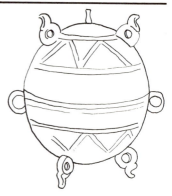

97
Chung: bell (musical instrument)

98
Tui: ball-shaped, lidded, ritual vessel (for food)

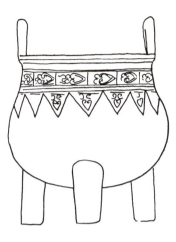

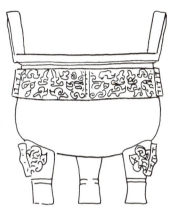

99
Shang dynasty: capital Anyang, *c.* 1300 B.C.

100
Shang dynasty: capital Anyang, *c.* 1100 B.C.

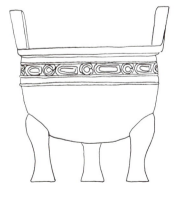

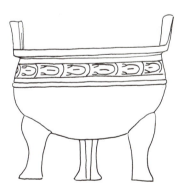

101
Beginning of the Spring and Autumn Annals period, 722–481 B.C.

102
Middle of the Spring and Autumn Annals period, 722–481 B.C.

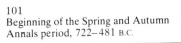

103
Shang dynasty: capital Cheng-chou, *c.* 1500 B.C.

104
Shang dynasty: capital Anyang, *c.* 1300 B.C.

105
Period of the Western Chou dynasty, 1027–771 B.C.

106
Middle of the period of the Western Chou dynasty, *c.* 850 B.C.

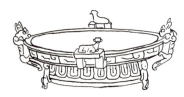

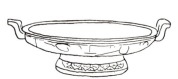

107
Middle of the Spring and Autumn Annals period, 722–481 B.C.

108
Warring States period, 480–221 B.C.

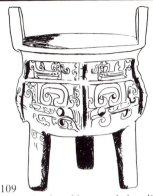

109
Ting: tripod cooking vessel, *t'ao-t'ieh* mask, H. 22.7 cm., Shang dynasty, Mus., P. Rep. China

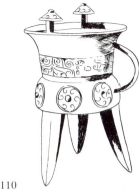

110
Chia: wine warmer, decoration: *t'ao-t'ieh* mask and spirals, Shang dynasty, Mus., P. Rep. China

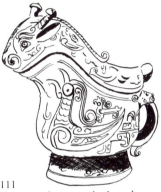

111
Huang: wine vessel shaped as a mythical animal, L. 31.5 cm., Shang dynasty, Mus., P. Rep. China

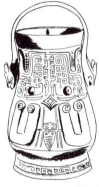

112
Hu: ritual wine vase with *t'ao-t'ieh* mask and cicada, H. 42 cm., late Shang dynasty, Mus., P. Rep. China

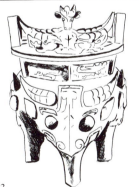

113
Li: tripod cooking vessel: lid, *t'ao-t'ieh,* mask, H. 27.5 cm., Western Chou dynasty, Mus., P. Rep. China

114
Hsien: tripod cooking vessel, 2 parts, rope-pattern decoration, H. 53 cm., Shang dynasty, Mus., P. Rep. China

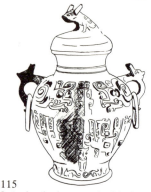

115
Lei: ritual wine vessel with dragons, *t'ao-t'ieh* mask, H. 27.5 cm., Western Chou dynasty, Mus., P. Rep. China

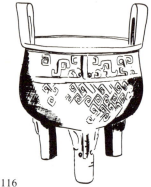

116
Ting: tripod cooking vessel, geometric decoration, H. 85 cm., Western Chou dynasty, Mus., P. Rep. China

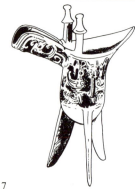

117
Chüeh: wine goblet with birds, H. 22 cm., Western Chou dynasty, 11th to 10th c. B.C., Mus., P. Rep. China

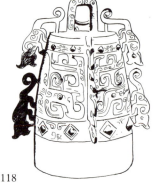

118
Chung: bell (musical instrument), *k'uei* dragons, H. 42 cm., Western Chou dynasty, Mus., P. Rep. China

119
Fu: ritual food vessel, *k'uei* dragons, H. 7.5 cm., Spring and Autumn Annals period, Mus., P. Rep. China

120
Ting: with intertwined dragons, H. 55 cm., Warring States period, 480 to 221 B.C., Mus., P. Rep. China

121

Ko: halberd blade with stylized dragon motif on the tang, bronze, Western Chou dynasty, 11th–10th c. B.C.

122

Ting, beginning of Warring States period, 480–221 B.C.

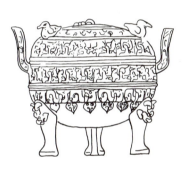

123

Ko: halberd blade with feline head on the tang, bronze, Western Chou dynasty, 11th–10th c. B.C.

124

Ting, mid-Warring States period, 480–221 B.C.

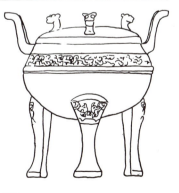

125

Ko: halberd blade with *t'ao-t'ieh* design on the tang, bronze, Western Chou dynasty, 9th–8th c. B.C.

126

Ting, beginning of the Ch'in dynasty, 255–207 B.C.

127
Knife: haft ending in a ram's head,
11th–10th c. B.C.

128
Knife: haft ending in a ram's head,
11th–10th c. B.C.

129
Knife: straight haft, curved blade,
7th–5th c. B.C.

130
Knife: narrow haft ending in affront-
ing heads of 2 birds, 7th–5th c. B.C.

131
Dagger: grooved haft ending in a
feline animal, 7th–5th c. B.C.

132
Dagger: grooved haft, double-edged
blade, 7th–5th c. B.C.

133
Clasp with intertwined dragons, bronze, 3rd c. B.C.

134
Small clasp with *t'ao-t'ieh* mask and inlaid glass, bronze, 3rd c. B.C.

135
Clasp with intertwined animals, bronze, 1st–2nd c. A.D.

136
Clasp: inlaid design of turquoises, bronze, 3rd c. B.C.

137
Small clasp shaped as a winged dragon, bronze, 4th–3rd c. B.C.

138
Clasp: inlaid design of turquoises, 4th–3rd c. B.C.

139
Mirror with scrolls, 6th–5th c. B.C., M.F.E.A., Stockholm

140
Mirror with 4 leaves on background of scrolls, 6th–5th c., B.C., M.o.K., Berlin

141
Mirror with 5 inclined 'T' motifs, 3rd c. B.C., private coll., Sweden

142
Mirror with 3 dragons on background of intertwined 'T's, 3rd c. B.C., M.F.E.A., Stockholm

143
Mirror with star-shaped motif, 3rd c. B.C., Coll. of H.M. King Carl XVI Gustav, Sweden

144
Mirror with intertwined stylized dragons, 3rd–2nd c. B.C., M.o.K., Berlin

145
Mirror with intertwined dragons and
zigzags, 3rd–2nd c. B.C., Coll. of
H.M. King Carl XVI Gustav, Sweden

146
Mirror with 'TLV' motifs and very
stylized dragons, 2nd c. B.C.,
M.F.E.A., Stockholm

147
Mirror with star motif and 4 dragons,
1st c. B.C., M.F.E.A., Stockholm

148
Mirror with 'TLV' motifs, tigers and
dragon band around rim, 1st c. B.C.
to 1st c. A.D., M.F.E.A., Stockholm

149
Multifoil mirror: intertwined flowers
and birds, T'ang dynasty, formerly
Beurdeley coll., Paris

150
Multifoil mirror: scroll decoration,
border of petals, T'ang dynasty,
formerly Beurdeley coll., Paris

151
Lei wen meanders

152
Braids

153
K'uei dragon with a crest and with a trunk-shaped mouth

154
K'uei dragon with an elephant's trunk and with the curved beak of a bird

155 Mask of a fantastic animal (a monster called *t'ao-t'ieh*) usually on a background of *lei wen* motifs

156
Cicadas

157
Decoration of tiles and scales

158 Decoration of spirals and meanders

159 Decoration of spirals and meanders

427

160
Flying horse on a swallow, bronze, H. 34.5 cm., Eastern Han, 1st–3rd c., Museums, P. Rep. China

161
Lamp carried by kneeling figure, H. 48 cm., Eastern Han, Museums, P. Rep. China

162
Stele: 2 Buddhas with flaming mandorla, H. 16 cm., Northern Wei, dated 472, A.A. Mus., San Francisco

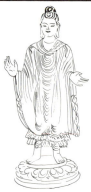

163
Standing Buddha Maitreya, H. 1.43 m., Northern Wei, dated 477, Rockefeller Coll., New York

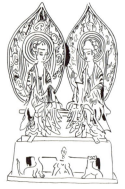

164
Stele: Śākyamuni and Prabhutaratna in a mystical conversation, H. 26 cm., dated 518, Guimet Mus., Paris

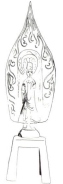

165
Standing Bodhisattva: Wei style, H. 24 cm., Sui dynasty, dated 589, A.A. Mus., San Francisco

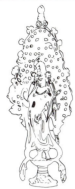

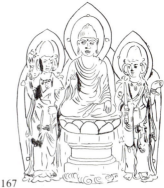

166
Kuan-yin in front of a pierced mandorla, H. 30 cm., T'ang, late 7th to early 8th c.

167
Buddhist triad, H. 22 cm., probably Sung, 960–1279, A.A. Mus., San Francisco

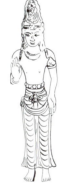

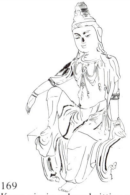

168
Standing Kuan-yin, H. 47 cm., 10th–11th c., Yün-nan, A.A. Mus., San Francisco

169
Kuan-yin in relaxed sitting position, H. 35 cm., late Yüan–early Ming, A.A. Mus., San Francisco

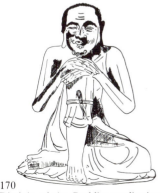

170
Disciple of the Buddha meditating, H. 55 cm., late Ming–early Ch'ing, 17th c., A.A. Mus., San Francisco

171
The Buddha Śākyamuni as a child, H. 18 cm., Ch'ing dynasty, 1644 to 1911, A.A. Mus., San Francisco

172
Incense-burner with handles

173
Incense-burner with 'millepede' handles

174
Incense-burner with handles

175
Incense-burner with fish-shaped handles

176
Tripod incense-burner with twisted handles and lobate body

177
Incense-burner with handles in the shape of halberd blades

178–80 a–b) Late coins, Chou c) late coin with rounded edges, early Han
d) late coin with squared edges, early Han e) late coin with pointed ends,
early Han f–g–h) knife-shaped coins, early Han i) drop-shaped coin,
late Chou j) circular coin with round hole, late Chou k) circular coins with
square holes

431

181
Goblet with flowers and palmettes, engraved silver, H. 6 cm., T'ang, late 7th c., Carl Kempe coll., Sweden

182
6-faceted cup with floral garlands, engraved silver, H. 6.5 cm., D. 7.7 cm., Carl Kempe coll., Sweden

183
Saucer-shaped spittoon, engraved gilt silver, H. 10.3 cm., Carl Kempe coll., Sweden

184
6-lobed bowl: saucer-shaped cover, engraved silver, H. 11 cm., D. 24 cm., Carl Kempe coll., Sweden

185
Cover of No. 184: lotus flowers and 'peacock-feather' border

186
8-lobed stem-cup, silver, H. 43 cm., Carl Kempe coll., Sweden

187
Ornament, gold inlaid with turquoises, D. 3.3 cm., Carl Kempe coll., Sweden

188
Small ladle: handle with the head of a duck, engraved silver, L. 26 cm., Carl Kempe coll., Sweden

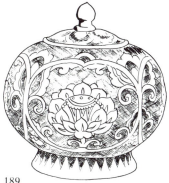

189
Round box with lotus flowers: bud-shaped lid, engraved silver, H. 6.3 cm., 8th c., Carl Kempe coll., Sweden

190
Flat shell-shaped box: grapes and birds, silver, L. 9.5 cm., 9th–10th c., Carl Kempe coll., Sweden

191
Box shaped as lotus leaf, engraved silver, L. 8.1 cm., Carl Kempe coll., Sweden

192
Lid of No. 191 with ducks beating their wings

193
Bowl with lotus petals, gilt, chased and embossed silver, D. 45 cm., late 9th c., Carl Kempe coll., Sweden

194
Detail of No. 193: each petal has 2 birds separated by a flower

195
6-lobed stem-cup on conical foot, silver, H. 5.5 cm., L. 15.4 cm., late 9th c., Carl Kempe coll., Sweden

196
Small dish with lotus flowers, gold, D. 13.6 cm., Sung dynasty, Carl Kempe coll., Sweden

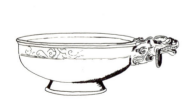

197
Cup with dragon-shaped handle, gold, D. 8.2 cm., Sung dynasty, Carl Kempe coll., Sweden

198
Cup: Chang-chien on a raft, silver, L. 20.5 cm., Yüan, dated 1345, P.D.F., London

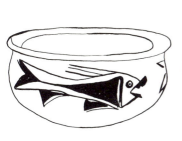

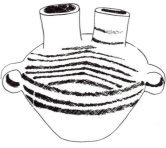

199
Bowl: Pan-p'o culture, red pottery, black decoration, H. 16 cm., 4th to 3rd mill. B.C., Mus., P. Rep. China

200
Vase with 2 mouths: Yangshao culture, red pottery, H. 11 cm., 3rd mill. B.C., Mus. Cernuschi, Paris

201
Bowl: Yangshao culture, painted pottery, H. 18 cm., early 3rd mill. B.C., Miao-ti-kou, Mus., P. Rep. China

202
Kuan: funerary urn, Panshan culture, pottery: spiral motifs, H. 30 cm., early 2nd mill. B.C.

203
Two-handled vase, fine-grained lustrous pottery, H. 31 cm., 2nd mill. B.C., Academia Sinica, Taipei

204
Kuan: funerary urn, Panshan culture, geometric decoration, H. 32 cm., early 2nd mill. B.C., Mus.,P.Rep.China

435

205
Vase: found in the Shang royal tombs, white pottery with relief decoration, H. 33 cm., F.G.A., Washington, D.C.

206
Lidded jar: geometric relief decoration, meanders, white pottery, H. 20 cm., A.A. Mus., San Francisco

207
Jue: wine vessel, based on Neolithic shapes, terracotta, H. 13 cm., M.F.E.A., Stockholm

208
Ting: tripod vessel with imitation braid, H. 28 cm., Honan, Museums, P. Rep. China

209
Hsien: tripod cooking vessel, corded decoration, H. 40 cm., Museums, R. Rep. China

210
Lei: ritual wine vessel, H. 28 cm., *c.* 1300–1100 B.C., Buffalo Mus. of Science, Buffalo, N.Y.

211
Tou: lidded stem-cup, grey glazed pottery, H. 37 cm., Eastern Chou, Mus. of Fine Arts, Boston

212
Hu: ritual vase with handles, grey terracotta, H. 19 cm., Eastern Chou, Buffalo Mus. of Science, Buffalo, N.Y

213
Kuan: black glazed pottery, H. 28 cm., Warring States period, Szu-ch'uan, B.M., London

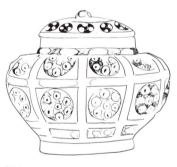

214
Lidded jar, pottery, inlaid glass cabochons, H. 11 cm., Warring States period, N.G.A., Kansas City

215
Ting: tripod lidded vase, pottery, H. 15 cm., Warring States period, Ch'ang-sha, private coll., Paris

216
Hu, grey pottery painted red, H. 58 cm., 3rd c. B.C., A.A. Mus., San Francisco

217
Lian: hill-jar, evoking the Taoist islands of the Immortals, H. 23 cm., V. & A., London

218
Hu: relief band depicting hunting scene, pottery, green lead glaze, H. 40 cm., private coll., Geneva

219
Ting: bear-shaped feet, green-glazed pottery, H. 15 cm., private coll., Paris

220
'*Po-shan-lu*' incense-burner: hill-shaped, pierced top, H. 16 cm., private coll., Paris

221
P'iao: ladle with dragon-shaped handle, green-glazed pottery, L. 23 cm., V & A., London

222
Hu, porc. stoneware—prototype of porcelain, H. 32 cm., late Han, V. & A., London

223
Ewer: spout: cock's head, porc. stoneware, brownish-black glaze, H. 21 cm., formerly Beurdeley coll., Paris

224
Jug in the Ch'ang-sha style: vertical grooves, H. 20 cm., private coll., Tokyo

225
Jar: tigers' heads in relief, porc. stoneware, celadon-green glaze, H. 23 cm., A.A. Mus., San Francisco

226
Small basin, porc. stoneware, olive-green celadon glaze, D. 20 cm., Six Dynasties period, V. & A., London

227
'Po-shan-lu' incense-burner as lotus bud, white-glazed stoneware, H. 24 cm.

228
Lidded jar with 4 handles, cream-glazed porc. stoneware, H. 28 cm.

229
Vase with short neck, cream-coloured porc. stoneware, H. 26 cm.

230
Bottle: classic shape up to the 18th c., stoneware, H. 22 cm.

231
Spherical pot, cream-coloured porc. stoneware, glaze: light grey, slightly granular, H. 20 cm.

232
Ewer with dragon-shaped handle, stoneware, celadon glaze, H. 24 cm., Kiang-su

233
Bottle with elongated neck

234
Vase with handles and a wide mouth

235
Pilgrim bottle

236
Bottle with short neck

237
Ewer inspired by the *oinochoe*

238
Bottle with elongated neck on a high foot

239
Simple ewer

240
Amphora with 2 dragon-shaped handles

241
Ewer with spout shaped as a bird's head

242
Ewer with a chimera-shaped handle

243
Gourd-shaped jug

244
Ewer with a spout shaped as a cock's head

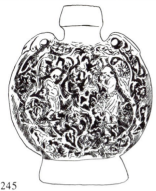

245
Pilgrim bottle: moulded decoration
(grape-harvest?), olive-brown glaze,
early T'ang, V. & A., London

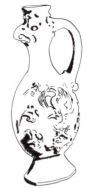

246
Ewer with phoenix, caramel-brown
and blue glazes, H. 32 cm., formerly
Beurdeley Coll. Paris

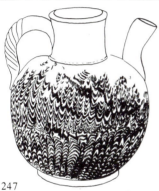

247
Ewer: marbled agate decoration
imitating Phoenician glassware, H.
12 cm., Mrs. A. Clark Coll., G.B.

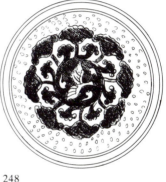

248
Dish inspired by Sassanian wares,
san-ts'ai (3-colour) lead glaze, D.
31 cm., formerly M. Calmann Coll.

249
Duck-shaped vase, orange-yellow
glaze, L. 32 cm., A. A. Mus., San
Francisco

250
Vase with handles, brown porc.
stoneware, black glaze, H. 19 cm.,
J.-M. Beurdeley Coll., Paris

251
Multifoil cup, cream-coloured porc. stoneware, *san-ts'ai* glaze, D. 13.6 cm., *c.*1090, A.A.Mus.,San Francisco

252
Pilgrim bottle, floral decoration, green and yellow glazes, H. 20 cm., A. A. Mus., San Francisco

253
Bottle with phoenix head surmounted by octagonal-cup spout, H. 38 cm., private coll., Milan

254
Baluster vase, funnel-shaped neck and mouth: shape from T'ang wares, H. 23 cm., private coll., Milan

255
Hsi: square dish for washing brushes, porcelain, floral motif, L. 11 cm., Mus. of Art, Cleveland

256
Narrow ovoid jar, called 'chicken leg', greyish-green glaze, H. 64 cm., private coll., Milan

257
6-lobed bowl: *Chün* ware, D. 20 cm., 12th c., E. Chow Coll., Geneva

258
Handled jar: white lines on a blackish-brown ground, H. 15 cm., Honan/Hopei, Capt. D. Malcolm Coll.

259
Funerary jar: relief decoration, stoneware, celadon glaze, H. 18 cm., Southern Sung period, A. Clark Coll.

260
Alms bowl, *Chün* ware, stoneware, lavender-blue glaze, D. 18 cm., E. Chow Coll., Geneva

261
Bottle with elongated neck: *Kuan* ware, H. 21 cm., from Chiao-t'an factory near Hangchou 1127–1279

262
Cylindrical vase, bluish celadon, H. 18 cm., early 12th c., Hsiu-nei-ssu factory, Nezu Mus., Tokyo

263
Small bowl with incised duck, cela-
don, D. 17 cm., Northern Sung 960
to 1127, J.-M. Beurdeley Coll., Paris

264
Mei-p'ing vase: *Tz'u-chou* ware,
brown peonies, cream ground, H. 41
cm., 12th c., Hosakawa Coll., Tokyo

265
Baluster vase: *Tz'u-chou* ware, black
peonies on green ground, H. 14 cm.,
late Sung, 12th c., private coll., Japan

266
Bottle: incised peonies, celadon, H.
27 cm., Northern Sung, Michel Cal-
mann Bequest, Guimet Mus., Paris

267
Mei-p'ing vase: *Tz'u-chou* ware with
brown peonies, H. 38 cm., Northern
Sung, V. & A., London

268
Mei-p'ing vase: *Tz'u-chou* ware,
blackish-brown lotus, H. 40.6 cm.,
Northern Sung, B. M., London

269/270 Examples of friezes showing stylized lotus petals

271
Small dish: white dragon reserved on blue ground, D. 16 cm., P. D. F., London

272
Tripod incense-burner with masks in relief on sides, D. 18 cm., F. M. Mayer Coll., U.S.A.

273
Dish: cobalt-blue clouds and waves, D. 47 cm., 2nd half of the 14th c., Topkapu S. M., Istanbul

274
Dish, celadon, dragon, clouds and flowers in biscuit, D. 43 cm., Topkapu S. M., Istanbul

275
Kendi: water-cooler, porcelain, peonies in underglaze copper red, H. 14 cm., the late Sir H. Garner Coll.

276
Tall temple vase, blue-and-white porcelain, H. 63 cm., dated 1351, Chien-hsi, P. D. F., London

277
Octagonal vase: panels in biscuit, H. 25 cm., Lung-ch'üan, Phil. Mus. of Art, Philadelphia

278
Bottle vase: short, 'Three-Friends' motif, underglaze copper red, H. 32 cm., J. M. Addis Coll., U.S.A.

279
Mei-p'ing vase: peonies, blue-and-white porcelain, H. 45 cm., Metropolitan Mus., New York

280
Tall baluster vase: moulded floral decor, stoneware, celadon glaze, H. 72 cm., City Art Mus., St. Louis

281
Ya-shou-pei ritual bowl to hold offerings of water, D. 20 cm.

282
Bowl in classical shape, D. 17 cm.

283
Lien-tzŭ bowl (shaped as a lotus seed), D. 16 cm.

284
Small teapot; usually without decoration, white porcelain

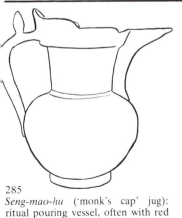

285
Seng-mao-hu ('monk's cap' jug): ritual pouring vessel, often with red glaze

286
Mei-p'ing vase, H. 31 cm.

288
Ewer: Near Eastern type, blue or copper-red underglaze decoration, H. 25 cm.

287
Lidded wine-jar, H. 28 cm.

289
Cha-tou or 'leys' jar with wide neck, H. 16 cm.

290
Bottle: underglaze blue or copper-red decoration, H. 34 cm.

291 'Full moon' gourd flask *(pien-hu):* type found again in the 18th c., H. 30.4 cm.

292
Plate: underglaze blue fish and aquatic plants, D. 41 cm., 14th c., Arch. Mus., Teheran

293
Plate: underglaze blue bouquet and peony-scroll border, D. 31 cm., early 15th c., Arch. Mus., Teheran

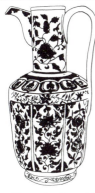

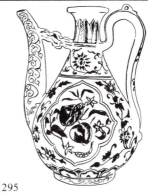

294
Ewer with underglaze blue floral decoration, H. 34 cm., early 15th c., Arch. Mus., Teheran

295
Ewer: Near Eastern type, peaches, floral motifs in underglaze blue, H. 27 cm., 15th c., Arch. Mus., Teheran

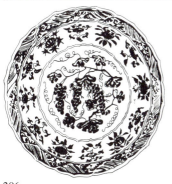

296
Multifoil plate: grapes, peonies, cloud border in underglaze blue, D. 43 cm., early 15th c., Arch. Mus., Teheran

297
Underside of No. 296 with 12 flowers

298
Double-gourd flask: 2 handles, flat belly in underglaze blue, H. 26 cm., Hsüan-te period, Arch. M., Teheran

299
'Full moon' gourd flask with 2 handles: polychrome decoration, H. 37 cm., mid-15th c., private coll.

300
Pot-bellied ewer: Near Eastern type, scrolls in underglaze blue, H. 25 cm., mid-15th c., Arch. Mus., Teheran

301
Jar with peony scroll in underglaze blue, H. 22 cm., mid-15th c., Arch. Mus., Teheran

302
Cup with 5 deer in underglaze blue, D. 35 cm., reign-mark of Chia-ching, 1522–66, Arch. Mus., Teheran

303
Lobed bowl with deer in underglaze blue, D. 14.5 cm., early 16th c., Arch. Mus., Teheran

04
Octagonal ewer: flowers and 2 sages in underglaze blue, H. 14.5 cm., late 16th c., Arch. Mus., Teheran

305
12-lobed plate: (centre) 2 of 8 trigrams *(pa-kua)* and storks, D. 45.5 cm., late 16th c., Arch. Mus., Teheran

06
Elephant-shaped water cooler, blue-and-white porcelain, H. 17 cm., late 16th c., Arch. Mus., Teheran

307
Bowl with plum-tree branches in underglaze blue, D. 25 cm., late 16th c., Arch. Mus., Teheran

08
Vase: 5-clawed dragon in underglaze blue, H. 53 cm., reign-mark: Wan-li, Arch. Mus., Teheran

309
Square vase with mythical animals in underglaze blue, H. 30 cm., T'ien-ch'i period, early 17th c.

310
Hen-shaped wine vessel, *san-ts'ai* (3-colour) biscuit, L. 15 cm.

311
Parrots, turquoise and aubergine or *san-ts'ai* biscuit, H. 28 cm.

312
Dog of Fo or chimera, turquoise and aubergine or *san-ts'ai* biscuit

313
Octagonal wine pot, spout shaped as an elephant's trunk, biscuit

314
Rouleau or cylindrical vase, often with reserved areas of colour on plain ground

315
Potiche: shape typical of the K'ang-hsi period

316
Plate: 60th-birthday gift for Emperor K'ang-hsi, 1713, P.D.F., London

317
Plate, *famille verte* enamels, D. 24 cm., formerly C.T. Loo Coll., Paris

318
Bowl: bird on a branch, *famille verte* enamels, D. 9 cm., private coll., London

319
Potiche with plum tree in flower on white ground, D. 22.5 cm., private coll., London

320
Vase with sapphire-blue floral decoration on white ground, H. 46 cm., formerly C.T. Loo Coll., Paris

321
Baluster vase, biscuit-white, manganese, and green, early K'ang-hsi period, Calouste Gulbenkian M., Lisbon

323
Round box: holds vermilion paste for seals

322
Kuan-yin vase or amphora, similar to the one carried by this goddess, H. 25 cm.

324
Apple-shaped vase, H. 7.2 cm., D. 10.5 cm.

325
3-string vase with 3 rings around the neck, H. 22 cm.

326
Water container known as a 'chicken coop', H. 4 cm., D. 12 cm.

327
Tall vase with lotus-petal or chrysanthemum motifs around the base, H. 20 cm.

328
Bottle vase with coiled dragon in relief on shoulder, H. 18 cm.

329
Gong-shaped bowl for washing brushes, H. 9 cm., D. 12 cm.

457

330
Vase: handles shaped as *ju-i* sceptre, polychrome enamel on purple ground

331
Baluster vase with faceted belly, dragon-shaped handles, blue-and-white porcelain

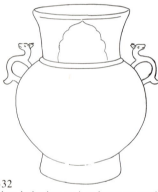

332
Vase imitating ancient bronze vessel, enamelled and gilt, Ching-te Chen factory

333
Vase with 4 small handles, polychrome enamel on blue ground

334
Square vase with bat-shaped handles, *famille rose* enamels, 2nd half of the 18th c.

335
Coupled vases, polychrome enamels (branches)

336
Small potiche, decoration: human figures in polychrome

337
Cylindrical vase: wavy sides, decoration usually monochrome

338
Gourd vase: inspired by a Ming shape, blue-and-white decoration

339
Ribbed vase with wide mouth: inspired by a ritual bronze, lavender-blue enamel, late 18th c.

340
Vase with pierced bird-shaped handles, glaze usually monochrome

341
Double-gourd vase with knot in relief, polychrome glaze with gold highlights

342
Vase with herons and lotus, *famille rose* enamels, H. 17.5 cm.

343
Miniature bottle with bulbous neck, polychrome enamels in European style, H. 8 cm.

344
Bowl, blue, yellow and green enamels, D. 24 cm., early Ch'ien-lung period

345
Bowl, *famille rose* enamels, D. 14.5 cm., early Ch'ien-lung period

346
Potiche, blue and yellow enamels, H. 27.5 cm., early Ch'ien-lung period

347
Leaf-shaped cup, yellow border, D. 27.5 cm., early Ch'ien-lung period

348
Bottle vase: peonies and flowering branches, *famille rose* enamels, H. 42 cm., Yung-cheng period

349
Cup, semi-eggshell porcelain, *famille rose* enamels, D. 20 cm., *c.* 1736–50, formerly C. T. Loo Coll., Paris

350
Plate with Mu Wang's horses, *famille rose* enamels, D. 24 cm., Ch'ien-lung period, private coll., Brussels

351
Plate: duck and peonies, *famille rose* enamels, D. 30 cm., Ch'ien-lung period, private coll., Brussels

352
Gourd: 8 Buddhist emblems, blue-and-white porcelain, H. 45 cm., 1736 to 1795, A.A. Mus., San Francisco

353
Lidded potiche, polychrome reserved on black ground, H. 47 cm., mid-18th c.

354
Potiche, Chia-ching period, 1522 to 1566

355
Potiche, late 16th c.

356
Potiche, mid-17th c.

357
Potiche, K'ang-hsi period, 1662 to 1722

358
Potiche, K'ang-hsi period, 1662 to 1722

359
Potiche, K'ang-hsi period, 1662 to 1722

360
Potiche, Yung-cheng period, 1723 to 1735

361
Potiche with faceted sides, Ch'ien-lung period, 1736–95

362
Potiche: blue and white floral design, copied from a 17th-c. design, 19th c.

363
Potiche: belly more rounded than in 18th c., mid-19th c.

364
Potiche with polychrome decoration, 2nd half of the 19th c.

365
Potiche, Canton porcelain, c. 1880

366
Standard-bearer, terracotta, yellow and blue glazes, H. 22 cm.

367
Official, terracotta, cream glaze, H. 19 cm.

368
Scythian or Turkish camel-driver, terracotta, green and orange-yellow glazes, H. 62 cm.

369
Actor or acrobat, terracotta, white slip, traces of colours, H. 39 cm.

370
Dignitary: Turkish headdress, Persian cloak, terracotta, H. 38 cm.

371
Foreign drummer or groom, terracotta, lead glaze, H. 23 cm.

372
Young woman, terracotta, traces of red and black, H. 30 cm.

373
High-ranking lady in court dress, terracotta, traces of polychrome, H. 36 cm.

374
Female musician playing cymbals, terracotta with *san-ts'ai* glaze, H. 36 cm.

375
Female dancer with long sleeves, red terracotta, H. 18 cm.

376
Female musician with flute *(p'i-p'a)*, terracotta, H. 21 cm.

377
Court lady, terracotta, H. 29 cm., mid T'ang dynasty, 8th c.

378
Servant's uniform, 6th–7th c.

379
Soldier's uniform, 6th–7th c.

381
Costume of an important dignitary of the court, beginning of the T'ang dynasty

380
Donor's costume, 6th–7th c.

382
Costume of a courtier, beginning of the T'ang dynasty

383
Costume of a female musician, 6th–7th c.

384
Dress of a court lady, beginning of
the T'ang dynasty

385
Back of No. 384

386
Dress of a court lady, 7th and
early 8th c.

387
Costume of a young dancer, 8th c.

388
Young woman's dress, 8th c.

389
Married woman's dress, 8th c.

390
Shou-lao with peach of immortality, porcelain, H. 21 cm., Ch'ien-lung period

391
Shou-lao (god of immortality) astride an axis deer

392
Wen-chang (patron of scholars), *blanc de Chine* porcelain, H. 18 cm., late Ming period

393
Kuan-ti (god of war), *blanc de Chine* porcelain, H. 17 cm., Ming period

394
Kuan-yin between Shan-ts'ai and Lung-nu, *blanc de Chine* porcelain, H. 25 cm., Ch'ien-lung period

395
Buddha as protector of gold and silversmiths, porcelain, H. 11 cm., Tao-kuang period

396
Li T'ai-po, the poet, and his wine vase, biscuit, L. 17 cm., K'ang-hsi period

397
Wen-chang or K'uei (god of literature) holding a large brush

398
The Ho-ho brothers (patrons of potters), biscuit with *san-ts'ai* glaze, H. 14 cm., K'ang-hsi period

399
T'ung-fang Shuo (the peach stealer), porcelain, H. 16 cm., late 18th c.

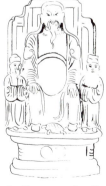

400
The monkey Shun Hu-tzu, porcelain, H. 16 cm., Ch'ien-lung period

401
Shang-ti (Supreme Lord), biscuit with turquoise glaze, H. 23 cm., end of the Ming dynasty

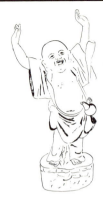

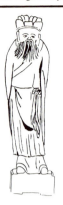

402
Pu-tai with gourd, *blanc de Chine* porcelain, H. 16 cm., 16th c.

403
King Chou (god of sodomy?), mellowed ivory, H. 19 cm.

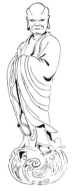

404
The Bodhisattva Ta-mo, white Fukien porcelain, H. 43 cm., 17th c.

405
Kanakavatsa: a disciple of the Buddha, one of the 18 *lo-han*

406 White elephant with alms bowl on its back: one of the 8 Buddhist precious objects *(pa-pao)*

407
Hsi Wang Mu (Queen Mother of the West): decoration on a plate, Ch'ien-lung period

408
Liu Hai, the Immortal catching the 3-legged toad

409
The Bodhisattva P'u-hsien wearing a yellow robe, riding a white elephant

410
Taoist philosopher discovering the *ling-chih* fungus, a symbol of longevity

411 Fu Hsi, the 1st of the 5 legendary emperors, creator of the 8 trigrams *(pa-kua)*

412
Chung-li Ch'üan with fan and peach of immortality

413
Chang Kuo-lao with musical instrument

414
Lü Tung-pin (god of medicine) with fly-whisk and sword

415
Ts'ao Kuo-chiu (patron of actors) with castanets

416
Li T'ieh-kuai, the lame beggar, with a pilgrim's gourd and an iron crutch

417
Han Hsiang-tzu (patron of musicians) with a flute

418
Lan Ts'ai-ho (patron of gardeners) with basket of flowers

419
Ho Hsien-ku (patron of the home and of homemakers) with a lotus flower

420
The Wheel of the Law

421
The conch shell

422
The lotus

423
The umbrella

424
The canopy

425
The vase

426
The paired fish

427
The mystic or endless knot (or entrails)

428
The jewel

429
The cash

430
The open lozenge

431
The pair of books

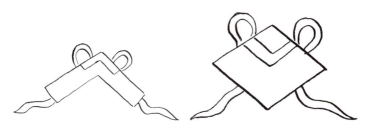

432
The musical stone

433
The solid lozenge

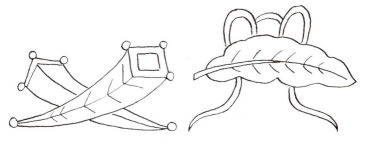

434
The pair of (rhinoceros's) horns

435
The Artemisia leaf

436
Armchair: type first produced during the Ming dynasty, H. 102 cm.

437
Chair, shaped as a *kuan mao shih* (scholar's cap), H. 111 cm.

438
Settee with fretwork back, decoration: key pattern, H. 97 cm., L. 217 cm., W. 120 cm.

439
Bench (nowadays used as a low table), H. 52 cm., L. 124 cm., W. 52 cm.

440
Altar table with a raised edge 'like a bird's tail', H. 82 cm., L. 180 cm.

441
Detail: table leg with open-work motif, H. 89 cm., L. 226 cm.

442
Square table with open-work on the rails, H. 82 cm., W. 104 cm.

443
Square table with open-work on rails, H. 84 cm., W. 104 cm.

444
Clothes cupboard: 2 superimposed chests (the upper for headgear), H. 154 cm., L. 73 cm., W. 58 cm.

445
Bookcase for a scholar's study, H. 160 cm., L. 82 cm., W. 40 cm.

446
Table with 8 legs, brown lacquer, H. 49 cm., L. 41.7 cm., T'ang dynasty, 8th c., Lee Yu-Kuan Coll.

447
Small table, red lacquer, H. 11.5 cm., L. 30 cm., Liang period 502 to 557, Lee Yu-Kuan Coll., Tokyo

448
Hexagonal table, red lacquer, marble top, H. 41 cm., Sung dynasty, 1069, Royal Scottish Mus., Edinburgh

449
Low table used on the *kang* (a wide couch), lacquer, H. 18 cm., L. 89 cm., Yüan dynasty, 14th c.

450
Stool-table, lacquer inlaid with burgau, H. 92.8 cm., 17th c., Lee Yu-Kuan Coll., Tokyo

451
Clothes cupboard, red lacquer, H. 218 cm., L. 110 cm., W. 47 cm., Ming period, early 17th c.

Korea

by Huguette Rousset

KOREA

Korea occupies a peninsula some 1,200 kilometres (750 miles) in length, stretching from the River Yalu to the Tsushima Straits; it is no more than 500 kilometres (312 miles) from east to west at its widest point. The eastern coast is rocky and treacherous, while the southern and western shores slope gently to the sea from the plains and paddy fields, creating thousands of islands, both large and small. The north of the country consists almost entirely of steep, wooded mountain-ranges that are formed from very ancient rocks; these ranges narrow into a backbone that becomes progressively less elevated and so produces the central plateaux and plains—the most fertile agricultural regions of the peninsula. The diverse and fragmentary nature of its geography has influenced the way in which Korea is divided into provinces, and in which its population is distributed. Its composite nature is reflected in its language (Hangul or *onmun*, created about 1446 by a commission of scholars, which can be written either with Chinese ideograms or with an alphabet of twenty-four letters) and also in its art, which mirrors faithfully the country's tormented past.

PREHISTORY. Korea's first ruler is said to have been Prince Tangun, the son of a celestial king and a she-bear, who descended from heaven on 3 October 2333 B.C. and federated the tribes of hunters and fishermen living as nomads in the northern part of the country. This legend clearly illustrates the civilizing influence of the people living on the far side of the River Yalu. During the Palaeolithic Age, Korean art had been influenced by ideas that had derived from continental China. Recent archaeological excavations near Seoul, at Kongju (province of South Chungchong) and Unggi (province of North Hamgyong), have uncovered traces of tools made of flakes of flint, together with choppers. Neolithic culture, which probably came from the Altaïc tribes in the north, spread along the coasts and rivers. Its comb-marked pottery is of two types: pottery of sandy clay, shaped by hand in the form of vases with rounded or pointed bases and found along the rivers to the north of the River Han, and flat-bottomed pots made of clay containing no sand, which are decorated with horizontal bands or motifs in the shape of fish-bones. Small communities living in semi-subterranean dwellings brought from Manchuria a type of handmade pottery formed from a coarse clay mixed with grit. Pottery that came from China at the beginning of the Iron Age and is found in the region of Kimhae (province of South Kyongsang) appears to be the forerunner of Japanese Yayoi pottery.

Bronze superseded stone for the manufacture of weapons and agricultural implements. Dolmens of a type similar to those found in Europe and South-east Asia have also been found.

Towards the middle of the 4th century B.C., the tribes settled in the region of P'yongyang were in close contact with China and brought iron home from there. That new discovery gave them political and economic superiority over the neighbouring tribes and enabled them to establish a small kingdom that extended from the Taedong to the River Liao (western Manchuria). Under the leadership of a religious ruler, the people of this kingdom named Choson improved their agriculture with the use of iron implements and bettered their living conditions by building the first wooden houses with under-floor heating (ondol), a system still in use today. Iron weapons, sarcophagi of wood and stone, harnesses and jewellery all testify to the rise of a ruling class. Wi Man, a Korean noble living in China, returned to his own country, deposed the religious ruler and reigned from 194 to 180 B.C., founding the kingdom of Wi Choson. This kingdom survived for a century before it was conquered by the Chinese under the Han dynasty, who converted it into a Chinese outpost, Lo-lang, that endured until A.D. 313. Several confederations were formed; Puyo in the Sungari basin and Chin in the Han basin were the largest. In all these principalities, the affairs of state were debated by a council consisting of the chiefs of clans. Families were organized on a patriarchal system, slavery was widespread, and shamanism was the state religion. Puyo later became the kingdom of Koguryo, whereas Chin was divided into three states: Mahan, Chinhan and P'yongan.

THE THREE KINGDOMS. After years of struggle, three families finally asserted their authority and established kingdoms: the Ko family founded the kingdom of Koguryo (37 B.C.–A.D. 668) in the region of southern Manchuria and northern Korea; the Puyo family founded the kingdom of Pakche (18 B.C.–A.D. 660), situated in the central basin of the River Han; the Kim family began a long period of rule when they set up the kingdom of Silla (57 B.C.–A.D. 668), referred to as Old Silla, which lay within the valley of the River Naktong in the south-east corner of the peninsula. The state of Kaya (42 B.C.–A.D. 562) also deserves mention; it was a confederation of villages stretching along the lower banks of the River Naktong, between Pakche and Silla, and was mainly under Japanese control.

Economic and artistic development proceeded along very similar lines in each of these kingdoms. The ruling families consolidated their authority by abolishing the councils of clans and handing on the title of ruler, first from brother to brother and then from father to son. Peasants and craftsmen were burdened with taxes and were liable to be subjected to forced labour, and yet their lot was nonetheless preferable to that of the slaves who were compelled to live in communities. The kings had palaces built for themselves and were buried in sumptuously decorated tombs. They were adept at making the best possible use of Chinese influences by successfully combining them with their own traditions, and they even helped introduce Chinese ideas into Japan.

Koguryo (37 B.C.–A.D. 668). The art of Koguryo, the first kingdom to proclaim its independence, is characterized by its power and its freshness of inspiration. Kings and noblemen built thousands of tombs between P'yongyang and Manchuria. Besides containing a vast quantity of funerary objects, these tombs are decorated with frescoes illustrating everyday life: the festivals, religious ceremonies, pastimes and dwelling-places of the kingdom's inhabitants, as in the famous Tomb of the Dancers at T'ung-kou (Man-

churia). In the last quarter of the 4th century, Buddhism replaced shamanism, and effigies of the Buddha (made of both metal and pottery) became more widespread. A statue of a Buddha cast at P'yongyang was discovered at the opposite end of the peninsula, in the province of South Kyongsang. Eventually, as a result of repeated attacks by the kingdom of Silla and its Chinese allies, the kingdom of Koguryo fell in 668.

Pakche (18 B.C.–A.D. 660). Immigrants who moved south from the banks of the River Yalu and settled in the most fertile regions of Korea, making Kongju (at that time Ungjin) their capital, founded the kingdom of Pakche, which had a brilliant civilization. Unfortunately, the palaces, tombs and monasteries that were once situated along the River Han were almost completely destroyed at the time of the conquest by Silla. Only ruins, tiles, bricks, funerary steles and foundation-stones remain as evidence of the skill of the kingdom's craftsmen. Pakche was introduced somewhat belatedly (late 4th century) to Theravāda Buddhism of the Lesser Vehicle but made up for the delay by a period of fervour during which many statues were carved or cast and missionaries were sent to Japan, a country with which Pakche maintained close links. The kingdom of Pakche was the centre of an advanced civilization that remained an influential force even after it had disappeared from the political arena.

Old Silla (57 B.C.–A.D. 668). It is surprising that, in spite of favourable agricultural and climatic conditions, and the existence of ample mineral deposits, the political and artistic development of Silla was slower than that of its neighbours. Its craftsmen applied their greatest creative endeavours to the construction of the many tombs around Kyongju and in the provinces of North and South Kyongsang. In famous tombs such as those of the Golden Crown and the Golden Bell and also in lesser-known tombs, objects of great value have been discovered—golden crowns, jewels, precious stones, metal vases and fine pottery. The architecture of the kingdom is known from surviving pagodas, lanterns and steles and from the oldest astronomical observatory still surviving in the Far East. The artists carved on rocks and cliffs their earliest representations of deities comprising the Buddhist pantheon. (Although introduced into the kingdom in the 5th century, Buddhism took more than a century to become firmly established.) Towards the end of the 7th century, Silla allied itself with Pakche and then requested aid from the Chinese T'ang dynasty so that it could turn its back on its ex-ally and conquer it before defeating the kingdom of Koguryo in its turn. As a recompense for this alliance, China sought to occupy Korea but encountered resistance in Silla and the southern provinces of Koguryo. Finally, Silla gained control over the entire peninsula and retained Kyongju as the capital of the vast kingdom known as United Silla.

UNITED SILLA (668–935). Throughout these three centuries of great economic and artistic activity, the art of Silla was transformed under the increasingly powerful influence of the Chinese T'ang dynasty. Buddhism, which had become the state religion, flourished and inspired artists and craftsmen even in fields of art that would not seem to be directly linked to religion. At the beginning of the period, the tradition of building tombs continued, and hundreds of tombs with burial chambers of bonded stones covered not only the outskirts of Kyongju (still the capital) but also the provinces of North and South Kyongsang. A number of them were spared by plunderers and still contain sumptuous funerary objects. This tradition of tomb-building gradually declined with the advent of Buddhism. The mountainous region

around Kyongju was embellished with fortresses, monuments commemorating royal visits and also temples such as that of Pulguk-sa with its white marble pagoda, monasteries, lanterns and stupas. Artists, attracted by the abundance of granite and other hard stones, carved designs in relief on rock-faces or hollowed out grottoes and hermitages such as the cave-temple of Sokkuram. The skill of the craftsman is evident in their pottery, tiles and bricks. The techniques of inlay and filigree-work spread from the west and began to be used in the decoration of jewellery and of ritual objects. The period of United Silla, also referred to as Great Silla, was one of assimilation, during which foreign ideas and techniques were adapted and assumed an undeniably Korean character.

KORYO (918–1392). One prince rebelled against the domination of Silla and established his capital at Kaesong, to the north of present-day Seoul. He took the name of Taijo and founded the Koryo dynasty. King Taijo's peaceful conquests were concluded by the marriage of his eldest daughter to the last king of United Silla. He and his successors tried to extend their power over the territory formerly occupied by the kingdom of Koguryo. They were successful, and so gave Korea frontiers that were not very different from today's. The artistic centre of the country was also moved—from Kyongju and the southern provinces to the new capital at Kaesong and the surrounding district. Then the Mongol invasion took place, destroying both political and artistic life.

The energy of the new kingdom of Koryo was reflected in all aspects of its art, which acquired a certain sophistication that was very much in keeping with the elegant life at court, where the refinements of the Chinese Sung court were imitated. The arts of painting, calligraphy, wood-carving and metalwork received a new impetus during this period, which also saw the production of the first green-glazed celadon wares. During the first century of the dynasty, the only form of decoration on the celadon wares was a brownish or greenish glaze, a technique inherited from southern China. The glaze acquired its characteristic colour and transparency later on, covering moulded, inlaid and incised designs. This harmonious combination of glaze and decoration had established the reputation of the potters of Koryo throughout the world when the Mongol invasion put an end to the golden age of Korean ceramics. Architecture was at first similar to that of the Three Kingdoms and United Silla, but later architects introduced innovations, abandoning symmetry and ceramic tiles and becoming preoccupied instead with integrating buildings into their environment. A school of Buddhist art grew up in the centre of Korea. Its vigorous style contrasted sharply with the languid style of Kyongju. Numerous steles perpetuating the memory of Zen masters continued to be erected either in temples or in the open countryside; the favourite motif on these was a tortoise supporting a carved stone slab. Buddhist statues, which were at first massive, became less so in time; the giant representations grouped in threes that were carved on rock-faces or sculpted from blocks of stone exhibit very pronounced local differences. Later, the influence of Mongol lamaism was to pervade Buddhist art to an increasing extent.

YI (1392–1910). General Yi song gye, a partisan of China, defeated the Mongols and drove them back to the River Yalu. He returned to Kaesong and deposed the king, but waited four years before founding his own dynasty. He named the country Chosun and made Seoul its capital, setting up his court in the recently completed palace of Kyongbok. The precepts of Confucianism were followed both in private and public life, and the administra-

tion of the country passed into the hands of scholars who took examinations based on those held in China. In the 16th century, the dynasty became less powerful as a result of struggles between rival factions and the Japanese invasions led by Hideyoshi. It was then that a Korean admiral invented the first armoured ships—the famous tortoise-ships that destroyed the Japanese fleet. When he retreated, Hideyoshi took back with him to Japan so many craftsmen and potters that his campaign was nicknamed the 'pottery war'. In later years, Korea had to repel attacks from the Manchus, and it then adopted a policy of strict isolationism until (in 1879) it was forced to open its ports, at first to Japan alone, and then to Western nations as well. The Japanese managed to install a governor-general. King Kojong abdicated in 1907, and his son was forced to sign a treaty of annexation in 1910.

During the protracted rule of this dynasty, the arts of Korea underwent many changes. Confucianism imposed a degree of discipline and moderation that restrained the exuberance of artists, with the result that works of art of this period cannot be considered as particularly creative or inspired. On the other hand, the architecture of fortresses, monumental gateways, palaces, pavilions and Buddhist and Confucian temples (based at this point on the principles of astrology and geomancy), became simpler and more restrained. Sculpture became rather dull, and the wooden masks worn by shamanite dancers were lifeless compared with those made in previous centuries. Though painting and calligraphy increasingly resembled their Chinese models, artists were still anxious to represent aspects of local life. Finally, Western painting exerted an influence on Korean art.

There was enormous variety in the ceramic wares. The *punch'ong* type—made of a paste similar to, though coarser than, that used for celadon ware—was in everyday use; its decoration could be impressed, painted or incised under a white slip. The majority of *punch'ong* wares, more commonly referred to by the Japanese name of *mishima*, were made in the southern region of the peninsula from the 14th century to the 17th. A wide variety of these wares was produced, among which were tea-bowls. They carried a rustic design applied with the brush and were particularly prized by Japanese tea-masters. A white porcelain, reserved for the use of the aristocracy, represents the Confucian ideal of quiet strength; it was made from kaolin fired at a high temperature, decorated with cobalt imported at great cost from China, and exported even to the Ming court. Black ceramic ware, known as *temmoku* in Japan, was made throughout the Yi dynasty.

A certain decline in the minor arts is noticeable. Bronze bells, ritual objects, shaman masks, etc. continued to be produced, but in addition there appeared lacquered chests and caskets inlaid with mother-of-pearl, tortoise-shell and metal and a very special type of handicraft—the production of *hwagaks* or painted horn. These consist of thin flakes of ox-horn painted with decorative motifs, landscapes or rustic scenes; assembled between thin strips of bone so as to produce a final effect reminiscent of stained-glass, the flakes covered the surfaces of chests, boxes, head-rests and other objects. It would seem that the art of living as described in Confucian philosophy is embodied in such works of art whose technique (inherited from the China of the T'ang dynasty) provides one of the few original features of these long centuries that are largely devoid of artistic creativity.

Korea

MAJOR MUSEUMS

National Museum, Kyongju, North Kyongsang
Tonghwa University Museum, Pusan, South Kyongsang
National Museum, Puyo, North Chungchong
National Museum of Korea, Seoul
Kansong Museum, Seoul
Ehwa Women's University Museum, Seoul
Chungang University Museum, Seoul
Kyonggi University Museum, Seoul
National Institute of Music, Seoul
Kyongbok Palace, Seoul
National Folklore Museum, Seoul
National Museum, Taegu

England
British Museum, London

U.S.A.
Museum of Fine Arts, Boston
Freer Gallery of Art, Washington, D.C.
Honolulu Academy of Arts, Honolulu

CONCISE BIBLIOGRAPHY

AKABOSHI, G. *Five Centuries of Korean Ceramics.* Tokyo and New York, 1975.
Asia Public Relations Center. Corée, 1945–1975. Seoul, 1975.
FORMAN, W. and BARINKA, J. *The Art of Ancient Korea.* London, 1963.
GOMPERTZ, G. St. G. M. *Korean Potters and Porcelain of the Yi Period,* London, 1968.
——————————— *Korean Celadon and Other Wares of the Koryo Period.* London, 1963.
GRISWOLD, A. B., KIM, C. and POTT, P. H. 'L'art en Corée' in *L'art dans le monde.* Paris, 1963.
KIM, C. and KIM, W. Y. *The Arts of Korea* (Katherine Watson, ed.). London, 1966.
MAC CUNE, E. *The Arts of Korea; An Illustrated History.* Rutland, Vt. and Tokyo, 1962.
MINISTRY OF CULTURE AND INFORMATION. *The Ancient Arts of Korea.* Seoul, 1972.
ROUSSET, H. *Arts de la Corée.* Fribourg, 1977.
SWANN, P. *Art of China, Korea and Japan.* London, 1963.

Modern Names of the Korean Provinces

1. North P'yongan
2. Changang
3. Yanggang
4. North Hamgyong
5. South P'yongan
6. South Hamgyong
7. South Hwanghae
8. North Hwanghae
9. Kangwon
10. Kyonggi
11. South Chungchong
12. North Chungchong
13. North Kyongsang
14. North Cholla
15. South Cholla
16. South Kyongsang
17. Cheju

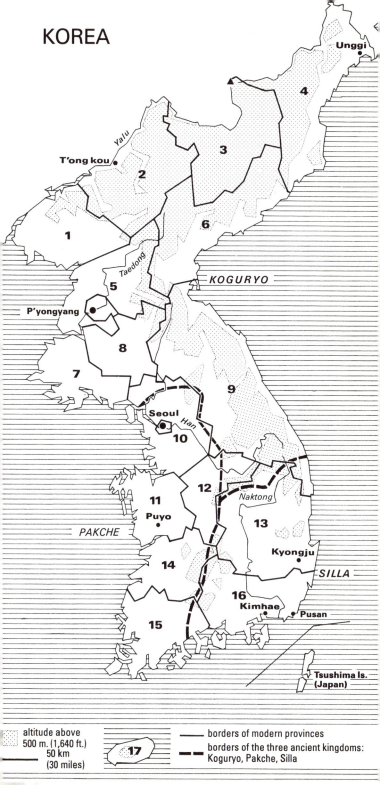

KOREA

Unggi

4

Yalu

3

T'ong kou

2

6

1

Taedong

KOGURYO

5

P'yongyang

8

7

9

Seoul

Han

10

12

11

Naktong

Puyo

13

PAKCHE

Kyongju

14

SILLA

16

Kimhae

15

Pusan

Tsushima Is.
(Japan)

altitude above
500 m. (1,640 ft.)
50 km
(30 miles)

17

borders of modern provinces
borders of the three ancient kingdoms:
Koguryo, Pakche, Silla

Korea
CHRONOLOGY

c. 2500–600 B.C.	Neolithic Age
c. 600–*c.* mid-4th century B.C.	Bronze Age
From *c.* mid-4th century B.C.	Iron Age

108 B.C. Decline of Wi Choson's kingdom
and establishment of the
Chinese outpost Lo-lang
(108 B.C. to A.D. 313)

	Silla (Old Silla)	57 B.C. to A.D. 668
Three Kingdoms {	Koguryo	37 B.C. to A.D. 668
	Pakche	18 B.C. to A.D. 660

668–935	United Silla
918–1392	Koryo Dynasty
1392–1910	Yi Dynasty
1910–45	Chōsen—Japanese general government
1945–	Republic of Korea

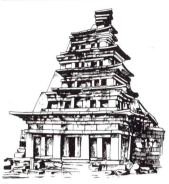

1

Pagoda, stone, H. *c.* 14 m., Pakche, early 7th c., Miruksa, Kyangri, North Cholla

2

Astronomical observatory, granite, H. 9.20 m., Old Silla, 7th c., Chomsongdai, Kyongju, North Kyongsang

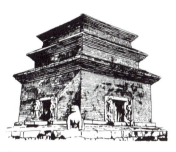

3

Punhwangsa pagoda, andesite bricks, H. 9.30 m., Old Silla, 7th c., Kyongju, North Kyongsang

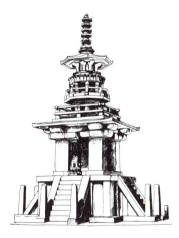

5

Buddha seated on a column, stone, H. 1.40 m., United Silla, 8th c., Mount Nam, Kyongju, North Kyongsang

4

Tabo pagoda, white granite, H. 10.40 m., United Silla, 751, Pulguk Temple, Kyongju, North Kyongsang

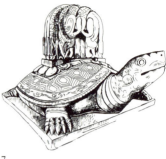

7
Funerary stele of King Taejong Muyol, stone, H. 3.10 m., United Silla, c. 670, Kyongju, North Kyongsang

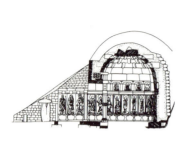

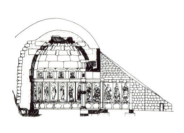

6
Sokkuram: cave-temple, north-south sections, before 1963 renovation, H. c. 8 m., United Silla, 775, Kyongju

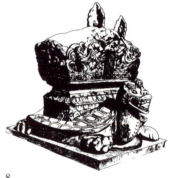

8
Funerary stele: Zen master Cholgam, stone, H. 1.40 m., United Silla, 868, Ssangbong Temple, South Cholla

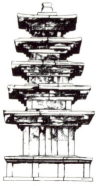

9
Five-story pagoda, stone, H. c. 9 m., Koryo, 10th c., Wangkungri, Iksan, North Cholla

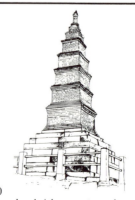

10
Pagoda, brick on stone base, H. 9.40 m., Koryo, Silluk Temple, Yoju, Kyonggi

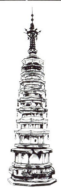

11
Stupa, stone, H. 2.27 m., Koryo, Kumsan Temple, North Cholla

12
Octagonal, nine-story pagoda, stone, H. 15.2 m., Koryo, Woljong Temple, Kangwon

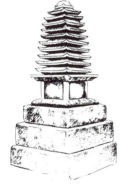

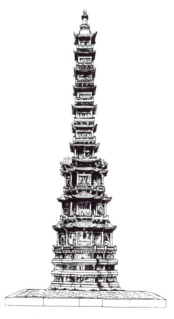

13
Pagoda, stone, H. 2.38 m., Koryo, 9th–10th c., Haein Temple, South Kyongsang

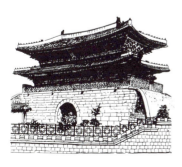

15
Namdae Gate, H. 5.46 m., Yi, 1448, Seoul

14
10-story pagoda, stone, H. 13.5 m., Koryo, 1348, Kyonchon Temple, Kyonggi; Kyongbok Palace, Seoul

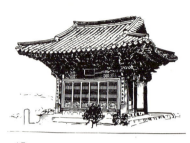

16
Chimney-stack of Chunchu Palace, Yi, 15th c., Kyongbok Palace, Seoul

17
Chosa pavilion, H. (front) 1.82 m., (sides) 3.64 m., Yi, 14th–15th c., Silluk Temple, Kyonggi

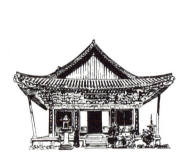

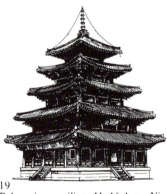

18
Daehung pavilion, H. (front) 5.46 m., (sides) 9.10 m., Yi, 1645, Tongdo Temple, South Kyongsang

19
Palsangjon pavilion, H. 16.4 m., Yi, 1624, Pobju Temple, North Chungchong

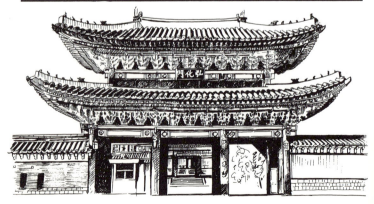

20 Honghwa gate, H. (front) 5.5 m., (sides) 3.65 m., Yi, 17th c., Chankyong Palace, Seoul

21 Roof-beams inside Daehung pavilion, Yi, 1645, Tongdo Temple, South Kyongsang

22
Lighthouse in the shape of a tortoise-ship, Yi, 18th c., Hallyo, South Kyongsang

23
Castle: defensive walls, watch-tower, Yi, late 18th c., Suwon fortress, Kyonggi

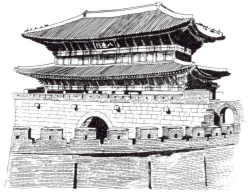

24 Defensive wall and Paldal gate, H. (gate front) 9.10 m., (sides) 3.65 m., Yi, late 18th c., Suwon fortress, Kyonggi

25
Lantern, stone, H. 2.10 m., United Silla, 880, Porinsa Temple, Jangheung, South Cholla

26
Lantern, stone, H. 2.06 m., Koryo, Pulguk Temple, Kyongju, North Kyongsang

27
Lantern, stone, H. 2.55 m., Koryo, 1017, Changto Temple, North Chungchong; now Kyongbok Palace, Seoul

28
House-shaped reliquary, gilt bronze, H. 18 cm., Koryo, 10th–11th c., Kansong Mus., Seoul

29
Five-story votive pagoda, gilt bronze, H. 1.55 m., Koryo, 12th to 13th c.

30
Eleven-story votive pagoda, bronze, H. 75 cm., Koryo, Nat. Mus., Seoul

31
Buddha: ornate mandorla, gilt bronze,
H. 17 cm., Koguryo, cast: P'yongyang,
found: Uirong, Nat. Mus., Seoul

32
Śākyamuni (?), gilt bronze, H. 15.1
cm., Koguryo, 6th c., Nat. Mus., Seoul

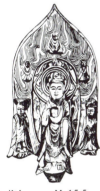

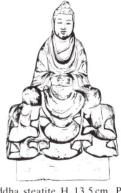

33
Triad, gilt bronze, H. 15.5 cm., Kogu-
ryo, 6th c., Koksan, North Hwanghae,
Nat. Mus., Seoul

34
Buddha, steatite, H. 13.5 cm., Pakche,
6th c., Kusunri, Puyo, South Chung-
chong, Nat. Mus., Seoul

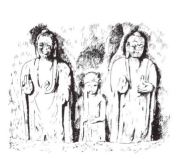

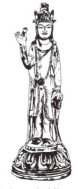

35
Buddhist triad, relief carving on rock,
Pakche, 7th c., Sosan, South Chung-
chong

36
Avalokiteśvara holding a jewel, gilt
bronze, H. 21 cm., Pakche, 7th c.,
Puyo district, Nat. Mus., Seoul

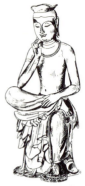

37
Maitreya seated, gilt bronze, H. 93.5 cm., Old Silla (?), 7th c., Nat. Mus., Seoul

38
Triad: Amitābha, Avalokiteśvara, Mahāstamaprata, granite, Old Silla, Kyongju, North Kyongsang

39
Amitābha seated, gold, H. 12.2 cm., United Silla, 7th c., Hwangboksa, Kyongju, Nat. Mus., Seoul

40
Maitreya standing, granite, H. 1.83 m., United Silla, 720, Kamsansa, Kyongju, Nat. Mus., Seoul

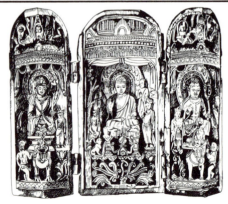

41 Triptych: Buddha between Mañjuśri and Samantabhadra, gilt wood, H. 13.9 cm., United Silla, 7th–9th c., Songwansa, South Cholla

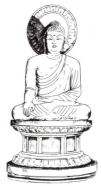

42
Guardian-king of East: reliquary, bronze, H. 21.6 cm., United Silla, 7th c., Kamunsa Temple, Nat. Mus., Seoul

43
Buddha meditating, granite, H. 3.26 m., United Silla, 775, Sokkuram sanctuary, Kyongju, North Kyongsang

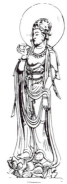

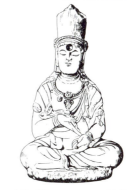

44
Mañjuśri, granite, H. 2 m., United Silla, 775, Sokkuram sanctuary, Kyongju, North Kyongsang

45
Seated Bodhisattva, stone, H. 92 cm., Koryo, 10th c., Hanson Temple, Nat. Mus., Seoul

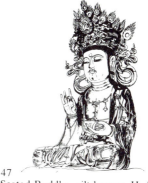

46
Colossal Miruk (Maitreya), stone, H. c. 7 m., Koryo, 10th c., Kwonchok Temple, Nonsan, South Chungchong

47
Seated Buddha, gilt bronze, H. 1.02 m., Yi, Eunhae Temple, North Kyongsang

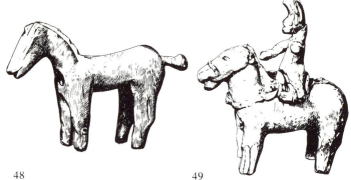

48
Horse, cast bronze, H. 3.25 cm., *c.* 3rd c. B.C., North Kyongsang, Nat. Mus., Seoul

49
Horse and rider, clay, H. 14.4 cm., Old Silla, Kyongju, North Kyongsang, Nat. Mus., Kyongju

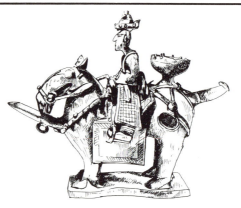

50 Vessel in the shape of a mounted horseman, grey sandstone, H. 23.4 cm., L. 26.8 cm., Old Silla, Golden Bell Tomb, Kyongju, North Kyongsang

51 Chariot, terracotta, H. 6.3 cm., L. 12 cm., W. 12.7 cm., Old Silla, royal tomb, Kyongju, North Kyongsang, Nat. Mus., Kyongju

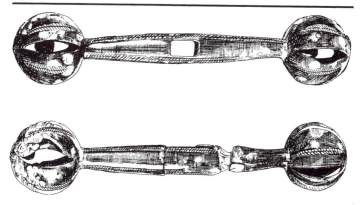

52 Horse-bits terminating in small bells, bronze, L. 1.75 cm., late Neolithic
Age, South Cholla, Nat. Mus., Seoul

53 Saddle-ornament, gilt bronze, H. 30 cm., W. 56.5 cm., Kaya, 5th–6th c.,
Koryong, North Kyongsang, Nat. Mus., Seoul

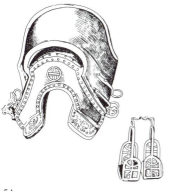

54
Saddle and stirrup, wood and metal,
Yi, 19th c.

55
Official token for obtaining three
post-horses, copper, Yi, 19th c., Nat.
Mus., Seoul

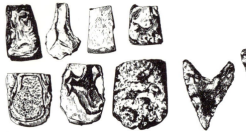

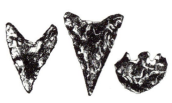

56
Stone tools, obsidian, flint, H. 2–10 cm., Neolithic Age, Pusan region, Nat. Mus., Seoul

57
Arrowheads, scraper, H. 2–9 cm., obsidian, Neolithic Age, Pusan region, Nat. Mus., Seoul

58
Censer: celadon: moulded, pierced design, white and brown slip, H. 15.5 cm., Koryo, 12th c., Nat. Mus., Seoul

59
Tortoise-shaped sundial, white porcelain, D. c. 30 cm., Yi, 15th c.

60
Duck-shaped water-dropper for dissolving an ink-stick, celadon, L. c. 8 cm., Koryo, Kansong Mus., Seoul

61
Water-dropper for dissolving an ink-stick, blue-and-white porcelain, L. c. 7 cm., Yi, 18th c.

62
Hat-box, red lacquered wood and metal, H. 23.5 cm., Yi, 19th c., Ehwa Woman's Univ. Mus., Seoul

63
Box for official seals, lacquered and carved wood, metal, H. 16.6 cm., Yi, 19th c.

64
Casket, *hwagak* (painted horn), wood, H. 25 cm., L. 21.5 cm., Yi, 18th–19th c., Ehwa Women's Univ. Mus., Seoul

65
Casket, wood inlaid with mother-of-pearl and shell, H. 20.4 cm., L. 32 cm., Yi, 18th c., Nat. Mus., Seoul

66 Jewel-box, lacquered wood inlaid with mother-of-pearl, H. 14.5 cm., L. 23 cm., Yi, 19th c., Ehwa Women's Univ. Mus., Seoul

68
Lantern, lacquered wood, bamboo and metal, H. 28 cm., Yi, 19th c.

67
Cabinet on stand, carved, lacquered wood, H. 60.2 cm., L. 53.5 cm., W. 32.7 cm., Yi, 18th c., Nat. Mus., Seoul

69
Head-rest, celadon with black and white design, H. 12.5 cm., L. 22.8 cm., mid-12th c., Nat. Mus., Seoul

70
Head-rest, wood, H. 48 cm., Yi, 18th–19th c., Nat. Mus., Seoul

71
Head-rest, wood inlaid with mother-of-pearl and shell, H. 13.3 cm., Yi, 19th c., Nat. Mus., Seoul

72
Powder-flask, lacquered and carved wood, L. 19.5 cm., W. 10.7 cm., Yi, 18th c., Nat. Mus., Seoul

73
Mask for religious dances, wood, H. 24 cm., Yi, Nat. Mus., Seoul

74
Mask for ritual dances, wood, H. 25 cm., Koryo, 12th–14th c., Hahoe, North Kyongsang, Nat. Mus., Seoul

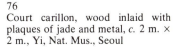

75
Drums for court dances, wood, bronze and skin, *c.* 2 m. × 1 m., Yi, 19th c.

76
Court carillon, wood inlaid with plaques of jade and metal, *c.* 2 m. × 2 m., Yi, Nat. Mus., Seoul

77
Vessel with spout: applied design, clay, H. 13.5 cm., Neolithic Age, Pusan region, Tongha Univ. Mus., Pusan

78
Vase: comb-marked, clay, H. 48.5 cm., Neolithic Age, Kyonggi Mus., Seoul

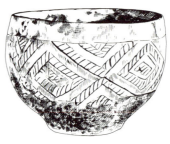

79
Shallow bowl: comb-marked, clay, H. 8.6 cm., Neolithic Age, Nongpodong, North Hamgyong, Nat. Mus., Seoul

80
Bowl with incised design, clay, H. 8 cm., Neolithic Age, North Hamgyong, Nat. Mus., Seoul

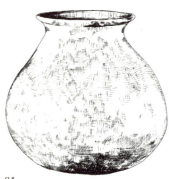

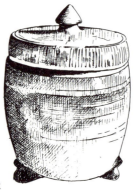

81
Jar: undecorated, red clay, H. 13.5 cm., Bronze Age, north-east coast, Nat. Mus., Seoul

82
Lidded jar, black pottery, H. 21.3 cm., Koguryo, P'yongyang area, Nat. Mus., Seoul

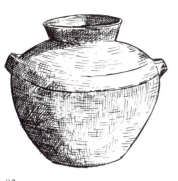

83
Jar: undecorated, grey clay, H. 17.5
cm., Koguryo, c. 5th c., Nat. Mus.,
Seoul

84
Two vases on a single pierced base,
clay, H. 25.5 cm., Kaya, 5th–6th c.,
Nat. Mus., Seoul

85
Duck-shaped vase, grey stoneware,
H. 15.5 cm., Kaya, 5th–6th c., South
Kyongsang, Nat. Mus., Seoul

86
Bowl with pendants: design in relief
on lid, H. 24 cm., Kaya, Ehwa
Women's Univ. Mus., Seoul

87
Shallow bowl: incised design, clay, H.
11.5 cm., Kaya, 5th–6th c., Naktong
basin, Ehwa Women's Univ. Mus.

88
Tall lidded bowl with a human figure
and animals, clay, H. 20 cm., Old
Silla, Kyongju, Nat. Mus., Kyongju

89
Vase: incised design of horses, clay,
H. 14 cm., Old Silla, Kyongju, North
Kyongsang, Nat. Mus., Kyongju

90
Boat on stand, clay, H. 15.5 cm., Old
Silla, Golden Bell Tomb, Kyongju,
North Kyongsang, Nat. Mus., Seoul

91
Lidded bowl, clay with *san-ts'ai*
(3-colour) glaze, H. 11 cm., United
Silla, Nat. Mus., Seoul

92
Jar: incised design, clay, H. 16.5 cm.,
United Silla, Taegu region, North
Kyongsang

93
Funerary urn: stamped design, grey
stoneware: yellow glaze, H. 39 cm.,
United Silla, Kyongju, Nat. M., Seoul

94
Vase, stoneware: natural glaze,
H. 17.6 cm., Koryo, 11th c.

95
Kundika vase (for holywater): incised design, celadon, H. 36.25 cm., Koryo, early 12th c., Kansong Mus., Seoul

96
Kundika vase, bronze inlaid with silver, H. 37.5 cm., Koryo, 12th c., Nat. Mus., Seoul

97
Wine-bottle, underglaze decoration: (iron) brown and white slip, H. 29.8 cm., Yi, 15th c., Nat. Mus., Seoul

98
Rice-bowl, decoration: white slip under celadon glaze, H. 12.2 cm., Yi, 15th c., Nat. Mus., Seoul

99 Bowl, red and black lacquered wood, H. 11.3 cm., Yi, 19th c., Nat. Mus., Seoul

100
Mirror, inlaid bronze, D. 12 cm., *c.*
3rd c. B.C., Nat. Mus., Seoul

101
Mirror, bronze, D. 11.4 cm., 3rd c.
B.C.–A.D. 2nd c., North P'yongan,
Nat. Mus., Seoul

102
Mirror with bells, inlaid bronze,
D. 12.3 cm., *c.* A.D. 2nd c., North
Kyongsang

103
Swords, bronze, L. *c.* 40 cm., late
Neolithic period, Nat. Mus., Seoul

104
Mirror: picture of a landscape,
bronze, D. 21 cm., Koryo, Nat. Mus.,
Seoul

105
Bowl with pendants, gold, H. 10 cm.,
Old Silla, tomb No. 98, Kyongju,
North Kyongsang

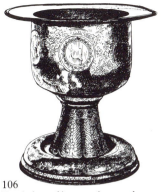

106
Bowl-shaped incense-burner, bronze, inlaid with silver, H. 37 cm., Koryo, Nat. Mus., Seoul

107
Candelabrum, bronze, H. 31.8 cm., Koryo, Kyonggi Univ. Mus., Seoul

108
Bell, bronze, H. 12 cm., Neolithic period, North Kyongsang, Nat. Mus., Seoul

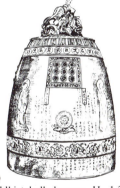

109
Buddhist bell, bronze, H. 1.32 m., D. 92 cm., Yi, 17th c., Kap Temple, South Chungchong

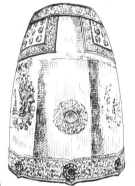

110
Buddhist bell called 'Emille', bronze, H. 3.33 m., D. 2.27 m., United Silla, 771, Kyongju, Nat. Mus., Kyongju

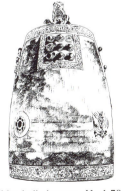

111
Buddhist bell, bronze, H. 1.70 m., D. 1 m., Koryo, 1010, Chonghung Temple, Seoul, Nat. Mus., Seoul

112
Clasps, cast bronze, L. 19 cm., 15.6 cm., *c.* 3rd c. B.C., Geumho, North Kyongsang, Nat. Mus., Seoul

113
Bells used by shaman women, bronze, L. *c.* 40 cm., Yi, 19th c., Kyonggi Univ. Mus., Seoul

114
Diadem, gold and precious stones, H. 11.5 cm., D. 20.7 cm., Kaya, 5th to 6th c., North Kyongsang

115
Royal crown, gold and precious stones, H. 44.5 cm., Old Silla, tomb No. 98, Kyongju, Nat. Mus., Kyongju

116
Roof-tile, red clay, D. 17.5 cm.,
Koguryo, *c.* 6th c., Nat. Mus., Seoul

117
Tile with phoenix, grey clay, H. 29.2
cm., Pakche, 7th c., Puyo, South
Chungchong, Nat. Mus., Seoul

118
Tile showing a landscape in relief,
grey sandstone, H. 29.7 cm., W. 28.9
cm., Pakche

119
Tile with a monster in relief, clay, H.
25.5 cm., United Silla, Taegu region,
North Kyongsang, Mus., Taegu

120 Tile: design in relief, grey sandstone, H. 31.45 cm., W. 31.03 cm.,
United Silla, Imhaejon Palace, Kyongju, North Kyongsang, Nat. Mus., Seoul

Japan

by Huguette Rousset

JAPAN

Japan consists of a group of scattered islands off the coast of mainland Asia, stretching in a crescent from the icy steppes of Siberia to the warm China Sea. It has seen successive waves of civilization, and from this excellent melting-pot has emerged a style of art sometimes so original that it is difficult to determine its sources of inspiration. The islands were originally joined to the mainland, but by the Quaternary era they had become separated, giving rise to Japan's long period of insularity. The country's landscapes vary from alluvial plains and barren mountains to enticing bays and precipitous coasts, and destructive typhoons, tidal waves and earthquakes are frequent. Living under such extreme conditions in every part of the country, the Japanese have developed the art of surviving, with their acute observation of nature, their spirit of resignation, which nevertheless is not devoid of humour, and their love of detail. Japanese art amply reflects all these characteristics, each of them predominating at some time during its history. Periods of recession alternated with periods of expansion, and spells of intense creativity were followed by times when artists merely copied styles from other lands, until finally under the last Tokugawa shoguns there was a brutal confrontation between the settled society and Commodore Perry's 'Black Ships' sent from the West. This encounter totally revolutionized Japan, which then emerged as an important power among the nations of the world.

PREHISTORY (pre-pottery and Jōmon periods). The earliest evidence of the people who lived in Japan dates from the late Palaeolithic period and consists of shaped pebbles, scrapers, axes, cutting-edges and arrowheads. These are the stone implements of people who gathered their food by hunting and fishing, covering vast distances in the course of their nomadic wanderings. At that time Japan was joined to the mainland of Asia, in the north by the Sakhalin islands and Hokkaido and in the south by Kyushu, which extended as far as Korea. Fragments of a pot found at Fukui (Kyushu) have been shown by radio-carbon analysis to date from about 10,000 B.C. The pot has a flat base, a feature that raises questions concerning its origin, since the earliest Jōmon pots have pointed bases and are undecorated, whereas the Fukui sherds are decorated with motifs in relief.

The small, dispersed communities of hunters and fishermen lived in semi-subterranean huts protected by extensive canopies of branches. They produced a surprisingly varied range of pottery called *jōmon doki* ('cord-marked earthenware'), which already shows a sensitive handling of the medium. Numerous types of vessel, fired under unpredictable conditions, have been found throughout the archipelago. Archaeologists divide the Jōmon culture into five periods: Proto-Jōmon (11th–6th millennia B.C.), Early Jōmon

(6th–3rd millennia B.C.), Middle Jōmon (3rd millennium B.C.), Late Jōmon (2nd millennium B.C.) and Final Jōmon (1000–400 B.C.).

Vessels from the Proto-Jōmon period have pointed bases and are either undecorated or have a design of impressions made by finger-nails or shells. In the Early Jōmon period the types of vessel became more numerous, the rims were thicker and more pronounced, the relief decorations grew more varied, cord-impressions appeared, and vessels then had flat bases with incised patterns produced by a bamboo spatula. Middle Jōmon vases and jars are larger, their surfaces being covered with patterns in relief, and at this point the first (remarkable) statuettes appeared; they take the form of figurines or smiling heads on the shoulders and rims of pots and may be survivals from earlier religious practices. In the Late Jōmon period, these statuettes spread to south Japan and became even more bizarre in appearance. The types of vessel became more numerous, and pots with spouts and bowls indicate the potters' mastery of kiln techniques. The stone artefacts dating from this time—barbed harpoons, arrowheads and polished axes—are skilfully worked. During The Final Jōmon period, the climate grew warmer, favouring the beginnings of agriculture. New types of pottery appeared: small bowls, bowls with feet, plates and pitchers, culminating in the Kamegaoka style, named after a site in north-west Aomori prefecture.

YAYOI PERIOD (3rd century B.C.–A.D. 3rd century). The Yayoi district of Tokyo, where fragments of pottery made during this time were first found, has given its name to this period. The influence of the Asian continent was gradually more pronounced during the Yayoi period, and the first paddy-fields appeared. The potters' wheel, imported from Korea, enabled craftsmen to make pots of a more beautiful shape than hitherto. The wheel was also used to produce tall funerary urns in Kyushu, where a social structure was slowly developing. Bronze and iron, also imported from Korea, gradually took the place of polished stone, and the technique of loom weaving was mastered. During the five hundred years of its existence, the Yayoi civilization, which had its roots in Kyushu, spread to the middle of the Japanese archipelago. Korean immigrants taught the local people how to cast bronze halberds and swords and perhaps also how to make the mysterious *dōtaku,* large ornate bells of indeterminate function, ranging in size from 9 cm. to 1.5 m. They also taught them to make weaving-looms and iron tools and weapons, though the use of bone fish-hooks and harpoons and of stone agricultural implements continued. Excavation of the sites of Toro (near Nagoya) and Karako (near Nara) has made it possible for archaeologists to form a clear picture of the daily life of these agricultural communities. The Yayoi civilization, which can be divided into three equal periods (Early, Middle and Late), witnessed a transition in Japan's economy from one of a nation of hunters and gatherers of food to one of a nation of food-producers.

Pottery lost the exuberance of Jōmon wares, heralding the restraint that was henceforth to be a permanent feature of Japanese art. About the Middle Yayoi period, economic life changed: fishing became more important, and the *kaizuka* (middens, i.e. refuse heaps) decreased both in number and in size. The different types of harpoons and fish-hooks, bow-nets and weights for fishing nets that have been found show that a distinction was made between the various sorts of fishing and that the fishermen used long boats propelled by paddles. Greater care was taken during the Yayoi period over burials, the dead being deposited either in archaic stone coffins called cists or in urns, whereas, during the Jōmon period, the practice had been merely to leave corpses in *kaizuka* shell-mounds.

CIVILIZATION OF THE GRAVE MOUNDS OR TUMULUS (A.D. 3rd–6th century). Towards the end of the Yayoi period, the ruling classes of Kyushu migrated towards central Japan, reaching the region of Kyoto-Nara. One clan, which was to become the imperial family, gradually subjugated the surrounding tribes. A permanent government was set up on the Yamato Plain, where it was to remain for more than fifteen centuries. The civilization that grew up within this developing society stamped its hallmark on the country's art before disappearing in the face of spreading Chinese civilization. The most spectacular of the many innovations during this period and the one used to describe it, was the building of grave mounds *(kofun)*. These were sometimes enormous; the tomb attributed to the Emperor Nintoku (whose traditional dates are 313–99) is 300 metres (984 feet) long. This civilization spread from Kyushu to Kantō (Tokyo region), but north of here its progress stopped for reasons unknown, unlike the Jōmon and Yayoi civilizations, which had spread throughout the archipelago, even reaching as far as Hokkaido.

Archaeologists distinguish three periods: Early, Middle and Late. The tombs of Ōzuka and Takehara in north Kyushu and the tomb of Takamatsu near Nara provide evidence of the advance of Chinese influence, while decorative motifs such as the *chokkōmon* (a motif consisting of straight lines and curves) and *haniwa* (grave figures of clay made for the slopes of tombs) show that their creators were people with a flair for original decoration. The *chokkōmon* is found embellishing sarcophagi, shields and weapons from Kyushu to the Yamato Plain. The *haniwa* were originally nothing more than pottery cylinders, whose function may have been to secure the earth around the base of a burial mound. Later they became figures faithfully, even if sometimes naïvely, representing the society of the age—warriors, falconers, leading citizens, ladies of the court, shamans, dancers, singers, ploughmen— accompanied by wild or domestic animals: horses, dogs, boars, deer, monkeys, birds. The so-called *haji* pottery was made for domestic use during this period, whereas the finer *sue* pottery (fired at a higher temperature) was intended for religious or ceremonial use alone. Some vases, evidently inspired by Korean models, have a tall pierced base and are decorated with human figures and animals in relief on top of the belly. Finally, this civilization was fond of ornaments, bracelets, buckles and jewels, and horse-trappings and sword-pommels of the period are also decorated.

ASUKA OR SUIKO PERIOD (538–645). One clan that had firmly established itself on the Yamato Plain consolidated its power, soon becoming the mighty imperial family, which still rules Japan today. A new capital, Asuka, was founded near Nara. At that time, power in religious matters was wielded by a military group, the Mononobe, whose members supported the native religion (Shinto). They had no wish to share this power with a family that expressed approval of a new religion. After a series of struggles within the imperial family, the conflict was resolved by a battle. Suiko, who supported Buddhism, emerged as empress in 592, thereby confirming the victory of that religion. Prince Shōtoku, the nephew of the empress, became regent of the kingdom. He assumed the task of spreading Buddhism throughout the country, founded monasteries and temples (including the famous Hōryūji Temple) and encouraged the arts. Buddhism, having been practised by Korean immigrants, was not unknown in Japan. The king of Pakche (known as Kudara in Japan), seeking an alliance with Japan in an effort to protect his kingdom from encroachment by the neighbouring kingdom of Silla (known as Shiragi in Japan), sent the Japanese Emperor Kimmei some *sūtras* and a Buddhist statue accompanied by a letter exalting the

new religion. The Northern Wei of China provided models for objects used in Buddhist rituals, for decorated reliquaries, tabernacles (including the famous Tamamushi), tapestries and statues of the Buddha with a mystic smile and sumptuous robes. The craftsmen who fashioned the precious materials were obviously very skilful, and these earliest Japanese Buddhist works of art show a complete break with previous artistic traditions.

NARA PERIOD (645–793). Chinese influence upon Japanese life became more and more pervasive. The Great Reform *(Taika)* of 645 conferred court ranks upon the heads of clans. An administrative system, whose officials were drawn from the nobility and from successful candidates in examinations resembling the Chinese type, was set up to control almost everything, including the number of hours spent at work and at leisure. It instituted a census every five years and also described in minute detail the duties and rights of dignitaries. The main beneficiary of this system was Buddhism, since temples were erected in each province at the state's expense. The Treasury became the patron of this golden age of Japanese Buddhist art. A permanent capital, Heijō ('the palace of peace') was founded in 710 on the site occupied today by the town of Nara. The *Kojiki* and *Nihon shoki,* chronicles relating the events of times gone by, were written, the oldest anthology of poems (the *Manyōshū*) was compiled, the life of the Buddha was told in scroll-paintings; and the Shōsō-in, a store-house in the Tōdaiji Temple grounds, was used to house Emperor Shōmu's possessions and art collection after his death in 756.

Artists derived their inspiration from far afield, mainly from India and Persia, through China as intermediary. Realism and mysticism were combined harmoniously in an art in which monsters and demons rubbed shoulders with the blessed. The ceremonial *sue* pottery—fired at more than 1200 °C (2192 °F)—continued to be made in a wide variety of styles. Another sort of pottery called *san-ts'ai* ('three-colour')—made in imitation of a certain Chinese T'ang ware—was the first type of Japanese pottery to be covered with glazes. Two new techniques were invented during this period: statues made of hollow dry-lacquer *(dakkatsu kanshitsu)* and statues of lacquer on a wooden core *(mokushin kanshitsu).* The largest statue in the world to have been produced by the *cire perdue* ('lost wax') process was the Great Buddha in the Tōdaiji Temple; it was made about 753. Statues of bronze and wood decorated the newly built temples of Yakushiji, Tōshō-daiji, Tōdaiji and Kōfukuji to name but a few. The wall-paintings in the Kondō at Hōryūji Temple reflect Indian influence.

HEIAN PERIOD (794–1185). The Emperor Kammu, in an attempt to escape from plots hatched by the Buddhist priesthood, established a new capital, Heian Kyō ('capital of peace and tranquillity') on the site of present-day Kyoto. This city, modelled on the Chinese pattern of streets intersecting at right angles, was to have a brilliant future as the capital of the arts and of literature. The long Heian period, characterized by refinement and elegance, is regarded as the classical age in Japan.

On their return from China, two monks founded two Esoteric Buddhist sects that were to exercise a considerable influence on the religious and artistic life of the country: Dengyō Daishi founded the Tendai sect in 805 and Kōbo Daishi the Shingon sect in 806. The aristocracy showed a great interest in Chinese literature and art. As relations with China weakened, Chinese influence upon painting and calligraphy gradually became less pronounced. The Fujiwara family governed the country in the name of the emperors, who at this time played merely a religious and representative role.

Esoteric and pietist sects created a style of Buddhist art conforming to their own aesthetic taste. Painting developed into two distinct styles: *kara-e* ('painting in the Chinese manner') and *yamato-e* ('painting in the Japanese manner'), and illustrated scrolls were created. About the year 1000, two ladies of the court wrote two masterpieces of Japanese literature: Murasaki Shikibu described the magnificence and intrigues of life at court in her novel about Prince Genji *(Genji Monogatari),* while Sei Shōnagon wrote down her thoughts and impressions in a group of essays *(zuihitsu)* entitled *Makura no sōshi* ('Pillow Book').

Sue pottery, now containing less carbon and lighter in colour, continued to be used for objects ranging from urns to incense-burners; these wares were decorated with delicately incised designs and had a grey glaze. The influence of Chinese T'ang sculpture declined noticeably. Many sculptures were carved during this period. Though their styles vary considerably, they all give an impression of strength and abundance. The gods and goddesses of Shinto began to be represented.

Towards the end of the period, great artists were at work, the most famous of these being Jōchō. The former prime minister Fujiwara Yorimichi converted his father Michinaga's villa into a temple, the famous Byōdō-in, which contains the Hōōdō ('Phoenix Hall'), whose ground-plan has a shape similar to that of a bird in flight. That part of the building houses Jōchō's image of the Buddha Amida meditating among celestial musicians, worshippers and winged figures. This statue was produced by the so-called *yosegi* technique, which involves joining several pieces of wood together, and the task of carving it was entrusted to a number of craftsmen all working simultaneously.

KAMAKURA PERIOD (1185–1333). The preceding period of bloodshed and pillage, of bloody battles between the Taira and Minamoto clans, of raids by monks who came down from the mountains, and of famines, ended with the victory of the Minamoto clan, which established a military government—the *bakufu* or shogunate—at Kamakura at the beginning of the period of the same name.

An administrative system based on bonds of suzerainty exercised a strict and rigorous control over the country's political and economic affairs. This system set up by Minamoto Yoritomo continued to operate under the Hōjō regents, despite being put to the test on many occasions. Kublai Khan wished to conquer Japan, and in 1274 he managed to land his forces in Hakata Bay (Fukuoka). His armies had to take to their boats again, but returned in 1281. A providential typhoon was to destroy the joint Korean and Mongolian fleet, and the Japanese, saved by their bravery and helped by the *kamikaze* ('divine wind'), were victorious. The nobility grew poorer, their riches falling into the hands of warriors *(samurai)* and then of merchants, who were becoming increasingly important.

Although no longer the seat of political power, Kyoto maintained its position as the principal artistic centre where the aristocratic art of the Heian period continued to flourish and Chinese Sung influence persisted. Buddhism remained a source of inspiration for sculpture and the minor arts. To the Buddhist Tendai and Shingon sects were added two others—the Kegon and Ritsu sects. The poet and Buddhist monk Hōnen founded the Jōdo sect, while the celebrated militant monk Nichiren disseminated the teachings of the *sūtra* of the Lotus of the Good Law *(Sadharma pundarika)* with such intransigence that he was frequently rebuffed. Chinese Ch'an Buddhism reached Japan where it became Zen Buddhism, which in time came to exert a powerful influence on the religious and artistic life of the country. In the

field of sculpture, the *ichiboku* (a statue carved from a single block of wood), continued to be carved from wood that was painted after treatment with lime. There was a return to the realism of earlier times, though this was balanced by a wealth of ornamental decoration. The *yosegi* technique (joining together several pieces of carved wood) was employed by great sculptors such as Unkei, Tankei, Kōben and Kōshō, but the work of a number of artists, whose names are unknown to us, displays a talent equal to theirs. Many palaces and monasteries were built. To the traditional styles immigrant Chinese monks added two new ones—the *Kara yō* (Chinese style) and the *Tenjiku yō* (Indian style). A small amount of glazed pottery based on Chinese models was produced for aristocratic use; domestic pots included the large storage jars with accidental glaze effects. Portraits, religious scenes, illustrated scrolls and anecdotal paintings depicted everyday life faithfully and with a touch of humour. Once again, however, wars broke out between feudal lords, and the city of Kamakura was seized and destroyed on 5 July 1333.

MUROMACHI PERIOD (1333–1573). After a period of fighting, the Ashikaga clan settled in Kyoto in the Muromachi quarter. The country continued to be disrupted by civil war, and imperial power was divided between two rival factions. The Southern Court moved to Yoshino, leaving the Northern Court in Kyoto under the protection of the Ashikaga shoguns. This state of affairs lasted until 1392, when it was ended by a settlement in the form of a compromise imposed by the Ashikaga: the two emperors were to take turns in ruling the country. In sharp contrast to a succession of peasants' revolts, famines and wars between feudal lords, accompanied by a slow decline in the authority of the shoguns (military governors of Japan, who exercised absolute rule, while the emperors were relegated to a nominal position), life at court, with its refined emperors and scholarly courtiers, was truly magnificent. Three great warriors appeared on the scene and eventually put an end to the state of anarchy: Oda Nobunaga, the *daimyō* ('feudal lord') of Owari province, Hideyoshi, a man of peasant stock, and Tokugawa Ieyasu, one of the five regents of the kingdom. In 1568, Oda Nobunaga captured Kyoto, and, in 1573, after a period of political chaos, he succeeded in putting an end to the Ashikaga shogunate.

From the beginning of the 15th century, contact had been renewed with the Chinese Ming court that had managed to overthrow the Mongols. Chinese influence is evident in the painting, calligraphy and poetry of the Muromachi period. Zen Buddhism, which was competing for superiority over other Buddhist sects, produced monks who were skilled painters; they followed the famous Chinese tradition of ink-painting and also continued to produce illustrated scrolls with religious themes. A great dynasty of painters, the Kanō, began to work under the protection of the Palaces, and great houses were built, such as the Golden Pavilion *(Kinkukuji)* and Silver Pavilion *(Ginkakuji)* at Kyoto. The quality of sculpture declined visibly, perhaps because Zen Buddhism gave such preference to sculpted portraits of abbots. Many of the abbots were also tea-masters; these masters codified the rules of tea ceremonies in minute detail, as well as the rules relating to the utensils used, the architecture of the pavilions where the tea ceremonies took place and, above all, to the gardens surrounding the pavilions. Certain famous aesthetes such as Musō Kokushi, showed great refinement and a true love of nature in the establishment of these gardens.

In 1543, a Portuguese ship was wrecked off the island of Tanegashima to the south of Kyushu. In this way the first Europeans arrived in Japan—Portuguese at first, then Spaniards, all of them being referred to as *Namban,*

meaning barbarians from the south, after the region where they first landed. These traders brought with them firearms and the Catholic religion, which they were allowed to preach in an atmosphere of complete tolerance. During this period the Kanō School was the official shogunate school of painting; the Tosa School became the chief *yamato-e* School, and a new type of theatre appeared—the *nō* dance-drama, for the performance of which masks and sumptuous costumes were required. Zeami was the great figure dominating this type of drama.

MOMOYAMA PERIOD (1573–1614). On the death of the military dictator of Japan Oda Nobunaga, the warlord Hideyoshi was forced to fight to establish his authority, and this he did with ferocious tenacity. He compiled a detailed land registry that enabled him effectively to control the tax yield. He turned the peasants into serfs bound to the land and instituted a system of collective responsibility, both for the village and for the family. And he managed to bring about a period of relative calm by setting up a police state that continued during the rule of his successors. He also invaded Korea, but the Koreans and Chinese forced the Japanese to withdraw, and with Hideyoshi's death in 1598, the war ended. Tokugawa Ieyasu, who had cleverly taken advantage of Hideyoshi's generosity, had become the most powerful *daimyō* in the country. Despite a succession of political intrigues followed by armed struggles, Ieyasu defeated all his rivals and, in 1604, made Edo—present-day Tokyo—the seat of the *bakufu*.

The Japanese continued to be intrigued by European missionaries. The Jesuits outnumbered other evangelists and had some clashes with the Franciscans. Tens of thousands of Japanese nobles, merchants and peasants became converted to Catholicism. Disputes also broke out between Portuguese and Spanish missionaries, and Jesuit influence began to make itself felt in political spheres. In 1614, Ieyasu expelled the Portuguese and Spanish missionaries, fearing that their countries might attempt to conquer Japan, but he continued to welcome the Dutch and other foreigners whose presence did not have undesirable political overtones.

This contact with the West gave birth to the original art known as *Namban* or 'southern barbarians' art. Screens, portraits, anecdotal scenes, religious and domestic objects all show the profound, and sometimes malicious, interest the Japanese had in the West. Western influence was also reflected in the imposing castles built at the time, although the interior decoration of these buildings remained Japanese in style, with painted or carved panels and lintels. There was a marked decline in sculpture, very little of which was produced apart from portraits of abbots and tea-masters. Painting and calligraphy received a new impetus and were often the work of Zen monks, whose sense of beauty influenced all the arts at this time. The period has been called the golden age of Japanese pottery, since during this period and the following one, the variety of wares was greater and the imagination of potters more fertile than at any other time in Japan's history. The main reason for it was the emphasis on the aesthetics of the tea ceremony. About 1574, the celebrated potter Chōjirō invented *raku* ware, which became the most popular type of pottery for *chawan* (tea bowls); the reputation of *raku* ware was enhanced by Kōetsu, one of the greatest potters of his age. The first porcelain was no doubt produced by Ri Sanpei, one of the Korean potters whom Hideyoshi brought back from his Korean expedition. There were so many types of pottery and centres of production that it is impossible to mention them all. Some of the most famous types are *Karatsu, Hagi, Satsuma, Kyōyaki* (Kyoto pottery), *Shino, Oribe, Seto, Tokoname, Shigaraki, Echizen, Tamba* and *Bizen*. These all continued to be produced during

later periods. The tea ceremony also influenced the architecture of residences and tea houses and led to the creation of gardens, abstract or otherwise, whose variety makes Kyoto charming. Besides the subject matter introduced into painting by *Namban* art, the great traditional styles continued to flourish: the Kanō school, landscape painting and illustrated scrolls. Towards the end of the period, a taste for genre painting developed, paving the way for *ukiyo-e* (pictures of the floating world), the fashionable world with emphasis on its ephemeral nature.

EDO PERIOD (1614–1868). The Tokugawa shoguns gradually established a firm government and created specialized departments that were in fact ministries in the modern sense of the word. The redistribution of land in order to reward faithful vassals provoked much dissatisfaction, particularly among the *rōnin* (masterless samurai), who caused constant, though not too serious, trouble. Some *rōnin* turned to Christianity, and the measures against Christians, which had never been applied strictly during Ieyasu's lifetime, were therefore rigorously enforced under Iemitsu, culminating in the punishment of the Christians defeated at the Battle of Shimabara (1638). The abjuration of faith demanded of these rebels (*fumi-e:* stamping on holy images) was more a gesture of civil obedience than a denial of metaphysical beliefs. The Dutch Protestants, who were considered unlikely to be entertaining ideas of invasion, were allowed to remain, but were confined to the small island of Deshima near Nagasaki: they continued to trade with Japan together with the Chinese, who were restricted to Nagasaki.

Apart from the small number of authorized ships and travellers, no one was allowed to enter or leave Japan without being imprisoned or suffering an even worse fate. The shoguns succeeded one another, never failing to keep a firm grip on the country, crushing revolts, remaining powerless to put an end to famines and encouraging the arts. Russian and English ships tried to make official contact, but their efforts were in vain. They were followed by the Americans, who experienced the same lack of success. Then, about 1845, the internal tension eased, and the situation became more relaxed. The year 1853 saw the arrival of the American Commodore Perry and his battleships, the Black Ships *(Kurobune)*. The *bakufu*, now terrified and aware that it was powerless to defend the country, opened two ports to foreigners—Shimoda in the south of the Izu peninsula and Hakodate on Hokkaido. Diplomatic relations with Western powers were gradually established, the burning issue of the day being whether Japan should accept or reject foreigners. The collapse of power culminated in a civil war, and a provisional government was set up in 1867.

The popularity of folk-tales stimulated great interest in the *kabuki* theatre, the puppet theatre and wood-block prints of the *ukiyo-e* School. Many very talented writers and artists worked at this time; the best known of these are the *kabuki* dramatist Chikamatsu Monzaemon, the painter and lacquerer Ogata Korin and the masters of wood-block printing such as Kiyonobu, Harunobu, Sharaku, Kiyonaga, Utamaro, Hiroshige and Hokusai. Although there is scarcely any evidence of originality in the architecture and sculpture of the time, the brilliant tradition of ceramic production continued unabated. Artists went on designing in the styles of previous ages, but showed a renewed interest in porcelain with underglaze or overglaze decoration. Vessels with a surface deliberately left rough (used in the tea ceremony), Nabeshima porcelain and the famous wares painted in several bright colours produced by the Kakiemon family and its descendants were just a few of a variety of outstanding types of porcelain created during this period. Artists of the Kanō and Tosa schools of painting continued to be active and the

Japanese built the magnificent mausoleum for Ieyasu at Nikko as an expression of gratitude for their well-being.

MEIJI ERA (1868–1912). Mutsuhito, a headstrong adolescent and the 122nd emperor of Japan, left Kyoto, moving his court to Edo, which he renamed Tokyo ('capital of the East'). He succeeded in surrounding himself with shrewd advisers and replaced the power of the shoguns by that of the emperor. He abolished the old territorial divisions and created departments with prefectures dependent on the central government. His posthumous title was *Meiji tennō* ('emperor of the era of enlightened government'). The whole world was amazed at the speed with which this transformation took place. Western scientific ideas had gradually been spread by the Dutch and Portuguese. The Japanese, who were very willing and able learners, translated European books and founded schools of Western science and literature. Writers continued to cultivate the Chinese style, but a new branch of Japanese literature, which had first appeared in the Edo period, became widespread: scientific treatises and books about natural history.

MAJOR MUSEUMS

Prefectural Museum, Maebashi, Gumma prefecture
Museum, Idojiri, Nagano prefecture
Museums, Kamakura, Kanagawa prefecture
Museum, Karako, Nara prefecture
Kobe City Museum of Namban Art, Kobe, Hyogo prefecture
Kyoto City Art Museum; Kyoto National Museum; Kyoto University Library, Kyoto, Kyoto prefecture
Tokugawa Art Museum, Nagoya, Aichi prefecture
Museums, Nara, Nara prefecture
Osaka Municipal Museum of Fine Arts, Osaka, Osaka prefecture
Museum, Sakai, Yamanashi prefecture
Shizuoka Archaeological Museum, Shizuoka, Shizuoka prefecture
Museum, Togariishi, Nagano prefecture
Tokoname Ceramic Research Center, Tokoname, Aichi prefecture
Tokyo National Museum; Tokyo University Archaeological Collection; Tokyo University of Arts Art Museum; Keio University Museum; Meiji University Museum; Nezu Institute of Fine Arts; Okura Shukokan Museum, Tokyo, Tokyo prefecture
Museum, Toro, Nagoya prefecture
Museum, Wakayama, Wakayama prefecture
as well as numerous temples and monasteries

CONCISE BIBLIOGRAPHY

AKIYAMA, T. *La peinture japonaise.* Paris, 1964.
BUHOT, J. *Histoire des arts du Japon,* vol. 1 *Des origines à 1350.* Paris, 1949.

Japan

ELISSEEFF, D. and V. *La civilisation japonaise.* Paris, 1974.

ELISSEEFF, V. *Japon.* (Archeologia mundi coll.) Paris, Geneva.

FREDERIC, L. *Japon: Art et civilisation.* Paris, 1969.

GROUSSET, R. *The Civilisations of the East* (trs. by Catherine Alison Philips). 4 vols. London, 1931–34.

HAGUENAUER, C. *Origines de la civilisation japonaise,* Part 1 *Introduction à l'étude de la préhistoire du Japon.* Paris, 1956.

JENYNS, S. *Japanese Pottery.* London, 1971.

——————— *Japanese Porcelain.* London, 1965.

KIDDER, J. EDWARD *The Birth of Japanese Art.* London, 1965.

——————————— *Masterpieces of Japanese Sculpture.* Tokyo, 1961.

——————————— *Japan before Buddhism: Ancient Peoples and Places.* London, 1959.

——————————— and ESAKA, TERUYA. *Joman Pottery,* Tokyo, 1968.

KOYAMA, F. *The Heritage of Japanese Ceramics.* New York and Tokyo, 1973.

LANDY, P. *Japan* (trs. by Mrs. H. S. G. Harrison). Geneva, 1965.

NOMA, SEIROKU. *The Arts of Japan* (trs. by John Rosenfield and Glenn Webb). 2 vols. Tokyo, 1966 and 1968.

MASUDA, T. *Living Architecture: Japanese* (Ron Toby ed.). London, 1970.

MUNSTERBERG, H. *The Arts of Japan.* 4th edn. Rutland, Vt., and Tokyo, 1967.

——————————— *Pageant of Japanese Art.* 6 vols. Rutland, Vt., and Tokyo, 1953.

ROUSSET, H. 'L'art du Japon' in vol. 4 *Encyclopédie générale de l'Homme.* Paris, 1971.

SMITH, B. *Japan: A History in Art.* London, 1965.

SWANN, P. *Art of China, Korea and Japan,* London, 1963.

YAMADA, C. F. (gen. ed.). *Decorative Arts of Japan.* Tokyo, 1964.

CHRONOLOGY

Pre-pottery period	
Jōmon period: proto-Jōmon	11th–6th millennia B.C.
early Jōmon	6th–3rd millennia B.C.
middle Jōmon	3rd millennium B.C.
late Jōmon	2nd millennium B.C.
final Jōmon	1000–400 B.C.
Yayoi period	3rd century B.C. to 3rd century A.D.
Grave-mounds (Tumulus) period	A.D. 3rd–6th century
Asuka (Suiko) period	538–645
Nara period	645–793
Heian period	794–1185
Kamakura period	1185–1333
Muromachi period	1333–1573
Momoyama period	1573–1614
Edo period	1614–1868
Meiji period	1868–1912

JAPAN

Names of the prefectures by islands

1. HOKKAIDO

HONSHU
2. Aomori
3. Akita
4. Iwate
5. Yamagata
6. Miyagi
7. Fukushima
8. Gumma
9. Tochigi
10. Ibaraki
11. Saitama
12. Tokyo
13. Kanagawa
14. Chiba
15. Niigata
16. Ishikawa
17. Toyama

18. Fukui
19. Gifu
20. Nagano
21. Yamanashi
22. Aichi
23. Shizuoka
24. Hyogo
25. Kyoto
26. Shiga
27. Osaka
28. Nara
29. Mie
30. Wakayama
31. Shimane
32. Tottori
33. Yamaguchi
34. Hiroshima
35. Okayama

SHIKOKU
36. Ehime
37. Kagawa
38. Kochi
39. Tokushima

KYUSHU
40. Nagasaki
41. Saga
42. Fukuoka
43. Oita
44. Kumamoto
45. Kagoshima
46. Miyazaki

RYUKYU ISLANDS (not pictu
47. Okinawa

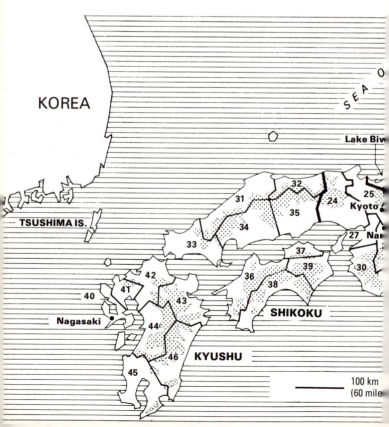

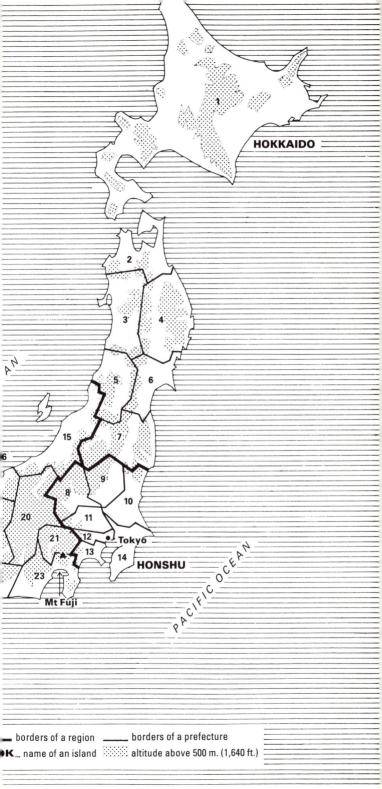

HOKKAIDO

HONSHU

PACIFIC OCEAN

Tokyo

Mt Fuji

—— borders of a region —— borders of a prefecture
●K … name of an island ⬚ altitude above 500 m. (1,640 ft.)

1
Foundations of pit dwellings, late
Yayoi period, Toro, Aichi pref.

2
Arrangement of *haniwa* (funerary
figurines) on a *zenpōkōen* (keyhole-
shaped) tumulus, Gumma pref.

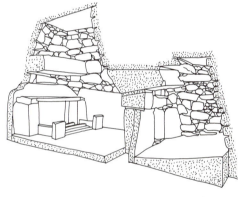

3 Ōzuka Tomb (cross-section): chamber-type tomb, funerary niche (left)
flanked by 2 *tomyōseki* (lamp stones), late Tumulus period, Fukuoka pref.

4 *Tomyōseki:* painted and incised, at right front of Ōzuka Tomb funerary
niche, late Tumulus period, Fukuoka pref.

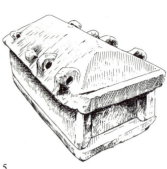

5
Sarcophagus, stone, late Tumulus period, Wakayama pref. Wakayama Mus.

6
Sarcophagus, *chokkōmon* design (intersecting curved and diagonal lines), stone, Tumulus period, Fukuoka pref.

7
Haniwa house, clay, L. 78.5 cm., middle Tumulus period, Miyazaki pref., Nat. Mus., Tokyo

8
Haniwa 2-storied house, clay, middle Tumulus period, Mie pref., Nat. Mus., Tokyo

9 *Haniwa* house: pitched roof, clay, L. 73.5 cm., middle Tumulus period, Gumma pref., Nat. Mus., Tokyo

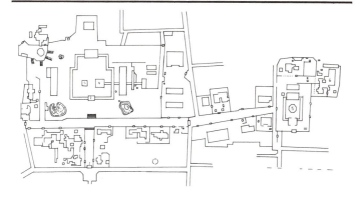

10 Hōryūji Temple complex (plan), *c.* 610, Nara pref.

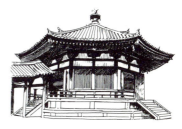

12
Yumedono of Hōryūji Temple, wood, 735–50, Nara pref.

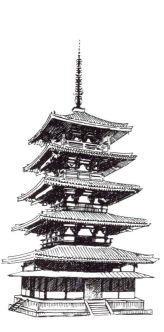

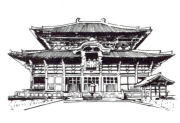

13
Great Buddha Hall of Tōdaiji Temple, (N.B. panelled bronze lantern in front.) Nara period, Nara pref.

11
5-storey pagoda of Hōryūji Temple, wood, Asuka period, Nara pref.

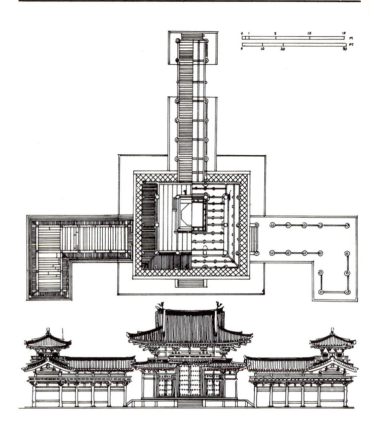

14 Phoenix Hall (Hōōdō) of the Byōdō-in (plan and elevation), wood,
Heian period, Kyoto pref.

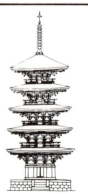

15
5-storey pagoda of Murōji Temple
(cross section), wood, early 9th c.,
Nara pref.

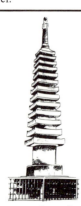

16
13-storey pagoda of Hannyaji
Temple, wood, Kamakura period,
Nara pref.

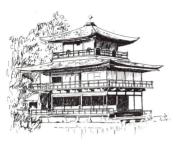

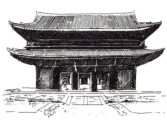

17
Golden Pavilion *(Kinkaku)* of Kin-kakuji Temple (Rokuonji), wood, built 1394, rebuilt 1955, Kyoto pref.

18
Sammon gate of Tōfukuji Temple, wood, Muromachi period, Kyoto pref.

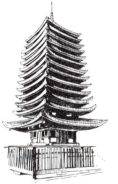

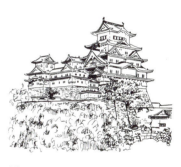

19
13-storey pagoda of Danzan Shrine, cypress-bark roof, 1532, Nara pref.

20
Himeji Castle, wood and stone, 1610, Himeji, Hyogo pref.

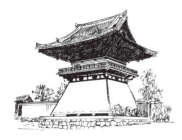

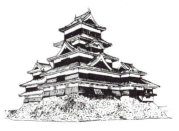

21
Bell Tower of Daitokuji Temple: hipped and gabled roof, wood, Momoyama period, Kyoto pref.

22
Matsumoto Castle, wood and stone, 1582, Matsumoto, Nagano pref.

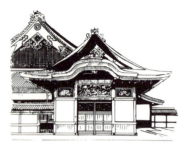

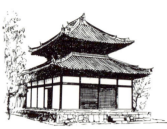

23
Kurumayose entryway, Ninomaru
Palace (1624–6) of Nijō Castle,
wood, Kyoto pref.

24
Golden Hall (Kondō) of Hōrinji,
wood, 1737, Nara pref.

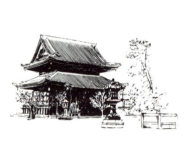

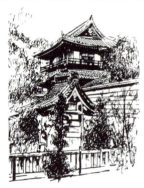

25
Mieidō of Chionin Temple, wood,
1633–9, Kyoto pref.

26
Kinnenji Temple, wood, built 13th
c., rebuilt 18th c., Kyoto pref.

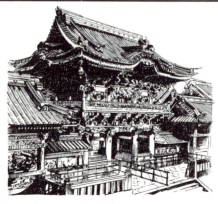

27 Yōmeimon gate of Tōshōgu mausoleum, 2 stories, decorated with
 sculpture (colors on wood), early 17th c., Nikkō, Tochigi pref.

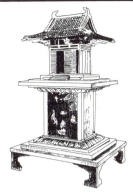

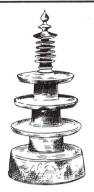

28
Tamamushi Shrine, laquered wood inlaid with beetle wings, Asuka period, Hōryūji Temple, Nara pref.

29
Miniature stupa, colours on wood, Nara period, Hōryūji Temple, Nara pref.

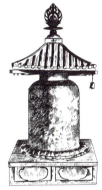

30
Miniature stupa, bronze, Heian period, Kuramadera Temple, Kyoto pref.

32
Balustrade ornament, ceramic, Edo period, Mus. of the Univ. of Arts, Tokyo

31
Miniature reliquary pagoda *(sharitō)*, gilt bronze with openwork, dated 1249, Saidaiji Temple, Nara pref.

33
Anthropomorphic form, clay, H. 4.8 cm., early Jōmon period, Hanawadai shellmound, Ibaraki pref.

34
Figurine, clay, H. 16.5 cm., middle Jōmon period, Sakai, Yamanashi pref., Nat. Mus., Tokyo

35
Hollow figurine (front), clay, H. 30 cm., middle Jōmon period, Chōjagahara, Niigata pref., Nat. Mus., Tokyo

36
Back of No. 35

37
Figurine, clay, H. 25.5 cm., middle Jōmon period, Sakai, Yamanashi pref., Sakai Mus.

38
Faceless figurine, clay, H. 9.5 cm., late-middle Jōmon, Fukuda shellmound, Mun. Mus., Osaka

39
Figurine, clay, H. 31 cm., late-middle Jōmon period, Satohara, Gumma pref.

40
Figurine, clay, H. 12.1 cm., Jōmon period, Shiizuka shellmound, Ibaraki pref., Mun. Mus., Osaka

41
Anthropomorphic form, clay, H. 18 cm., late-middle Jōmon period, Aomori pref.

42
Hollow, bell-shaped figurine, clay, H. 26.4 cm., middle-late Jōmon period, Nakayashiki, Kanagawa pref.

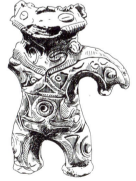

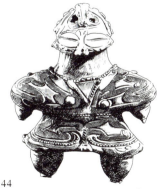

43
Hollow figurine, clay, H. 27.1 cm., late-middle or late Jōmon period, Fukuda shellmound, Ibaraki pref.

44
Hollow figurine, clay, H. 26.2 cm., late Jōmon period, Miyagi pref., M. Kusumoto Coll.

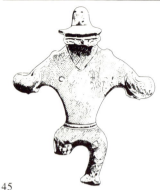

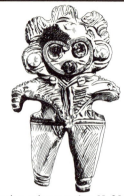

45
Figurine, clay, H. 19.3 cm., late Jōmon period, Tateishi, Aomori pref., Mun. Mus., Osaka

46
Figurine, colours on clay, H. 20.4 cm., late Jōmon period, Shimpukuji shell-mound, Saitama pref., M. Takeo Coll.

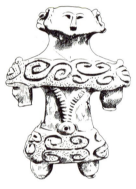

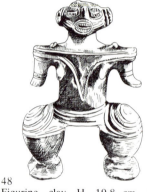

47
Figurine, colours on clay, H. 19 cm., late Jōmon period, Muroran, Hok-kaido, Nat. Mus., Tokyo

48
Figurine, clay, H. 19.8 cm., late Jōmon period, Tokomai, Aomori pref., Nat. Mus., Tokyo

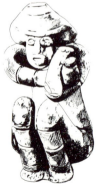

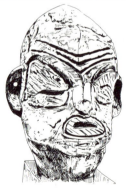

49
Figurine: woman carrying a jar, clay, H. 21.5 cm., late-middle Jōmon pe-riod, Higashi Yuno, Fukushima pref.

50
Figurine: head, clay, H. 9 cm., mid-dle or late Yayoi period, Ibaraki pref., Nat. Mus., Tokyo

51
Haniwa figurine: female shaman with mirror, clay, H. 68.5 cm., Tumulus period, Gumma pref., Nat. Mus., Tokyo

52
Back of No. 51

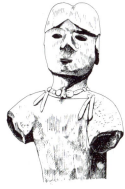

53
Haniwa figurine, clay, H. 40 cm., late Tumulus period, Nara pref., Nat. Mus., Tokyo

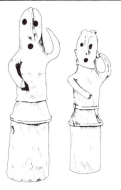

55
Haniwa figurines: 2 singing dancers, clay, H. 64 cm., 57 cm., Saitama pref., Nat. Mus., Tokyo

54
Haniwa figurine: female dancer, colours on clay, H. 88.5 cm., Tumulus period, Gumma pref., Nat. Mus., Tokyo

541

56
Haniwa figurine: warrior (front),
clay, H. 133 cm., late Tumulus pe-
riod, Gumma pref., Nat. Mus., Tokyo

57
Back of No. 56

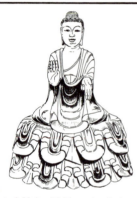

58
Haniwa figurine: falconer, clay, H.
74.5 cm., Tumulus period, Gumma
pref., Yamato Bunkakan Mus.

59
Seated Yakushi Nyorai, gilt bronze,
H. 44 cm., Asuka period, Nat. Mus.,
Tokyo

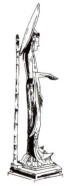

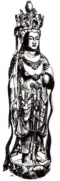

60
Kudara Kannon (Avalokiteśvara):
Korea, wood, H. 208.2 cm., Asuka
period, Hōryūji Temple, Nara pref.

61
9-headed Kannon, wood, Asuka
period, H. 39 cm., Hōryūji Temple,
Nara pref.

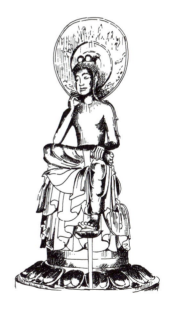

63
Shaka Triad by Tori Busshi, bronze, H. 92.3 cm., W. 96.9 cm., Asuka period, Hōryūji Temple, Nara pref.

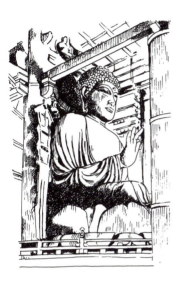

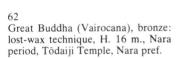

62
Great Buddha (Vairocana), bronze: lost-wax technique, H. 16 m., Nara period, Tōdaiji Temple, Nara pref.

64
Miroku Bosatsu (Maitreya), wood, H. 138 cm., Asuka period, Chūgūji Temple, Nara pref.

65
Bazara Daishō, colours on clay, H. 167 cm., Nara period, Shin Yaku-shiji Temple, Nara pref.

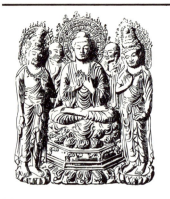

66
Buddha with attendants, copper,
Nara period

67
Gakkō Bosatsu (Candraprabha),
clay, H. 206.3 cm., Nara period,
Tōdaiji Temple, Nara pref.

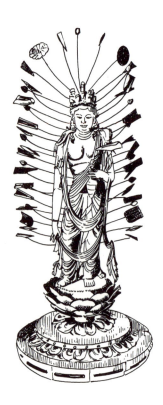

69
Seated Buddha, bronze, H. 82 cm.,
Nara period, Jindaiji Temple, Nara
pref.

68
11-headed Kannon (Ekadasa-
mukha), sandalwood, H. 1 m., Nara
period, Hokkeji Temple, Nara pref.

70
KōmokuTen (1 of 4 Guardian Kings),
colours on clay, H. 163.6 cm., Nara
period, Tōdaiji Temple, Nara pref.

71
Yuima (Vimalakirti), dry lacquer, H. 110 cm., Nara period, Hokkeji Temple, Nara pref.

72
Kannon Bosatsu (Avalokiteśvara), bronze, H. 30 cm., Nara period, Nat. Mus., Tokyo

73
Infant Buddha in a bowl, gilt bronze, D. 89.5 cm., Nara period, Tōdaiji Temple, Nara pref.

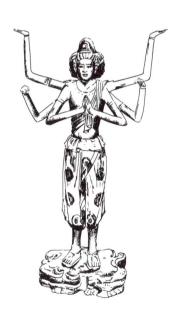

75
Abbot Ganjin (Chien Chen), colours on dry lacquer, H. 80.5 cm., Nara period, Tōshōdaiji Temple, Nara pref.

74
Ashura (Asura), colours on dry lacquer, H. 153 cm., Nara period, Kōfukuji Temple, Nara pref.

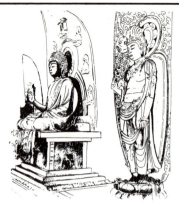

76 Yakushi Triad: Yakushi Buddha flanked by Gakkō Bosatsu & Nikkō Bosatsu, bronze, H. 256 cm., 315 cm., Nara period, Yakushiji Temple, Nara pref.

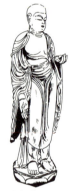

77
Nichiren, *ichiboku* (carved from a single block of wood), H. *c.* 1 m., Heian period, Nara Mus.

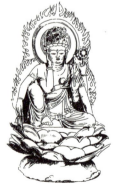

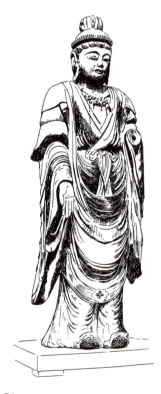

79
Nyoirin Kannon (Cintamanicakra), cypress wood *ichiboku,* H. 109 cm., Heian period, Osaka pref.

78
Kichijō Ten (Sri-mahadevi), *ichiboku,* H. 136 cm., Heian period, Nat. Mus., Tokyo

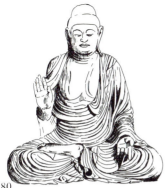

80
Seated Buddha, colours on cypress
wood, H. 106.4 cm., Heian period,
Murōji Temple, Nara

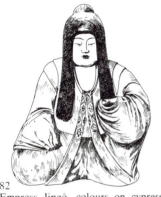

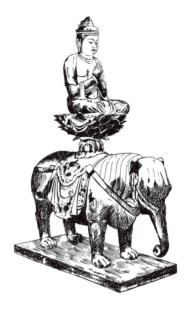

82
Empress Jingō, colours on cypress
wood, H. 95 cm., Heian period,
Yakushiji Temple, Nara pref.

81
Fugen Bosatsu (Samantabhadra), *yo-
segi* (assembled wood), H. 56 cm.,
Heian period, Okura Mus., Tokyo pref.

83
Shintō god, *ichiboku,* H. 97 cm.,
Heian period

84
Shishiku Bosatsu, colours on cypress
wood, H. 171 cm., Nara or Heian pe-
riod, Tōshōdaiji Temple, Nara pref.

85
Kongō Kōkūzō (Akaśagarbha), wood, dry lacquer, H. 97 cm., Heian period, Jingōji Temple, Kyoto pref.

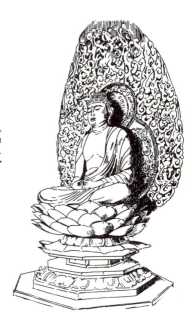

87
Prince Shōtoku by Enkai, *yosegi*, H. 58 cm., Heian period, Hōryūji Temple, Nara pref.

86
Amida (Amitabha) by Jōchō, gilt wood, *yosegi*, H. 295 cm., 1053, Phoenix Hall, Byōdō-in, Kyoto pref.

88
1 of the 12 Heavenly Kings *(Jūni-jinshō)*, wood, H. 91 cm., Heian period, Kōfukuji Temple, Nara pref.

89
Mekira (1 of the 12 Heavenly Kings), wood, H. 91 cm., Heian period, Kōfukuji Temple, Nara pref.

90
11-headed Kannon (Ekadasa-
mukha), *c.* 130 cm., Heian period,
Nara Mus.

91
Miroku Bosatsu (Maitreya), sandal-
wood, H. 94 cm., Nara or Heian
period, Murōji Temple, Nara pref.

92
Yakushi Nyorai (Bhaisajyaguru),
gilt wood, Heian period, Nat. Mus.,
Tokyo

93
1000-armed Kannon (Sahasra-
bhuja), *ichiboku,* Heian period,
Nat. Mus., Tokyo

94
Celestial worshipper *(apsara)*, colours
on wood, H. *c.* 50 cm., Heian period,
Phoenix Hall, Byōdō-in, Kyoto pref.

95
1000-armed Kannon by Tankei, gilt
wood, H. 165 cm., Kamakura peri-
od, Myōhōin Temple, Kyoto pref.

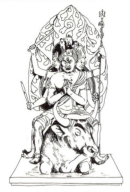

96
Daiitoku, 1 of the 5 Deva Kings (Godaisonmyō-ō), wood, Kamakura period, Daitokuji Temple, Kyoto pref.

97
Tentōki by Kōben (?), wood, H. 77 cm., Kamakura period, Kōfukuji Temple, Nara pref.

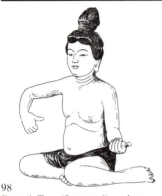

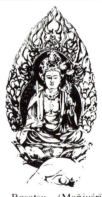

98
Benzai Ten (Saravasti), colours on wood, H. 98 cm., 1266, Tsurugaoka Hachimangū shrine, Kamakura City

99
Monju Bosatsu (Mañjuśrī), gilt wood, Kamakura period, Kokkeji Temple, Nara pref.

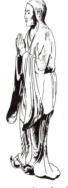

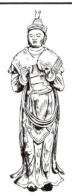

100
Old woman praying by Tankei (?), *yosegi*, H. 154 cm., Kamakura period, Myōhōin Temple, Kyoto pref.

101
Jimmo Ten by Tankei (?), colours on wood *(yosegi)*, H. 169 cm., Kamakura period, Myōhōin Temple

103
Ichiji Kinrin Nyorai, colours on wood,
H. 77 cm., late Heian or Kamakura
period, Chūsonji Temple, Iwate pref.

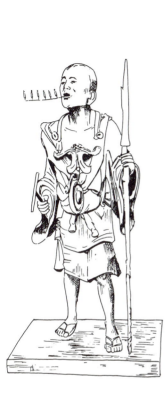

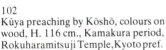

102
Kūya preaching by Kōshō, colours on
wood, H. 116 cm., Kamakura period,
Rokuharamitsuji Temple, Kyoto pref.

105
Uesugi Shigefusa in court dress,
wood, H. 68 cm., Kamakura period,
Meigetsuin, Kanagawa pref.

104
Jizō Bosatsu (Kshitigarbha), wood
and metal, H. c. 120 cm., Kamakura
period, Nat. Mus., Kyoto

106 Amida (Amitabha) between Seishi (Mahasthamaprapta) and Shō
 Kannon (Avalokiteśvara), gilt wood, Kamakura period

107
Mujaku (Asanga): Indian patriarch
by Unkei, colours on wood, H. 194
cm., c. 1208–12, Nara pref.

108
Seshin (Vasubandhu) by Unkei,
colours on wood, H. 189.5 cm., 1208,
Rokuharamitsuji Temple, Kyoto pref.

109
Misshaku Kongō, 1 of 2 Benevolent
Kings by Unkei & Tankei, colours on
wood, H. c. 8 m., 1203, Nara pref.

110
Taira no Kiyomori as a monk, colors
on wood, H. 85 cm., Rokuharamitsuji
Temple, Kyoto pref.

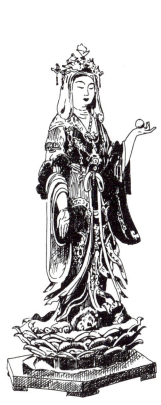

111
Kichijō Ten (Sri-mahadevi), colours on wood, H. 90 cm., Kamakura period, Jōruriji Temple, Kyoto pref.

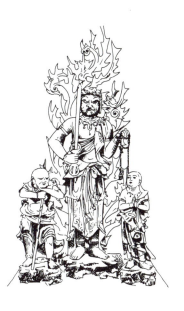

112
Demon, colours on wood, H. *c.* 30 cm., Kamakura period, Hōryūji Temple, Nara pref.

114
The monk Shunjōbō Chōgen, colours on wood, *yosegi,* H. 82 cm., Tōdaiji Temple, Nara pref.

113
Fudō, Kongara, Seitaka by Kōen, colours on wood, H. *c.* 1 m., 1311, Jōruriji Temple, Nara pref.

116
The monk Eison by Zenshun, wood, H. 91 cm., Kamakura period, Saidaiji Temple, Nara pref.

115
Monju Bosatsu (Mañjuśrī) riding a lion, gilt wood, H. 45 cm., Kamakura period, Hannyaji Temple, Nara pref.

117
Great Buddha of Kamakura, bronze, cast in *igarakuri* technique, H. *c.* 10 m., 1252, Kamakura City

118 Fūjin (god of wind) and Raijin (god of thunder), colours on wood, H. 111 cm., 100 cm., Kamakura period, Myōhōin Temple, Kyoto pref.

119
Basū Sennin (Vasu Vasistha) by Tankei, colours on wood, *yosegi,* H. 155 cm., 1254, Kyoto pref.

121
Nyoirin Kannon (Cintamanicakra), wood, H. 2 m., Kamakura period, Ryōzanji Temple, Kyoto pref.

120
Demon, colours on clay, H. *c.* 2 m., Muromachi period, Nara Mus.

122
Prince Siddhartha, colours on wood, H. 33 cm., Muromachi period, Ninnaji Temple, Kyoto pref.

123
Misshaku Kongō (Gharbavira), clay and wood, H. 2 m., Muromachi period, Sammon gate, Kyoto pref.

124
Seated Buddha by Kōei, colours on wood, Muromachi period, Sammon gate of Tōfukuji Temple, Kyoto pref.

125
The monk Ikkyū, colours on wood, Muromachi period

126
Kannon Bosatsu (Avalokiteśvara), wood, Muromachi period

127
Candlestick shaped as Portuguese man, Oribe ware, H. 27 cm., Momoyama period

128
Three Dutchmen, colours on terracotta, H. 9 cm., Momoyama period

129
Fujiwara Kamatari, ivory, H. *c.* 35 cm., Edo period

130
Maria Kannon with Christ child (Chinese or Japanese copy), porcelain, H. 32 cm., Edo period

132
Monk, stone, Edo period, Murōji Temple, Nara pref.

131
Hotei (in Japan: 1 of 7 gods of Happiness), wood, Edo period, Mampukuji Temple, Kyoto pref.

133
Woman carrying a vase, Kakiemon ware, H. 36 cm., late 17th c., Nat. Mus., Tokyo

134
Hermit, *netsuke* (toggle) by Hoshin, boxwood, H. *c.* 2.5 cm., late 18th c., Nat. Mus., Tokyo

135
Man drinking sake, *netsuke* by Ikko, ivory, H. *c.* 2 cm., mid 18th c., Nat. Mus., Tokyo

136
Peasant woman and child, *netsuke* by Tōkoku, colours on ivory, H. *c.* 3 cm., 19th c., Nat. Mus., Tokyo

137
Jars (scale drawing): Kantō types, early Jōmon period

138
Jar with pointed base; rope-pattern design, clay, H. 28 cm., early Jōmon period, Chiba pref. Nat. Mus., Tokyo

139
Jar with pointed base; impressed design, clay, H. 23.5 cm., early Jōmon period, Niigata pref.,Nat.Mus.,Tokyo

140
Jar: impressed design, clay, H. *c.* 30 cm., early Jōmon period, Shiroyama shellmound, Nat. Mus., Tokyo

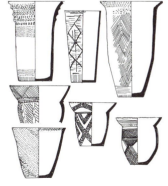

141
Jar: decorated with shells, clay, H. 34 cm., early Jōmon period, Nagano pref., Nat. Mus., Tokyo

142
Jars: Kyushu types, early-middle Jōmon period

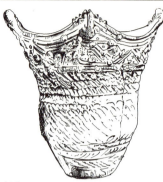

143
Jar: cylindrical, incised and impressed design, clay, H. 37.5 cm., Jōmon period, Aomori pref., Keio Univ. Mus.

144
Jar: applied decoration, clay, H. 21 cm., early-middle Jōmon period, Tokyo region, Meiji Univ. Mus., Tokyo

145
Jar: incised decoration, clay, H. 16 cm., early-middle Jōmon period, Osaka region

146
Plate shaped as human torso, clay, H. 10.5 cm., early-middle Jōmon period, Aomori pref.

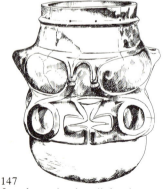

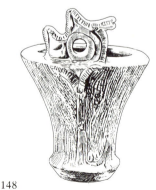

147
Jar: decoration in relief, colours on clay, H. 40 cm., middle Jōmon period, Nagano pref. Togariishi Mus.

148
Jar: snake-shaped ear, clay, H. 19.5 cm., middle Jōmon period, Nagano pref., Togariishi Mus.

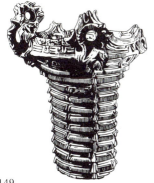

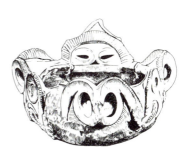

149
Jar: applied and incised decoration, clay, H. 37 cm., middle Jōmon period, Toyama pref., Nat. Mus., Tokyo

150
Vase neck: decorated with a head, clay, D. 23.5 cm., middle Jōmon period, Nagano pref. Togariishi Mus.

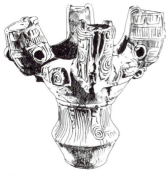

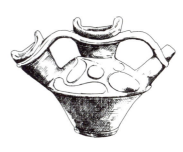

151
Jar: decorated with 4 heads, clay, H. 34.3 cm., middle Jōmon period, Idojiri, Nagano pref., Idojiri Mus.

152
Ewer, clay, H. c. 20 cm., middle Jōmon period, Iwate pref.

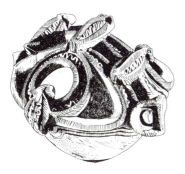

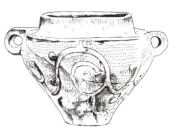

153
Bowl: insect motives on handle, clay, H. 17 cm., middle Jōmon period, Nagano pref.

154
Jar with handles: stippled decoration, clay, H. 22 cm., middle Jōmon period, Nagano pref., Togariishi Mus.

155
Bowl: undulating rim, incised deco-
ration, clay, D. *c.* 20 cm., middle
Jōmon period, Nat. Mus., Tokyo

156
Pot with spout: incised decoration,
clay, H. 12 cm., Jōmon period, Akita
pref., Meiji Univ. Mus., Tokyo

157
Jar: decorated rim, clay, H. 20 cm.,
Jōmon period, Kagoshima pref.,
Arch. Coll.: Univ. Mus., Tokyo

158
Jars with pointed bases: type found in
Kyoto region, late-middle/late Jō-
mon period

159
Jar with spout: moulded and impress-
ed decoration, clay, H. *c.* 20 cm., late-
middle Jōmon period, Kanto Plain

160
Jar with spout: moulded decoration,
H. 11.5 cm., late Jōmon period,
Iwate pref., Meiji Univ. Mus., Tokyo

161
Jar: undulating rim, incised decoration, H. *c.* 50 cm., late-middle Jōmon, Chiba pref., Nat. Mus., Tokyo

162
Plate: impressed, moulded decoration, clay, L. 16.6 cm., Jōmon, Fukuda shellmound, Ibaraki pref.

163
Censer-shaped vessel, clay, H. 12.6 cm., late Jōmon period, Numazu shellmound, Miyagi pref.

164
Plate: incised design, stone, L. 14.5 cm., late Jōmon period, Numazu shellmound, Miyagi pref.

165
Stem-cup, clay, D. 21 cm., late Jōmon period, Kamegaoka, Aomori pref.

166
Bowl with foot: scalloped rim, clay, late Jōmon period, Kamegaoka, Aomori pref., Nat. Mus., Tokyo

167
Jar with pointed base: undulating rim, clay, H. 26 cm., late Jōmon period, Shiga pref., Univ. Mus., Tokyo

168
Vase: incised decoration, clay, H. 11 cm., late Jōmon period, Aomori pref., Nat. Mus., Tokyo

169
Jar, clay, H. c. 25 cm., early Yayoi period, Itazuke, Fukuoka pref.

170
Jar: scratched decoration, clay, H. 17 cm., Yayoi period, Itazuke, Fukuoka pref., Meiji Univ. Mus., Tokyo

171
Wide-necked vase, clay, H. 14 cm., early Yayoi period, Itazuke, Fukuoka pref.

172
Jar: impressed decoration, clay, H. 25 cm., early Yayoi, Nagoya pref.

173
Jar: incised decoration, clay, H. 16 cm., early Yayoi period, Osaka region

174
Pitcher: pierced foot, incised decoration, clay, H. 27 cm., middle Yayoi period, Nara region

175
Vase: colours on clay, H. 11.5 cm., early Yayoi period, Karako, Nara pref., Karako Mus.

176
Stem-cup with lid: applied decoration, clay, H. 22 cm., middle Yayoi period, Osaka, Nat. Mus., Tokyo

177
Vase: relief design, clay, H. 18 cm., middle Yayoi period, Fukushima pref., Nat. Mus., Tokyo

178
Vase: incised decoration with applied medallions, clay, H. 36 cm., middle Yayoi, Tokyo

179
Vase with faces on 2 sides: incised decoration, clay, H. 25 cm., middle Yayoi period, Fukushima pref.

180
Jar: distinct median line, bronze, H. 34 cm., middle Yayoi period, Nagasaki pref., Nat. Mus., Tokyo

181
Vase with face: scratched decoration, clay, H. 68.5 cm., Yayoi period, Ibaraki pref., Nat. Mus., Tokyo

182
Cup with large pierced foot: rope impressed, incised decoration, clay, H. 36.5 cm., Yayoi period, Okayama pref.

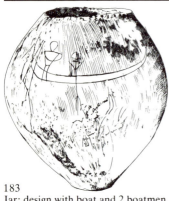

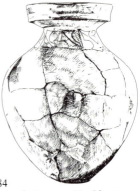

183
Jar: design with boat and 2 boatmen, clay, H. 28 cm., late Yayoi period, Karako, Nara pref., Nat. Mus., Tokyo

184
Vase: *haji* ware, H. 39 cm., early Tumulus period, Okayama pref., Nat. Mus., Tokyo

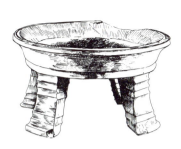

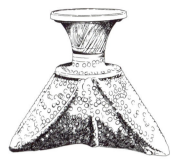

185
Plate with 4 legs, jasper, H. 12.6 cm., early Tumulus period, Okayama pref., Nat. Mus., Tokyo

186
Bottle: *sue* ware, H. 14.2 cm., late Tumulus period, Aichi pref., Nat. Mus., Tokyo

187
Vase: decorated with human figures, animals: *sue* ware, H. 33.5 cm., late Tumulus period, Nat. Mus., Tokyo

188
Oven and cooking pot: *haji* ware, H. *c.* 55 cm., late Tumulus period, Hyogo pref., Nat. Mus., Tokyo

189
Jar: ash-gray glaze, H. 32 cm., Asuka period, Nat. Mus., Tokyo

190
Urn: *san-ts'ai* (three-colour) ware, H. 15.8 cm., Nara period, Nat. Mus., Tokyo

191
Teppachi bowl: *san-ts'ai* ware,
D. 27 cm., Nara period, Shōsō-in,
Nara pref.

192
Dish: *san-ts'ai* ware, D. 37.5 cm.,
Nara period, Shōsō-in, Nara pref.

193
Jar: *sue* ware, H. 29 cm., Heian
period, Keio Univ. Mus., Tokyo

194
Jar: decorated *sue* ware, H. 40.3
cm., Heian period, Keio Univ. Mus.,
Tokyo

195
Jar with 3 feet: *sue* ware, H. 12 cm.,
Heian period, Nat. Mus., Tokyo

196
Vessel with spout, green-glazed
pottery, H. 25 cm., Heian period,
Gumma pref. Mus.

197
Jar: *sue* ware, incised decoration, H. 39.5 cm., Kamakura period

198
Jar: old Seto ware, H. 27.3 cm., Kamakura period, Nat. Mus., Tokyo

199
Long-necked vase: Tokoname ware, H. 28 cm., Kamakura period, Tokoname Mus., Aichi pref.

200
Jar: *sue* ware, H. 27.5 cm., Kamakura period, Ishikodera Temple, Yuyama, Ehime pref.

201
Vase: Seto ware, glaze decoration, H. *c.* 25 cm., Kamakura period, Nat. Mus., Tokyo

202
Bowl: Tokoname ware, D. 30 cm., Kamakura period, Tokoname Mus., Aichi pref.

203
Jar: Shigaraki ware, incised decoration, H. 35 cm., Muromachi period

204
Altar vase: old Seto ware, H. 26 cm., Muromachi period

205
Kettle, iron, D. 24.5 cm., Muromachi period, Kumano Shrine, Wakayama pref.

206
Tea ceremony kettle, iron, D. 25 cm., Muromachi period, Nat. Mus., Tokyo

207
Incense-burner, lacquer on wood, woven wood top, D. 13 cm., H. 9.5 cm., Muromachi period

208
Altar bowl, glazed stoneware, *Namban* style, D. 20 cm., Momoyama period, Mus. of Namban Art, Kobe

209
Tea bowl, called Ayame, early Karatsu ware, D. 12.2 cm., Momoyama period

210
Sake flask: Tamba ware, H. 27 cm., Momoyama period

211
Cup: Shino ware, D. 27 cm., H. 13.5 cm., Momoyama period, Suntory Gallery, Tokyo

212
Tea jar: Bizen ware, H. 31.5 cm., Momoyama period

213
Water vessel, called Yabure bukuro, Iga ware, H. 21 cm., Momoyama period

214
Incense-burner: decorated with a lion, Oribe ware, H. 21 cm., Momoyama period, Nat. Mus., Tokyo

215
Vase, called Namazume, old Iga ware, H. 27 cm., Momoyama period

216
Tea jar: Bizen ware, H. 10 cm., Momoyama period

217
Water bowl: Chōsen Karatsu ware, H. 17.3 cm., Momoyama period

218
Sake flask: old Bizen ware, H. 29 cm., Momoyama period, Nezu Mus., Tokyo

219
Small jar: Bizen ware, H. 26.5 cm., Momoyama period

220
Water jar: old Karatsu ware, H. 30 cm., Momoyama period

221
Dish, called Nadeshiko, red Shino ware, D. 16.8 cm., Momoyama period

222
Dish: Karatsu ware, D. 36.5 cm., Momoyama period

223
Cup: willow decoration, Shino ware, D. 24.4 cm., H. 6.4 cm., Momoyama period

224
Lidded box, Oribe ware, H. 13 cm., L. 22 cm., W. 19 cm., Momoyama period

225
Cup used as an incense-burner; Shino ware, H. 8 cm., Momoyama period

226
Tea pot: Oribe ware, H. 28 cm., Momoyama period

227
Vase: old Tamba ware, H. 26 cm.,
Momoyama period

228
Sake flask: Nabeshima ware, H.
30.7 cm., early Edo period

229
Vessel with spout, old Takatori
ware, H. 22.3 cm., Edo period

230
Jar by Nonomura Ninsei, enamel
decoration, H. 29.3 cm., Edo
period, Nat. Mus., Tokyo

231
Jar: Karatsu ware, underglaze deco-
ration in black iron glaze, H. 16.2
cm., mid-17th c.

232
Tea bowl, called Daitoku by Chōjirō,
black *raku* ware, H. 8.5 cm., Momo-
yama period

233
Vase, called Jurōjin, Iga ware, H. 28 cm., Edo period, Nezu Mus., Tokyo

234
Dish: design of buckwheat in flower, Nabeshima ware, D. 30.3 cm., Edo period

235
Dish: old Kutani ware, D. 48 cm., Edo period

236
Dish: old Kutani ware, D. 35 cm., 18th c., Nat. Mus., Tokyo

237
Cup with handle: pierced and inlaid, Bizen ware, D. c. 30 cm., Edo period

238
Tea pot by Mokubei, applied decoration, H. 9.5 cm., Edo period

239
Pitcher: Banko ware, H. 15 cm., late 18th c.

240
Tea bowl by Kenzan, H. 8 cm., late 17th c.

241
Square bottle: decorated with European figures, old Imari ware, H. 19 cm., Edo period

242
Jar by Nonomura Ninsei, H. 43.3 cm., Edo period, Idemitsu Gallery, Tokyo

243
Vase: Hirasa ware, design of flowers and birds, H. 36 cm., late 19th c.

244
Candlestick: decoration with figures, Imari ware, H. 25 cm., Edo period

245
Haniwa monkey, clay, H. 28 cm., late Tumulus period, Ibaraki pref., Nat. Mus., Tokyo

246
Haniwa dog, clay, H. 46.3 cm., late Tumulus period, Gumma pref., Nat. Mus., Tokyo

247
Haniwa boar, clay, H. 50 cm., late Tumulus period, Gumma pref., Nat. Mus., Tokyo

248
Haniwa horse in harness, clay, H. 87.5 cm., late Tumulus period, Nat. Mus., Tokyo

249
Haniwa turkey, clay, H. 55 cm., late Tumulus period, Gumma pref., Nat. Mus., Tokyo

250
Koma inu (lion-dog): old Seto ware, H. 28 cm., Muromachi period, Nezu Mus., Tokyo

251
Quail by Namejo, bronze, H. *c.* 10 cm., Edo period, Nat. Mus., Tokyo

252
Incense-burner shaped as mandarin duck, bronze, gold, and silver, H. *c.* 8 cm., mid-18th c.

253
Incense-burner (pheasant) by Nono-mura Ninsei, enamel on pottery, H. 17 cm., Edo period, Nat. Mus., Tokyo

254
Haniwa boat, clay, L. 101 cm., middle Tumulus period, Miyazaki pref., Nat. Mus., Tokyo

255
Haniwa boat, clay, L. 80 cm., late Tumulus period, Kyoto region, Nat. Mus., Tokyo

256
Model of a Portuguese carrack, wood, 1616

257
Chisels, borers; stone, pre-pottery age, northern Japan, Nat. Mus., Tokyo

258
Arrowheads; obsidian, flint, pre-pottery age, central and north Japan

259
Needles, hairpins, drop earrings; bone, horn; late Jōmon period, Nat. Mus., Tokyo

260
Hairpins, needles, pendants; bone, horn, ivory; late Jōmon period, Miyagi pref., Nat. Mus., Tokyo

261
Fish-hooks, harpoon-heads; gold, horn, ivory; late Jōmon period, Miyagi pref., Nat. Mus., Tokyo

262
Fish-hooks, harpoon-heads; bone, middle Yayoi period, Kantō Plain, Nat. Mus., Tokyo

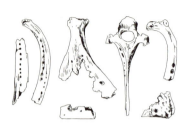

263
Oracle bones, early Yayoi period, Kanagawa pref., Nat. Mus., Tokyo

264
Hunting scene: design on a bronze bell *(dōtaku)*, late Yayoi period, Kagawa pref.

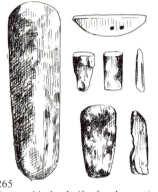

265
Axes, chisels, knife for harvesting rice; stone, late Yayoi period, Nara pref., Nat. Mus., Tokyo

266
Mould for sword-making, sandstone, L. 50 cm., middle Yayoi period, Fukuoka pref., Nat. Mus., Tokyo

267
Sword, bronze, L. 29 cm., late Yayoi period, Kumamoto pref., Nat. Mus., Tokyo

268
Sword and halberds, bronze, L. 20 to 35 cm., Yayoi period, central Japan, Nat. Mus., Tokyo

269
Stirrups, bronze, H. 27 cm., late
Tumulus period, Fukuoka pref.

270
Stirrups, inlaid metal, H. *c.* 25 cm.,
Edo period, Mus. of Namban Art,
Kobe City

271
Saddle, lacquered and inlaid wood,
Kamakura period

272
Saddle, lacquered wood, Momoyama
period, Nat. Mus., Tokyo

273
Saddle with Latin inscription, lac-
quer on wood, Momoyama period,
Univ. Mus., Kyoto

274
Trappings, gold, silver, bronze; late
Tumulus period, Nara pref., Nat.
Mus., Tokyo

275
Bracelets, shell, early Yayoi period, Yamaguchi pref.

276
Bracelet, ritual objects; stone, jasper; early Tumulus period, Mie pref., Nat. Mus., Tokyo

277
Armour and helmet, iron, late Tumulus period, Kyoto region, Nat. Mus., Tokyo

278
Breastplate from suit of armour, iron, middle Tumulus period, Hiroshima pref., Nat. Mus., Tokyo

279
Helmet, iron, late Tumulus period, Hyogo pref., Nat. Mus., Tokyo

280
Haniwa quiver: *chokkōmon* decoration, clay, H. 150 cm., Tumulus period, Kyoto region, Nat. Mus., Tokyo

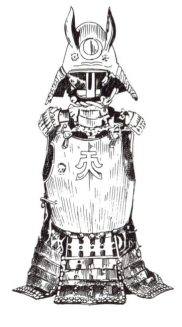

282
Helmet, iron, H. 25 cm., Muromachi period

281
Helmet (upper part), beaten iron, Momoyama period

284
Helmet visor, iron, Muromachi period

283
Suit of armour with helmet, iron and silk lacing, Muromachi period, Nat. Mus., Tokyo

285
Sword pommel, bronze, D. 12 cm., late Tumulus period, Fukuoka pref., Nat. Mus., Tokyo

286
Sword guard: decorated with Portuguese ship, D. 7.5 cm., Momoyama period

287 Sword guard, iron and bronze, Edo period

288
Sword guard: decorated with 2 dragons by Seizui, H. 8.5 cm., late 19th c.

289
Sword guards: decorated with stars and crosses, D. 7.5 cm., Edo period

291
Censer, bronze, L. 36.5 cm., Kama-
kura period, Ryūkoin Temple,
Wakayama pref.

290
Censer, brass, L. 36 cm., Asuka
period, Nat. Mus., Tokyo

292
Hanging gong, bronze, L. 24 cm.,
H. 9.5 cm., Heian period, Zenrinji
Temple, Kyoto pref.

293
Standing gong, bronze, H. 97 cm.,
Nara period, Kōfukuji Temple,
Nara pref.

294 Buddhist ritual objects, bronze, Kamakura period, Iwayadera Temple,
Aichi pref.

295
Ritual bell *(dōtaku):* linear decoration, frieze of stags, bronze, H. 60 cm., Yayoi period, Nat. Mus., Tokyo

296
Ritual Object *(vajra),* gilt bronze, H. 25 cm., Heian period, Nat. Mus., Tokyo

297
Christian bell, bronze, H. 60 cm., 1577, Shunkoin Temple, Kyoto pref.

298
Back of No. 297

299 Bell, bronze, H. 80 cm., 19th c., Mus. of Namban Art, Kobe City

300
Ewer, bronze, H. *c.* 30 cm., Nara period

301
Brazier with 5 feet, marble, H. *c.* 25 cm., Nara period, Shōsō-in, Nara pref.

302
Head of a staff: dragon design, bronze, H. (head): 30 cm., Muromachi period, Nat. Mus., Tokyo

303
Buddhist pendant ornament *(keman)*, gilt bronze, relief and openwork, H. 32 cm., L. 29 cm., Heian period

304
Altar pendant of Yakushi Nyorai, wood, Kamakura period

305
Buddhist abbot's staff, gilt bronze, L. 88 cm., Heian period, Todaiji Temple, Nara pref.

306
Ornaments: 7 radiating appendages, bronze, D. 12.5 cm., Yayoi period, Kagawa pref., Nat. Mus., Tokyo

307
Mirror with fine lines, bronze, D. 22 cm., middle Yayoi period, Osaka pref., Nat. Mus., Tokyo

308
Mirror: TLV motif, bronze, D. 15.6 cm., middle Yayoi period, Saga pref., Nat. Mus., Tokyo

309
Mirror with 4 houses, bronze, D. 23 cm., early Tumulus period, Nara pref.

310
Mirror with *chokkōmon* motif, bronze, D. 28 cm., early Tumulus period, Nara pref.

311
Mirror with 6 bells around periphery, bronze, D. 13 cm., late Tumulus period, Ibaraki pref., Nat. Mus., Tokyo

312
Mirror, bronze, D. 23 cm., Kama-
kura period, Saidaiji Temple, Nara
pref.

313
Mirror, bronze, D. 22.5 cm., Muro-
machi period

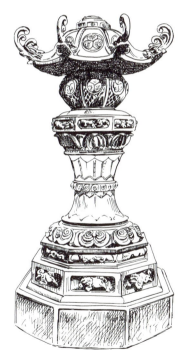

314
Mirror, bronze, D. 24 cm., Momo-
yama period, Nat. Mus., Tokyo

316
Coin (value, one *bu*): in circulation,
18th and 19th c., silver, H. 1.5 cm.

315
Lantern: crest of Tokugawa family,
copper, late 17th c., Nikkō, Tochigi
pref.

317
Mask, clay, D. 14.5 cm., late Jōmon
period, Univ. Mus., Tokyo

318
Gigaku mask, colours on wood, H.
c. 22 cm., Nara period, Nat. Mus.,
Tokyo

319
Bugaku mask for performing Raryō-
ō, wood, H. 38 cm., Heian period,
Kanzeonji Temple, Fukuoka pref.

320
Bugaku mask for performing Chikyū,
colours on wood, H. *c.* 25 cm., Heian
period, Kasuga Shrine, Nara pref.

321
Bugaku mask, red lacquer on wood, H. *c.* 25 cm., Kamakura period, Tsurugaoka Hachimangū shrine

322
Nō mask: *Ko omote,* lacquer on wood, H. *c.* 25 cm., Muromachi period, Nat. Mus., Tokyo

323
Nō mask, lacquer on wood, H. *c.* 23 cm., Momoyama period, Nat. Mus., Tokyo

324
Nō mask, lacquer on wood, H. *c.* 24 cm., Edo period, Nat. Mus., Tokyo

325
Incense box in the shape of Oto Goze by Ninnami Dohachi, H. 11.5 cm., pottery, early 18th c.

326
Lidded vase, red lacquer, H. 32 cm., Muromachi period

327
Lantern, bronze openwork, H. 31 cm., Muromachi period, Nat. Mus., Tokyo

328
Ink-stone box by Kōetsu, *makie* and lacquer on wood, H. 13 cm., L. 26 cm., W. 22 cm., Edo period

329 Tray, lacquer on wood, (side): 32.5 cm., early Edo period

330
Cross with Buddha in centre, cast iron, mid-19th c.

331
Fumi-e representing Christ, metal, H. 13 cm., L. 19 cm., Edo period, Nat. Mus., Tokyo

332
Fumi-e representing the Virgin Mary, wood, H. 11.6 cm., Momoyama period, Nat. Mus., Tokyo

333
Box for ink-sticks *(suzuribako)*, *makie* lacquer, H. 4 cm., mid-17th c., Nat. Mus., Tokyo

334 Box decorated with Europeans, lacquer and gilt on wood, (side): 42 cm., Momoyama period

335
Chalice decorated with flowers and crosses, lacquer and gilt on wood, H. 7 cm., Momoyama period

336
Container for Eucharist, lacquer, mother-of-pearl on wood, D. 12 cm., Momoyama period, Kanagawa pref.

337
Inrō (seal/medicine case), *ojime* (cord) *netsuke;* lacquer, painted wood, H. 7 cm., 18th c., Nat. Mus., Tokyo

338
Powder box, lacquer on wood, H. 45 cm., Momoyama period, Nat. Mus., Tokyo

339
Sake flask, carved bamboo, H. 25 cm., mid-17th c.

340
Flower holder by Minkoku, wood, H. *c.* 30 cm., late 18th c.

341
Small Chinese chest *(karabitsu)*, *makie* lacquer, mother-of-pearl inlay, H. 30 cm., Heian period

342
Sutra box, gilt bronze, H. 25 cm., L. 38.5 cm., Heian period, Kimpusenji Temple, Nara pref.

343
Sutra box, bronze with relief in gilt bronze and silver, 1164, Itsukushima Shrine, Hiroshima pref.

344
Top of No. 343

345
Box, lacquer on wood, H. 13 cm., L. 40 cm., Muromachi period, Kumano Shrine, Wakayama pref.

346
Sutra box, gilt bronze with openwork, H. 10 cm., L. 30 cm., 1535, Yōhōji Temple, Kyoto pref.

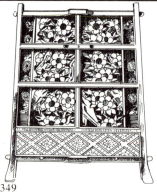

347 Ink-stone box, *makie,* lacquer, inlay on wood, H. 8 cm., L. 24 cm., W. 23 cm., Muromachi period

348
Cabinet, wood and bronze, H. 77 cm., Muromachi period, Daifukuji Temple, Shizuoka pref.

349
Cabinet, lacquered wood and metal, H. 89 cm., Muromachi period, Daifukuji Temple, Shizuoka pref.

350
Chair, *makie* and lacquer on wood, H. 105 cm., Momoyama period, Tankoji Temple, Kyoto pref.

351
Reading stand, *makie* and lacquer on wood, H. 57 cm., Momoyama period, Nat. Mus., Tokyo

352
Chest and mirror, *makie* and lacquer on wood, H. *c.* 1 m., Momoyama period

353
Chest and mirror, *makie,* lacquer, and inlay on wood, H. *c.* 1 m., Edo period, Nat. Mus., Tokyo

354 Chest of drawers, *makie* and lacquer on wood, H. 79 cm., Momoyama period, Kōdaiji Temple, Kyoto pref.

355 Jewel box, *makie* and lacquer on wood with mother-of-pearl and bronze inlay, H. 13 cm., Momoyama period, Nat. Mus., Tokyo

356 Decorative panel: the 3 Wise Monkeys by Hidari Jingorō, colors on
 wood, 17th c., Tōshōgū mausoleum, Nikkō, Tochigi pref.

356 Decorative panel: the 3 Wise Monkeys by Hidari Jingorō, colours on
 most important and famous Bodhisattvas (q.v.). From c. 10th century

358
Banner, gilt bronze, H. *c.* 25 cm., Asuka period, Hōryūji Temple, Nara pref.

359
Lantern panel with relief and openwork, bronze, H. 4.63 m., Nara period, Tōdaiji Temple, (cf. No. 13)

360
Transom *(ramma),* colours on openwork, wood, early Edo period, Nishi Honganji Temple, Kyoto pref.

361
Bracket carving: sleeping cat. colours on wood, 17th c., Tōshōgū mausoleum, Nikkō, Tochigi pref.

GLOSSARY

Abbreviations

Budd.	Buddhism
Bur.	Burma
Camb.	Cambodia
Ch.	Champa
Hind.	Hinduism
Ind.	Indonesia
Jap.	Japan
Kor.	Korea
L.	Laos
Mh.	Mahāyāna
P.	Pāli
q.v.	*quod vide*, 'which see'
S.E.A.	South-east Asia
Skt.	Sanskrit
S.L.	Sri Lanka
Th.	Theravāda
Thai.	Thailand
v.	*vide*
VN	Vietnam

Agastya A *rishi (q.v.)*, regarded as the author of the Veda and Sama-Veda (hymns), worshipped in southern India (as the first teacher of the ancient Dravidians), portrayed in Indonesian art.

Airlanga Indonesian ruler (1016–49), born on Bali, who effected the reunification of almost the whole of Java. His reign, a period of intense literary and artistic activity, saw the beginnings of eastern Javanese art.

Aiyanār A local deity worshipped in southern India. Aiyanār is considered to be the son of Śiva and Mohinī (the feminine guise in which Vishnu seduced Śiva).

Amoghapāśa A form of Avalokiteśvara *(q.v.)*, 'with the unfailing noose'.

arhat 'Respectable', 'worthy', one who attains the 4th degree of holiness which enables him to attain total Nirvana as soon as his present life comes to an end (Budd.). The ideal state towards which a Buddhist should strive (Th.).

Avalokiteśvara 'the Lord who looks down' (in compassion); one of the most important and famous Bodhisattvas *(q.v.)*; from *c.* 10th century in China, a female Avalokiteśvara appeared.

avatar (Skt. *avatāra*) descent; the term used for the incarnations of Vishnu, made necessary by the deterioration of the world; traditionally 10 in number, of which Rama is seventh and Krishna *(q.v.)* the eighth.

bakufu literally, government of the tent, headquarters (of the shogun, *q.v.*); originally designated only the headquarters in the field of the shogun; later became synonymous with the feudal military government. Founded by Minamoto Yoritomo in 1190, it ended in 1868 with the restoration of the Meiji emperor.

Bālakrishna Krishna *(q.v.)* as a child.

Banasbati or, better, Vanaspati, 'Lord of the forest', 'tree-king', the name sometimes given to a fabulous bird combining the features of a bird of prey with those of a horned lion (Thai.); sometimes mistaken for the *Kāla (q.v.)*.

Bhāgavatī 'The Happy One', a word used in Champa, especially at Po Nagar at Nha-trang, to refer to Devī *(q.v.)*.

Bhairava 'The Terrible', one of the forms of Maheśvara (Śiva, *q.v.*) and a popular deity in Mahāyāna Buddhism.

bodhighara A building erected around a Bodhi Tree.

Bodhisattva 'Enlightened Being' (Skt.). Th.: a being resolved to reach the state of a Buddha, especially the historical Buddha before he attained Enlightenment; by extension, all the successive Buddhas up to the time of Enlightenment (P. Bodhisatta). Mh.: legendary laymen of exemplary virtue and compassion who refuse to strive to achieve Nirvana in order that they may instead devote themselves to the service of others; the faithful find in them help and protection; although there are countless Bodhisattvas, only certain of them are of particular importance.

Brahmā Lord and creator of the universe and of all beings, disseminator of the Veda and one of the three main Hindu deities. Budd.: the Brahmā gods, inhabiting the highest celestial planes, are the upholders of the Doctrine and intervene on Earth on various occasions in the course of the Buddha's life.

bugaku a spectacle consisting of dances and music introduced into Japan in the 5th century from the Korean kingdom of Silla. Reserved for the imperial court and still performed nowadays (Jap.).

cakra Skt., disc, wheel, arm and symbol of sovereignty, one of the attributes of Vishnu; *v.* Wheel of the Law.

candi or *tjandi:* temple, sanctuary-tower or funerary monument of 'Indo-Javanese' style (Ind.).

celadon light-green coloured glaze; term used for stonewares and porcelains.

chawan tea bowl, an important utensil in the tea ceremony (Jap.).

chedi Thai pronunciation of *cetiya* (P.) or *caitya* (Skt.), a word denoting a religious building in general. In Thailand the word is often used in the narrower sense of a stupa *(q.v.)*.

chokkōmon decorative motif characteristic of the proto-historic civilization in Japan. It consists of straight lines and curves combined in a regularly repeated pattern.

chua VN, Buddhist temple (the sanctuary is usually in the shape of a slanting H).

chün stonewares of the Song period made in Honan province; the glaze is thick and opaque and the basic colours lavender or soft green.

dagaba P., synonym of *thūpa* (Skt. stupa), S.L.

dakkatsu kanshitsu A lacquer technique, a hollow statue consisting of several layers of fabric or paper coated with lacquer and applied to a clay mould which is then removed (Jap.).

Glossary

dēn VN, a national or regional temple, dedicated to a spirit or to the memory of a famous person.

deva, devatā (Skt.) a god, a deity of indeterminate rank; some live on earth, others in celestial palaces on Mount Meru, a mythical mountain, the centre of the universe.

devāle sanctuary of a Brahminic or Mahāyānic deity, S.L.

Devī 'The Goddess', the commonest name for the consort of Siva. She is also regarded as the daughter of the Himalayas.

Dharmapāla guardian, upholder of the Law, a deity of the Mahāyānic and tantric pantheon.

dikpāla guardian, protector of each of the cardinal points or of the heavenly regions.

Di-lac VN for Maitreya *(q.v.)*.

dinh VN, temple of a guardian-spirit, communal temple and communal house.

'dogs of Fo' (i.e. of Buddha) Buddhist lions guarding temples, altars and the home.

dōtaku bronze bells of the Yayoi period. They are embellished with decorative motifs or with scenes of hunting and fishing. Their origin and function are unknown (Jap.).

dvārapāla guardian of a door or of a sacred place.

five-colours (Chinese, *wu-ts'ai*) Sino-Siamese polychrome porcelain of the Ayuthia and Bangkok periods (18th–19th centuries), Thai. *pen-carang,* pronounced *bencharong.*

fumi-e 'stamping on images'; the Japanese were made to trample underfoot a Christian image to prove that they had renounced Christianity.

Gajasimha a mythical animal, a lion with the head or trunk of an elephant.

ganas 'tribe', demigods attendant on Śiva; they are divided into nine classes.

Ganeśa 'Chief of the *ganas*', an elephant-headed deity, the son of Śiva and Pārvatī (one of the names of Devī, *q.v.*).

garuda mythical bird that generally combines the features of a bird of prey, a feline and a human being (S.E.A.); king of the birds, the enemy of serpents and Vishnu's mount.

gigaku a ceremonial dance originating in central Asia and introduced into Japan through the Korean kingdom of Pakche (Jap.).

gopura carriage-gateway, monumental gate of a town or temple.

Gotama P., or Gautama (Skt.), the name of the historical Buddha—the name is that of the paternal clan, descended from Gotama, the ascetic.

haji(-ki) *Haji* ware, the name of the pottery intended for domestic use in Japan, was made during the proto-historic period (3rd–12th centuries).

hamsas mythical geese living in the Himalayas. The *hamsa* is ridden by Brahmā *(q.v.)* and sometimes by Varuna, the god who is the guardian of the West.

Hangul, Han'gul The Korean alphabet created in 1446 by a commission of scholars brought together by King Sejong. It originally consisted of seventeen consonants and eleven vowels, but nowaday has only fourteen consonants and ten vowels.

haniwa 'clay ring', proto-historic Japanese funerary figurines (5th–7th centuries), which were deposited outside the tumulus. At the beginning of the *Kofun* (ancient grave-mound) period, they were merely hollow, clay cylinders, but later they evolved into figures modelled in the round.

Harihara a composite deity; a combination of Hari, a title of Vishnu, *(q.v.)* and Hara, a title of Śiva, who has characteristics of both deities.

Hevajra a terrible manifestation of the transcendent Buddha, Akshobhya; a mystical guardian deity of lamaism.

Hō-phap VN for Dharmapāla *(q.v.)*.

hwagak Korean decorative technique. A painted design is applied to thin scales of ox-horn which are then stuck on to an object, the joints between them being held together by sticks of bone. This technique was employed during the later part of the Yi period (18th–19th centuries).

ichiboku Japanese technique by which a statue is carved from a single block of wood, in contrast to *yosegi (q.v.)*.

Ichiji Kinrin Nyorai (Skt., Tathagata) supreme title of the Buddha in Esoteric Buddhism (Jap.).

igarakuri Japanese bronze-casting technique that consists of casting horizontal sections of a statue that are then stacked to build a statue of considerable height.

inrō 'seal holder', small usually rectangular pill-box (Jap.), attached to the belt by means of a silk cord having a *netsuke (q.v.)* or toggle at its end.

irimoya a type of roof characteristic of Buddhist architecture during the Kamakura period (1185–1333) (Jap.).

Jātaka The 'Births' (rebirths), canonical stories (547 texts called 'the 550 *Jātaka*') of the previous lives (animal, divine, human) of the Buddha in the course of his long progression towards the Final Birth.

ji Japanese word for a Buddhist temple, e.g. Hōryūji.

Jimmo Ten a guardian king (Jap.).

jinja Japanese name for a Shintō sanctuary, e.g. *Kasuga-jinja*.

Jōmon the name of the oldest prehistoric Japanese pottery. The word means 'cord-marked'. The Jōmon period is subdivided into five phases: proto-Jōmon (11th–6th millennia B.C.), early Jōmon (6th–3rd millennia B.C.), middle Jōmon (3rd millennium B.C.), late Jōmon (2nd millennium B.C.) and final Jōmon (1000–400 B.C.).

kabuki This type of spectacle (Jap.) was originally a mere dance, but developed in the 16th century into a theatrical play with several actors. Such theatrical entertainment was enjoyed by the masses when first introduced and is still very popular today. Its most famous playwright was Chikamatsu Monzaemon (1653–1724).

Kāla The 'Time'—one of the names of Yama *(q.v.)*, the god of the dead. The word is often used to denote the grotesque mask of a monster's head known as *kīrtimukha (q.v.)*.

kalan the name for a sanctuary-tower in Champa.

Kara-e painting in the Chinese style, executed during the Heian period (794–1185) (Jap.).

Kāśyapa (Skt.; P. Kassapa), one of the Buddhas of the Past, the 24th immediate predecessor of the historical Buddha, Gotama.

kendi a type of ewer with a bulging spout peculiar to S.E. Asia; the potters of China and Thailand (Sukhothai period) often produced such ewers in the shape of animals.

kinnara, kinnarī (or *kinnaras*) mythical beings, half-human and half-horse (or half-bird), who dwell in the Himalayas (Budd.).

kīrtimukha 'Face of glory', a lion-like mask without arms; originally a scroll-like ornament, occasionally serves as a mount for deities; often referred to as *Kāla (q.v.)*.

Kofun bunka (civilization of grave mounds, tumulus or ancient tombs). This proto-historic Japanese civilization (3rd–7th centuries) is characterized by the building of huge tombs for emperors and princes.

Kongara acolyte, protector of the faith in Esoteric Buddhism (Jap.).

Glossary

Krishna The 'Black', 'the one who is dark-skinned', the 8th *avatāra (q.v.)* of Vishnu and one of his most popular manifestations; often regarded as the Supreme Being.

Kshitigarbha 'He whose matrix is the Earth', the name of a Bodhisattva (Mh.).

kuei a bronze ritual vessel for holding grain, standing on a low, slightly flaring foot-ring; sometimes has handles; may be known as *yu,* a name also given to tripod ewers.

kut a funerary stele erected behind or above the funerary casket (Ch., late cults).

kuti (Skt., P.) hut, cell of a monk.

Kūya Shōnin a preaching monk of the Jōdō sect of Buddhism (Jap.).

Kyanzittha the name of one of the sons of Aniruddha (Bur.); a fervent Buddhist, one of the greatest rulers of Pagan (1084–1113), and the uniter of Burma.

Lakshmī Goddess of good luck and of beauty, consort of Vishnu and mother of Kāma, the god of love; *v.* Śrī.

Lokanātha 'Lord of the world', one of the names of Avalokiteśvara *(q.v.).*

Lokapāla a Guardian of the Universe. There are eight of them in Hinduism (guarding the cardinal points and the intermediate quarters).

maebyong Korean name for the Chinese *mei-p'ing* ('prunus-blossom') vase with an elongated neck and bulging shoulders, intended to hold a branch of prunus-blossom, dating from the Sung period (960–1279).

Mahāparinirvāna The 'Great Final Blowing-out' (Budd., Skt., P. *Mahāparinibbāna*), which occurred, according to tradition, at Kuśinagara on the night of the full Moon of Kārttika (Nov.) 543 B.C.; the death of the Buddha in the sense that it is the final stage of the series of rebirths.

Mahāyāna Skt., 'Great Vehicle' or, more literally, 'Great means of progression'. This is the name given to this doctrine, born of early Buddhism, by its adherents, who consider that it provides the most efficacious path to salvation by according a vital role to the Bodhisattvas *(q.v.)* and to the transference or sharing of their merits.

Mahishāsuramardinī an aspect of Devī *(q.v.)* who destroyed the buffalo-demon, Mahisha.

Maitreya 'The Compassionate One', the future Buddha who is at present in the Tushita heaven until his final, human birth (Th., P. Metteyya); one of the principal Bodhisattvas.

makara a mythical aquatic animal combining the features of a crocodile with those of a dolphin; it has a trunk, large teeth, two feet and a tail that tends to be transformed into a foliated scroll.

makie Japanese lacquer technique in which metallic dustings of gold or silver are sprayed on wet lacquer to produce a design in relief.

mandala (Skt.) a circular figure, symbolic of the universe.

mandapa open hall, pavilion, pillared vestibule.

Mañjuśrī 'Pleasant splendour/glory', one of the principal Bodhisattvas of Mahāyāna Buddhism and of Tantrism, sometimes represented seated on a lion.

Māra One of the greatest gods in the Domain of Desires and of Death (in his role as the one who places obstacles in the way of those who strive for Enlightenment and Nirvana); he is regarded as the Tempter, as Satan.

Māravijaya 'Victorious over Māra', an epithet applied to the Buddha who routed the demon hosts that had been sent to attack him and thereby forced Māra to acknowledge his superiority; symbolized by the gesture

of touching the Earth, of calling the Earth to witness *(bhūmisparśa mudrā)*.

Mātali Indra's charioteer who as Indra's companion and confidant frequently accompanies him on visits to Earth.

mishima Japanese word for Korean *punchong (q.v.)* ceramics from the early Yi period (1392–1910).

Moggallāna or, better, Mahāmoggallāna (P.; Skt. Maudgalyāyana); with Sāriputta (Sāriputra), one of the great disciples of the Buddha, famed for his command of supernatural powers.

mokushin kanshitsu a lacquer process that consists of covering a wooden shape with several layers of fabric (linen) soaked in lacquer and completing the modelling of the statue with a paste made from starch, sawdust and incense-powder mixed in liquid lacquer (Jap.).

mondop Thai pronunciation of *mandapa (q.v.)*.

mudrā (Skt.) a seal, mark, a gesture of the hands and fingers to which a mystical significance is attached (v. The Gestures of the Buddha).

Nāga a mythical creature, half-man, half-serpent, having the ability to adopt the form of either; dwells in and is a guardian of subterranean regions and water. *Nagārāja:* king of the *Nāgas*.

Namban ('southern barbarians'), Japanese term for Europeans: *Namban* art resulted from contact between the Japanese and Europeans, who arrived in Japan at the end of the 16th century.

Nat a local god, spirit, or manes of revered people; the cult derives its origin from a probable fusion of animist ideas with borrowings from Buddhist cosmology (Bur.).

netsuke a small button or toggle (Jap.), attached to a cord (usually of wood or ivory) that is used to hold the *inrō (q.v.)* in place and to prevent it from falling from the belt.

nō Japanese theatre whose origins lie in the sacred dances of the Heian period (794–1185). In the 14th century, dialogue was added, extolling heroes or recounting legends. Its most famous playwright was Zeami Motokiyo (1363–1443). This traditional, yet still flourishing, theatre is characterized by its costumes and masks.

ondol a method of heating used in Korea since proto-historic times. It consists of a series of under-floor earthenware pipes circulating hot air (Kor.).

Padmapāni 'The Lotus-bearer', an epithet applied to Avalokiteśvara *(q.v.)* and a particular aspect of his.

pagoda Western term for a tower-like building of several storeys in a Chinese, Korean or Japanese temple complex or for a stupa *(q.v.)*, particularly in China and Burma.

Pattinī the goddess of chastity, worshipped in Sri Lanka; a cult of Brahminic origin introduced from southern India.

Pho-hiên VN for Samantabhadra *(q.v.)*.

Phra Malai Thai., the name of a Singhalese monk. The 'tale' of his visits to Hell and to Heaven is very popular in S.E.A., particularly in Thailand.

pi a disc, symbol of Heaven and possibly of the sun.

pradakshinā (Skt.) rite of circumambulation round a cult object in the auspicious direction, i.e. keeping it to the right.

Prajñāpāramitā 'Perfection of Wisdom', a Bodhisattva of female appearance sometimes looked upon as the (spiritual) Mother of all the Buddhas (Mh.).

prang Thai pronunciation of Skt. *prānga,* and the name used in Thailand to refer to a sanctuary-tower, especially to the tower on a tall, pyramidal

base with a high roof, a feature of temples of the Ayuthia and Bangkok periods.

prāsāt Skt. *prāsāda,* palace, temple; the term is used in the sense of temple (Thai.) or sanctuary-tower (Camb.).

punch'ong, punchong An abbreviation of *punjang chong sagi,* a Korean term denoting a ceramic receptacle with a powdered green glaze. It is applied to ceramics of the early Yi period (1392–1910) destined for domestic use that are decorated and have impressed designs; there is a wide variety of shapes and types. These wares carry on the tradition of the celadon *(q.v.)* wares of the Koryo period. The equivalent Japanese term is *mishima (q.v.).*

Quan-ām VN, Avalokiteśvara *(q.v.)* in a feminine form, especially as Quan-ām, 'the giver of children'.

rākshasa Skt., a type of nocturnal demon, generally evil, often terrifying.

ratha chariot, or by extension rock.

rishi Skt. (P. *issi*), a sage, hermit, holy men to whom the Vedic hymns are said to have been revealed; their favourite abode is the Himalayas.

sa A Korean word signifying a Buddhist temple, e.g. Pobju-*sa.*

samādhi (Skt., P.) concentration, religious meditation; together with a perfect way of life, this is indispensable for attaining the highest wisdom (*v.* The Gestures of the Buddha).

Samantabhadra 'auspicious/pleasing everywhere', a Bodhisattva sometimes represented seated on an elephant (Mh.).

san-ts'ai ('three-colours', Japanese, *sansai*) pottery (Jap.) of the Nara period (645–793) that has a glaze of two or three colours: green and beige or green, ochre and beige.

Shishiku Bosatsu one of the Bodhisattvas *(q.v.,* Jap.).

shogun (Jap.) general, field marshal; highest military rank in Japan until the Meiji restoration (1868) and also title of the military regent, who exercised the actual political power in Japan.

Śiva one of the great gods of Hinduism, corresponding to the Vedic deity Rudra; redoubtable, a restorer, master of those who practise Yoga. His devotees (Śivaites) regard him as the supreme God, while Buddhists consider him the most powerful of the gods dwelling on Earth.

Skanda or Kārttikeya, the god of war, son of Śiva (exogenous) or of Śiva and Pārvatī (or of Gangā), sometimes of Agni, the god of fire.

Śrī Good luck, glory, prosperity, beauty; the goddess of Good Luck, consort of Vishnu (*v.* Lakshmī); an honorary title (deities, sovereigns, etc.).

Śrīvijaya Sumatran kingdom (Palembang region) that exerted its authority over the Malay Peninsula from the second half of the 8th century until the second half of the 13th. The art of Śrīvijaya is, in the case of Thailand, that of the Malay Peninsula influenced by Indonesian art.

stupa (Skt.) originally a tumulus, the quintessential Buddhist monument, consisting of a dome supported by a base and surmounted by tiers of parasols.

sue(-ki) Sue ware, a high-fire grey pottery, produced in Japan under Korean influence from the 5th–13th centuries; used primarily for offerings and for funerary cults (*suero* means to offer).

Sūrya Sun, Sun-god; he rides in a chariot drawn by horses (usually seven).

suzuribako a box containing a stone against which sticks of Indian ink are rubbed and a water-dropper; the ink is scraped off and then dissolved in water (Jap.).

t'ao-t'ieh (motif) a decoration in the form of a fantastic animal mask.

Tārā 'She who helps to cross', the assistant or consort of Avalokiteśvara

(Mh.); a sort of female Bodhisattva who can form a couple with the transcendent Buddhas (Tantrism).

Tāvatimsa P.; Skt. Trayastrimśa, the Heaven of the Thirty-three gods presided over by Indra, on the summit of Mount Meru, the mythical centre of the terrestrial universe.

temmoku Japanese name for the Chinese ceramics of the Sung dynasty from Che-ch'iang. It is generally used to refer to brownish-black Chien wares.

Tenjiku-yō A Japanese Buddhist style of architecture inspired by Indian architecture.

teppachi a ceramic bowl with a shape inspired by that of the begging-bowls carried by Buddhist monks (Jap.).

tera or *dera* Japanese word for a Buddhist temple, e.g. Kyomizu-*dera*.

thān-diēu VN, for *kinnara* (*q.v.*).

that Thai. for Skt. stupa (*q.v.*).

Theravāda P., 'Doctrine of the Elders', the word used to refer both to the Buddhist sect whose adherents follow the teaching contained in the Pāli Canon and to the Doctrine expounded in this Canon (frequently called Hīnayāna, 'Small means of progression', 'Lesser Vehicle' as the result of an incorrect extension of the term's meaning made, with pejorative intent, by the adherents of Mahāyāna Buddhism, *q.v.*).

Thiên-vüöng VN, for *Lokapāla* (*q.v.*).

ting a tripod cooking vessel of bronze with three solid legs, thus differing from the hollow-legged *li*.

tōmyōseki altar-lamp stones. A Japanese word also used to denote the painted slabs flanking the cists of proto-historic tombs.

torāna door (gate) in the balustrade surrounding a stupa (*q.v.*).

tsuba a Japanese sword-guard, oval in shape and having apertures for the sword blade and a knife. They are often ornately decorated with inlay or piercing.

ts'ung symbol of the earth, 'outside square, inside round', a rectangular polyhedron through which a cylinder passes, extending beyond the top and bottom of the polyhedron.

Uesuge Shigefusa A Japanese nobleman and founder of a clan.

ukiyō-e pictures of the floating world. This name is used to refer to colour and black and white woodblock prints from Japan of the 17th to late 19th centuries.

Umā 'Light', one of the names of the consort of Śiva, *v.* Devī.

Umāmaheśvara a group formed by Śiva (Maheśvara, 'the eminent Lord') seated, embracing Umā; Umāmaheśvaramūrti.

U Thong an archaeological site in Thailand (mainly Neolithic–11th century). Some of the Buddhist sculpture carved in central Thailand from the 13th century to the beginning of the 15th and reflecting influences from various sources is described as being in the 'U-Thong style', but this style's name is not, in fact, derived from the site.

vāhalkada a raised construction at the base of large stupas, its faces oriented towards the cardinal points; characteristic of Sinhalese architecture, S.L.

Vairocana 'The Maker of Brilliant Light', the most important of the five transcendent Buddhas (Mh.), who is distinguished by a special gesture *(bodhyagrī mudrā)*.

Vājimukha A deity with a horse's head, corresponding to the incarnation of Vishnu as Hayagrīva, the destroyer of the predatory demons of the Vedas; there is some risk of confusion with Kalkin, another *avatar* (*q.v.*), of Vishnu, but one who is yet to come.

Glossary

vajra (Skt.) thunderbolt, diamond; the distinguishing feature of the Vajrayāna (the Vehicle of the Diamond, Means of Progression by the Thunderbolt), one of the forms of tantric Buddhism, the third great doctrine of Buddhism with Mahāyāna *(q.v.)* and Therāvada *(q.v.)* Buddhism.

Vajradhara 'Thunderbolt-bearer'—another name for the transcendent Buddha Vajrasattva (pre-eminent in the hexad), the Bodhisattva Vajrapāni or one of the sixteen Vajra-Bodhisattvas (Tantrism).

Van-thù VN for Mañjuśrī *(q.v.)*.

vatadāgē a reliquary-sanctuary with a circular plan; a type of pillared architecture erected around certain stupas, S.L.

Vessabhū P., Buddha of the Past, the 21st of the 24 Predecessors of the historical Buddha.

vihān Thai pronunciation of vihara *(q.v.)*.

vihara a monastery (Budd.), monks' cells or chapels for images (often of considerable size).

vina stringed instrument from India.

Vishnu one of the three great gods of Hinduism, a benevolent preserver and saviour of the world and protector of human beings, who manifests his power by his successive incarnations (Skt. *avatāra, q.v.*). He is usually depicted as a four-armed man holding his attributes:—the disc *(cakra q.v.),* the conch, the mace and the lotus (or the Earth, S.E.A.).

Viśvakarman God of the Heaven of the Thirty-three Gods (*v.* Tāvatimsa), the architect of the universe and overseer of the gods.

Wat, Vat a group of buildings forming a Buddhist monastery (Thailand, Laos, Cambodia), perhaps best translated as 'temple-palace'.

Wheel of the Law *dharmacakra,* Skt. (*dhamma cakka,* P.), the symbol of Buddhist Law as taught by the Buddha (the First Sermon preached in the Deer Park at Sārnāth: 'the Turning of the Wheel of the Law'). The mark of the Wheel appears on the palms of the Buddhas' hands and on the soles of their feet.

Yakshas a class of mythical creatures, sometimes cannibalistic; some are servants of the gods, while others are supposed to have received the teachings of the Buddha and to have become his ardent disciples.

Yama King of Hell, god of the dead, who judges the dead before they can enter the celestial palaces (Budd.).

yamato-e a style of painting of purely Japanese inspiration practised during the Heian period (794–1185).

Yayoi the name of the Japanese Neolithic pottery that succeeded Jōmon pottery. Its name is that of the district of Tokyo where fragments of it were first discovered. The Yayoi period, which lasted for six centuries (3rd c. B.C.–A.D. 3rd c.), is usually divided into three phases of roughly equal duration: early, middle and late Yayoi. Technically only slightly more developed than Jōmon *(q.v.)* ceramics, Yayoi wares differ from them basically by their rounder shapes and much sparser decoration—which may even be totally absent.

yosegi a Japanese technique for constructing a statue by assembling several pieces of wood carved separately, in contrast to the *ichiboku (q.v.)* technique.

Zen Japanese pronunciation of the Chinese *ch'an* (from Skt. *dhyāni,* 'meditation'); a Buddhist sect which was introduced into Japan from China in the middle of the 12th century. It exerted a considerable influence on Japanese art, especially on ink-painting.

zenpōkōen the characteristic shape (resembling a keyhole) of the tumuli of the Great Tomb or Tumulus period (3rd–6th centuries) (Jap.).